OF WOMEN AND THE ESSAY

OF *Women* AND THE *Essay*

AN ANTHOLOGY
FROM 1655 TO 2000

EDITED BY *Jenny Spinner*

The University of Georgia Press

ATHENS

Permissions and credits appear on pages 365–366,
which constitute an extension of this copyright page.

© 2018 by the University of Georgia Press
Athens, Georgia 30602
www.ugapress.org
All rights reserved
Designed by Kaelin Chappell Broaddus
Set in 11/13.5 Garamond Premier Pro
by Kaelin Chappell Broaddus
Printed and bound by Thomson-Shore, Inc.
The paper in this book meets the guidelines for
permanence and durability of the Committee on
Production Guidelines for Book Longevity of the
Council on Library Resources.

Most University of Georgia Press titles are
available from popular e-book vendors.

Printed in the United States of America
18 19 20 21 22 P 5 4 3 2 1

Library of Congress Cataloging-in-Publication Data

Names: Spinner, Jenny, editor.
Title: Of women and the essay : an anthology from 1655 to 2000 / edited by
Jenny Spinner.
Description: Athens : The University of Georgia Press, [2018] | Appendix:
Further reading, 1500–2000 — Page . | Includes bibliographical references.
Identifiers: LCCN 2018019195| ISBN 9780820354248 (hardback : alk. paper) |
ISBN 9780820354255 (pbk. : alk. paper)
Subjects: LCSH: American essays—Women authors. | English essays—Women authors.
Classification: LCC PS683.W65 O3 2018 | DDC 824/.0089287—dc23
LC record available at https://lccn.loc.gov/2018019195

CONTENTS

ACKNOWLEDGMENTS

This book, having taken more than a decade and a half to complete, is as old as my marriage to my husband, Peter. It has witnessed the birth of our four sons, Aidan, Quinn, Ciaran, and Finnian, then occasionally tucked itself out of the way while we have raised them. I am grateful most of all to them, my family, for their encouragement and support as I have simultaneously tended to these women essayists. In a decade-plus of research and writing, so many people have come and gone from this project that I cannot hope to name, or even remember, them all. But they left their mark, offering essay leads, asking tough questions about my selections, or providing bibliographic information about essayists they knew and loved, as did, for example, Charles G. Morris II, grandson of Elisabeth Morris. I am particularly indebted to Lynn Z. Bloom, my dissertation adviser at the University of Connecticut, who remains a mentor, a friend, and a fellow cheerleader of women's essays. A fellowship from the University of Connecticut Humanities Institute kick-started my initial recovery work, allowing me to travel frequently to the British Library and to the Beinecke Rare Book & Manuscript Library at Yale University. A summer research grant from Saint Joseph's University during the start of my tenure there helped me continue my work. I am also grateful to Patrick Madden, whom I met while talking women and essays at an Associated Writing Programs conference many years ago. Pat kept checking in over the years to make sure I was still working on this book and reminding me of its value to anyone who studied and cared about essays. Finally, I would like to thank the editors at the University of Georgia Press for their support of the essay, and for adding this book to their fine collection.

OF WOMEN AND THE ESSAY

Omission and Erasure

The primary goal of this book is to pull women writers from the cutting room floor of essay scholarship and return them to their rightful place in the essay canon. The book brings together forty-six women essayists whose work spans nearly four centuries and, in doing so, proves that women have participated in the essay tradition since its modern beginnings in the sixteenth century. Most of their essays fit easily into the main narrative of the development of the modern essay. One of the reasons I attempt to insert these writers back into the essay tradition by way of a history of the essay itself is to demonstrate that very point. The essay form need not contort itself to accept these women as they were or are. Many of them achieved significant success within whatever essay form ruled the day; others bent the rules, though sometimes imperceptibly, to make room for themselves. All told, they represent the missing piece to a larger history of the essay. In our own age, in which women's unrestricted and unchallenged participation in the essay genre is extraordinary only for its ordinariness, it's hard to imagine a need for this argument. Yet in the hands of the scholars and editors working in the field, the essay has long remained a motherless genre. Not only motherless, at times the essay seems to have had no sisters, nor even an adopted aunt. The truth is, these mothers and sisters and aunts have been there all along, helping to write the essay into history. They did so even as they themselves were often erased from critical and literary spheres. Ultimately and significantly, these women were also often erased from a literary canon that perpetuates its own omissions.

This anthology attempts to bring them back into the fold using the very vehicle that ushered them out, or, rather, that helped exclude them in the first place. As Lynn Z. Bloom's research on the essay canon reveals, exposure

by way of an anthology—particularly one designed for a college composition course—offers an essayist a better chance of survival by placing her in the direct sight line of current and potential readers of nonfiction (401). The problem for many women essayists is that editors have often overlooked their work when compiling anthologies. Bias against women writers, and against writers of color even more so, certainly accounts for a portion of the neglect. But bias against the genre of nonfiction is likely responsible as well. In fact, one of the reasons feminist recovery projects may be so late in coming to the essay is that the essay itself has long occupied bottom-shelf status in the hierarchy of literature, despite occasional bursts of revival and renewal that bring the essay up to eye level. Thus, women who write essays endure a second layer of neglect by composing in a historically understudied and underappreciated form.

All told, essay annuals and anthologies to date have done little to record an accurate history of women essayists. In the handful of extant collections attempting to map a history of the essay as a whole, few women appear from periods prior to the twentieth century. Alice Meynell and Agnes Repplier, both writing at the turn of the twentieth century, are included more often than any other women in anthologies from the first half of the century. In more recent collections, Meynell and Repplier are largely absent. Virginia Woolf replaces them and is later joined by Joan Didion and Annie Dillard, Woolf's most oft-anthologized descendants. Popular essay annuals from the early twentieth century represent women just as poorly, primarily promoting the work of male writers.

Critical scholarship on the essay—where we might turn for a broader history and genre study—is no more helpful. In fairness, scholars of the essay are trapped in a catch-22: To undertake a critical analysis of women essayists, scholars must know the work they created, generally by way of anthologies. To include women essayists in anthologies, editors must know their work, generally by way of critical analysis and scholarship. Secondary works on women essayists rarely venture beyond the Female Essay Triumvirate of Woolf, Didion, and Dillard. In one slightly more comprehensive study, *The Politics of the Essay: Feminist Perspectives* (1993), editors Ruth-Ellen Boetcher Joeres and Elizabeth Mittman highlight the work of feminist essayists like Hélène Cixous, Christa Wolf, June Jordan, and Audre Lorde. In their introduction, however, the editors erroneously suggest that "it is really only in the past century that women in greater numbers have begun to claim the essay as a form of their own" (13). Such a pronouncement, even as it is prefaced by a solid argument

about the difficulties of women composing in the essay genre in earlier centuries, ignores the centuries of women writers who did just that.

On the surface, it may appear that women in earlier centuries were simply composing in a man's form, alongside male counterparts, in a literary marketplace men controlled. It is true, after all, that women writers could not hope to publish without considering those marketplace concerns—and the social, cultural, and sometimes even spiritual dictates behind them. But we cannot situate the beginning of women's essay writing at a moment when such concerns were no longer strictures, or even at a point when some women writers boldly threw them off anyway. Doing so disregards the important work of so many of the earliest women essayists. For these writers, the courage was in the act itself (the essaying), even if its form looked, at least superficially, to be an acquiescence to or dutiful replication of the male-authored essay. In some cases, women essayists made the form their own simply by making it at all.

DEFINITIONS

Disagreement about what constitutes an essay in the first place has also hindered the search-and-rescue mission. In his 1921 article "The Field of the Essay," Charles Whitmore complains about the tendency to use *essay* to designate "any piece of prose of moderate length" on "a bewilderingly various subject-matter" (551). When scholars and editors write *essay*, what they really mean, Whitmore argues, is *essay-quality*, that is, the "tone or an attitude" of a work, not the shape of the work itself (557). Whitmore's proposal to rein in use of the term would surely fall on deaf ears in the twenty-first century, when forms are made to be broken, even as we self-consciously make our way through our own bramble of labels including *creative nonfiction, literary journalism*, and *essays*, among others. In our own time, these broader labels often serve as topologic umbrellas for forms within the form. Huddled under the category of *essay*, for example, are literary essays, creative essays, personal essays, nature essays, science essays, political essays, scholarly essays, and more.

In fact, what Whitmore finds problematic—too many essayistic writings bearing the label of *essay*—is actually essential when we begin to chart a history of essays by women. In different ages, the essay itself, but especially the essay as accessed by women, flourished under guises that Whitmore would have relegated to sidebar status: letters, travel sketches, and newspaper and magazine columns, among them. These essayistic writings are an equally important

component of the main story most frequently offered to us by way of such "masters" as Michel de Montaigne and Francis Bacon in the sixteenth century, Richard Steele and Joseph Addison in the eighteenth century, and Charles Lamb and William Hazlitt in the nineteenth century, to name just a few. In fact, if we focus less on form and more on tone and attitude, then we not only create a more inclusive tradition but also begin to understand more acutely how women essayists handled the demands that any form of writing, but especially the more personal essay, made on authors.

The preponderance of essays in this book may be classified as either *personal, informal, literary*, or *belletristic* (choose your own label). Some may take the shape of letters or newspaper columns or biblical meditations, but they share the essayistic qualities of personal presence, inward reflection, and intimacy. Even so, in any given essay, one or more of these qualities may be stylistic maneuvers crafted for effect. Missing from this book is the one type of essay eventually sanctioned for women writers, many of whom took it up with varying degrees of success: the polemical essay. Such essays called for the right of women to be educated, or not; insisted women should have the vote, or not; and pleaded for the end of slavery, or its continuation. This type of essay alone could—and should—fill a book dedicated to a branch of the genre marked less by the whisper of intimacy and more by the noise of impassioned argument. In other words, this subject matter diverts from Montaigne's declaration in his preface to the *Essais*: "I am myself the matter of my book" (2). To write essays as Montaigne did required literary nerve, a determined spirit, a sense of self, and the willingness to put that self out there (however crafted its written version may be). Women essayists had more to weigh than artistic impulse, or even a human "duty" to share themselves, if they were to succeed as writers.

In the twenty-first century, a period that is sometimes criticized for its compulsion to divulge but that also offers essayists unfettered stylistic and thematic opportunities, it can be hard to appreciate the complexity of Montaigne's gutsy pronouncement. To wander about a subject, here offering one's thoughts, here relaying one's observations and experiences, here countering classical or prevailing wisdom, requires an authorization that is both internal—*I grant myself the right to write on such (personal) matters*—and external—*My world (my family, my church, my city, my country) grants me the right to write on such (personal) matters*. The authority behind such a process, which in many ways signaled ownership of textual subjectivity, was no simple matter for the essay's earliest practitioners. What proved tricky, even risky, for Montaigne, who in

this new genre made the author central to the text, was all the more so for his female contemporaries. Any kind of public writing was generally considered inappropriate for women in his era. The little public writing they produced was confined primarily to pious works; female piety was considered inborn, or at least an expectation. Given this climate, the authority of the essayist, sanctioning himself to write of himself, was certainly daring, even for Montaigne. But it was all the more daring, dangerous even, for women writers.

Ultimately, though, the fact that women have not been included in the main historical narrative of the essay has less to do with ongoing arguments over definition than with feminine exclusion. After all, if we are to take Whitmore at his word, if scholars have been quick to label as essays even marginally essayistic writings, there is no reason why the marginally essayistic or just plain marginal writings of women would not be/are not a part of the essay's story—let alone those writings by women essayists such as Eliza Haywood, Fanny Fern, Agnes Repplier, and Katharine Fullerton Gerould that fit easily into the master narrative as it has heretofore been constructed.

FEMININE FORM

One of the greatest ironies of a form so long assigned to the domain of men is that its writers are often portrayed in feminine terms. This characterization leaves unquestioned the incongruous assumption that men were suited to write womanly prose, but not women. In "She: Portrait of the Essay as a Warm Body," Cynthia Ozick suggests that the hallmark of the essay is its femininity, its inner subjectivity (186). But early women writers struggled to claim that subjectivity in their published writings. While it may be considered feminine to look inward, it is men, at least historically, who have been sanctioned to translate that vision into text—though they risk emasculating themselves in the process. In "Emerson and the Essay," for example, William Gass directs readers to see that nineteenth-century familiar essayists like Abraham Cowley and Charles Lamb are "effeminate and sickly, full of resentment and weakness, procrastinators, passive as hens, nervous, unwed" (30). Not to worry, though. For Gass, the feminine aspect of an essay is merely a warm-up for the big (masculine) show: "The essayist is in a feminine mood at first, receptive to and fertilized by texts, hungry to quote, eager to reproduce . . . [but soon] its father will be introduced, a little like the way a woman introduces her fiancé to friends, confident and proud of the good impression he will make" (26). However tongue-in-cheek his argument, Gass accurately captures a common

critical framework that others have taken seriously—and have continued to project.

In contrast, Rachel Blau DuPlessis uses the idea of the essay as "feminized space" to positively highlight the stylistic maneuvers characteristic of the form. For DuPlessis, the essay claims its feminine space "through interruption, through beginning again and again, through fragmentation and discontinuities, but most of all its distrust of system, its playful skepticism about generalization" (34). Cast as such, the feminized space of the essay becomes fertile, strong, purposeful. In the end, it remains a fascinating, frustrating paradox that a wide range of scholars and critics who permit and perpetuate male domination of the essay canon without questioning female writers' exclusion continue to define the essay as a feminine space.

The answer to this paradox lies in our understanding of the climate in which early women essayists wrote. Although the space of an essay may be feminine, essay writing was initially a male affair. It was not a woman who first occupied that space but a white, well-educated, well-traveled nobleman's son who had money and a room of his own. "Intellectual freedom depends upon material things," Woolf famously writes in *A Room of One's Own* (108). Montaigne's dogged habit of essaying over the course of nine years was the product of an age that allowed him moments of peace (granted, amid violent religious civil wars), a class that allowed him periods of leisure, and a gender that spared him quotidian domestic and parental responsibilities. Francis Bacon, Montaigne's English contemporary, recognized this latter benefit. In his oft-quoted essay "Of Marriage and Single Life," Bacon, who himself never married, writes, "He that hath wife and children hath given hostages to fortune; for they are impediments to great enterprises, either of virtue or mischief. Certainly the best works, and of greatest merit for the public, have proceeded from the unmarried or childless men" (23). Like Montaigne, after years of public service, Bacon retired and spent the rest of his life writing, something he could do more easily without the "impediments" of family. Had he a wife and children, his wife would have been responsible for their domestic space, still leaving Bacon some measure of freedom to write. The biographies of the women included in this book are noteworthy for revealing just how many of them juggled enormous domestic responsibilities—marriage, children, ailing relatives, household duties—along with their writing careers.

In the latter years of the Renaissance, women who dared write generally confined themselves to pious works in which they emphasized their devotion and apologized for writing at all. Unlike earlier forms of confessional prose,

whose self-revelation served some greater purpose, Montaigne's writings were an experiment in open-ended reflection. Their ends were their means; their means, their ends. In an age in which negative views of women saturated the intellectual and literary tradition, such an experiment was virtually impossible for women writers. It required an unthinkable leap from pious prose to that which was thoroughly self-indulgent. Moreover, it was widely believed that while women might be capable of recording the details of their private lives, they lacked the capacity to rise above those details to reflect on them (Stanton 4). At the same time, in a complex double bind, what women wrote—namely, that which related to their spiritual lives—*had* to move beyond mere recording in order to fulfill the function that permitted its existence in the first place: helping other women lead pious lives. For women in the sixteenth century to authorize self-study as Montaigne did, for its own sake, seems unfathomable in such a world. And it was—for at least another half century.

FRENCH BEGINNINGS:
MARIE LE JARS DE GOURNAY

Few sixteenth-century women had access to the quality of education Montaigne himself received. This fact further illustrates the challenges women writers faced in making essaying possible. When Montaigne composed his essays, he knew Seneca and Cicero and Plutarch well enough that he could not only converse with them in his writing but also position them against one another. These signature traits of the early essay required wide reading of classical literature, which in turn required facility in Latin. Neither part of the learned reading public whom other writers addressed, nor sufficiently educated to publicly display their learning, most women lacked the authority to speak in published texts—that is, to speak as essayists. Granted, if essay writing in the sixteenth century was subversive, it was subversive for both men and women. But gender very much influenced the impact of essay writing, as Montaigne initiated it, on the writer, on the reader, and on the relationship among the writer, the reader, and the text.

One Renaissance woman who attempted to mimic Montaigne's literary experiment was Marie le Jars de Gournay, the French writer perhaps best known (and most frequently maligned) as Montaigne's *fille d'alliance* or "adopted daughter" (although for centuries following her death, her connection to him was all but erased). In 1584, two years after the publication of its second edition, Gournay began reading Montaigne's *Essais*. That event changed her life.

Montaigne's essays appealed to the independent and spirited young Gournay, who was self-taught in both Latin and Greek and who harbored the same humanist penchant for the classical authors—Virgil, Seneca, Plutarch, and especially Plato—as her male contemporaries. However, it was Montaigne's unique and absorbing self-portrait, his voice on the page, that, according to Richard Hillman, led Gournay to imagine Montaigne as a "spiritual and intellectual 'father'" (7). Four years after reading his work, Gournay visited Montaigne in Paris, establishing the beginnings of a lifelong friendship and literary alliance.

When Montaigne died in 1592, Gournay appointed herself his literary executor. Gournay's role in Montaigne's legacy began with her 1595 edition of his complete essays, to which she affixed a lengthy and exuberant preface. Therein, Gournay defends Montaigne against critics, professes her admiration of his work, and, most significantly, discusses her attempts to imitate him: "I cannot take a step, whether in writing or speaking, without finding myself in his footsteps" (85). But as Hillman explains, Gournay's preface also "engages equally in self-justification, largely in angry feminist terms that do not necessarily serve her argument (or square with Montaigne's own views, for that matter)" (8). In attempting to assume her own voice, rather than simply argue for Montaigne's, Gournay miscalculated the public's acceptance of that experiment. Besieged by criticism when the preface was published, she later retracted it, claiming temporary insanity. Gournay then revised her work and republished it in subsequent editions of the essays.

References to Montaigne and stylistic maneuvers characteristic of Montaigne pervade Gournay's essays and literary criticism. To understand both the possibility and impossibility of a Renaissance woman writer like Gournay duplicating Montaigne's efforts, Cathleen Bauschatz points to a period method of writing rooted in studying and copying an earlier text. According to Bauschatz, the "unwritten assumption" behind this method of imitation is that "the aspirant writer must be very similar to the author he attempts to imitate—if not in language or place in history, then at least in breeding, education, social status, and, most importantly, gender" (352). While Gournay felt connected to Montaigne's intimate voice, his footsteps at some point outpaced hers. Unable to truly imitate him, she got left behind by the fact of her sex. For Gournay to imitate Montaigne's form and achieve her own voice, she had to separate herself from him. She did so in fits and bursts, perhaps one reason why her writing has often been dismissed as disjointed and rambling. Essentially, however, Gournay fell short not only of imitation, but of imitation

made her own. In the development of any literary genre, imitation of or conversation with writers of earlier works often marks the significant twists and turns and straightaways of the genre's journey. Perhaps more than for any other genre, writers of the essay looked to earlier practitioners and texts for validation and motivation. Gournay found corroboration in Montaigne's essays, but it was not enough to overcome the limitations of the age in which she wrote. Furthermore, the connection she felt when reading Montaigne did not fully translate to her attempts to imitate him.

Yet Montaigne's ability to inspire such a connection with Gournay and other Renaissance women, if primarily as *readers* of his self-study, is important, particularly to the development of the essay. Significantly, female readers of Montaigne, not male readers, were generally most receptive to his project. Such is the great paradox of the essay genre and its writers. It is the private nature of Montaigne's essays that most appealed to—indeed, was most directed at—women readers. It is the private nature of essays in general, the intimacy of the writer's self-portrait, that often leads to the genre being termed "feminine." And yet in the form's earliest days, women were the least likely to write and publish essays. In other words, once that private sphere became public through the public, textual space of the essay, women long associated with the private sphere found themselves outsiders once again. In order for her to *essay* anyway, the brave woman writer had to seize the moment, with or without public approval, as Margaret Cavendish would do in the seventeenth century. Alternatively, she had to wait for the genre to evolve in her favor. It would do so in the eighteenth century, when the public-private space of the periodical essay would blur just enough for the woman essayist to slip through the transition.

THE SEVENTEENTH CENTURY

In 1603 John Florio published the first English translation of Montaigne's essays, introducing Montaigne to a host of English readers and writers who had not read him in the original French. Some scholars argue that the essay would have developed in England with or without Montaigne, pointing to the success of the essay in England even as the form never quite caught on in France. Others debate the extent of Montaigne's influence on Bacon, often referred to as the "father of the English essay" or the "father of the formal essay," the latter epithet differentiating his approach from Montaigne's informal one. If we set aside the particulars of who begat whom, we can say without question that Montaigne inspired numerous English writers who openly expressed their ad-

miration of his work and attempted to emulate him. The earliest such writer was the immensely popular Sir William Cornwallis, author of two volumes of *Essays* in 1600 and 1601.

In 1655 Margaret Cavendish, Duchess of Newcastle, published one of the earliest-known essay collections by a woman. Cavendish's *The World's Olio* contains essays on various social, philosophical, historical, and scientific topics, ranging from blushing to monsters to atoms. The book is indeed remarkable for its very existence. Using her own name, not a pseudonym, Cavendish published over two hundred essays on multifarious topics written in a confident, genuine voice. What made Montaigne possible is also, at least to some extent, what made Cavendish possible: money and the absence of domestic responsibilities. Cavendish's education, however, was far inferior to Montaigne's. As the daughter of a wealthy gentry family, Cavendish had access to private tutors, but her education was never a priority. Rather, it was somewhat chaotic, as evidenced by her erratic, multigenre oeuvre marked by spurts of imagination and genius as well as copious errors. Cavendish hated to revise. In "An Epistle to the Reader" that begins *The World's Olio*, she attributes this fault to her "lazy disposition," women's innate inability to spell, and the fact that "there is more Pleasure and Delight in making than in mending." In his 1752 *Memoirs of Several Ladies of Great Britain*, George Ballard writes understandingly of Cavendish's propensity for error, noting that at least the works are her own, which is "preferable to fame built on other people's foundation, and will very well atone for some faults in her numerous productions" (301). Ballard's inclusion of Cavendish in his volume of notable women writers is alone proof that readers well into the eighteenth century knew and appreciated her work.

After serving for two years as a maid to Queen Henrietta Maria, Cavendish married William Cavendish, Marquis of Newcastle, a retired royalist general and a widower with grown children. The marquis reportedly did not pressure his new wife to bear children. While Cavendish's access to public life was limited, she participated in courtly life as a maid. She and her exiled husband lived outside of England for fifteen years until Charles II was restored to the throne. Most of all, like Montaigne, Cavendish had a certain degree of nerve—that is, a desire to write and publish. This aspiration was all the more significant in her case because of the gender barriers she had to cross—or ignore—in order to authorize herself to write in the first place. Virginia Woolf, expressing both the admiration and frustration she felt when reading Cavendish, writes notably, "There is something noble and Quixotic and high-spirited, as well as crack-brained and bird-witted, about her" ("Duchess of Newcastle" 77). Even

in her own time, Cavendish was considered eccentric, not only because of her bizarre dress and mannerisms, but also because of her unfeminine desire, at least by her period's standards, to publish and make a name for herself. In *The World's Olio*, Cavendish boldly declares to her reader that she writes for no greater reason than for her own pleasure: "I have my delight in writing and having it printed; and if any take a delight to read it, I will not thank them for it; for if any thing please therein, they are to thank me for so much pleasure; and if it be naught, I had rather they had left it unread."

Cavendish borrowed from both Montaigne and Bacon in order to make possible the essayistic voice of a haphazardly educated, somewhat sheltered, but determined seventeenth-century woman. In a single essay, she can be both distant like Bacon and confessional like Montaigne. In her essay "Of Painting," included in this book, Cavendish combines aphoristic pronouncement with personal observation and questioning of popular opinions. In effect, she challenges arguments against painting or makeup based on inconsistent moral grounds. Why, she asks, is the male art of "gunpowder, guns, swords, and all engines of war for mischief" praised but the female art of painting condemned? After all, "the one brings love, the other begets hate." Instead, Cavendish argues against the use of makeup because it is "dangerous, ill-favoured, and sluttish," noting that most cosmetics contain mercury and will disfigure rather than enhance. On the other hand, she approves of safer adornments that "give a graceful advantage of the person." While "dressing is the poetry of women," it also benefits the nation both by keeping women occupied and by supporting commercial trade.

Mihoko Suzuki contends that the nature of the essay form itself—"at once impartial and autobiographical, at once authoritative and exploratory" (13)—is what allowed Cavendish to articulate her voice. Were it as simple as that, however, many other women would have followed suit, taking up the essay for the purpose of self-expression or self-study when no other form would accommodate them. The rare few, like Cavendish, who did write essays prior to the eighteenth century required something of Montaigne's spirit, if not the advantages of his life, to adapt the form for their own use. And they risked criticism and censure even as they did so.

THE EIGHTEENTH CENTURY

The eighteenth century marked a significant turning point in the development of the essay form and, in turn, the possibility of engagement for both

male and female writers. Prior to this time, essays first appeared in collected volumes. But in the eighteenth century the essay branched out, claiming space in both new and established forms. It was born in the period's newly established newspapers and magazines and born again in travel writings and letters. For women, the letter was already familiar and approved territory. A woman who wrote letters betrayed no social conventions, at least in the act of composition, for letter writing, considered practical and unpresumptuous, belonged in a woman's domain.

Following a Renaissance revival of the letter, collections of letters enjoyed enormous popularity in the eighteenth century, particularly those purportedly unintended for public scrutiny. Male and female writers purposely exploited this trope. Women could easily separate themselves from the commercial world of publication as well as from any attacks on prose deemed too familiar, too intimate, by claiming their letters were never written for the public eye. After all, one could hardly fault a personal letter for its frankness. Two years before her death, Lady Mary Wortley Montagu handed her letters over to an English clergyman. She included a note telling the cleric the letters should "be dispos'd of as he [thought] proper," thereby sparing herself the responsibility of publication while at the same time ensuring it (qtd. in Halsband, "Introduction to Volume I" xvii). Some of the most familiar and personal essayistic voices of the period are found in letters like Montagu's.

More than anything, though, it was the periodical essay that dominated the literary scene in the eighteenth century and gave rise to the woman essayist. While only a handful of periodicals existed prior to the eighteenth century, by the year 1800, that number reached at least twenty-five hundred titles (Tierney 183). So many new opportunities for publication served a generation of women writers well; they became active participants in the print culture as never before. While women were targeted as an important if not essential component of the reading public, they were also invited to contribute their writings. They most often did so in letters to the editor. But some women were regular contributors of essays, and a handful wrote and edited their own periodicals.

The intimacy that Montaigne had modeled in sixteenth-century France conflicted with the intellectual climate of eighteenth-century England, which celebrated objectivity and a certain detached authorial reserve. However, rather than limit women periodical writers, this conflict proved fundamentally advantageous to them. Women would have had difficulty presumptuously re-

vealing their observations and thoughts to their readers anyway. Instead, they utilized various rhetorical masks that were trademarks of the periodical essay. Indeed, what made the woman essayist possible in the eighteenth century has much to do with the periodical essay's embrace of fiction (via personae and invented anecdotes and observations) as a means of conveying its message.

That the periodical essay had a message served women writers well, too. They were increasingly compelled to use moral intentions as a means of authorizing and legitimizing their works. Essayists writing before the eighteenth century had been left to represent their own ideas and thoughts without literary convention to serve as a buffer. The eighteenth-century periodical's reliance on fiction made it all the more possible for women to participate in the essay genre, extending the realm of the imagination to public discourse while keeping the world at bay through use of those fictional techniques. It allowed writers to adopt variant genders, depending on the purpose of the periodical, the makeup of the readership, and the message. As much as the periodical essay's adoption of fictional elements forced writers to choose the appropriate gender for the perspective and experience they wished to offer, it also gave them the chance to speak from the other side. With their real identities, and sometimes their gender, obscured by pseudonyms, woman writers could invent characters to speak for them when they could not speak for or as themselves.

As the eighteenth century wore on, women were bound increasingly by a new ideology dictating what a woman was and how she should behave. Unlike earlier portrayals of women as innately corrupt, this new philosophy highlighted their inherent goodness. A woman, therefore, was to be a paragon of virtue, the moral guardian of both home and nation. Yet her influence on the nation, as with any involvement in public affairs, must be indirect, by way of her influence on her family. The power of goodness had its price, though. While more women began writing and publishing at this time, they were expected to write in their role as moral guardians, instructing other women how to behave and, especially, how to avoid pitfalls that might cost them their dearest possession: their chastity or their reputation. In the context of this ideology, instructing undoubtedly ranked higher for a writer than merely entertaining—although the best writers often managed to do both. No matter whom, or what, a woman's goodness intended to serve, her writing was to reflect the virtues defining her place in the feminine sphere. Women who honored the code, both in their writing and in their lives, were likely to earn praise, while women who did not were frequently condemned. By the end of the century,

even as it became more acceptable for women to publish their work, the critical success of that work continued to depend on public perception of both the woman behind the text and the moral teacher within the text.

Under the influence of Steele's *The Tatler* and Addison and Steele's *The Spectator*, two of the earliest and most influential periodicals of the century in both England and America, the age-old "woman question" became a literary obsession. That so many English and American periodical writers—male and female—modeled their own essays after the ones appearing in these publications is evidence alone of their impact on the essay form's development and promulgation. Not only did many writers emulate the style of *The Tatler* and the *The Spectator*, but, more importantly, they also emulated its attitude toward women in general and women readers in particular.

Multiple forces influenced how women read and wrote periodicals. These learned responses also directly and indirectly influenced women's decisions as writers and literary entrepreneurs with a product or message to sell. The periodical essayists included in this book readily joined their male colleagues in discussions about what constituted femininity and feminine behavior, as evidenced by their essays on such topics as friendship between women (Frances Brooke); female fashion and the perils of vanity (Eliza Haywood); and women's declining influence on men (Charlotte Lennox). Female periodical essayists certainly were not confined exclusively to such topics. Montagu likely wrote her political periodical *The Nonsense of Common-Sense* mostly in response, and in opposition, to the periodical *The Common Sense*. Judith Sargent Murray's essay on plagiarism, included in this book, is another exception to essays on the popular woman question, although Murray, too, wrote many columns about women's issues.

As the woman question began to dominate the pages of periodicals, and as woman herself became more narrowly defined, the possibilities for feminine expression began to narrow as well. Women writers responded in various ways to the challenge of shouldering the "symbolic baggage" of womanhood (Mack 9). Either because they truly held such values and beliefs or because the success of their writings depended on it, most women adopted the same values and beliefs the larger culture promoted. The periodical essays in this book all present views similar to those promoted in mainstream periodicals and magazines. Brooke's *The Old Maid*, for example, takes a middle-of-the-road position on issues related to courtship and marriage, a favorite topic in the periodical press. Rather than stand up for women at all costs, Brooke's Miss Singleton, in her essay on friendship, criticizes the propensity of women, motivated by jealousy

and pettiness, to gossip about one another. In fact, Miss Singleton stops short of discussing more public aspects of friendship, leaving that matter to "a writer of the other sex," for whom she believes such discussions are more appropriate. In Haywood's *The Female Spectator*, too, women are often castigated for bad choices and poor behavior. So is the woman in Haywood's "Hoops," also featured in this book, who causes a commotion at the market because she insists on bowing to the ridiculous fashion of extended hoop skirts.

Despite views that seemed to differ little from those of their male counterparts, women periodical essayists did, in fact, adapt the genre to their own project—even if such changes were so subtle as to barely distinguish women's writings from men's. One such move was Haywood's invention of an all-female club of contributors to *The Female Spectator*. Male-authored periodicals typically marginalized women's voices, presenting them as evidence of women's follies or including them primarily in service to the voices of the male editors. *The Female Spectator* talked to women from the perspective of women, however. Haywood's club included the personae of a wife, a virgin, a widow, and the Female Spectator herself. That a single editor invented these multiple perspectives does not matter as much as the multiplicity itself. Haywood created a community of voices who shared in the authority of advice giving. Similarly, the multiple voices stitching together Lennox's *The Lady's Museum* represent an alternative conveyance of authority. While the standard male periodical may have presented a number of invented voices, including female ones, it still relegated the final editorial word to a single male voice of authority. *The Female Spectator* and *The Lady's Museum* dispersed that authority among a number of primarily women participants, both real and invented and often indistinguishable from the author's "true" voice.

The woman essayist, and the woman periodical essayist in particular, posed a contradiction in terms to a genre that began overtly to define itself by its first-person interaction with the world. While Montaigne benefited from the secluded study in his château—in his own writing, he perpetuated the image of the French nobleman ensconced in his ivory tower—in reality, and significantly, he spent a good deal of time outside his tower and involved in public life. The ability to maneuver about a public space is essential for the essayist, even as the essay is marked by so much internal wandering. In the eighteenth century as never before, participation in that outer world—that is, the freedom to navigate between private and public spheres, both textually and literally—became essential to the project of the essayist. Men belonging to the middle and upper classes found passage to the outside direct and fairly easy to

obtain. The woman writer, on the other hand, experienced only indirect access gleaned from sympathetic male family and friends.

Montagu and Hester Lynch Thrale Piozzi are two exceptions. Their travel letters and essays mark their atypical movement in a world outside the home, and outside of England for that matter. Montagu wrote about Turkey and other points east; Piozzi, about more common destinations in Europe. Well ahead of the bright age of women travel writers in the nineteenth century, these women wrote at a time when their excursions were discouraged. Women who traveled were expected to do so in the footsteps of their husbands, and they rarely embarked on journeys without chaperones. (Montagu and Piozzi each traveled with their husbands.) However, the fact that their journeys involved no commission or patronage or other duty made them freer to write as they pleased. Like letters, travel essays allowed women to take hold of a genre in ways other literary forms did not. As with epistolary essayists, the voices of these women travelers convey an intimacy not found in the work of periodical essayists or even, for that matter, male travel writers.

In general, however, women essayists "lacked access to the public spaces where the typical essayist picked up his tattle and did his spectating," as Nina Baym cleverly notes (xii–xiii). Men of the period primarily tattled and spectated in the infamous London coffeehouses. In the opening number of *The Tatler*, for example, Isaac Bickerstaff announces that he will send his correspondents to various London coffeehouses in order to gather material for the periodical. Many periodicals relied on these businesses as a symbolic setting that epitomized and centralized (male) London life. The papers also considered coffeehouses a real source of material and a place to publicize themselves to patrons who shared the establishments' subscriptions to their periodicals. Each coffeehouse attracted a different clientele. But one consistent factor was that women, especially respectable women, rarely participated in coffeehouse life. To gather material for their own work, women periodical essayists thus turned to the one place where they already had access: their own domestic sphere. On the one hand, it was fortunate that the periodical essay was already turned in that direction, giving women writers a ready entrance into the genre. On the other hand, as Baym argues, such domestic spaces were no match for public ones in terms of the range of subject matter and opportunity for critical reflection and engagement with the world (xiii).

Even as many male writers dismissed the private conversations of women as "tattling," they used the periodical of the age to make these conversations public and, in the process, to reform them. That is, in the name of helping

women, male periodical writers like Addison and Steele co-opted the private conversable world of women and moved it to a public one dominated by men. In that sense, eighteenth-century women essayists joined their male colleagues in a conversation that was theirs from the beginning. Modified for the public space, particularly in the hands of male writers, that conversation again became something male, however. That even contemporary scholars continue to define the essay as a feminine space illustrates how entrenched in the social psyche is this connection between women and interior/domestic conversation. What such an idea does not account for, however, is that historically, at least in print, male writers still dominated and controlled that space. Any works by eighteenth-century women essayists must be read in that context: various gender and genre demands shaped the self behind their nonfiction prose. Still, those written selves were also shaped by unique strategies, developed in a unique age of the essay. Both the strategies and the age made it possible for women essayists to write and be read.

THE NINETEENTH CENTURY

Despite their absence from lists of influential nineteenth-century essayists, an extraordinary number of women writers of the era became best-selling authors, or achieved success as professional authors. The patchwork nature of the essays women wrote in this period reveals a genre in flux and authors grappling with possibilities, both for their writing and for themselves. Nineteenth-century women wrote newspaper essays that employed conventions from eighteenth-century periodical essays, incorporated elements of the sentimental and domestic fiction that women novelists of the period had popularized, and embarked on the modern journalist's search for truth based on firsthand observations. Additionally, nineteenth-century women wrote literary essays in the form of obituaries, critical reviews, travel sketches, and regional sketches rich in local color. Contemporary critics often bemoan the "second-class" status of the essay. Yet it is precisely because of that status that society's true second-class citizens—and third-class citizens, for that matter—gained access to the genre. Unlike the novel, or even poetry, the essay in the nineteenth century remained relatively new territory, and women benefited from choosing a mostly uncharted medium often dismissed as low art.

Like their contemporary counterparts, many nineteenth-century women essayists first published their work in the period's growing number of magazines. Magazine editors appreciated the draw of women writers for women

readers. Many of these writers had difficulty, though, breaking into the erudite pages of upper-end periodicals like the *Atlantic Monthly*, one of the most important American publications of the century. Even at that, Gail Hamilton was a frequent contributor to the *Atlantic Monthly*, as was Louise Imogen Guiney—this status was a mark of their significant success as writers. Additionally, Margaret Fuller served as editor and contributor for the transcendentalist journal *The Dial*. For most women, however, their uneven access to education often proved to be disadvantageous. This was particularly true for a periodical like the *Atlantic Monthly*, which privileged informational and subject-specific essays over the personal essay (Marchalonis 8). Not that academic credentials were any kind of guarantee. African American essayist Anna Julia Cooper, who had a doctorate degree, had difficulty getting editor W. E. B. Du Bois to accept her submissions to the black periodical *The Crisis* (Moody-Turner).

More typically, nineteenth-century women essayists turned to newspapers, where knowledge could be acquired and conveyed through reporting, through personal observations and experiences, and through advocacy subjects they already knew well. In the nineteenth century, the newspaper shared in the spread of the essay as much as the magazine did, providing a broad and continuous audience base for the form. Of the nineteenth-century essayists represented in this volume, over half wrote regularly for newspapers. Gertrude Bustill Mossell, who advocated for a black press to serve black readers, is especially worth noting. She served as the editor of the women's department for the *New York Age*, one of the most influential black newspapers of the period. Later, she worked as woman's editor for the *Indianapolis World*. Mossell also penned a biweekly advice column, "Our Woman's Department," for the *New York Freeman*, making her the highest-paid black newspaperwoman at the time and one of the first black women journalists to have her own column (Wright 98–99).

Two eighteenth-century periodical essay conventions—an invented authorial persona and the blurring of fact and fiction—continued to characterize the essay well into the nineteenth century. More and more, at least for men, however, artistry rather than an ideological preference for objectivity or a need for an authorial veil motivated such conventions. With the exception of Mark Twain and Charles Lamb, few of the readily named male essayists of the nineteenth century relied on personae or pseudonyms for their works. In contrast, a greater percentage of women writers hung on to these fictive identities in order to maintain their artistic and personal integrity—that is, to protect their visions as writers and their reputations as women.

Of the essayists included in this book, Sara Payson Willis Parton wrote as Fanny Fern, Sara Jane Clarke Lippincott as Grace Greenwood, Mary Abigail Dodge as Gail Hamilton, and Violet Paget as Vernon Lee. Although Eliza Lynn Linton had written fiction under her own name, she chose anonymity when she first published essays criticizing modern Victorian women. Readers variously proclaimed her a man and a woman. Mossell used her husband's name, publishing *The Work of the Afro-American Woman* (1894) as Mrs. N. F. Mossell. While Mossell's book celebrates black women of all walks of life, scholars debate why she chose a professional name that highlighted her status as a married woman. Perhaps she felt that identifying as a wife was her civic duty, or that she was giving a nod to nineteenth-century norms. Mossell may even have been offering a calculated concession to her husband in an age in which black masculine authority was often challenged (Braxton xxviii).

Even if many nineteenth-century women essayists were compelled to employ conventions of the eighteenth-century periodical essay long after male writers had abandoned them, these conventions still served them well. Such practices enabled these writers to offer genuine voices and genuine glimpses of their private selves, however shaped for the public page. The task was not simple, however. As had their peers in the eighteenth century, nineteenth-century women writers negotiated ideologies of womanhood that undoubtedly affected their work in one way or another. They had to negotiate personal and cultural definitions of their selves, as well as variant ideas about whether or not those selves should be revealed in public. The "Cult of Domesticity," as critics later termed it, took hold with enormous influence in the nineteenth century, relegating middle-class women to a life that focused on home and family and frowned on their participation in the male public sphere. Nineteenth-century male writers did not escape the burden of their own ideology of masculinity, which insisted men both fulfill responsibilities outside the home and successfully govern their households. On top of that, they had to be models of strength and bravado. These expectations provide one reason why the emotional, hedging, inward-turning male essayist may have seen himself, or been perceived as, something less than a man.

For both male and female essayists, any self that was discovered and revealed in the process of essaying had to be balanced against the idealized, expected male or female self that each gender ideology dictated. Still, the journeys of production and reception differed for male and female writers, and again for male and female writers of color. As had been the case in previous centuries, for a woman writer to authorize a public and personal voice in non-

fiction prose required a much greater leap than for most male writers to do the same. The gender ideology of male writers already supported their authority in public and private spheres. The leap that women of color had to make in order to authorize their public and personal voices was greater still.

A number of popular women essayists of the period found their true identities becoming a hotly contested issue. This phenomenon demonstrates in one small way how the nineteenth-century reading public struggled to accept, and also judged, the public endeavors of women in the context of their private lives—that is, in the context of who they were as women. The public generally accepted women's increasingly personal authority through the essay as long as it also accepted the woman in and behind the text. Yet it was difficult for a writer to both separate her private self from her public work and to include it therein. After all, critics and readers alike were inclined to read woman-authored texts as representations of the woman author herself.

At times, nineteenth-century women essayists went to great lengths to keep their true identities hidden. They did so in order to allow the selves they created in their essays to bear the brunt of public notice. In *Eminent Women of the Age* (1869), a collection of biographies of important nineteenth-century women written by their contemporaries, Fern includes letters she exchanged with Hamilton while writing Hamilton's profile for the volume. In one of these letters, Hamilton warns Fern as follows: "I shall have a lifelong quarrel even with you, if you spread before the public anything which I myself have not given to the public. I have really very strong opinions on that point; and notwithstanding its commonness, I consider no crime more radically heinous than the violation of privacy. . . . So much of the woman as appears in an author's writings is public property by her own free will. All the rest belongs to her reserved rights" (Fern 204–5). Fern herself surely understood Hamilton's concerns. Even after Fern had accomplished as a writer what few men had been able to do, developing a substantial following as the highest-paid newspaper writer in America at the time, she continued to hide her identity from her family for many years. Her strong, often biting sarcasm, not to mention her support of women's and children's rights, made her an easy target for those who accepted women's writing only if it conformed to their ideas about what a woman should be.

The chance to advocate for causes they held dear ultimately compelled many nineteenth-century activists to take the public stage by way of the essay. Male and female writers alike generally shared the notion that literature must

serve some higher purpose than entertainment. Directed to be the guardians of their country's and their family's moral souls, women in particular likely felt this charge keenly when they took up their pens. Many of their essays reveal little of themselves, in contrast to the familiar essay that Lamb and others had begun to explore with such success in this century. Familiar essayists like Lamb, bolstered by the romantic aesthetic and its emphasis on reflection, embraced the modern essay's project of self-discovery as few writers had been able to do in the previous century. But society more readily sanctioned this project for men than for women. In fact, by the beginning of the twentieth century, Lamb had become the poster gentle*man* both for the style of essay and the person in and behind the essay (male but not threatening, vulnerable, eccentric, even a touch mad) that best represented the age. Katharine Fullerton Gerould, writing at the turn of the next century, noted that the voice of the familiar essayist demands "literary gifts of a very high order" ("An Essay on Essays" 411). The true gift, however, was the personal, social, and political freedom in which to express that voice at all.

Like their white counterparts—Americans Catharine Esther Beecher, Sarah Moore Grimke, and Louisa S. McCord, and Britons Edith Jemima Simcox, Clementina Black, and Sarah Grand—black women essayists in the nineteenth century used the polemical essay primarily to respond to issues like abolition, Reconstruction, women's rights, and women's roles in the home and in the workforce, especially as they affected girls and women of color. In fact, the majority of essays by nineteenth-century black women writers were polemical, rather than personal. This preponderance indicates the challenges that all women, but especially women of color, faced in navigating the realities of their social status and the public authorization of their private voices. While many black women essayists may not have been able, or willing, to write the type of familiar or personal essay white men made popular and some white women practiced, they did in fact claim the authority of the political essayist. Only rarely is a familiar essay like Mossell's "A Lofty Study," which describes an ideal study for a woman writer, devoid of any reference to race. In fact, Mossell's essay stands out even in her own collection. The rest of the essays in *The Work of the Afro-American Woman* are more formal, celebrating the achievement of African American women.

Much more typical of this period are the essays written by well-known and well-regarded figures like Anna Julia Cooper and Maria Stewart, the latter of whom is often credited as being the first African American woman essayist.

Ten years after Stewart published her "Religion and the Pure Principle of Morality," Ann Plato's *Essays* (1841) would become the first published volume of essays by an African American, male or female. Plato's brief religious essays are short on personal presence and long on biblical reflection. They avoid any discussion of contemporary issues, and they adhere closely to the tradition of pious writing that would have been acceptable for a teenaged girl from an elite, educated African American community.

Many of the most successful nineteenth-century women essayists managed to weave the polemical and the familiar, discovering and revealing a private voice amid pleas for justice and other instructional goals. One of the most prolific feminist writers of her day, Frances Power Cobbe wrote scores of articles and books addressing causes such as educational opportunities for women, domestic violence, and women's suffrage. While Cobbe defined herself as an essayist "almost *pur et simple*" and celebrated that mode of writing over others, she appreciated the social possibility of the essay more than its literary possibility—even as many of her most enduring essays exceed the bounds of journalistic exigency (76).

An activist like Cobbe, Lydia Maria Child wrote many articles and essays designed to expose the cruelty of slavery during her tenure as a journalist and editor. Child's popular "Letters from New-York" columns offered her a literary respite from traditionally didactic or even journalistic prose, however. In these letters, Child seemed to understand well how the mind of the essayist worked. As the essayist's thoughts darted from one subject to the next, her varying intent—to describe, to prattle, to inform, to make art of language itself—darted along with them. In "Letter XVI," for example, Child intermingles observations of a house fire with reflections on wealth and jabs at slavery and southern aggression—then ends with sympathy for "a voice of wailing from the houseless and the impoverished" (103). Her framing of the letter, beginning as she does with the house fire and including long descriptions of the garden attached to the home that had been destroyed, eases the reader in with the personal—though no reader of Child's would have been taken off guard by her well-known abolitionist views that surface. To some extent, the political motivations behind many of the century's women essayists enabled them. In other words, rather than preventing these writers from fully engaging in the essay form, political motivations gave them a higher purpose for bringing themselves to the page. Once again, many women used their status as moral guardians both to motivate and to validate their writing. However, the belletristic

moves in the best of their essays give their works broad appeal and lasting literary qualities.

The nineteenth century saw a growing cultural consciousness of women writers as a group and of women's writing as a body of work. While eighteenth-century women had, for the most part, written with little collective sense of identity, nineteenth-century women began to see themselves as part of a community of other women writers who authorized and supported one another, even when they did not know each other personally. A woman who created and authorized a personal identity in print in turn empowered and encouraged other women to do the same. Arguably, women essayists emerged in greater numbers in the nineteenth and twentieth centuries in part because they no longer saw themselves as writing alone, even as they began to develop distinct voices in their essays. A sense of community surely inspired confidence in their individual subjectivities.

Nineteenth-century women essayists sought one another out as mentors, and they were invited to write about one another's works in anthologies like *Eminent Women of the Age*. Moreover, they reviewed one another's writing for critical publications, often with a fair and generous spirit and an empathy derived from their personal understanding of the obstacles women writers faced. By the end of the century, many women essayists had achieved the status of professional writers, successfully marketing their work, and themselves, and making a living from their endeavors. Their successes undoubtedly buoyed them and others, positioning them at the cusp of great possibility, for themselves as women, for their profession as writers, and for the essay.

THE TWENTIETH CENTURY

For the first few decades of the twentieth century, critics of the essay wrangled over the form's primary aim and appropriate degrees of familiarity. At the heart of this debate were the matters of whether the essay was on its deathbed, who was responsible, and what, if anything, should be done to resuscitate it. Some of those who predicted death was at hand blamed a glut in the market. The notion that too many writers were publishing mediocre essays seemed to be an accusation aimed especially at the many women now taking advantage of opportunities to publish. Others placed the blame on genteel essayists who eschewed the contemporary present for a softer, romanticized past that privileged respectability and good manners. For many writers and critics engaged in this debate, the essayist was almost always male. This was the case

even though women like Agnes Repplier, Vernon Lee, Elisabeth Woodbridge Morris, Alice Meynell, and Katharine Fullerton Gerould, to name just a few, were not only popular and prolific essayists but also, in some cases, ardent advocates of the genteel tradition.

The image of the essayist that Graham Good describes in his preface to *The Observing Self* (1988) is the very characterization popularized and even perpetuated by the genteel essayists: "a middle-aged man in a worn tweed jacket in an armchair smoking a pipe by a fire in his private library in a country house somewhere in southern England, in about 1910, maundering on about the delights of idleness, country walks, tobacco, old wine, and old books, blissfully unaware that he and his entire culture are about to be swept away by the Great War and Modern Art" (vii). As Good points out, the genteel essayist's mindset seemed especially out of touch at the outbreak of World War I. By the time mid-twentieth-century essayists like Elizabeth Bowen, M. F. K. Fisher, and Elizabeth David came along, writing about war and food respectively during and after World War II, the genteel tradition had permanently shuffled into that nostalgic past its writers so desired. In its heyday, however, women essayists writing in the genteel tradition differed little from their male counterparts in subject, tone, and style. To some extent, they, too, assumed the voice of the bookish country gentleman, leaving behind personal politics and feminine subjectivities in order to natter on about the significant insignificancies of a gentlemanly world.

Repplier's mid-twentieth-century biographer George Stewart Stokes argues that any "feminine" attributes in Repplier's substantial oeuvre are reduced to a handful of essays that take some aspect of womanhood as their chief subject. The essays Stokes names, "The Eternal Feminine," "The Spinster," "The Literary Lady," and the "Temptations of Eve," appealed to male readers, he contends, "because of their literary and historical references, and in spite of their subject matter" (222–3). Stokes adds admiringly, "That indeed is one of the wonders of Agnes Repplier: she could win a man to an avid reading of her by the way in which she expressed herself, even when that of which she wrote would have been scorned by that very man if offered to him by a less consummate artist" (223). It is hard to say how much of the female genteel essayist's subjectivity was deliberate and how much was simply an expression of the role she understood the essayist to play, as well as the degree to which she identified with the world of the genteel essayist. What is clear is that, to a large extent, the woman behind the genteel essay rarely pushed aside the idea of the gentleman essayist in order to claim the space as her own. In the rare cases when the

woman essayist, or essaying woman, does appear in these works, she is a gentle-woman. Like her male counterpart, she is bookish, well-mannered, and genial, chatty but not gossipy.

Virginia Woolf is one essayist who does not easily fit the mold of the genteel essayist, even though critics often lump her into the genteel tradition. In subject matter Woolf ranged wider than many women essayists of her time, addressing multifarious literary themes with intellectual rigor. Unlike genteel essayists, she also ventured into the realm of gender politics. Her writing tackles the subject of women themselves in arguments for their political, social, personal, and sexual freedoms. In 1881 Woolf's father, Leslie Stephen, had helped launch the debate about the mortality of the form with "The Essayists," which appeared in *Cornhill Magazine*. Stephen bemoaned what the essay had become in a fragmented, harried society (291).

Woolf echoed her father's lament in her own work, but her view of the essay, what she said about it and how she practiced it, is more complex. In "The Modern Essay," Woolf describes the paradox the writer faces: "Never to be yourself and yet always—that is the problem" (217). In that essay, Woolf also celebrates the work of Max Beerbohm, one of the few contemporary essayists she praises, for his ability to do exactly what she describes above. She writes: "The essays of Mr Beerbohm lie, with an exquisite appreciation of all that the position exacts, upon the drawing-room table. There is no gin about; no strong tobacco, no puns, drunkenness, or insanity. Ladies and gentleman talk together, and some things, of course, are not said" (218). Beerbohm is for Woolf the perfect gentleman essayist. The triumph of his style is that the reader does "not know whether there is any relation between Max the essayist and Mr Beerbohm the man. We only know that the spirit of personality permeates every word that he writes" (217).

For more than thirty years Woolf contributed critical essays to the *Times Literary Supplement*, collecting the best of them in the critically acclaimed *The Common Reader* (1925) and *The Second Common Reader* (1932). The essays in these volumes reflect Woolf's characteristic style and message: controlled effusiveness. Offering advice to fellow essayists in "Montaigne," Woolf sanctions abandon, then urges them to rein it in: "Let us say what comes into our heads, repeat ourselves, contradict ourselves, fling about the wildest nonsense, and follow the most fantastic fancies without caring what the world does or thinks or says. For nothing matters except life; and, of course, order. . . . *This freedom, then, which is the essence of our being, has to be controlled*" (63; emphasis added). What separates Woolf from many women essayists writing in previous

centuries is the command of her essayistic voice and her unerring sense of style. Her critical essays are marked by a surety of her aesthetics and intellectually informed judgment. She makes more accusations, particularly regarding the historic dismissal of women writers, than she makes excuses, blaming a patriarchal literary establishment for its exclusion of women writers.

Woolf is one of the most important essayists of the twentieth century, in part because she articulated, through writings in and about the form, the most difficult project of the essayist: creating an intimate voice. Feminists claim her for her nonfiction writings about the internal and external struggles of women. However, Woolf-the-essayist often comes to contemporary readers by way of her least representative work—namely, autobiographical essays and sketches that first appeared in *The Death of the Moth and Other Essays* (1942) and *The Moment and Other Essays* (1947). Woolf's husband, Leonard Woolf, collected and edited both volumes after her suicide in 1941. Essays like "A Sketch of the Past," in which Woolf admits to being sexually abused by an uncle—just the kind of inappropriate subject matter left unsaid in Beerbohm's drawing room—are atypically frank for a woman essayist at the turn of the century. Perhaps for this reason, she did not publish this essay in her lifetime.

Woolf confronted the question of how to write (of) herself in nearly all of her writing, fiction and nonfiction alike. But the very nature of the essay form at the turn of the twentieth century, with its emphasis on subjectivity and portrayal, allowed her to work out a solution and offer it to others. In the end, her essays convincingly meld Woolf-the-essayist and Woolf-the-woman so that they appear as one, packaged for readers but never betrayed to them. Although she framed it as a stylistic necessity, the reserve Woolf argued for was nonetheless a by-product of an age and a tradition that twentieth-century essayists of both genders began to buck. These writers favored an essay that embraced less genial, less controlled, and, really, less homogenous subjectivities, all shaped by a messier modern world. Straddling both the genteel and modern traditions, Woolf's essays serve as a bridge leading the women essayists who followed her into the franker, often less controlled space of the contemporary essay.

One essayist writing on the modern side of the bridge was Rebecca West, the nom de plume of Cicily Fairfield. West began her career as a columnist for the weekly suffragist newspaper the *Freewoman* and later contributed essays to the socialist newspaper the *Clarion*. She then moved on to the London *Daily News and Leader*, the *Statesman*, the *Time and Tide*, and the *New York Herald Tribune*, among others. There was nothing genteel about the persona

West developed in her essays, the best of which she collected in two volumes, *The Strange Necessity* (1928) and *Ending in Earnest* (1931). West's portrait of Beerbohm in "Notes on the Effect of Women Writers on Mr. Max Beerbohm," included in this book, illustrates the confident persona that marks her essays, as well as her lifelong political and social agenda dedicated to the rights of women. Unlike Woolf, West found Beerbohm ridiculously out of touch.

Significantly, in the development of her own literary aesthetics, West managed both to criticize the male persona the nineteenth-century essay tradition perpetuated and to honor the tradition that produced him. Although influential in the modernist movement, West differed from male critics like T. S. Eliot and Ezra Pound in her praise of previous literary traditions, particularly the romantic movement of the past century that had produced so many familiar essayists. She contrasted particularly with Eliot, who insisted that the modernist writer must not only separate himself from tradition but surrender his subjectivity. In that way, West believed that one could be a modernist writer without forsaking tradition or herself. Like Woolf, West served as a symbolic connector between past and present essay traditions, celebrating the potential of modernism without discounting the influence of its literary past or the importance of the person(al). The latter of these is certainly key to the project of the essay.

It was one thing to argue theoretically for the personal and another to claim it in essays, especially for minority women writers who until the twentieth century had participated minimally in the familiar essay tradition. Genteel essayists like Gerould, Meynell, and Repplier were all white. They had succeeded in a tradition that embraced with nostalgia a nearly uniform white and privileged past. During the reign of the newspaper essay, white feminists and socialists like West as well as women of color took advantage of a movement that broadened the possibility for essay subjects and voices. For example, Alice Ruth Moore Dunbar-Nelson wrote of the condition of African Americans and women for the Pittsburgh *Courier*; Edith Maude Eaton, writing as Sui Sin Far, described the plight of newly emigrated Chinese Americans in her essays for the *Los Angeles Express* and the New York *Independent*; and Gertrude Simmons Bonnin or Zitkala-Sa, included in this book, contributed essays on Native Americans to the *Atlantic Monthly* and *Harper's Magazine*.

With few exceptions, minority essayists in the twentieth century must have found it difficult to separate the politics of everyday living—let alone systematic, institutional injustices—from the breezy subjectivity of either the familiar essayist or the genteel essayist. "Constant pressure hardly makes for the imag-

inative freedom requisite to personal essayists," note the editors of the 1941 groundbreaking anthology *The Negro Caravan: Writings by American Negroes* (Brown et al. 837). Perhaps that is why so many white and minority women writers, while cited in studies of advocacy or polemical essays, have been left out of studies of the essay as a literary form: there was a mistaken assumption, even among critics of color, that literary quality must inevitably sink under the weight of the message. Writers like Zitkala-Sa in the early part of the century began to prove that assumption invalid, paving the way in later decades for essayists like Zora Neale Hurston, Alice Walker, and Sara Suleri, included in this book, who document their individual and collective experiences as minority women in engaging, personal voices.

One of the most significant events in the development of the contemporary essay occurred just after the First World War with the founding of the *New Yorker* magazine. The *New Yorker* provided an important outlet for another new breed of essayists and attracted some of the best, most notably E. B. White. White's work for the *New Yorker* and later for *Harper's Magazine* epitomizes the defining characteristics of the contemporary personal essay. In simple prose, he weaves personal experience and observation into a narrative reflecting on some larger life issue, almost always with gentle humor. In White's hands, the nineteenth-century familiar essay began to make peace with the modern literary world.

Many writers have followed in White's footsteps, choosing a form that lends itself to the paradoxes of human experience and to the interplay of personal experiences and sociopolitical critique, observations and reflections, and discussions of historical and current issues. Representative writers included in this book are Cynthia Ozick, Joan Didion, and Anne Fadiman. Ozick writes nostalgically about the Bronx pharmacy her parents owned, and a drugstore culture now lost. Didion, one of the most influential essayists of the twentieth century whose work in the field of New Journalism opened up additional possibilities for the essay writer, addresses the challenges of returning to a childhood home/hometown. Fadiman tells of her family's love of books and describes how her family (mis)treats the tender pages of their affection, as compared to other bibliophiles.

White helped to legitimize the personal voice for contemporary writers and critics, blurring the line between the informal and formal branches of the essay. Indeed, one of the marks of the contemporary essay is its hybrid nature. Some of the best mid- to late twentieth-century essayists engage in a stylized criticism—of literature, society, self—that lacks the pretense of objectivity

found in the driest of formal essays. Because so much of contemporary essaying takes place along a continuum, cultural and literary critics as diverse as Susan Sontag, Elizabeth Hardwick, and Jenny Diski each find a place within the genre. In Diski's book reviews, the reading writer often peers over the edge of the book to gaze into a mirror, into the world around her, into the eyes of the reader looking back.

While E. B. White may have provided an opening in the form, women essayists began to force that opening even wider as the twentieth century wore on. They wanted essays to accommodate the varied experiences of their lives, and the varied subject positions they occupy, in voices far different from White's. In her essay "Language," included in this book, Kyoto Mori laments the fact that her native tongue, with its linguistic idiosyncrasies embedded in Japanese culture, does not allow her—or Japanese women in general—to speak their minds. Whenever Mori returns to Japan, where she is caught between fear and nostalgia, she worries most about becoming trapped there, "unable to speak except in that little-bird voice." In "The Witch's Husband," Judith Ortiz Cofer recounts a return to her native Puerto Rico to help care for her aging grandparents. Her grandfather suffers from dementia; her grandmother, from the Puerto Rican woman's "martyr complex," the "idea that self-sacrifice is a woman's lot and her privilege." During the visit, Ortiz Cofer's grandmother uses an old fantastical tale to frame an explanation for why she temporarily left her husband when she was younger.

In some ways, Ortiz Cofer's essay is reminiscent of ones from earlier centuries that interweave multiple voices and fictive elements. However, the subject matter of a woman's infidelity, the writer's frank reflection, and Ortiz Cofer's own authorial ownership all solidly belong to a twentieth-century essay form. Ortiz Cofer, who spent her childhood shuttling back and forth between the United States and Puerto Rico, was educated in standard English and not exposed to Spanish and Latin American literature until after she had become a writer. She told an interviewer once that she wrote out of that fractured experience—and made it her own. In many ways, Ortiz Cofer speaks for the path of the contemporary essayist: "I think that every writer aims to do something new with the language that has been used and abused. If I have done that, maybe that's my own contribution to an always evolving literature" (Ocasio 734).

Contemporary nature and science essayists like Annie Dillard, Linda Hogan, and Gretel Ehrlich, all of whom are represented in this book, are interested in human interactions, often their own, with the natural environment. Moreover, they are concerned with the ways in which cultural values shape

definitions of the myriad natural landscapes that make up their homelands. One of the most popular of these writers, Dillard turns her essayist's eye onto the smallest details of the natural world. Her meticulous observations serve not merely to record and describe but to expound. In "Living Like Weasels," included in this book, Dillard bends so close to the weasel that she notes "just a dot of a chin, maybe two brown hairs' worth"—so close, in fact, that for sixty seconds she and the weasel are one. To borrow Dillard's metaphor, they peer into one another's brains. It is such inward looking that eventually leads Dillard out again, where she translates her observations into instructions for living.

An offshoot of the nature essay, the twentieth-century garden essay proliferated in Britain and the United States as cultivated by two centuries of writers, including Britons Gertrude Jekyll, Vita Sackville-West, Margery Fish, Beverley Nichols, and Mirabel Osler and Americans Louise Beebe Wilder, Elizabeth Lawrence, Eleanor Perényi, and Jamaica Kincaid. After her retirement in 1958 as an editor of the *New Yorker*, Katharine S. White contributed fourteen "Onward and Upward in the Garden" essays to the magazine during the next twelve years. In so doing, she helped to define the garden essay as an authentic body of literature, one worthy of serious literary criticism and inclusion in a magazine that catered to an audience of elite, sophisticated readers.

White and, in particular, Jekyll and Lawrence are important not simply to the development of the garden essay, but to the writers who come after them. Nearly every garden writer in the last few decades refers to one of these three women at some point in her essays, columns, or books. In her essay "The Garden in Winter," Kincaid wishes she could tell Jekyll (if only Jekyll were alive) that Jekyll is all wrong about the beauty of winter gardens. Although Kincaid admires Jekyll, there is clearly a point at which Kincaid, the black woman from Antigua, begins to divert from Jekyll, the white British horticulturist. Kincaid's essay diverts along with her, injecting race into an essay tradition more likely to focus on plant species than on human ones. The opening passage in "The Garden in Winter" includes a friend's mother's disdain of the "nigger colors" of a variety of lilies growing in the friend's garden. By the end of the essay, Kincaid, unable to find beauty in her own dead winter garden, almost but not quite longs for the warmth of the West Indies.

Despite a century of critics predicting the genre's demise, the last two decades of the twentieth century witnessed yet another revival of the essay. This resurgence both embraced and subverted traditional forms, and it made room for a multiplicity of voices. Given submission and publication rates in print

and online outlets, as well as their commercial successes, women certainly can be credited with helping to haul the essay (back) into literary relevance. They did not do so one outlier at a time—as the earliest history of women essayists often reads. Rather, they did so as a collective of outliers. Individual voices matter, but as history shows us, the collective helps to validate those voices and to spur new ones to write against or alongside the others.

Undeniably, the image of the essayist as a middle-class gentleman persists in some critical quarters, and a "heavy maleness," as *Slate* writer Katy Waldman puts it, continues to hang about the nonfiction genre in general, at least in terms of critical appreciation. The paradoxical configuration of the essay as feminine space, despite its domination by men in the genre's critical history or just plain history, persists as well. But the essay perseveres because writers have found ways to adapt contemporary concerns and trends to a form that by its malleable, meandering nature is well equipped for survival. The essay thrives because, despite how critics frame it, or talk about it, our own current century of women essayists is leading it along, bending it, reshaping it, injecting its voices and experiences into it. This book celebrates the women who came before these writers, women who for the past four centuries have attempted to know themselves, and be known, through the essay form. Without them, it is hard to imagine what the essay—and those of us who write essays—would be.

PRINCIPLES OF SELECTION

In the course of compiling this anthology, I came to appreciate the work of my antecedents and contemporaries, especially the editors of the numerous essay anthologies published in the beginning of the twentieth century. I value these individuals' efforts even if their exclusion of women is one of the reasons why so few essayists from prior centuries are known today. I am particularly fond of essayist and editor Christopher Morley, who, in the preface to the 1921 edition of his *Modern Essays*, apologizes for once thinking that editors "led lives of bland sedentary ease" now that he, too, has felt the "pangs of the anthologist" (iii). The many years of research this book required, as I unearthed hundreds of essays and essayists, ultimately proved easier—at least in terms of conscience—than the selection process.

Offered here boldly is a history, a canon; offered here humbly is a representative history, a representative canon, shaped by editorial circumstances and my own pleasure. The essays included here, despite some renditions of the form that no longer thrive, despite some archaic turns of phrase and old-fashioned

philosophies or idea(l)s, contain qualities that defy age. They feature a pulse, a voice, a reflection or pronouncement that reaches beyond itself. Such essays are at once personal—and thus timeless; or intellectually probing—and thus timeless; or historically significant—and thus timeless. Mostly they are personal. I remain fascinated by the way that women in different centuries have navigated the modern essay's dual projects of self-discovery and self-disclosure. Toward the end of the publication process, I encountered one of the realities of modern-day canon creation: the permissions process. The essays included here are, frankly, ones for which I could secure permissions rights at a reasonable cost. I had to make some difficult decisions due to such costs. Yet so many fine essayists remain to shoulder the history of women's participation in the essay genre.

Because I had to begin somewhere, and because I had to begin with the intention of ending in my own lifetime, I followed several self-imposed guidelines. First and foremost, I focused on essays originally written in English. Left for other scholars to explore are essays composed in languages other than English. The unfortunate result of such a guideline is that the essay presents itself here predominantly as a white, Anglo-centric genre in the first two centuries. To counter that, I dug as deeply as I could to find women of color writing the belletristic-leaning essays that this book features. Until the nineteenth century, I came up empty-handed. While the contemporary essay, and our contemporary times, invite diverse voices, that has not always been the case—and it shows in the essay's history. I also ended my search at essays published up to the year 2000. Originally, I had hoped to include a number of the essayists representing the genre in our time, especially because they add such diversity—in voice and form—to our understanding and appreciation of the form. In the end, I decided it was far more important to pull together what came before—primarily because it has not been done before.

With two exceptions, all of the writers included in this book produced at least one volume of essays. Such a guideline eliminated hundreds of nineteenth-century and twentieth-century essayists who frequently contributed to periodicals but never collected their writings. I made an exception in order to include two authors whose impressive oeuvre of nonfiction prose was posthumously collected by contemporary critics: Margaret Fuller and Zora Neale Hurston. That guideline also meant avoiding one-hit wonders and not searching for essays that fit a particular theme. The goal here was to map a tradition of the essay by creating an anthology of essay writers, rather than an anthology of essays. Even at that, it caused me considerable consternation to

forego Marita Bonner's 1925 "On Being Young—a Woman—and Colored." How important to read Bonner's essay alongside Zora Neale Hurston's "How It Feels to Be Colored Me," published three years later. While Bonner wrote a handful of essays for *The Crisis* and *Opportunity*, she was first and foremost a fiction writer and playwright.

I also chose not to include essayists, and essays, so tied to their cultural present or historical moment that little can be wrenched away for a contemporary reader, at least not without voluminous footnotes. In a similar vein, I left out predominantly polemical and political essayists. With no small regret, I excluded writers like Anna Julia Cooper, Hannah Arendt, and bell hooks; although influential writers with a stake in the essay tradition, they did not compose essays that fit into the framework of this particular book.

As you scan the essays included, you may think to yourself, *But where is Mary Wollstonecraft? Angela Carter? Florence King? Audre Lorde? Sue Hubbell? Nancy Mairs? Bailey White? Sandra Tsing Loh? Naomi Shihab Nye?* They were here, and then they were not, and yet they still are—at least in the appendix, which contains the names of nearly two hundred additional women essayists. I hope that you find as much pleasure in reading this history as I did in helping to piece it back together.

NOTES ON THE ESSAYS

As with any reprinting of previously published work, some judgments had to be made with regard to how to present the materials. Readers should note the following:

1. Original source(s) of publication appear in a note attached to the title of each essay.
2. Regarding seventeenth- and eighteenth-century texts: In general, these texts have been reformatted to conform to contemporary standards. Misspellings due either to convention or to error that may result in confusion have been corrected; punctuation matches the original, with few exceptions; capitalization of non–proper nouns has not been retained, nor has italicization of proper nouns; the long "*f*" has been replaced by "s"; and titles have been created for periodical and epistolary essays that did not originally have them. The titles created are "Hoops" for Haywood's essay, "Female Friendship" for Brooke's essay, "Love and

Power" for Lennox's essay, "Belgrade Village" for Montagu's essay, and "Plagiarism" for Murray's essay.

3. The text for each selection appears in full.

4. Any numbered footnotes are original to the text.

THE *Seventeenth* CENTURY

MARGARET CAVENDISH

(1623–73)

Margaret Cavendish, Duchess of Newcastle, was one of the most prolific women writers in seventeenth-century England, authoring more than a dozen books that included essays, poetry, drama, science fiction, natural philosophy, biography, and autobiography. Born Margaret Lucas in Colchester, Essex, Cavendish was the eighth and last child of Thomas and Elizabeth Lucas. Her otherwise idyllic childhood was marked by two important events: the death of her father and the English Civil War. In 1642 anti-royalists destroyed the Lucas estate. Loyal to the Stuart court, Cavendish subsequently fled to Oxford, where she became a lady-in-waiting to Queen Henrietta Maria.

The education Cavendish received as the daughter of a wealthy gentry family and later as a member of the court was unremarkable. In her autobiographical essay "A True Relation of My Birth, Breeding, and Life" (1656), she notes that her education was "rather for formality than benefit," explaining that her mother "cared not so much for our dancing and fiddling, singing and prating of several languages; as that we should be bred virtuously, modestly, civilly, honorably, and on honest principles." In 1645, by then in Paris with the deposed court, she left her post to marry William Cavendish, Marquis of Newcastle, an exiled Royalist general, widower, and father of five grown children. Margaret Cavendish never bore any children, and that left her to free to pursue her writing and her interest in natural philosophy. In 1653 she published her first folio volume, *Poems and Fancies*. In 1655 she published *The World's Olio*, a collection of aphorisms and short reflections on subjects that range from crying on one's wedding day to the origin of thunder. Of the two branches of the essay then sprouting from the tree of belletristic nonfiction, *The World's Olio* more closely resembles the formal branch of Francis Bacon rather than the in-

formal branch of Michel de Montaigne. Two of the three books that make up *The World's Olio* are devoted primarily to one- and two-line aphorisms, which Cavendish labels "Short Essayes."

Margaret Cavendish's eccentricities, both in person and on the page, made her a literary celebrity in London. Following the restoration of Charles II in 1660, she and her husband returned to England, where William Cavendish reclaimed his estates and was named Duke of Newcastle. Cavendish continued to write and publish until her death in 1673. Centuries later, Virginia Woolf celebrated Cavendish-the-essayist in "The Duchess of Newcastle," a biographical essay. By then, Cavendish was mostly forgotten in the pages of literary history and, as Woolf seems to argue, most unfortunately so.

Of Painting

From *The World's Olio* (London, 1655), pp. 84–87.

There be some that condemn the art of painting in women, others that defend it; for, say they, as nature hath made one world, so art another, and that art is become the mistress of nature; neither is it against nature to help the defects. Besides, those that find out new arts, are esteemed so, that they become as petty gods, whether they become advantageous to man, or no; as the memory of those that found out the art of gunpowder, guns, swords, and all engines of war for mischief; and shall they be more praised and commended than those that find out arts and adornments? as painting, curling, and other dressings; for the one destroys mankind, this increaseth it; the one brings love, the other begets hate. But some will say, those arts defend their lives; but where they once use them to defend their lives, they use them ten times to destroy life; and though it is no fault in the inventor, but in the user; no more is painting, when it is used for a good intent, as to keep or increase lawful affection. But, say they, it is a dissembling to make that appear otherwise than it is. 'Tis answered, no more than to keep warm in winter; for cold is natural, so is the sense of it in winter; but clothes to keep it out are artificial; and the true use of the art of painting is to keep warm a lawful affection. Besides, if we must use no more than what nature hath given us, we must go naked; and those that have a bald head, must not wear a peruke, or cap to cover it; and those that are born with one leg shorter than the other, must not wear a high shoe to make them even, nor indeed wear any shoes at all, especially with heels, be-

cause they make them seem higher, but go with the feet bare; and those that are crooked, must wear no bombast; and many such examples may be brought. But, say some, it is a bawd to entice, in begetting evil desires. It is answered, no more a bawd than nature is in making a handsome creature; but if they must do nothing for fear of enticing, then mankind must neither cut their hair, nor pare their nails, nor shave their beards, nor wash their selves, which would be very slovenly, for fear they should appear so handsome, as they may persuade and entice the lookers on to evil desires; which if so, let them be like swine, and wallow in mire; but it is to be feared, that the mire will be too hard for the evil desires; so as there may be more brought in defense of painting, than can be said against it. Wherefore, say they, it is lawful both in maids and wives; the one, to get a good husband; the other, to keep her husband from coveting his neighbour's wife; for it is an honour for maids to get good husbands, because it is a kind of reproach to live unmarried; for marriage is honourable, and gives a respect to women, unless they be incloistered, which all constitutions will not agree withall; and an honest wife's care is to please her husband, if she can, when she hath him; for marriage is the end of an honest mind to all but widows, for they, when they marry again, do as it were cuckold their dead husband, and their living. Besides, if they have children, they make a distraction and division in their families, and most commonly to the ruin of the first husband's estate, having so great a share, and so much power, according to our laws; and though they should not murder themselves, as the custom hath been in other counties, but contrary rather, to preserve their health, and to dry their eyes after a while of those obsequies of tears, which are sacrifices to the dead, yet to live a retired life, to show their unalterable affections; for though it be fit for a widow to put off her violent passion of sorrow as well as she can, yet there is no humour becomes that condition better than sadness; for sadness, which is a moderate grief, looks full of fortitude, and is humble, modest, graceful, and so far from discomposing any part, as it gives a settled, and majestical face: So painting is most disallowable in widows, for they should take the example of Judith, where it is said, when she went to Holofernes, she anointed herself as she did usually in her husband Manasses' time, which it seems she used not after he was dead, before this time; for as they have none to displease, so ought they not to allure. But some will say, that their poverty is such, as they know not how to live, and they may be presented to such a fortune, as may make them live happy, and free from the misery that poverty compels them to. It is answered, that nature is satisfied with a little, if their ambition be not great:

but if not they must make use of the old proverb, which is, that necessity hath no law, in case they present not their necessity to be greater than it is.

But to return to beauty, it is pleasing, either natural or artificial, and both to be admired; for if art be commendable, why not in the face, as well as in the feet in dancing measures, or as in the hand upon music instruments, or in the voice, or in the art of oratory, and poetry, which will sooner increase desires: yet this is allowed of in all places and times, not only in temporal society, but in spiritual unions, where David, the Beloved of God, was a great master in the knowledge and practice of them. And if these arts be commendable, and are graces to all parts of the body, shall it be condemned only for colour in the face? And as beauty is the adornment of nature, so is art the adornment of beauty; and this saith the defendant against the plaintiff. But all opinions have, or most of them, sides, and factions; but my opinion is so far with the defendant, as I believe all adornments of beauty are lawful for women, if the intention be good.

Yet I am utterly against the art of painting, out of three respects; the first is dangerous, for most paintings are mixed with mercury, wherein is much quicksilver, which is of so subtle a malignant nature, as it will fall from the head to the lungs, and cause consumptions, and is the cause of swelling about the neck and throat. The next is, that it is so far from adorning, as it disfigures: for it will rot the teeth, dim the eyes, and take away both the life and youth of a face, which is the greatest beauty. Thirdly and lastly, the sluttishness of it, and especially in the preparatives, as masks of sear clothes, which are not only horrid to look upon, in that they seem as dead bodies emboweled or embalmed, but the stink is offensive. Then the pomatum and putis, which are very uneasy to lie in, wet and greasy, and very unsavoury; for all the while they have it on, it presents to their nose a chandler's shop, or a greasy dripping-pan, so as all the time they fry as it were in grease; neither will their perfumes mend it, and their oils: And though I cannot say they live in purgatory, because they shun all hot places, for they cannot have the comfortable heat of the fire, and shun the natural heat of the sun, as they must live always, as if they were at the North Pole, for fear the heat should melt away their oil, and oily drops can be no grace to their face. Dry painting shrivels up the skin so, as it imprints age in their face, in filling it full of wrinkles; wherefore paintings are both dangerous, ill-favoured, and sluttish, besides the troublesome pains.

But for other adornments in women, they are to be commended, as curling, powdering, pouncing, clothing, and all the varieties of accoutrement, in that they have none of the said former qualities, but give a graceful advantage to

the person. Besides, dressing is the poetry of women, in showing the fancies, and is the cause of employing the greater part of a commonwealth; for in four parts, three of them are in the arts of adornments; for it is not only, tailors, embroiderers, perfumers, milliners, feathermakers, jewelers, mercers, silkmen, seamsters, shoemakers, tiremen, and many, many more, but every one of these trades have many trades belong to them; as for example, how many trades belong from the silk-worm to the lady's gown? and from the golden mine to the lace that is laid upon it? and so in order to all other things, which is the cause of keeping a commonwealth in union, in busying and employing their minds, which keeps them from factious thoughts, and designs. Besides, it distributes and spreads the maintenance of the kingdom; for without particular commerce, and traffic, a commonwealth cannot stand, and subsist: for though many a commonwealth may subsist without the help of their neighbours, yet it cannot live without their own employment and dividement among themselves: for as some share in lands, so others in offices, and the rest in trades, wherein all traffic, from the one to the other; so that every man lives by his neighbour, and not altogether upon himself.

THE *Eighteenth* CENTURY

ELIZA HAYWOOD

(1693–1756)

The details of Eliza Fowler Haywood's early years are sketchy. Most likely she was born in London, where, as she notes in the preface to the collected volumes of her periodical serial *The Female Spectator* (1744–46), she received an education better than most girls at the time. At age nineteen, Eliza Fowler married Valentine Haywood, a clergyman who was fifteen years her senior. Haywood soon left her husband, however. Her departure from her marriage was a bold move for an eighteenth-century woman, and it cast the first of many dark shadows over Haywood's reputation in the coming years. For the rest of her life, she was frequently the target of gossip and attacks from other prominent writers. The most notorious attacks came from the poet Alexander Pope.

While still with her husband, Haywood had begun acting for the stage. She had also published her first novel, *Love in Excess* (1719–20), a widely successful example of the period's popular amatory fiction. In all, the incredibly prolific Haywood, desperate to earn a living from her writing and to support herself and her children, published more than seventy books in her lifetime, including novels, plays, and periodical essays. Her first attempt at essays was a serial called *The Tea Table* (1724). *The Female Spectator*, *The Parrot* (1746), and *The Young Lady* (1756) followed.

The most well-known of Haywood's periodicals, *The Female Spectator* appeared monthly from April 1744 to May 1746. It had the further distinction of being one of the first periodicals written by a woman for women. Typical of the eighteenth-century periodical, *The Female Spectator* offers its entertainment and wisdom by way of a club of characters. Readers' letters, many, if not all, of which Haywood likely wrote herself, inspired the characters' commentary and anecdotes. Unlike other periodicals, especially those authored

by men, Haywood's publication features a club composed entirely of female personae: Mira, a happily married woman; Euphrosine, a beautiful young virgin; an unnamed "widow of quality"; and the Female Spectator herself.

In the preface to *The Female Spectator*, Haywood confesses that she had seen the error of her licentious ways and returned to the moral path of feminine goodness, a trait the periodical sought to inspire in its female readers. But Haywood's transformation may also have been a marketing strategy in an age that held women, and women authors, to high moral standards. Something of the old Eliza Haywood, spirited and entertaining, remains amid the didacticism of *The Female Spectator* essays. Haywood died in 1756 and is buried in Westminster, London.

Hoops

First appeared on July 6, 1745, in book 15 of *The Female Spectator* serial and reprinted in *The Female Spectator*, 1744–46. This version is from *The Female Spectator*, 4 vols. (London, 1775), vol. 3, pp. 159–60.

I believe, however, that if the ladies would retrench a yard or two of their extended hoops they now wear, they would be much less liable, not only to the inconveniencies my correspondent mentions, but also to many other embarrassments one frequently beholds them in when walking the streets.

How often do the angular corners of such immense machines, as we sometimes see, though held up almost to the arm-pit, catch hold of those little poles that support the numerous stalls with which this popular city abounds, and throw down, or at least indanger the whole fabric, to the great damage of the fruiterer, fishmonger, comb and buckle-sellers, and others of those small chapmen.

Many very ugly accidents of this kind have lately happened, but I was an eye-witness from my window of one, which may serve as a warning to my sex, either to take chair or coach, or to leave their enormous hoops at home, whenever they have any occasion to go out on a Monday, or Friday, especially in the morning.

It was on one of the former of those unhappy days, that a young creature, who, I dare answer, had no occasion to leave any one at home to look after her best cloaths, came tripping by with one of those mischief-making hoops, which spread itself from the steps of my door quite to the posts placed to keep

off the coaches and carts; a large flock of sheep were that instant driving to the slaughter-house, and an old ram, who was the foremost, being put out of his way by some accident, ran full-butt into the foot-way, where his horns were immediately entangled in the hoop of this fine lady, as she was holding it up on one side, as the genteel fashion is, and indeed the make of it requires:—In her fright she let it fall down, which still the more encumbered him, as it fixed upon his neck;—she attempted to run, he to disengage himself,—which neither being able to do, she shrieked, he baaed, the rest of the sheep echoed the cry, and the dog, who followed the flock, barked, so that altogether made a most hideous sound:—Down fell the lady, unable to sustain the forcible efforts the ram made to obtain his liberty;—a crowd of mob who were gathered in an instant, shouted.—At last the driver, who was at a good distance behind, came up, and assisted in setting free his beast, and raising the lady; but never was finery so demolished:—The late rains had made the place so excessive dirty, that her gown and petticoat, which before were yellow, the colour so much revered in Hanover, and so much the mode in England, at present, were now most barbarously painted with a filthy brown;—her gause cap half off her head in the scuffle, and her *tête de mouton* hanging down on one shoulder. The rude populace, instead of pitying, insulted her misfortune, and continued their shouts till she got into a chair, and was quite out of sight.

These are incidents which, I confess, are beneath the dignity of a Female Spectator to take notice of; but I was led into it by the complaint of Leucothea, and the earnestness she discovers to have her letter inserted.

It is not, however, improper to show how even in such a trivial thing as dress, a good or bad taste may be discerned, and into what strange inconveniencies we are liable to fall by the latter.

Of this we may be certain that wherever there is an impropriety, there is a manifest want of good taste;—if we survey the works of the divine source and origin of all excellence, we shall find them full of an exact order and harmony,—no jostling atoms disturb the motion of each other,—every thing above, below, and about us is restrained by a perfect regularity:—Let us all then endeavour to follow nature as closely as we can, even in the things which seem least to merit consideration, as well as in those which are the most allowed to demand it, and I am very sure we shall be in no danger of incurring the censure of the world, for having a bad taste.

FRANCES BROOKE

(1724–89)

Born in Claypole, England, Frances Moore Brooke was only three when her father, a curate, died. After her mother died early as well, Brooke began writing poetry and drama, but it was the publication of her essay serial *The Old Maid* that first drew her to the public's notice. Published from November 1755 to July 1756 under Brooke's pseudonym Mary Singleton, *The Old Maid* consists of thirty-seven numbers written in the mode of the popular periodicals of the day. The issues include invented letters to the editor and a club of fictional characters who offer observations and opinions on social matters and current theatrical productions. Three such characters who appear in the essay below are the spinster Mary Singleton, her niece Julia, and Julia's friend Rosara.

In 1756 Frances Moore married Rev. John Brooke, rector of Colney, Norfolk, and in 1757 the reverend left for America to serve as a military chaplain. Frances Moore Brooke stayed behind in London, giving birth to their son and continuing to write. After unsuccessful attempts to publish plays, she began writing novels, including the widely praised *Julia Mandeville* (1763). When France ceded Canada to Britain in 1763, Brooke joined her husband in Quebec, where he was serving as chaplain. She lived there for the next five years, and the experience provided material for her novels *The History of Emily Montague* (1769) and *All's Right at Last* (1774), both set in Canada. Back in London, Brooke at last achieved success as a playwright, particularly for her comic opera *Rosina*, which was produced in 1782. She died in 1789.

Female Friendship

First appeared on March 6, 1756, in issue number 17 of *The Old Maid* serial and reprinted in the collected edition *The Old Maid*. This version is from a revised and corrected edition, *The Old Maid* (London, 1764), pp. 136–44.

> The bloom of opening flowers, unsully'd beauty,
> Softness, and sweetest innocence she wears,
> And looks like nature in the world's first spring.
> —ROWE

> —Is ought so fair,
> In all the dewy landscapes of the spring,
> In the bright eye of Hesper, or the morn,
> In nature's fairest forms, is ought so fair,
> As virtuous Friendship?
> —ARENSIDE

My niece's friend, Rosara, came to town on Tuesday morning, to pass a few months with us: she is really a fine creature, and has all that vivid bloom of youth and health, which might be expected at eighteen, from a year's uninterrupted residence amongst the Dryads that people the embowering shades of Rutland: the purity of the air, and the cheerfulness arising from the sight of nature in all her genuine charms, which even winter cannot entirely destroy in that garden of England, have given a life to her complexion, which Rouge can never come up to, and which even Julia in some degree wants. As she has by being so long in the country happily escaped the barbarous hands of those mortal enemies to beauty, French hair-dressers, the adorning of her head is just what my correspondent of last week recommends, and has a great similitude to the Egyptian maid in *Prior's Solomon*,

> ——Her hair,
> *Unty'd, and ignorant of artful aid,*
> *Adown her shoulders loosely lay display'd,*
> *And in the jetty curls ten thousand Cupids*
> *play'd.*

If we credit history and tradition, both the king and the poet were men of gallantry, and no ill judges of female charms; and if my fair country-women

will not listen to such heathenish fellows as Horace and Tibullus, I hope the celebrated Jewish monarch and the Christian poet may deserve some credit with them; and persuade them, that to depart from nature and simplicity, in the embellishment of their persons, is to lose more than half their power of pleasing.

Rosara's whole dress is perfectly genteel, but so elegantly plain and simple, and so void of all fantastically modish ornaments, that she will appear an angel to the men, and a mere country creature to the ladies and the beaux. She is most unfashionably neat and delicate, and strikes more senses than one with the ideas of roses and lilies: in a word, she is, in every respect, the reverse of those ladies, whom my correspondent of last week very judiciously distinguishes by the appellation of hedge-hogs, which animal they not only resemble in their quills, but in their love of dirt: by the way, I think Rosara, and those who imitate her, in her external as well as internal purity, may not improperly be called ermines. I am so pleased with Rosara's drapery, that I intend to persuade my niece, who is, in the dressing of her hair, a little inclined to the porcupine, though still a superstitious votary to the goddess of cleanliness, to copy her; and if I can prevail on these two girls to be handsome in spite of the fashion, and show the ladies how much their native charms are superior to art, I think we shall stand some chance to turn the tide, and drive the friseurs back to Paris: I am speaking here against my own interest, for by the assistance of these operators, the grizzled locks of an old woman of fifty look just as well as the polished jett, or shining auburn tresses of a young one of eighteen.

Rosara was received by me with the regard due to her merit; and by Julia, with all the open, undissembled warmth of genuine friendship: it was with some surprise I saw tears of joy in the eyes of both at their meeting: and after dinner, having sent them with a married lady, to *King Lear*, I retired to my closet, and from contemplating with unspeakable satisfaction the amiable and virtuous regard of these young women for each other, could not avoid reflecting with equal concern upon the present too great neglect of this and all other social affections. By all writers in times of simplicity and virtue, as are generally the beginning of all states, we find this virtue celebrated almost equally with public spirit: whether we are upon the decline as to that last I shall not take upon me to determine, the enquiry being more proper for a writer of the other sex; but in regard to friendship, though no subject is, by the ancients, treated with more warmth and enthusiasm, yet amongst us, who are so much wiser than these whimsical philosophers, a man would be looked upon as a madman who should pretend to it.

The name of friend, held sacred by the best ages, in our days stands for lit-
tle more than a favorite companion in midnight riots, or a confederate in de-
bauchery and vice: or at best, one connected with us in schemes of interest or
ambition; for one whom chance, not choice, has made our associate in busi-
ness or in pleasure.

I would be understood here to mean the friendships of the men only, for
I by no means intend to include the ladies in this charge; their gentle souls,
especially in this town, the nursery of sincerity and truth, are so open to ev-
ery virtuous affection, that it is impossible to pass a day in good company
without being sensible of the generous warmth of female amity, and their pi-
ous zeal even for their absent friends. Did you observe, says Miss Fickle, how
shockingly Lady Truman was dressed the other night at the opera? I protest it
grieved me, for she is my friend. Have you heard, says another, that Bell Fash-
ion went to Windsor in a post-chaise with Jack Wildair, and was out three
nights? I am sure its true, or I would not mention it, for you know *I have a
friendship for her*.

I could bring many instances of this kind, to prove the astonishing force of
female friendship but the observation of my polite readers; will furnish them
with examples enough to prove the truth of my assertion, and to convince
them, that this amiable goddess, who, we are told by ignorant moralists, is fled
with Astrea to Heaven, in reality has fixed her residence in the bosoms of the
British fair. Our inimitable English Homer says,

> A gen'rous friendship no cold medium knows,
> Burns with one love, with one resentment glows,
> One should our interests, and our passions be.
> —POPE

Who that is acquainted with that inseparable pair, Lady Lovemore and Mrs.
Modish, but will allow they have lived up to the very letter of their descrip-
tion? They scorn a cold medium in any thing; and whether the inspiring bur-
gundy, or more inspiring citron-water, invite to bacchanalian revels; whether
the smart ensign or wealthy heir warm their souls to gallantry; whether the
dear cards or enchanting dice call to the joys of play; they are equally in earnest
in all. Have they not both, for these seven years past, burned with love, that is,
with one kind of love, and not infrequently for the same object? And for the
same space of time have they not glow'd with one constant and equal resent-
ment, against every woman younger and handsomer than themselves? Their
interests are so much one, that they always cheat at cards for each other, being

of Montaigne's opinion, that justice itself should give place to friendship: as for their passions, I have already said enough to show you how much they are the same.

But to be serious: perhaps our frozen clime is unfavorable to those virtues which require warmth of heart and enthusiasm of sentiment; and as it preserves us from the crimes of those regions where burning suns fire the blood to jealousy and revenge, it denies us in a great measure the transport of animated vivacious affections; and confines us in general to a mediocrity in virtue, as well as in vice.

I shall conclude these rambling unconnected thoughts on friendship with an ode, written by the author of the two already published in this paper.

ODE TO FRIENDSHIP

No more fond love shall wound my breast,
In all his smiles deceitful dressed,
I scorn his coward sway,
And now with pleasure can explore
The galling chains I felt before,
Since I am free to day.

To day with friendship I'll rejoice,
Whilst dear Lucinda's gentle voice
Shall soften every care:
O, Goddess of the joy sincere!
The social sigh! the pleasing tear!
Thy noble bonds I'll wear.

When first, ill-fated, hapless hour!
My soul confesst Amintor's power,
Lucinda shar'd my grief;
And leaning on her faithful breast,
The fatal passion I confesst,
And found a soft relief.

My steps she oft was wont to lead
Along the fair enamel'd mead,
To sooth my raging pain;
And oft with tender converse strove
To draw the sling of hopeless love,
And make me smile again.
O, much lov'd maid! whilst life remains,

To thee I'll consecrate my strains,
For thee I'll tune my lyre;
And, echoing with my sweetest lays,
The vocal hills shall speak the praise
Of friendship's sacred fire.

CHARLOTTE LENNOX

(1729?–1804)

Little is known of Charlotte Ramsey Lennox's childhood other than that she spent a number of years in America, where her father, a member of the British Army, had been deployed to serve as captain to a company of foot soldiers. As Lennox used material from her early life in America in her later novels, some critics claim her as the first American novelist. Eventually she returned to England and settled in London, where she met and married Alexander Lennox. Until his death in 1797, this husband and father of her two children proved to be a spiritual and financial drain. Lennox ultimately turned to writing. In 1747 she published her first book, a collection of verses titled *Poems on Several Occasions.*

Better remembered as a successful writer of novels, especially *The Female Quixote* (1752), Lennox also authored the majority of eleven issues of *The Lady's Museum,* a serial which appeared from March 1760 to January 1761. Aimed at instructing female readers, the periodical features a true "museum" of components: a serial novella, "The History of Harriot and Sophia"; letters, poems, and translations; lessons in geography, history, and philosophy; and a series of essays authored by The Trifler. In her preface, Lennox makes the following promises: "I will always be as witty as I can, as humorous as I can, as moral as I can, and upon the whole as entertaining as I can." Despite her reputation as an author and her connection to such prominent literary figures as Samuel Richardson and Samuel Johnson, Lennox died a penniless widow in 1804.

Love and Power

First appeared as "The Trifler Number II" in April 1760 in the second
number of *The Lady's Museum* monthly serial and reprinted in volume
1 of *The Lady's Museum* (London, 1760), pp. 81–84.

From the account I have already given of my temper and inclinations, it will be
readily supposed that the love of power, which our great satirist asserts to be
the ruling passion of my sex, is not the least prevailing one of mine; and there-
fore I will candidly acknowledge that the too perceptible decline of our influ-
ence has often been the subject of much painful reflection to me.

We live no longer in those happy times, when to recover one stolen fair one,
whole nations took up arms; when the smile of beauty was more powerful
than the voice of ambition; when heroes conquered to deserve our favour, and
poets preferred the myrtle to the laurel crown.

In this degenerate age instances of dying for love are very rare, and instances
of marrying for love are still rarer. Formerly, if a lady had commanded her lover
to bring her the head of a lion, he would have gone to Africa in search of the
savage conquest, though death were to have been the consequence of his obe-
dience: but now, what lady would presume so much upon her authority, as to
exact from her lover the sacrifice of a party at whist, or a match at Newmarket!

However desirous I am to find the cause of this decline of our empire in
the depraved manners of men, yet justice obliges me to own that we ourselves
are not wholly free from blame. Beauty, like the majesty of kings, weakens its
influence when familiarised to common view. The face that may be seen ev-
ery morning at auctions, at public breakfastings, and in crowded walks; every
evening at assemblies, at the play, the opera, or some other fashionable scene
of pleasure, soon loses the charm of novelty, and effaces the impression it first
made. We may gaze upon a fine picture till the grace of the attitude, the loveli-
ness of the features, and the strength of the colouring cease to surprise and de-
light us; and unhappily many of our present race of beauties are too solicitous
about their personal charms to attend to the improvement of their minds: so
that a fine woman is indeed often no more than a fine picture.

It has been observed, that there is no country in the world where women
enjoy so much liberty as in England, and none where their sway is so little
acknowledged. In Spain, where the severe father, and jealous brother, guard
the secluded maid from all converse with men, she will conquer more hearts

being desired

by being seen once without a veil, than one of our beauties who appears with her neck and shoulders uncovered at every place of publick resort during the whole season.

The Spanish lover passes whole nights at his mistress's door, and employs sighs, tears, serenades, and tender complaints to move her compassion; bribes the vigilant duenna with half his estate to procure him a short interview at a grated window: and for this inestimable favour he exposes himself to the rage of her relations, who probably stand ready to punish his presumption with death; while he, regardless of the insidious stab, contemplates her by the faint light of the moon, with enthusiastic rapture.

For her sake he enters the dreadful lists, and encounters the fiercest bull of Andalusia; the spectators tremble at his danger; he looks up to the balcony where she is seated, and catches fortitude from her eyes. Should he be wounded in the unequal combat, a sign from her gives him new force and courage: again he assails his furious antagonist, and drives him bellowing about the field. The lady waves her handkerchief to him as a token of her joy for his victory; the lover, half dead with fatigue and loss of blood, but triumphing more in that instance of her regard for him than in the loud acclamations he hears on every side, turns to the place where she stands, kisses his sword, and is carried out of the lists. *modesty is valued by lennox*

Thus ardent are the flames which love inspires in a country where the promiscuous assembly, the wrangling card-table, the licentious comedy, and late protracted ball, are not permitted to rob beauty of its most engaging charms, the blush of unsullied modesty, and the soft dignity of female reserve.

With us the lover dresses at his mistress, sings, dances, and coquets with her, expects to dazzle her with superior charms, and loves her for the superficial qualities he admires in himself. He hopes not to gain her heart in reward of his services and constancy, but claims it as a price due to the resistless graces of his person. *romance is not what is was*

Such is the low state of our power at present, and such it will continue till our own prudence and reserve supply the place of imposed retiredness, and throw as many difficulties in the lover's way as the tyranny of custom does in other countries. Beauty, like the Parthian archer, wounds surest when she flies, and we then most certain of victory when we have not courage enough to invite the attack.

LADY MARY WORTLEY MONTAGU

(1689–1762)

Born Mary Pierrepont in Covent Garden, London, Lady Mary Wortley Montagu was left in the care of her inattentive father, the Duke of Kingston, when her mother died young. Her three younger siblings faced the same fate. If her father paid little mind to her education, Montagu nonetheless benefited from his well-stocked library, claiming to have taught herself Latin before the age of eight. From a young age, Montagu immersed herself in the epistolary tradition that Renaissance writers had revived from antiquity and that grew increasingly popular in the eighteenth century. In 1712 she eloped with Edward Wortley Montagu. In the beginnings of what would prove to be an unhappy marriage, Mary Worley Montagu turned to writing.

One of her first published endeavors was an essay for the July 28, 1714, edition of the *The Spectator*. One year later, Montagu contracted smallpox, a disease which left her disfigured. When Montagu's husband was appointed in 1716 as ambassador extraordinary to the court of Turkey, she decided to travel with him. This choice would result in some of her best-known and most successful writings chronicling her journeys to Turkey and elsewhere in Europe. The "Turkish Embassy Letters," as scholars refer to them, offer an astute traveler's glimpse into Eastern culture, particularly for that time. Furthermore, as a woman, Montagu turned her eye on sights and spaces male travelers either ignored or could not access.

When Edward Montagu failed to secure a truce between Austria and Turkey—one of his diplomatic mandates—he was replaced as ambassador, and he and his wife returned to England in 1718. Subsequently, Montagu continued publishing poetry and became embroiled in notorious feud with Alexander Pope. From December 1737 to March 1738, she published a periodical titled

The Nonsense of Common Sense. In 1739, she left England for Italy and spent over twenty years living on the Continent. Montagu returned to England in 1761, after the death of her husband, from whom she had been unofficially separated for decades. She died of breast cancer in 1762. Two years before her death, Montagu handed copies of the letters she had composed on her many journeys to an English clergyman, Benjamin Sowden, along with a note telling him that the letters should "be dispos'd of as he [thought] proper." Montagu's family attempted to block publication of the manuscript, but the letters were published in 1763 under the title *Letters Of the Right Honourable M—y W——y M——e: Written, during her Travels in Europe, Asia and Africa.*

Belgrade Village

Appeared as "Letter XXXVII" in the *Letters of the Right Honourable Lady M—y W——y M——e*, 3 vols. (London, 1763), vol. 2, pp. 129–37.

To the Lady ——.

BELGRADE VILLAGE, JUNE 17, O.S.

I heartily beg your ladyship's pardon; but I really could not forbear laughing heartily at your letter and the commissions you are pleased to honour me with. You desire me to buy you a Greek slave, who is to be mistress of a thousand good qualities. The Greeks are *subjects* and not *slaves*. Those who are to be bought in that manner are either such as are taken in war, or stolen by the Tartars, from Russia, Circassia or Georgia, and are such miserable awkward poor wretches, you would not think of any of them worthy to be your house maids. 'Tis true, that many thousands were taken in the Morea; but they have been, most of them, redeemed by the charitable contributions of the Christians, or ransomed by their own relations at Venice. The fine slaves, that wait upon the great ladies, or serve the pleasures of the great men, are all bought at the age of eight or nine years old, and educated with great care to accomplish them in singing, dancing, embroidery, etc. They are commonly Circassians, and their patron never sells them, except it is as a punishment for some very great fault. If ever they grow weary of them, they either present them to a friend, or give them their freedom. Those that are exposed to sale at the markets, are always either guilty of some crime, or so entirely worthless, that they are of no use at all. I am afraid you will doubt the truth of this account, which, I own, is very different from our common notions in England; but it is no less truth for all

that. —— Your whole letter is full of mistakes from one end to the other. I see you have taken your ideas of Turkey from that worthy author Dumont, who has writ with equal ignorance and confidence. 'Tis a particular pleasure to me here, to read the voyages to the Levant, which are generally so far removed from truth, and so full of absurdities. I am very well diverted with them. They never fail giving you an account of the women, whom, 'tis certain, they never saw, and talking very wisely of the genius of the men, into whose company they are never admitted; and very often describe mosques, which they dared not even peep into. The Turks are very proud, and will not converse with a stranger, they are not assured is considerable in his own country. I speak of the men of distinction; for, as to the ordinary fellows, you may imagine what ideas their conversation can give of the general genius of the people.

As to the balm of Mecca, I will certainly send you some; but it is not so easily got as you suppose it, and I cannot in conscience advise you to make use of it. I know not how it comes to have such universal applause. All the ladies of my acquaintance at London and Vienna, have begged me to send pots of it to them. I have had a present of a small quantity (which I'll assure you is very valuable) of the best sort, and with great joy applied it to my face, expecting some wonderful effect to my advantage. The next morning the change, indeed, was wonderful; my face was swelled to a very extraordinary size, and all over as red as my Lady H——'s. It remained in this lamentable state three days, during which you may be sure I passed my time very ill. I believed it would never be otherwise; and to add to my mortification, Mr. W——y reproached my indiscretion without ceasing. However, my face is since in *status quo*; nay, I am told by the ladies here, that 'tis much mended by the operation, which I confess I cannot perceive in my looking glass. Indeed, if one was to form an opinion of this balm from their faces, one should think very well of it. They all make use of it, and have the loveliest bloom in the world. For my part, I never intend to endure the pain of it again; let my complexion take its natural course, and decay in its own due time. I have very little esteem for medicines of this nature; but do as you please, Madam; only remember, before you use it, that your face will not be such as you will care to show in the drawing room for some days after. If one was to believe the women in this country, there is a surer way of making one's self beloved, than by becoming handsome, though you know that's our method. But they pretend to the knowledge of secrets, that, by way of enchantment, gives them the entire empire over whom they please. For me, who am not very apt to believe in wonders, I cannot find faith for this. I disputed the point last night with a lady, who really talks very sensibly on any other sub-

ject; but she was downright angry with me, in that she did not perceive she had persuaded me of the truth of forty stories she told me of this kind; and, at last, mentioned several ridiculous marriages, that there could be no other reason assigned for. I assured her, that in England, where we were entirely ignorant of all magic, where the climate is not half so warm, nor the women half so handsome, we were not without our ridiculous marriages; and that we did not look upon it, as any thing supernatural, when a man played the fool for the sake of a woman. But my arguments could not convince her against (as she said) her certain knowledge. To this she added, that she scrupled making use of charms herself; but that she could do it whenever she pleased; and staring in my face, said (with a very learned air) that no enchantments would have their effects upon me, and that there were some people exempt from their power, but very few. You may imagine how I laughed at this discourse: but all the women are of the same opinion. They don't pretend to any commerce with the devil, but only that there are certain compositions adapted to inspire love. If one could send over a ship-load of them, I fancy it would be a very quick way of raising an estate. What would not *some* ladies of our acquaintance give for such merchandize? Adieu, my dear lady——I cannot conclude my letter with a subject that affords more delightful scenes to the imagination. I leave you to figure to yourself, the extreme court that will be made to me, at my return, if my travels furnish me with such a useful piece of learning.

HESTER LYNCH THRALE PIOZZI

(1741–1821)

Born in Wales, Hester Lynch (Salusbury) was the only child of devoted, indulgent, and financially strapped parents. While she benefited from the instruction of a private tutor, her education was erratic and often interrupted. As her mother wished to secure a financially stable husband for her, Hester Lynch married Henry Thrale in 1763. She came to have a notoriously difficult relationship with the wealthy brewer. The couple had twelve children, but only four survived infancy.

In 1765 Hester Thrale met Samuel Johnson, who was more than twenty-five years her senior. This influential meeting precipitated an intense friendship between the two intellectuals. Johnson, who was a frequent guest at the Thrales' country home in Streatham, encouraged Thrale to keep a diary and publish her poetry; in turn, Thrale become Johnson's confidante. Again with Johnson's encouragement, in 1776 Thrale began writing *Thraliana*, a book most like a diary in substance, if not in form. Unpublished until 1942, the autobiographical hodgepodge that constitutes *Thraliana* offers a personal account of Thrale's life from 1776 to 1809.

Thrale's husband died in 1779; Johnson, in 1784. Eager to capitalize on the publishing frenzy excited by Johnson's death and to establish her own literary reputation, Thrale hastily put together the *Anecdotes of the Late Samuel Johnson* (1786), her first major publication. Her *Letters to and from the Late Samuel Johnson* (1788) soon followed. Both books sold well but received mixed reviews, partly due to Thrale's frank portrayal of the oft-cranky Johnson, and partly due to the errors she made in her rush to publication. In 1784, much to the dismay of her friends and family, Thrale married Italian singer Gabriel Piozzi. Published in 1789, *Observations and Reflections Made in the Course of*

a Journey through France, Italy, and Germany is based on a journal she kept while on a honeymoon tour of Europe with her second husband. The work is as much about Hester Thrale Piozzi as it is about the places she visited.

Reviews of the book were mixed, with the most negative criticism directed toward Thrale Piozzi's conversational narrative voice, a purposeful stylistic maneuver meant to counter the ornate prose common in her day. As Thrale Piozzi's biographer James Clifford admits, the experiment was only a partial success. But it was an important experiment nonetheless in its attempt to record a more genuine authorial voice. Thrale Piozzi went on to publish three additional books over the next twelve years. In 1795 she and her second husband moved to her native Wales. After years of living as an invalid, Gabriel Piozzi died in 1809. Thrale Piozzi lived another decade, dying in 1821 of injuries sustained from a fall from a couch.

Lille

From the second volume of *Observations and Reflections* (London, 1789), pp. 384–89.

Where every thing appears to me to be just like England, at least just by it; and in fact four and twenty hours would carry us thither with a fair wind: and now it really does feel as if the journey were over; and even in that sensation, though there is some pleasure, there is some pain, too; the time and the places are past;—and I have only left to wish, that my improvements of the one, and my accounts of the others, were better; for though Mr. Sherlock comforts his followers with the kind assertion, That if a hundred men of parts travelled over Italy, and each made a separate book of what *he* saw and observed, a hundred excellent compositions might be made, of which no two should be alike, yet all new, all resembling the original and admirable of their kind.—One's constantly-recurring fear is, lest the readers should cry out, with Juliet—

Yea, but all this did I know before!

How truly might they say so, did I mention the oddity (for oddity it still is) in this town of Lille, to see dogs drawing in carts as beasts of burden, and lying down in the marketplace when their work is done, to gnaw the bones thrown them by their drivers: they are of mastiff race seemingly, crossed by the bull-dog, yet not quarrelsome at all. This is a very awkward and barbarous practice however, and, as far as I know, confined to this city; for in all others, people

seem to have found out, that horses, asses, and oxen are the proper creatures to draw wheel carriages—except indeed at Vienna, where the streets are so very narrow, that the men resolve rather to be harnessed than run over.

How fine I thought these churches thirteen years ago, comes now thirteen times a-day into my head; they are not fine at all; but it was the first time I had ever crossed the channel, and I thought every thing a wonder, and fancied we were arrived at the world's end almost; so differently do the self-same places appear to the self-same people surrounded by different circumstances! I now feel as if we were at Canterbury. Was one to go to Egypt, the sight of Naples on the return home would probably afford a like sensation of proximity: and I recollect, one of the gentlemen who had been with Admiral Anson round the world told us, that when he came back as near as our East India settlements, he considered the voyage as finished, and all his toils at an end—so is my little book; and (if Italy may be considered, upon Sherlock's principle, as a sort of academy-figure set up for us all to draw from) my design of it may have a chance to go in the portfolio with the rest, after its exhibition-day is over.

With regard to the general effect travelling has upon the human mind, it is different with different people. Brydone has observed, that the magnetic needle loses her habits upon the heights of Ætna, nor ever more regains her partiality for the *north*, till again newly touched by the loadstone: it is so with many men who have lived long from home; they find, like Imogen,

That there's living out of Britain;

and if they return to it after an absence of several years, bring back with them an alienated mind—this is not well. Others there are, who, being accustomed to live a considerable time in places where they have not the smallest intention to fix for ever, but on the contrary firmly resolve to leave *sometime*, learn to treat the world as a man treats his mistress, whom he likes well enough, but has no design to marry, and of course never provides for—this is not well neither. A third set gain the love of hurrying perpetually from place to place; living familiarly with all, but intimately with none; till confounding their own ideas (still undisclosed) of right and wrong, they learn to think virtue and vice ambulatory, as Browne says; profess that climate and constitution regulate men's actions, till they try to persuade their companions into a belief most welcome to themselves, that the will of God in one place is by no means his will in another; and most resemble in their whirling fancies a boy's top I once saw shown by a professor who read us a lecture upon opticks; it was painted in regular stripes round like a narrow ribbon, red, blue, green, and yellow; we set

it a-spinning by direction of our philosopher, who, whipping it merrily about, obtained a general effect the total privation of all the four colours, so distinct at the beginning of its *tour;—it resembled a dirty white!*

With these reflections and recollections we drove forward to Calais, where I left the following lines at our inn:

> Over mountains, rivers, vallies,
> Here are we return'd to Calais;
> After all their taunts and malice,
> Ent'ring safe the gates of Calais;
> While, constrain'd, our captain dallies,
> Waiting for a wind at Calais,
> Muse! prepare some sprightly sallies
> To divert *ennui* at Calais.
> Turkish ships, Venetian galleys,
> Have we seen since last at Calais;
> But tho' Hogarth (rogue who rallies!)
> Ridicules the French at Calais,
> We, who've walk'd o'er many a palace,
> Quite well content return to Calais;
> For, striking honestly the tallies,
> There's little choice 'twixt them and Calais.

It would have been graceless not to give these lines a companion on the other side the water, like Dean Swift's distich before and after he climbed Penmanmaur: these verses were therefore written, and I believe still remain, in an apartment of the Ship inn:

> He whom fair winds have wasted over,
> First hails his native land at Dover,
> And doubts not but he shall discover
> Pleasure in ev'ry path round Dover;
> Envies the happy crows which hover
> About old Shakespeare's cliff at Dover;
> Nor once reflects that each young rover
> Feels just the same, return'd to Dover.
> From this fond dream he'll soon recover
> When debts shall drive him back to Dover,
> Hoping, though poor, to live in clover,
> Once safely past the straits of Dover.
> But he alone's his country's lover,

Who, absent long, returns to Dover,
And can by fair experience prove her
The best he has found since last at Dover.

JUDITH SARGENT MURRAY

(1751–1820)

Born in Gloucester, Massachusetts, Judith Sargent Murray was the oldest of eight children in a wealthy seafaring family. Despite her family's wealth, however, Judith Sargent was not encouraged in her education because she had been born a girl. She grew to resent this fact. With the help of a reading tutor and brief attendance at a local writing school, Sargent nonetheless took advantage of the family's library, reading whatever she could get her hands on, including novels, poetry, drama, and essays. In 1769 she married John Stevens, another wealthy sea captain. Soon after, she met John Murray, a traveling Universalist minister who arrived in Gloucester at the invitation of the Sargent family. Eventually, a group of Gloucester citizens, including John and Judith Stevens, helped establish the first Universalist church in America and named John Murray their minister.

Judith Sargent Murray's Universalist beliefs challenged the established Puritan religion of the Massachusetts colony. Her faith, together with the ensuing American Revolution, inspired her to question other unchallenged norms, including the treatment of women. Ten years after she wrote it, Judith Sargent Murray's first publication, "Desultory Thoughts Upon the Utility of Encouraging a Degree of Self-Complacency, Especially in Female Bosoms," appeared in the October 1784 issue of *The Gentleman and Lady's Town and Country Magazine* under the name Constantia, a pseudonym Murray would use frequently in her writing career. In the essay, Murray demands better education for women and encourages women to believe in themselves. In 1786 John Stevens fled creditors and abandoned his wife and home. He died in 1787 before he could pay off his debts, but Murray was eventually able to resolve them. In 1788 she married the preacher John Murray. In 1791 she gave birth to a daugh-

ter, Julia Maria, and embarked on a busy decade of raising her child and writing. One of Murray's best-known essays, "On the Equality of the Sexes," appeared in the *The Massachusetts Magazine* in 1790.

Beginning in 1792 and continuing for the next two years, Murray penned two monthly columns for *The Massachusetts Magazine*: "The Gleaner," using a male pseudonym, and the "Repository," using the name Constantia. Murray later assembled these popular essays, in addition to new and previously unpublished essays and two plays, into a three-volume collection titled *The Gleaner*, which she published in 1798. The original 759 subscribers to *The Gleaner* included George and Martha Washington as well as John Adams. While the book was only moderately successful, Murray earned enough money to send her daughter to one of the best schools in Boston. She fulfilled her desire to give her child the kind of education that she herself had been denied. After the publication of *The Gleaner*, Murray wrote only sporadically for the rest of her life; she was preoccupied with the care of her daughter, her four stepchildren, and her invalid husband. She died in 1820 at the Mississippi home of her daughter and son-in-law.

Plagiarism

Appeared as "Letter LVII" in volume 2 of *The Gleaner* (Boston, 1798), pp. 230–39.

Perhaps he never saw the kindred line—

I pity, from my soul, every candidate for literary fame! If they are warm in the pursuit, and engaged with ardour in the profession of their election—if they are industrious in their application, and unoffending in their subjects, diligently labouring to endow them with every valuable property, of which they are susceptible—if the precepts they inculcate are enforced by the example of their own lives—if they do and are all this, they certainly have *much merit*, and are entitled to no stinted share of that applause, for which they are probably solicitous! But alas! how are their steps environed with peril! their family, their education, their persons, their characters—these all become standing subjects of conversation! while their matter, and their manner, are regarded as free plunder, and the invidious critic is deaf to the voice of candour!

What author but trembles at the critic's lash! and how many are deterred from the eventful path, by the apprehension of the lion in the way! And was

real merit soothed and encouraged, were faults detected and pointed out with mildness, was strict *impartiality observed, and justice always the aim*, I, for my part, should bid the lion roar on, wishing, very sincerely, that his terrors might become properly influential.

It is the opinion of some persons of sound judgment and great abilities, that nothing more is left for a modern writer, than to give a *new dress to old ideas*; but great men are not infallible, and possibly this conclusion may be rather hastily drawn. Solomon said *"there was nothing new under the sun;"* but since the days of Solomon, what profound discoveries have been made; how momentous, how honorary, and how useful! How have the arts and sciences improved, and how has knowledge increased in the world. The use of the loadstone—printing, that capital vehicle of information—the art of war, *meliorated* by the composition and use of gun-powder, &c. &c. while hardly a day passes, on the which novelty peeps not out.

It is, perhaps, true, that the heaviest charge preferred against literary adventurers, is that of plagiarism: After an original thought, a hue and cry is raised— it is traced from author to author—the cheek of innocence is tinged with the indignant blush, excited by suspicions of fraud; and a group of respectable characters are supposed to stand convicted of the high crime of *knowingly* and *wittingly purloining their neighbours' goods.*

To condemn, upon presumptive evidence, is both treacherous and cruel, and it is a procedure which finds no place in the decisions of equity. I do not contend that plagiarism is never practiced—far from it; I believe it constitutes the essence of many a volume, and that it is a kind of depredation, which is too often the *dernier resort* of the scribbler; but I *insist*, and I can produce proof positive of my assertion, that the charge of plagiarism is frequently *unfounded*, and consequently *unjust*. Originality is undoubtedly rare, and it is probable it will become still more so. A writer finds many subjects touched, and retouched, if not wholly exhausted; and, should his abilities embrace a new object, or even a novel arrangement, he is condemned, ere he can establish his hypothesis, however self evident it may be, to combat the giant prejudice, to wage war with a host of cavillers, to oppose himself to the burnished shafts of criticism, and to withstand the secret machinations of envy. But, every discouragement notwithstanding, I humbly conceive there is much more originality in the world, at this present time, than is commonly imagined.

What, I would ask, constitutes originality? or, in other words, cannot an original thought be twice conceived? Let not the critic sneer, before he permits me to explain myself. An idea is expressed in conversation, and a stander-by

declares—*"I had this moment the same thought, Sir."* Query: In whose bosom was the idea original? Suppose, that in the days of Homer, there had arisen, in the wilds of America, or in any other remote part of the globe, a genius, who had delineated every idea of that immortal bard, who had painted the charms of another Helen, arming monarchs and heroes in the licentious cause of a perfidious woman! whose fertile brain had teemed with other Hectors, skillfully opposing them to that Achillean arm, which was nerved for their destruction: suppose his sentiments, his similes and expressions had been nearly similar; and, (since nature, liberal in her operations, might have produced a *second prodigy*, the suggestion cannot be justly said to wear the features of *impossibility*) suppose proof irrefragable had been furnished, that not the smallest intercourse had subsisted between these children of indulgent munificence, and that they had not even a knowledge of each other's existence; should we not, in such an arrangement, have characterized both bards, as possessing original excellence?

For my own part, I am so far from regarding it as wonderful, that a *similarity of talents should exhibit a similarity of ideas, and even of expressions, that I am really astonished such similarity is not more frequently demonstrable.* Let us reflect for a moment—Two beings, endowed with strong understandings and clear perceptions, are educated in different and far distant parts of our world; but their language, their government, and particularly their religion is the same; from the same decalogue their precepts are drawn; virtue is the goal to which they are pointed, and from one source every excitement to virtue is educed. Maturity is at length attained; and, setting down to contemplate a given subject, ought they to be accused of plagiarism, although their productions receive a kindred stamp?

The good divine, whose mind hath been early imbued from that identical fount at which his contemporaries have quaffed, receives a like education, and like academical honours; and with religious sentiments exactly corresponding with his brethren, he mounts the pulpit, and opens the sacred book, ordained at once a standard of his testimony, and the origin from whence he is to deduce those momentous truths, on which he is to expatiate. His text cannot vary, and he may be a stranger to the *flagitious crime of stealing*, although the branches growing upon one root, should resemble each other.

A writer may, *without being a just subject of reprehension*, enrich his page with the most brilliant thoughts of another; *he may himself be deceived*; from extensive and miscellaneous reading, scattered ideas, sentiments, and sometimes sentences, are collected. The volume of memory containeth many pages;

and from childhood to ripening and declining years, what multifarious images are inscribed thereon. From this reservatory we naturally draw, and, it *may sometimes happen*, that ideas deduced from thence, *may be mistaken for original productions of the mind.*

I once had a friend—were I at liberty to name him, every individual, acquainted with his *uncommon worth*, would bow to his superior merit: Ah! how have his fine qualities and gigantic talents been obscured by a train of adverse circumstances, all pointed and brought home to his bosom, by a natural propensity to melancholy. Unfortunate son of genius! I drop a tear over thy present misfortunes, while I recollect, with unabating admiration, the radiant commencement of thy career. I know it, dear Sir, this apostrophe is nothing to the present purpose; and I sit corrected.

This poet (for a genuine poet he verily was) possessed a strong understanding, with a correct judgment, and a glowing fancy; and, what is not commonly an appendage to these advantages, his memory, also, was astonishingly retentive; and he was as far removed from the *practice* as he was from the *necessity* of plagiarism. Our bard, thus highly qualified, employed himself one morning in penning a poetical epistle to a friend, whose abilities were respectable. The epistle finished, forwarded and received, was perused with much surprise; for, strange to tell, it contained a number of lines that were found verbatim in a favourite author, with whose productions the person addressed had recently furnished his library! and *said lines bore on their margin no quotation marks!* It is the part of a *sincere friend* to point out a fault, and our poet was questioned on the subject; he detested plagiarism, and positively asserted his entire property in the problematic essay; but, *to the law and to the testimony*—the book was produced, and the poet eagerly seizing it, cast his eyes on the title page, which he no sooner traced than instantly recognizing, he clasped it to his bosom with all that strong enthusiasm and *fine frenzy* which ever marked his character. The volume proved an *old acquaintance, which had been the delight of his boyish days, and of which he had long been in pursuit*; and it appeared, that writing in a similar manner, and on the same topic, he had drawn those lines from the store-house of memory, where they had been many years safely lodged, unconscious that the well adapted fugitives were not the *true born offspring of his own brain*. Now this, gentle reader, is a kind of plagiarism, if such it can be called, which cannot come under the description of fraud; and whatever may be the *effect* of its *operation*, it is indisputably *guiltless* in its source.

But while *I pledge my veracity* for the *authenticity* of the foregoing anecdote, I readily grant that circumstances seldom concur to produce events of this

complexion; and, conceding thus far, I expect that every person accustomed to reflection, will unhesitatingly acknowledge the propriety of what I have advanced, (viz) *that similarity of ideas and expressions, when the subject is the same*, may often originate in different minds, evidently obtaining in those bosoms, where inborn integrity and conscious propriety had implanted *so strong a sense of right and wrong*, as to create a just and spontaneous abhorrence to whatever could, *in the remotest degree, be denominated plagiarism*. I had lately an opportunity of conversing on this subject, with a female, to whom I am *naturally attached*—she has for many years been a scribbler, and she feelingly lamented that she had repeatedly seen ideas, and complete sentences, issue from the press, which had long been contained in her manuscripts, and which she had flattered herself with the privilege of presenting, as *original thoughts!* This, however, happened more frequent in her prosaic, than in her poetical productions; yet, even in the last, she adduced some instances of considerable similarity; from which, by way of illustration, and for the amusement of the reader, I take the liberty to select two. On the 28th of January, 1784, this penwoman wrote some lines on a particularly interesting occasion, which lines contain the following simile:

> As the fond matron, while the flame ascends,
> Which her whole int'rest in one ruin blends,
> Wildly exclaims—Give me my infant train;
> Possess'd of them, the strokes of fate were vain:
> 'Scap'd from the wreck, she sees her girls and boys,
> And one short moment perfect peace enjoys.

Early in the year 1784, copies of the whole of this poem were put into the hands of several gentlemen, who may perhaps recollect it; but still it is *only a manuscript*; and it is not until within a few months, that she has met with that beautiful production, entitled, the *Botanic Garden*, the offspring of an elegant European pen, first *published in the year* 1793; in which *she* observed, in the following highly finished lines, *the same thought*.

> "Th' illumin'd mother seeks with footsteps fleet,
> Where hangs the safe balcony o'er the street;
> Wrapped in her sheet, her youngest hope suspends,
> And panting, lowers it to her tip-toe friends:
> Again she hurries on affliction's wings,
> And now a third, and now a fourth she brings;
> Safe all her babes, she smoothes her horrent brow,
> And bursts thro' bickering flames, unscorch'd, below."

Now it is *demonstrably certain*, that neither of these writers *borrowed*, or, more plainly speaking, *purloined* from each other. Producing, therefore, the foregoing lines as a proof in point, I proceed to the second instance. Previous to her perusal of the *Botanic Garden*, she had been requested to write an ode on a very affecting occasion: This ode was to be publicly chanted, for the benefit of a worthy young man; and it was an address to the benevolence of the audience. It is not my design to give the ode entire; I only transcribe the part which is necessary to introduce the lines that she imagined similar—thus they are *expressed*:

> Ye spirits bland, from heav'n descend,
> Around this hallow'd temple bend,
> With aspect all benign
> Philanthropy, first-born of truth,
> Of paradise the fairest growth,
> Replete with powers divine.
>
> Hov'ring around, we feel you press,
> This consecrated sane to bless,
> Its pious rites to guard:
> Benevolence, religion twines
> With blest munificence designs,
> And is its own reward.
>
> Benevolence, whose genial sway
> Commission'd hath the new-born day,
> And burst the pris'ner's chains—
> Its progress can arrest despair,
> Can smooth the furrow'd brow of care,
> While mild compassion reigns.
>
> Thus, when enwrapped in Howard's guise,
> To mortals lent from yonder skies,
> And borne on mercy's wing;
> The depth of human woe he fought,
> With lenient balm assuaging fraught,
> Returning light to bring.—&c. &c.

The ode was published; and the writer was some time afterwards attracted by a resemblance in the following energetic lines, found also in the *Botanic Garden*:

> "The spirits of the good, who bend from high
> Wide o'er these earthly scenes their partial eye,
> When first array'd in virtue's purest robe,
> They saw her Howard traversing the globe;
> Saw on his brow her fun-like glory blaze,
> In arrowy circles of unwearied rays."

Many are the instances, which, from my own individual experience, I could record; and my volumes of manuscripts, that I was positive were enriched with many original thoughts, from my delay to publish, have now, alas! been generally forestalled. My plans, my ideas, my metaphors, *ah, well-a-day!* in almost every thing I have been anticipated; and whenever my lucubrations are presented, *innocent as I am*, the probability is, that I shall find myself indicted in the high spirit of literature for the debasing crime of plagiarism! Yet these essays, although the offspring of many a careful hour, deducing very possibly their highest charm from novelty, have now lost, even in my own estimation, much of their power to interest and to please; and I do not, I am free to own, very deeply lament their fate.

But a recent discovery having stripped of originality this my youngest born, *my pet*, that I have cherished with such unremitted tenderness, culling for it the fairest flowers, *gleaning* every sweet, and adorning it up to my best abilities; and now to find, that after all, I have been rearing the bantling of another! It is really almost too much for my philosophy to bear; nor can my utmost equanimity prevent the hag vexation from adding another score to those furrows, which time and disappointment have already so deeply indented!!!

No, I can never part with it—still it is the child of my adoption, and I must ever remain its protecting father. Sympathizing reader, I will tell thee the story. Thou knowest how much I have prided myself upon the *title* of these numbers: It was ample enough for my purpose; it was unassuming; yea, as humble as the smallest particles which fall from the granary of the opulent dealer; and yet by the wonderful force of its elastic power, it could extend itself over the vast fields of science, wandering upon the superficies of the grounds, and snatching those gems which are sometimes the reward of industrious mediocrity.

It was, I have a thousand times said, a complete shield *from every accusation of literary theft*. It was—in short, it was abundantly commensurate with my most sanguine wishes; and what, in my estimation, inexpressibly enhanced its value, was, that I imagined it had *never before been thus appropriated*. Judge then, what were my sensations, when, two days since, turning over a volume

written by Voltaire, I observed, among his account of literary publications, the following paragraph, which, by way of exciting thy commiseration, I shall transcribe, verbatim.

*"Miserable pamphlets!—the Gleaner!—*the Fault finder, &c.—*Wretched productions! inspired by hunger, and dictated by stupidity and a disposition to lying! &c.&c."*

To find my *boasted title* thus unexpectedly flashed in my face; and to meet it, too, *coupled with infamy*!!!—But my feelings may be better *imagined* than *described*; and the candid reader, while he acquits me of an instance of *plagiarism*, so *impolitic*, and so *absurd*, will not fail to sympathize with, and to vindicate.

<div align="right">The mortified Gleaner.</div>

THE *Nineteenth* CENTURY

MARY RUSSELL MITFORD

(1787–1855)

Mary Russell Mitford was the daughter of a wealthy heiress and a surgeon whose addiction to gambling continually kept the family in financial straits. Yet like many children of affluent families at this time, she had access to books and read avidly from a young age. Mitford spent four years at the prestigious Abbey School in London, where she received a solid classical education that included training in Latin. Her first publication in 1810 was *Poems*. While she was most devoted to this genre, it could not earn her the income that her father needed to keep the family out of debt. Even attempts at writing for the stage, for which Mitford received moderate critical success, failed to produce enough money.

Forced to sell their luxurious home on the outskirts of Reading in 1820, Mitford and her family moved to a cottage in Three Mile Cross, the country village she would later immortalize in her prose sketches. The first of these sketches was published in 1823 in the *Lady's Magazine*, a then little-known periodical. The magazine's circulation increased substantially due to the popularity of Mitford's colorful prose. In 1824 she published the first volume of *Our Village*, a collection of twenty-four of her village sketches. A genre-bending mix of fiction and essayistic musings, the book quickly became a best seller, and Mitford went on to publish four additional volumes. After her mother's death in 1830, she continued to write and to care for her father until his death in 1842. Never marrying, Mitford eventually abandoned the deteriorating cottage that had been the home setting of her well-remembered essays and moved to a new one in Swallowfield. She died there in 1855.

Violeting

From the first volume of *Our Village* (London, 1824), pp. 100–106.

March 27th.—It is a dull gray morning, with a dewy feeling in the air; fresh, but not windy; cool, but not cold;—the very day for a person newly arrived from the heat, the glare, the noise, and the fever of London, to plunge into the remotest labyrinths of the country, and regain the repose of mind, the calmness of heart, which has been lost in that great Babel. I must go violeting—it is a necessity—and I must go alone: the sound of a voice, even my Lizzy's, the touch of Mayflower's head, even the bounding of her elastic foot, would disturb the serenity of feeling which I am trying to recover. I shall go quite alone, with my little basket, twisted like a bee-hive, which I love so well, because *she* gave it to me, and kept sacred to violets and to those whom I love; and I shall get out of the high-road the moment I can. I would not meet any one just now, even of those whom I best like to meet.

Ha!—Is not that group—a gentleman on a blood horse, a lady keeping pace with him so gracefully and easily—see how prettily her veil waves in the wind created by her own rapid motion!—and that gay, gallant boy, on the gallant white Arabian, curveting at their side, but ready to spring before them every instant—is not that chivalrous-looking party Mr. and Mrs. M. and dear B.? No! the servant is in a different livery. It is some of the ducal family, and one of their young Etonians. I may go on. I shall meet no one now; for I have fairly left the road, and am crossing the lea by one of those wandering paths, amidst the gorse, and the heath, and the low broom, which the sheep and lambs have made—a path turfy, elastic, thymy, and sweet, even at this season.

We have the good fortune to live in an unenclosed parish, and may thank the wise obstinacy of two or three sturdy farmers, and the lucky unpopularity of a ranting madcap lord of the manor, for preserving the delicious green patches, the islets of wilderness amidst cultivation, which form perhaps the peculiar beauty of English scenery. The common that I am passing now—the lea, as it is called—is one of the loveliest of these favoured spots. It is a little sheltered scene, retiring, as it were, from the village; sunk amidst higher lands, hills would be almost too grand a word: edged on one side by one gay high-road, and intersected by another; and surrounded by a most picturesque confusion of meadows, cottages, farms, and orchards; with a great pond in one corner, unusually bright and clear, giving a delightful cheerfulness and daylight to the

picture. The swallows haunt that pond; so do the children. There is a merry group round it now; I have seldom seen it without one. Children love water, clear, bright, sparkling water; it excites and feeds their curiosity; it is motion and life.

The path that I am treading leads to a less lively spot, to that large heavy building on one side of the common, whose solid wings, jutting out far beyond the main body, occupy three sides of a square, and give a cold shadowy look to the court. On one side is a gloomy garden, with an old man digging in it, laid out in straight dark beds of vegetables, potatoes, cabbages, onions, beans; all earthy and mouldy as a newly dug grave. Not a flower or flowering shrub! Not a rose-tree or currant-bush! Nothing but for sober melancholy use. Oh how different from the long irregular slips of the cottage-gardens, with their gay bunches of polyanthuses and crocuses, their wallflowers sending sweet odours through the narrow casement, and their gooseberry-trees bursting into a brilliancy of leaf, whose vivid greenness has the effect of a blossom on the eye! Oh, how different! On the other side of this gloomy abode is a meadow of that deep, intense emerald hue, which denotes the presence of stagnant water, surrounded by willows at regular distances, and like the garden, separated from the common by a wide, moat-like ditch. That is the parish workhouse. All about it is solid, substantial, useful;—but so dreary! so cold! so dark! There are children in the court, and yet all is silent. I always hurry past that place as if it were a prison. Restraint, sickness, age, extreme poverty, misery, which I have no power to remove or alleviate,—these are the ideas, the feelings, which the sight of those walls excites; yet, perhaps, if not certainly, they contain less of that extreme desolation than the morbid fancy is apt to paint. There will be found order, cleanliness, food, clothing, warmth, refuge for the homeless, medicine and attendance for the sick, rest and sufficiency for old age, and sympathy, the true and active sympathy which the poor show to the poor, for the unhappy. There may be worse places than a parish workhouse—and yet I hurry past it. The feeling, the prejudice, will not be controlled.

The end of the dreary garden edges off into a close-sheltered lane, wandering and winding, like a rivulet, in gentle "sinuosities" (to use a word once applied by Mr. Wilberforce to the Thames at Henley), amidst green meadows, all alive with cattle, sheep, and beautiful lambs, in the very spring and pride of their tottering prettiness: or fields of arable land, more lively still with troops of stooping bean-setters, women and children, in all varieties of costume and colour; and ploughs and harrows, with their whistling boys and steady carters, going through, with a slow and plodding industry, the main business of

this busy season. What work bean-setting is! What a reverse of the position assigned to man to distinguish him from the beasts of the field! Only think of stooping for six, eight, ten hours a day, drilling holes in the earth with a little stick, and then dropping in the beans one by one. They are paid according to the quantity they plant; and some of the poor women used to be accused of clumping them—that is to say, of dropping more than one bean into a hole. It seems to me, considering the temptation, that not to clump is to be at the very pinnacle of human virtue.

Another turn in the lane, and we come to the old house standing amongst the high elms—the old farmhouse, which always, I don't know why, carries back my imagination to Shakespeare's days. It is a long, low, irregular building, with one room, at an angle from the house, covered with ivy, fine white-veined ivy; the first floor of the main building projecting and supported by oaken beams, and one of the windows below, with its old casement and long narrow panes, forming the half of a shallow hexagon. A porch, with seats in it, surmounted by a pinnacle, pointed roofs, and clustered chimneys, complete the picture! Alas! it is little else but a picture! The very walls are crumbling to decay under a careless landlord and ruined tenant.

Now a few yards farther, and I reach the bank. Ah! I smell them already—their exquisite perfume steams and lingers in this moist heavy air. Through this little gate, and along the green south bank of this green wheat-field, and they burst upon me, the lovely violets, in tenfold loveliness. The ground is covered with them, white and purple, enamelling the short dewy grass, looking but the more vividly coloured under the dull, leaden sky. There they lie by hundreds, by thousands. In former years I have been used to watch them from the tiny green bud, till one or two stole into bloom. They never came on me before in such a sudden and luxuriant glory of simple beauty,—and I do really owe one pure and genuine pleasure to feverish London! How beautifully they are placed too, on this sloping bank, with the palm branches waving over them, full of early bees, and mixing their honeyed scent with the more delicate violet odour! How transparent and smooth and lusty are the branches, full of sap and life! And there, just by the old mossy root, is a superb tuft of primroses, with a yellow butterfly hovering over them, like a flower floating on the air. What happiness to sit on this tufty knoll, and fill my basket with the blossoms! What a renewal of heart and mind! To inhabit such a scene of peace and sweetness is again to be fearless, gay, and gentle as a child. Then it is that thought becomes poetry, and feeling religion. Then it is that we are happy and good. Oh, that my whole life could pass so, floating on blissful and innocent

sensation, enjoying in peace and gratitude the common blessings of Nature, thankful above all for the simple habits, the healthful temperament, which render them so dear! Alas! who may dare expect a life of such happiness? But I can at least snatch and prolong the fleeting pleasure, can fill my basket with pure flowers, and my heart with pure thoughts; can gladden my little home with their sweetness; can divide my treasures with one, a dear one, who cannot seek them; can see them when I shut my eyes; and dream of them when I fall asleep.

LYDIA MARIA CHILD

(1802–1880)

One of the most influential writers and editors of the nineteenth century, Lydia Maria Francis Child was born in Medford, Massachusetts. After the death of her mother, she moved to Maine to live with an older married sister. There, she witnessed the plight of native Abenaki and Penobscot people. This experience fueled her later advocacy on behalf of the country's most disadvantaged inhabitants, including Native Americans, African slaves, women, and children. When she was nineteen, Child returned to Massachusetts to live with her brother, a Unitarian minister who took charge of her education. In 1824, she published to great acclaim a historical novel, *Hobomok: A Tale of Early Times*. By the time she married her husband, David Lee Child, in 1828, Lydia Maria Child had published a children's book and a second novel, as well as edited the first American children's magazine, *Juvenile Miscellany*.

With her husband contributing more debt than income to the family finances, Child became the principal breadwinner. Her prolific writing endeavors kept the family solvent and earned her a solid literary reputation that sometimes bordered on celebrity status. In the 1830s, Child and her husband joined forces with abolitionist William Lloyd Garrison, and Child quickly began writing for the cause. This decision would cost her dearly in the eyes of the American public. Upon the publication of *An Appeal in Favor of That Class of Americans Called Africans* in 1833, sales of her other books quickly dropped. Although she was also forced to relinquish editorship of her children's magazine, Child was undeterred. She published several more antislavery books.

In 1838, the impoverished Child could not refuse an offer of editorship of the abolitionist newspaper the *National Anti-Slavery Standard*. As editor, Child also began contributing a popular column she titled "Letters from New-

York." These essays mixed her personal reflections on life in New York City with discussions of the causes she held dear. The result helped revive flagging readership, increasing subscriptions exponentially during her two-year tenure. In 1843, after resigning from the newspaper, Child published a collected volume of her columns in *Letters from New-York*, a book that proved exceedingly successful and helped to restore her reputation as a writer. A second volume, *Letters from New-York, Second Series*, appeared in 1845. Until her death in 1880, Child continued to write and publish, and she served as editor of Harriet Jacob's now well-known slave narrative, *Incidents in the Life of a Slave Girl* (1861).

Metropolis

First appeared as "Letter X" on October 21, 1841, in the
National Anti-Slavery Standard and later collected in
Letters from New-York (New York, 1843), pp. 56–60.

OCTOBER 21, 1841

In a great metropolis like this, nothing is more observable than the infinite varieties of character. Almost without effort, one may happen to find himself, in the course of a few days, beside the Catholic kneeling before the cross, the Mohammedan bowing to the East, the Jew veiled before the ark of the testimony, the Baptist walking into the water, the Quaker keeping his head covered in the presence of dignitaries and solemnities of all sorts, and the Mormon quoting from the Golden Book which he has never seen.

More, perhaps, than any other city, except Paris or New Orleans, this is a place of rapid fluctuation, and never-ceasing change. A large portion of the population are like mute actors, who tramp across the stage in pantomime or pageant, and are seen no more. The enterprising, the curious, the reckless, and the criminal, flock hither from all quarters of the world, as to a common centre, whence they can diverge at pleasure. Where men are little known, they are imperfectly restrained; therefore, great numbers here live with somewhat of that wild license which prevails in times of pestilence. Life is a reckless game, and death is a business transaction. Warehouses of ready-made coffins, stand beside warehouses of ready-made clothing, and the shroud is sold with spangled opera-dresses. Nay, you may chance to see exposed at sheriffs' sales, in public squares, piles of coffins, like nests of boxes, one within another, with

a hole bored in the topmost lid to sustain the red flag of the auctioneer, who stands by, describing their conveniences and merits, with all the exaggerating eloquence of his tricky trade.

There is something impressive, even to painfulness, in this dense crowding of human existence, this mercantile familiarity with death. It has sometimes forced upon me, for a few moments, an appalling night-mare sensation of vanishing identity; as if I were but an unknown, unnoticed, and unseparated drop in the great ocean of human existence; as if the uncomfortable old theory were true, and we were but portions of a Great Mundane Soul, to which we ultimately return, to be swallowed up in its infinity. But such ideas I expel at once, like phantasms of evil, which indeed they are. Unprofitable to all, they have a peculiarly bewildering and oppressive power over a mind constituted like my own; so prone to eager questioning of the infinite, and curious search into the invisible. I find it wiser to forbear inflating this balloon of thought, lest it roll me away through unlimited space, until I become like the absent man, who put his clothes in bed, and hung himself over the chair; or like his twin-brother, who laid his candle on the pillow, and blew himself out.

You will, at least, my dear friend, give these letters the credit of being utterly unpremeditated; for Flibbertigibbet himself never moved with more unexpected and incoherent variety. I have wandered almost as far from my starting point, as Saturn's ring is from Mercury; but I will return to the varieties in New-York. Among them, I often meet a tall Scotsman, with sandy hair and high cheek-bones—a regular Sawney, with tartan plaid and bag-pipe. And where do you guess he most frequently plies his poetic trade? Why, in the slaughter-houses! of which a hundred or more send forth their polluted breath into the atmosphere of this swarming city hive! There, if you are curious to witness incongruities, you may almost any day see grunting pigs or bleating lambs, with throats cut to the tune of Highland Mary, or Bonny Doon, or Lochaber No More.

Among those who have flitted across my path, in this thoroughfare of nations, few have interested me more strongly than an old sea-captain, who needed only Sir Walter's education, his wild excursions through solitary dells and rugged mountain-passes, and his familiarity with legendary lore, to make him, too, a poet and a romancer. Untutored as he was, a rough son of the ocean, he had combined in his character the rarest elements of fun and pathos; side by side, they glanced through his conversation, in a manner almost Shakspearean. They shone, likewise, in his weather-beaten countenance; for he had "the eye of Wordsworth, and the mouth of Molière."

One of his numerous stories particularly impressed my imagination, and re-mains there like a cabinet picture, by Claude. He said he was once on board a steamboat, full of poor foreigners, going up the Mississippi to some place of destination in the yet unsettled wilderness. The room where these poor emigrants were huddled together, was miserable enough. In one corner, two dissipated-looking fellows were squatted on the floor, playing All-fours with dirty cards; in another, lay a victim of intemperance, senseless, with a bottle in his hand; in another, a young Englishman, dying of consumption—kindly tended by a venerable Swiss emigrant, with his helpful wife, and artless daugh-ter. The Englishman was an intelligent, well-informed young man, who, being unable to marry the object of his choice, with any chance of comfortable sup-port in his own country, had come to prepare a home for his beloved in the Eldorado of the West. A neglected cold brought on lung fever, which left him in a rapid decline; but still, full of hope, he was pushing on for the township where he had planned for himself a domestic paradise. He was now among strangers, and felt that death was nigh. The Swiss emigrants treated him with that thoughtful, zealous tenderness, which springs from genial hearts deeply imbued with the religious sentiment. One wish of his soul they could not grat-ify, by reason of their ignorance. Being too weak to hold a pen, he earnestly de-sired to dictate to some one else a letter to his mother and his betrothed. This, Captain T. readily consented to do; and promised, so far as in him lay, to carry into effect any arrangements he might wish to make.

Soon after this melancholy duty was fulfilled, the young sufferer departed. When the steamboat arrived at its final destination, the kind-hearted Cap-tain T. made the best arrangements he could for a decent burial. There was no chaplain on board; and, unused as he was to the performance of religious ceremonies, he himself read the funeral service from a book of Common Prayer, found in the young stranger's trunk. The body was tenderly placed on a board and carried out, face upwards, into the silent solitude of the primeval forest. The sun, verging to the west, cast oblique glances through the foliage, and played on the pale face in flickering light and shadow. Even the most dissi-pated of the emigrants were sobered by a scene so touching and so solemn, and all followed reverently in procession. Having dug the grave, they laid him care-fully within, and replaced the sods above him; then, sadly and thoughtfully, they returned slowly to the boat.

Subdued to tender melancholy by the scene he had witnessed, and the un-usual service he had performed, Captain T. avoided company, and wandered off alone into the woods. Unquiet questionings, and far-reaching thoughts of

God and immortality, lifted his soul toward the Eternal; and heedless of his footsteps, he lost his way in the windings of the forest. A widely devious and circuitous route brought him within sound of human voices. It was a gushing melody, taking its rest in sweetest cadences. With pleased surprise, he followed it, and came, suddenly and unexpectedly, in view of the new-made grave. The so kindly Swiss matron, and her innocent daughter, had woven a large and beautiful cross, from the broad leaves of the papaw tree, and twined it with the pure white blossoms of the trailing convolvulus. They had placed it reverently at the head of the stranger's grave, and kneeling before it, chanted their evening hymn to the Virgin. A glowing twilight shed its rosy flush on the consecrated symbol, and the modest, friendly faces of those humble worshippers. Thus beautifully they paid *their* tribute of respect to the unknown one, of another faith, and a foreign clime, who had left home and kindred, to die among strangers in the wilderness.

How would the holy gracefulness of this scene have melted the heart of his mother and his beloved!

I had many more things to say to you; but I will leave them unsaid. I leave you alone with this sweet picture, that your memory may consecrate it as mine has done.

ANN PLATO

(1820?–?)

Little is known of Ann Plato's life other than her ties to Hartford, Connecticut. Scholars suspect she was born in the early 1820s, the eldest daughter of Deborah Plato and Henry Plato, a farmer who owned land in Hartford. Ann Plato was probably just a teenager—perhaps as young as sixteen—when she published her first and only book in 1841. *Essays, Including Biographies and Miscellaneous Pieces, in Prose and Poetry* has the distinction of being the first book of essays published by an African American. Plato's work includes essays on education and religious topics. The latter would have appealed to the members of Hartford's African American community, to whom she addressed her writings.

Plato belonged to the African Congregational Church of Hartford, which had established the city's first all-black school in 1830. The church's pastor, Dr. James W. C. Pennington, an author himself, wrote the laudatory preface to Plato's book. Therein, he suggests that if the book is "met with due encouragement, her talents will receive an impetus which will amply repay her patrons, and the generation in which she lives." In 1840, the Elm Street Zion Methodist Church, Hartford's other major African American church, opened the South African School on its premises. Plato became the school's head teacher. No trace of the remainder of Plato's life after her 1847 departure from the South African School has been discovered.

Reflections upon the Close of Life

From *Essays, Including Biographies and Miscellaneous Pieces, in Prose and Poetry* (Hartford, Conn., 1841), pp. 72–74.

Written on Visiting the Grave Yard at New Haven, Ct.

"When we contemplate the close of life, the termination of man's designs and hopes; the silence that now reigns among those who, a little while ago, were so busy or so gay; who can avoid being touched with sensations at once awful and tender? What heart but then warms with the glow of humanity? In whose eye does not the tear gather, on revolving the fate of passing short lived man?"

The graves before me, and all around me, are thickly deposited. The marble that speak the names, bid us prepare for DEATH. How solemn is the thought that soon we, too, must lay low in the grave. The generations that now exist must pass away; and more arise in their stead, to fill places which they now occupy, and do effectual good.

Some of the marble speaks of those who have not long since died; others appear quite ancient. Yet, memory can never fill the places of most of these, who slumber here in tombs. Trace back—their relations are not among the living. Ere a day they slumbered in the silent grave.

In the grave by my side sleeps some sainted priest; the marble speaks his fame. Perhaps he has undergone the fatigues of life; he has been an eminent servant in his Master's calling, and now has his reward in heaven. He has died the death of the righteous; he has given up this world "with joy, and not with grief." He has had different stations in life; he has, perhaps, been in various parts of the world, has proclaimed the gospel to the heathen, he has experienced prosperity and adversity; he has seen families and kindred rise and fall; and he has now closed his eyes upon this world forever more.

Methinks I see before me the family burying ground. At the head sleeps the father and the mother. The children are deposited within the ground. The words about seem to say, live and die as did this family; upon this saying I did relent.

As I walked on, I seated myself down upon a grave; it was the grave of an infant. It seemed to be sleeping on until the resurrection "of both great and small." I said, before this day shall close, I too may sleep in death. Have I pre-

served that cheerful, and innocent countenance which this infant has shown? Then I prayed to the Lord to shelter me, and to deliver me from all evil.

I saw a countless number of trees. Among them was a willow. I thought of what a child once said. "Tree, why art thou always sad and drooping? Am I not kind unto thee? Do not the showers visit thee, and sink deep to refresh thy root? Hast thou sorrow at thy heart?" Then said an author—"but it answered not. And as it grew on, it drooped lower and lower; for it was a weeping willow."

I stooped myself down over the grave of an aged sire. I said to him, tell me of this grave! Methought that he answered—"ask him who rose again for me." Noble sire, thou hast seen peace and war succeeding in their turn; the face of thy country undergoing many alterations; and the very city in which thou dwelt, rising in a manner new around thee.

After all thou hast beheld, thine eyes are now closed forever. Thou wast becoming a stranger amidst a new succession of men. A race who knew thee not, had arisen to flit the earth. Thus passeth the world away; "and this great inn is by turns evacuated and replenished, by troops of succeeding pilgrims."

"O vain and inconstant world! O fleeting and transient life. When will the sons of men learn to think of thee as they ought? When will they learn humanity from the affliction of their brethren; or moderation and wisdom, from a sense of their own fugitive state?"

MARGARET FULLER

(1810–50)

Perhaps best known for her involvement in the American transcendentalist movement, Margaret Fuller was the first of nine children. Her father, a Massachusetts lawyer, dealt with his disappointment over not having a son by providing Fuller with a son's education. She received rigorous training in Latin, literature, and philosophy. When her father died unexpectedly in 1835, Fuller accepted a teaching position at Bronson Alcott's Temple School in Boston in order to support her family. Later she moved to Providence, Rhode Island, where she taught at the Greene Street School. There, though, she felt isolated from the Boston transcendentalists whom she had befriended several years earlier.

In 1839 Fuller returned to Boston and published her first book, a translation of Johann Eckermann's *Conversations with Goethe in the Last Years of His Life*. Fuller also hosted the first of five annual "Conversations with Women" gatherings that brought together educated Bostonian women and provided her with needed income. At Ralph Waldo Emerson's urging, she assumed editorship of the new and controversial newspaper *The Dial* in 1840. This role often included writing more than half of the periodical herself. After she turned the editorship of the struggling periodical over to Emerson in 1842, Fuller remained a contributor. One of her most notable submissions is "The Great Lawsuit. Man versus Men. Woman versus Women," which she later revised, expanded, and published in book form as *Woman in the Nineteenth Century* (1845). In 1843 Fuller published a book of travel sketches, *Summer on the Lakes*.

Soon after, Horace Greeley, editor of the *New-York Daily Tribune*, hired Fuller as the newspaper's literary critic. She contributed more than 250 reviews

and essays during her tenure there. In 1846, she published a collection of her essays in *Papers on Literature and Art*. That same year, she sailed for England, where she continued to work as a foreign correspondent for the *Daily Tribune*. From England, Fuller traveled to Paris, then Italy, where she met Giovanni Angelo D'Ossoli. The Italian nobleman would eventually become her lover and the father of her son, Angelo. Fuller continued to file dispatches from Italy during the Italian Revolution, but when Greeley learned of her liaison with Ossoli, he ceased publishing her columns. Fuller and Ossoli continued to live as a married couple, but Italy's political turmoil and their own scandalous relationship plagued their lives. In 1850 they decided to return to the United States with their son, but their ship ran aground off Fire Island, and the entire family drowned.

The Celestial Empire

First appeared in the November 13, 1845, issue of the *New-York Daily Tribune* and reprinted in the *New-York Weekly Tribune*. This version is from the November 13, 1845, issue of the *New-York Daily Tribune*, p. 2.

During a late visit to Boston, I visited with great pleasure the Chinese Museum which has been opened there, and which will be seen to still greater advantage in New-York next summer, because there will be more room to display to advantage its rich contents.

There was great pleasure in surveying there, if merely on account of their splendor and elegance, which, though fantastic according to our tastes, presented an obvious standard of its own by which to prize it. The rich dresses of the imperial court, the magnificent jars, the largest worth three hundred dollars, and looking as if it was worth much more, the present-boxes and ivory work, the elegant interiors of the home and counting-room—all these gave pleasure by their perfection, each in its kind.

But the chief impression was of that unity of existence, so opposite to the European, and, for a change, so pleasant from its repose and gilded lightness. Their imperial majesties do really seem so "perfectly serene" that we fancy we might become so, under their sway, if not "thoroughly virtuous," as they profess to be. Entirely a new mood would be ours, as we should sup in one of those pleasure boats by the light of those fanciful lanterns, or listen to the tinkling of those Pagoda bells.

The highest conventional refinement of a certain kind, is apparent in all that belongs to the Chinese. The inviolability of custom has not made their life heavy but shaped it to the utmost adroitness for their own purposes. We are now somewhat familiar with their literature, and we see pervading it a poetry subtle and aromatic, like the odors of their appropriate beverage. Like that, too, it is all domestic—never wild. The social genius, fluttering on the wings of compliment, pervades every thing Chinese. Society has moulded them body and soul, the youngest children are more social and Chinese than human, and we doubt not the infant, with its first cry, shows its capacity for self-command and obeisance to superiors.

Their great man, Confucius, expresses this social genius in its most perfect state and highest form. His golden wisdom is the quintessence of social justice. He never forgets conditions and limits; he is admirably wise, pure and religious, but never towers above humanity—never soars into solitude. There is no token of the forest or cave in Confucius. Few men could understand him because his nature was so thoroughly balanced and his rectitude so pure; not because his thoughts were too deep or high for them. In him should be sought the best genius of the Chinese, with that perfect practical good sense whose uses are universal.

At one time I used to change from reading Confucius to one of the great religious books of another Eastern nation, and it was always like leaving the street and the palace for the blossoming forest of the East, where in earlier times we are told the angels walked with men and talked, not of earth, but of Heaven.

As we looked at the forms moving about in the Museum, we could not wonder that the Chinese consider us, who call ourselves the civilized world, barbarians, so deficient were those forms in the sort of refinement that the Chinese prize above all. And our people deserve it for their senselessness in viewing *them* as barbarians, instead of seeing how perfectly they represent their own idea. They are inferior to us in important developments, but on the whole, approach far nearer their own standard than we do to ours. And it is wonderful that an enlightened European can fail to prize the sort of beauty they do develop. Sets of engravings we have seen representing the culture of the tea plant have brought to us images of an entirely original idyllic loveliness. One long resident in the country has observed that nothing can be more enchanting than the smile of love on the regular but otherwise expressionless face of a Chinese woman. It has the simplicity and abandonment of infantine, with the fullness of mature feeling. It never varies, but it does not tire.

The same sweetness and elegance, stereotyped now, but having originally a deep root in their life as a race, may be seen in their poetry and music.—The last we heard, both from the voice and several instruments, at this Museum for the first time, and were at first tempted to laugh, when something deeper forbade. Like true poetry, the music is of the narrowest monotony, a kind of rosary, a repetition of phrases, and, in its enthusiasm and conventional excitement, like nothing else in the heavens or on the earth. Yet both the poetry and music have in them an expression of birds, roses and moonlight; indeed they suggest that state "where music and moonlight and feeling are one," though the soul seems to twitter, rather than sing of it.

It is wonderful with how little practical insight travelers in China look on what they see. They seem to be struck by points of repulsion at once, and neither see nor tell us what could give us any real clue to their facts. I do not speak now of the recent lecturers in this city, for I have not heard them; but of the many, many books into which I have earlier looked with eager curiosity—in vain! I always found the same external facts, and the same prejudices which disabled the observer from piercing beneath them. I feel that I know something of the Chinese when I read Confucius, or look at the figures on their teacups, or drink a cup of *genuine* tea—rather an unusual felicity, it is said, in this ingenious city, which shares with the Chinese one trait at least. But the travelers rather take from than add to this knowledge, and a visit to this Museum would give more clear views than all the books I ever read yet.

The juggling was well done, and so solemnly, with the same concentrated look as the music. I saw the juggler afterwards at Ole Bull's concert, and he moved not a muscle while the nightingale was pouring forth its sweetest descant. Probably the avenues wanted for these strains to enter his heart, had been closed by Imperial Edict long ago. The resemblance borne by this juggler to our Indians is even greater than we have seen in any other case. His brotherhood does not, to us, seem surprising. Our Indians, too, are stereotyped, though in a different way; they are of a mold capable of retaining the impression through ages, and many of the traits of the two races, or two branches of a race, may be seen to be identical, though so widely modified by circumstances. They are all opposite to us, who have made ships and balloons, and magnetic telegraphs as symbolic expressions of our wants and the means of gratifying them. We must console ourselves with these and our organs and pianos for our want of perfect good breeding, serenity and "thorough virtue."

GRACE GREENWOOD

(1823–1904)

Grace Greenwood was the pen name of Sara Jane Clarke Lippincott, who was born in Pompey, New York. The great-granddaughter of Puritan minister and writer Jonathan Edwards, Greenwood published her first poem when she was only thirteen years old. In 1842 her family moved to New Brighton, Pennsylvania, near Philadelphia, and Greenwood began writing her first journalistic letters for the *New York Mirror* and the *Home Journal*. Signed "Grace Greenwood," these letters were instantly successful. They established Greenwood's literary reputation and created a readership for her further work in such popular periodicals as *Godey's Lady's Book*, *Graham's Sartain's*, and the *Saturday Evening Post*.

Greenwood's abolitionist views ultimately led to her dismissal from *Godey's*, however. In response, Gamaliel Bailey, editor of the abolitionist newspaper the *National Era*, hired Greenwood as his assistant. She moved to Washington, D.C., where, in addition to her duties for Bailey, she served as a Washington correspondent for the *Saturday Evening Post*. In 1850 Greenwood published her first book, the best-selling *Greenwood Leaves: A Collection of Sketches and Letters*. The equally successful *Greenwood Leaves: A Collection of Sketches and Letters, Second Series* followed in 1854. That same year, Greenwood published *Haps and Mishaps of a Tour in Europe*, one of the most successful of her books. This volume features letters she filed during her eighteen months in Europe as a correspondent for the *National Era* and the *Saturday Evening Post*.

In 1853 Greenwood had married Leander K. Lippincott, and this marriage was reportedly unhappy. Years later, after being indicted for fraud while working as chief clerk of the General Land Office of the Department of the Interior, Lippincott fled the country in order to evade arrest. He left Greenwood and their daughter, Annie, to fend for themselves. Greenwood continued what she had been doing for the last two decades, writing prolifically for the periodical press and publishing her letters in collected volumes. These ef-

forts earned what she needed to support herself and her daughter. After her daughter married, Greenwood returned to Washington, D.C., and then, when Greenwood grew ill, she moved to her daughter's home in New Rochelle, New York. Greenwood continued to write until her death in 1904.

My First Hunting

From *Greenwood Leaves: A Collection of*
Sketches and Letters (Boston, 1850), pp. 28–33.

"That's what I call a title distinguished for its femininity," says a roguish-eyed friend, peering saucily over my shoulder.

"Ah, never you mind, Fred; it's a harmless little fancy of my own," as the lady said, when she led her footman to the altar.

I love to look upon a sportsman. I don't mean one of your moustached amateurs, who sallies out once a year, perhaps, in white gloves and gaiters, and with scarce manly strength sufficient to hold his fowling-piece at arms' length; one whom you might fancy mistaking a hen for a pheasant, and taking aim at her through an eye-glass, while it requires no violent exercise of the imaginative faculty to behold her placing her claw upon her bill and performing certain contemptuous gyrations therewith. Bah! not such an one. *His* has been bad shooting from the very root; he has never known a good aim; his whole existence has missed fire. But a full-chested, strong-limbed, spring-footed, keen-eyed, fearless-hearted, born and predestinated Nimrod! One who snuffed powder in his cradle, whose first known amusement was peppering the cat with potato-balls from a pop-gun; one who from his boyhood has gone forth shooting and to shoot, feeling within himself a divine right to scatter the plumage of the proudest young turkey that ever strutted on a prairie; to call down by the crack of a rifle, the circling eagle from the arch of heaven; to bring to a death-halt the bounding career of the finest stag that ever tossed his antlers through the wilds, or snuffed the air on the peaks of the Alleghanies.

Such an one, oh, most courteous reader, allow me to present to you—Henry Grove, the younger, son of the Colonel, and a citizen of the west. He has been and is the very cousin of cousins; was my first tutor in mathematics and mischief, philosophy and play-acting, history and horsemanship, logic and leaping fences; a very jewel of a joyous-spirited fellow, full of fun, frolic and frankness; with a heart "as large as all out-doors," and as warm as all in-doors, and

grew up idolizing her cousin

with just sufficient beauty to save himself from vanity, and susceptible damsels from a too sudden bestowal of their unsolicited affections. Yet I have remarked the dash of the dare-devil in his composition to be peculiarly captivating to young ladies just out, who had been puritanically reared. I do not intend to intimate that my well-beloved kinsman is that horror of careful mammas, "a wild young man." I am inclined to believe that the goodness of people, now-a-days, is in inverse proportion to their pretensions. Harry Grove makes few pretensions; *ergo*, he is quite good enough to serve as a hero, in these degenerate times, when our mental dishes to be palatable, *must* be slightly spiced with wickedness.

But Henry is not my present hero; I am my own heroine; yet he will figure largely, though secondarily, in "this strange, eventful history."

Though the very embodiment of health, in the main, Harry had once a long and distressing illness. We came near losing him when he was fifteen. As soon as the crisis of his fever was passed, I, by special request, was appointed sick-room companion and supernumerary nurse. I never left him for a day. Though a fragile child of ten years, I never wearied of those heart-prompted cares; my whole soul was whelmed with joy, gushing heavenward with fervent thanksgiving to the God of life. Ah, is it not a blessed thing to behold eyes beaming upon us, all light and love, we had thought to have seen dim with the eclipse of death; smiles on the lip, a glow on the cheek we had thought to have seen stiff with the rigidity which no affection and no passion may move, touched with the icy chill which not even a mother's last, lingering kiss may melt into warmth; to see the spirit of life pervading that form we had thought to have laid away in silence and dust forever!

One beautiful and summer-like morning in September, when Harry was just strong enough to walk about the yard with the assistance of a cane, a large hunting party left our town, taking conveniences for camping out, provisions and wine, armed and equipped as the law of sporting directs, for a week's crusade against all sorts of game to whom Heaven had given the freedom of the woods, and who had been obligingly fattening themselves to furnish glory and good living to as arrant a set of scapegraces as ever broke college with a whoop and a hurrah!

Half a dozen merry fellows came dashing and ha-ha-ing up to our door for Harry's elder brothers, who were to join them. Harry, like a noble, manly boy as he was, strove hard to be happy with and for them, but I saw his lip quiver as he offered his favorite dog and gun to a young stranger from the city. At last,

far

with many regrets, politely and earnestly expressed, that the invalid could not accompany them, they were off—all gone. Harry watched them sadly as they wound up the hill opposite the window, and when the last of all, his noble hound, after giving one long, wistful look backward, turned again and disappeared, the poor boy, sighing deeply, sank back into his arm-chair and covered his face with his emaciated hands. Presently I saw fast tears gliding through the pale and almost transparent fingers! They were the first I had seen him shed, and seemed wrung from my own heart; so, winding my arms about his neck I spoke words of affection and good cheer, which, though childlike, were effectual. He began by calling himself hard names; he was a "woman," "a girl," a "very baby, and a booby-baby at that." Then he drew up his head, and curled his lip, and dashed away his tears, and "Richard was himself again."

"Sudden a thought came like a full-blown rose."

"Oh, Cousin Harry!" I exclaimed, "there are flocks of birds in the orchard. Go out and shoot *them!* I'll carry the gun."

"*What* gun, Grace? Did you not see that they took them all?"

Here *was* a damper; but trust a woman, even in embryo, for scheming. I set out instantly on an exploring expedition. Every chamber and closet in the roomy old mansion was ransacked, and finally my labors were rewarded by finding, among some rubbish in the attic, a clumsy musket, once belonging to our grandfather. Its battered appearance was presumptive evidence of its having gone through the "seven long and bloody wars;" but there were barrel and stock entire. It was a *bona fide* engine of destruction and death, and I bore it away in triumph, though with a slight shudder, as I thought how many redskins it might have sent to their spiritual hunting grounds.

Harry smiled as, with mock-heroic air, I presented arms; but laughed outright when he came to examine the musket.

"Why, Grace," said he, *"there is no hammer to this lock!"*

After a little explanation as to the offices of the important agent in the discharge of fire-arms, which had thus inopportunely "come up missing," I suddenly exclaimed, "I have it now! You just load the gun, and pour the powder into the pan, and I will follow *with a coal of fire in the tongs*, and—and I think I dare touch it off, cousin."

I thought Harry would have died of extravagant merriment. He rolled on the floor in a perfect paroxysm of laughter, but becoming calm, vowed he would take up my proposition for its very fun and oddity.

So behold us sallying forth—Harry, to whom a strange strength seemed given, bearing the gun, and I very busily engaged in efforts to keep coal and courage alive.

The first bird at which we took aim was a "chipmunk," who sat on the fence leisurely gnawing a kernel of corn. Never shall I forget the moment when Harry whispered *"now!"* I reached out the tongs, but a sudden mist came over my eyes; then a quiver started from my heart and ran along my arm; the coal descended on to Harry's wrist instead of into the pan; he, with an exclamation more hot than holy, dropped the gun; the gun fell on to the coal and then went off, frightening away the "chipmunk" with its report, but, (believe it or not, my reader,) sending a "whizzing death" through the fat sides of a toad, which we had before remarked demurely seated on a stone near where we stood.

This laughable accident having restored to Harry his good nature and to me my courage, the gun was re-loaded, a new coal procured, my eyes and nerves were true to me—there was a flash, a smoke, a stunning report, and

"Lo, the struck *blue-bird*, stretched upon the plain!"

At last, wearied with our labors and satisfied with glory, we gathered up our spoils and turned homeward.

It is strange, but though many years have passed, I still remember distinctly just what game I held in my pinafore on that day, viz: one blue bird, two chipping-birds, a meadow-lark, and a red-breasted robin. The toad I did not count. All of these, with the exception of the robin, a part of whose neck only had been carried away, were literally torn to pieces.

To my disappointment, I found none but servants to whom to display the proofs of my valor. My sweet cousin Alice was at school, and my aunt and uncle taking their morning drive. I waited impatiently for their return, and meeting them on the portico, held up my bloody trophies, exclaiming, "See the game that cousin Harry and I shot while you were gone!" The colonel, patting my cheek, pronounced me a "brave girl;" but my aunt, sadly smiling, said only, "This must have been the robin that sung on our lattice at prayer-time this morning. Poor bird! its song of praise is ended!"

This gentle reproof quivered like an arrow in my heart. I turned hastily, threw away the mangled remains of all but the robin, and with that sought my room. There I folded the dead bird to my breast, and wept over it bitter and passionate tears. I was agonized with contrition when I bethought me that He who had created worlds on worlds, had not disdained to mould that tender

form, to tint its plumage with one of the colors glowing in the bow which He hung in the heavens, and to breathe the soul of song into its trembling little bosom. Then bowing down my head, I fervently promised never, never to take from a happy-winged creature the existence which the Father of all in his wisdom had bestowed. Thank Heaven, that vow is yet unbroken—the *necessary* destruction of wasps, mosquitoes, and horse-flies always excepted.

HARRIET MARTINEAU

(1802–76)

Born in Norwich, England, Harriet Martineau, daughter of a wealthy importer and textile manufacturer, received an unusually good education compared to most Victorian girls. Although contemporary scholars largely ignored her, she was one of the most well-known writers in England during her lifetime. Martineau was initially educated to be a governess. However, she changed course when she gradually began to lose her hearing at age twelve. Urged to pursue needlework, one viable occupation for a woman considered disabled at that time, Martineau instead began to write. Her first publication, an essay titled "Female Writers of Practical Divinity," was published in the *Monthly Repository* in 1822.

When her father died, Martineau was free to pursue writing as an occupation. The notion that professional activity was inappropriate for members of well-to-do families no longer constrained her. By 1830 Martineau was working as the *Monthly Repository*'s only paid writer, with over fifty contributions to her name, the majority of them book reviews. From 1832 to 1834, she published her highly successful *Illustration of Political Economy* series. These twenty-five novella-length stories meant to educate the public about a current economic problem, and they launched her literary career. For the next two years, Martineau traveled throughout America and gathered material for three subsequent books. Two of them, *Society in America* (1837) and *How to Observe Morals and Manners* (1838), reveal her acumen as a sociologist. The latter is noteworthy in this regard; it was one of the first books to outline a sociological methodology.

Despite increasingly poor health, Martineau continued to write, publish, and involve herself in some of the most important social reform movements of her time. In 1852, she joined the staff of the *London Daily News*. Over the

next fifteen years, she published more than sixteen hundred articles on topics ranging from the importance of women's education to the evils of slavery to the rights of women and the poor. In 1846 Martineau had a house built for herself in the Lake District, where she became a neighbor of William Wordsworth and his wife, Dorothy. Like the Wordsworths, Martineau witnessed the changes brought on by the developing railways, which carried hordes of tourists to their home area. With that in mind, she published a travel guide, *A Complete Guide to the English Lakes* (1855), in addition to dozens more books before her death in 1876 at her Lake District home.

Mrs. Wordsworth

First appeared on January 20, 1859, in the *London Daily News* and reprinted in *Biographical Sketches* (New York, 1869), pp. 86–92.

The last thing that would have occurred to Mrs. Wordsworth would have been that her departure, or anything about her, would be publicly noticed amidst the events of a stirring time. Those who knew her well, regarded her with as true a homage as they ever rendered to any member of the household, or to any personage of the remarkable group which will be forever traditionally associated with the Lake District; but this reverence, genuine and hearty as it was, would not, in all eyes, be a sufficient reason for recording more than the fact of her death. It is her survivorship of such a group which constitutes an undisputed public interest in her decease. With her closes a remarkable scene in the history of the literature of our century. The well-known cottage, Mount, and garden at Rydal will be regarded with other eyes, when shut up, or transferred to new occupants. With Mrs. Wordsworth, an old world has passed away before the eyes of the inhabitants of the District, and a new one succeeds which may have its own delights, solemnities, honors, and graces, but which can never replace the familiar one that is gone. There was something mournful in the lingering of this aged lady—blind, deaf, and bereaved in her latter years; but *she* was not mournful, any more than she was insensible. Age did not blunt her feelings, nor deaden her interest in the events of the day. It seems not so very long ago that she said that the worst of living in such a place (as the Lake District) was its making one unwilling to go. It was too beautiful to let one be ready to leave it. Within a few years, the beloved daughter was gone; and then the aged husband, and then the son-in-law; and then the devoted friend, Mr.

Wordsworth's publisher, Mr. Moxon, who paid his duty occasionally by the side of her chair; then she became blind and deaf. Still her cheerfulness was indomitable. No doubt, she would in reality have been "willing to go" whenever called upon, throughout her long life; but she liked life to the end. By her disinterestedness of nature, by her fortitude of spirit, and her constitutional elasticity and activity, she was qualified for the honor of surviving her household—nursing and burying them, and bearing the bereavement which they were vicariously spared. She did it wisely, tenderly, bravely, and cheerfully, and she will be remembered accordingly by all who witnessed the spectacle.

It was by the accident (so to speak) of her early friendship with Wordsworth's sister that her life became involved with the poetic element, which her mind would hardly have sought for itself in another position. She was the incarnation of good sense, as applied to the concerns of the every-day world. In as far as her marriage and course of life tended to infuse a new elevation into her views of things, it was a blessing; and on the other hand, in as far as it infected her with the spirit of exclusiveness which was the grand defect of the group in its own place, it was hurtful; but that very exclusiveness was less an evil than an amusement, after all. It was a rather serious matter to hear the Poet's denunciations of the railway, and to read his well-known sonnets on the desecration of the Lake region by the unhallowed presence of commonplace strangers; and it was truly painful to observe how the scornful and grudging mood spread among the young, who thought they were agreeing with Wordsworth in claiming the vales and lakes as a natural property for their enlightened selves. But it was so unlike Mrs. Wordsworth, with her kindly, cheery, generous turn, to say that a green field with buttercups would answer all the purposes of Lancashire operatives, and that they did not know what to do with themselves when they came among the mountains, that the innocent insolence could do no harm. It became a fixed sentiment when she alone survived to uphold it; and one demonstration of it amused the whole neighborhood in a good-natured way. "People from Birthwaite" were the bugbear—Birthwaite being the end of the railway. In the summer of 1857, Mrs. Wordsworth's companion told her (she being then blind) that there were some strangers in the garden—two or three boys on the Mount, looking at the view. "Boys from Birthwaite," said the old lady, in the well-known tone which conveyed that nothing good could come from Birthwaite. When the strangers were gone, it appeared that they were the Prince of Wales and his companions. Making allowance for prejudices, neither few nor small, but easily dissolved when reason and kindliness had opportunity to work, she was a

truly wise woman, equal to all occasions of action, and supplying other persons' needs and deficiencies.

In the "Memoirs of Wordsworth" it is stated that, she was the original of

> "She was a phantom of delight,"

and some things in the next few pages look like it; but for the greater part of the Poet's life it was certainly believed by some who ought to know that that wonderful description related to another, who flitted before his imagination in earlier days than those in which he discovered the aptitude of Mary Hutchinson to his own needs. The last stanza is very like her; and her husband's sonnet to the painter of her portrait in old age discloses to us how the first stanza might be so also, in days beyond the ken of the existing generation. Of her early sorrows, in the loss of two children and a beloved sister who was domesticated with the family, there are probably no living witnesses. It will never be forgotten by any who saw it how the late, dreary train of afflictions was met. For many years Wordsworth's sister Dorothy was a melancholy charge. Mrs. Wordsworth was wont to warn any rash enthusiasts for mountain walking by the spectacle before them. The adoring sister would never fail her brother; and she destroyed her health, and then her reason, by exhausting walks, and wrong remedies for the consequences. Forty miles in a day was not a singular feat of Dorothy's. During the long years of this devoted creature's helplessness she was tended with admirable cheerfulness and good sense. Thousands of Lake tourists must remember the locked garden gate when Miss Wordsworth was taking the air, and the garden chair going round and round the terrace, with the emaciated little woman in it, who occasionally called out to strangers, and amused them with her clever sayings. She outlived the beloved Dora, Wordsworth's only surviving daughter. After the lingering illness of that daughter (Mrs. Quillinan), the mother encountered the dreariest portion, probably, of her life. Her aged husband used to spend the long winter evenings in grief and tears—week after week, month after month. Neither of them had eyes for reading. He could not be comforted. She, who carried as tender a maternal heart as ever beat, had to bear her own grief and his too. She grew whiter and smaller, so as to be greatly changed in a few months: but this was the only expression of what she endured, and he did not discover it. When he too left her, it was seen how disinterested had been her trouble. When his trouble had ceased, she too was relieved. She followed his coffin to the sacred corner of Grasmere churchyard, where lay now all those who had once made

her home. She joined the household guests on their return from the funeral, and made tea as usual. And this was the disinterested spirit which carried her through the last few years, till she had just reached the ninetieth. Even then, she had strength to combat disease for many days. Several times she rallied and relapsed; and she was full of alacrity of mind and body as long as exertion of any kind was possible. There were many eager to render all duty and love—her two sons, nieces, and friends, and a whole sympathizing neighborhood.

The question commonly asked by visitors to that corner of Grasmere churchyard was—where would *she* be laid when the time came? the space was so completely filled. The cluster of stones told of the little children who died a long lifetime ago; of the sisters Sarah Hutchinson and Dorothy Wordsworth and of Mr. Quillinan, and his two wives, Dora lying between her husband and father, and seeming to occupy her mother's rightful place. And Hartley Coleridge lies next the family group; and others press closely round. There is room, however. The large gray stone which bears the name of William Wordsworth has ample space left for another inscription; and the grave beneath has ample space also for his faithful life-companion.

Not one is left now of the eminent persons who rendered that cluster of valleys so eminent as it has been. Dr. Arnold went first, in the vigor of his years. Southey died at Keswick, and Hartley Coleridge on the margin of Rydal Lake; and the Quillinans under the shadow of Loughrigg; and Professor Wilson disappeared from Elleray; and the aged Mrs. Fletcher from Lancrigg; and the three venerable Wordsworths from Rydal Mount.

The survivor of all the rest had a heart and a memory for the solemn *last* of everything. She was the one to inquire of about the last eagle in the District, the last pair of ravens in any crest of rocks, the last old dalesman in any improved spot, the last round of the last pedler among hills where the broad white road has succeeded the green bridle-path. She knew the District during the period between its first recognition, through Gray's "Letters," to its complete publicity in the age of railways. She saw, perhaps, the best of it. But she contributed to modernize and improve it, though the idea of doing so probably never occurred to her. There were great people before to give away Christmas bounties, and spoil their neighbors as the established almsgiving of the rich does spoil the laboring class, which ought to be above that kind of aid. Mrs. Wordsworth did infinitely more good in her own way, and without being aware of it. An example of comfortable thrift was a greater boon to the people round than money, clothes, meat, or fuel. The oldest residents have long borne witness that the homes of the neighbors have assumed a new character

of order and comfort, and wholesome economy, since the Poet's family lived at Rydal Mount. It used to be a pleasant sight when Wordsworth was seen in the middle of a hedge, cutting switches for half-a-dozen children, who were pulling at his cloak, or gathering about his heels: and it will long be pleasant to family friends to hear how the young wives of half a century learned to make home comfortable by the example of the good housewife at the Mount, who was never above letting her thrift be known.

Finally, she who had noted so many last survivors was herself the last of a company more venerable than eagles, or ravens, or old-world yeomen, or antique customs. She would not in any case be the first forgotten. As it is, her honored name will live for generations in the traditions of the valleys round. If she was studied as the Poet's wife, she came out so well from that investigation that she was contemplated for herself; and the image so received is her true monument. It will be better preserved in her old-fashioned neighborhood than many monuments which make a greater show.

GAIL HAMILTON

(1833–96)

Born in Hamilton, Massachusetts—one-half of the inspiration behind her pen name Gail Hamilton—Mary Abigail Dodge was the daughter of a farmer and a former schoolteacher, both of whom encouraged her to develop her intellectual abilities. She attended boarding school in Cambridge, then the Ipswich Female Seminary, where she learned, among other subjects, Latin and French. Female seminaries such as the one Hamilton attended offered women educational opportunities. But their ultimate goal was to prepare women to be wives and mothers. Hamilton wanted instead to be a writer, telling her brother in a March 12, 1860, letter that she couldn't "afford the time" to marry. After teaching for several years, she moved to Washington, D.C., at the invitation of Gamaliel Bailey, then editor of the abolitionist newspaper the *National Era*. Hamilton had submitted essays and poems to this respected periodical. In Washington, D.C., she served as a governess for Bailey's six children and continued writing. In addition to contributions to the *Atlantic Monthly*, Hamilton worked as a Washington correspondent for the Boston-based *Congregationalist*. She covered congressional debate for the paper.

When Bailey died in 1860, Hamilton returned to Massachusetts to care for her own dying mother. There, she began a full-time writing career, publishing more than twenty-five books, including essays, a novel, and children's stories. Her first book-length publication was *Country Living and Country Thinking* (1862), a collection of essays on the relationships between men and women that had originally appeared in a nine-part series for the *National Era*. In 1863 Hamilton published a collection of familiar essays titled *Gala-Days*, which features her signature biting humor. *A New Atmosphere* followed in 1865, and Hamilton revisits therein the subject of her first book, a woman's right to ed-

ucation and self-fulfillment outside the bounds of marriage and motherhood. Hamilton returned to Washington after the war to cover civil service reform for the *New York Tribune*. In 1880 part-time journalists were excluded from congressional galleries; a group of prominent male journalists handed down this rule to effectively bar women from working as Washington correspondents. Hamilton eventually returned to Massachusetts, where she continued to publish predominantly religious works until her death in 1896.

Happiest Days

From *Gala-Days* (Boston, 1863), pp. 409–36.

Long ago, when you were a little boy or a little girl,—perhaps not so very long ago, either,—were you never interrupted in your play by being called in to have your face washed, your hair combed, and your soiled apron exchanged for a clean one, preparatory to an introduction to Mrs. Smith, or Dr. Jones, or Aunt Judkins, your mother's early friend? And after being ushered into that august presence, and made to face a battery of questions which were either above or below your capacity, and which you consequently despised as trash or resented as insult, did you not, as you were gleefully vanishing, hear a soft sigh breathed out upon the air,—"Dear child, he is seeing his happiest days"? In the concrete, it was Mrs. Smith or Dr. Jones speaking of you. But going back to general principles, it was Commonplacedom expressing its opinion of childhood.

There never was a greater piece of absurdity in the world. I thought so when I was a child and now I know it; and I desire here to brand it as at once a platitude and a falsehood. How the idea gained currency, that childhood is the happiest period of life, I cannot conceive. How once started, it kept afloat, is equally incomprehensible. I should have supposed that the experience of every sane person would have given the lie to it. I should have supposed that every soul, as it burst into flower, would have hurled off the imputation. I can only account for it by recurring to Lady Mary Wortley Montague's statistics, and concluding that the fools *are* three out of four in every person's acquaintance.

I for one lift up my voice emphatically against the assertion, and do affirm that I think childhood is the most undesirable portion of human life, and I am thankful to be well out of it. I look upon it as no better than a mitigated form of slavery. There is not a child in the land that can call his soul, or his body, or his jacket his own. A little soft lump of clay he comes into the world, and is

moulded into a vessel of honor or a vessel of dishonor long before he can put in a word about the matter. He has no voice as to his education or his training, what he shall eat, what he shall drink, or wherewithal he shall be clothed. He has to wait upon the wisdom, the whims, and often the wickedness of other people. Imagine, my six-foot friend, how you would feel, to be obliged to wear your woollen mittens when you desire to bloom out in straw-colored kids, or to be buttoned into your black waistcoat when your taste leads you to select your white, or to be forced under your Kossuth hat when you had set your heart on your black beaver: yet this is what children are perpetually called on to undergo. Their wills are just as strong as ours, and their tastes are stronger, yet they have to bend the one and sacrifice the other; and they do it under pressure of necessity. Their reason is not convinced; they are forced to yield to superior power; and, of all disagreeable things in the world, the most disagreeable is not to have your own way. When you are grown up, you wear a print frock because you cannot afford a silk, or because a silk would be out of place,—you wear India-rubber overshoes because your polished patent-leather would be ruined by the mud; and your self-denial is amply compensated by the reflection of superior fitness or economy. But a child has no such reflection to console him. He puts on his battered, gray old shoes because you make him; he hangs up his new trousers and goes back into his detestable girl's-frock because he will be punished if he does not, and it is intolerable.

It is of no use to say that this is their discipline, and is all necessary to their welfare. It is a repulsive condition of life in which such degrading *surveillance* is necessary. You affirm that an absolute despotism is the only government fit for Dahomey, and I may not disallow it; but when you go on and say that Dahomey is the happiest country in the world, why—I refer you to Dogberry. Now the parents of a child are, from the nature of the case, absolute despots. They may be wise, and gentle, and doting despots, and the chain may be satin-smooth and golden-strong; but if it be of rusty iron, parting every now and then and letting the poor prisoner violently loose, and again suddenly caught hold of, bringing him up with a jerk, galling his tender limbs and irretrievably ruining his temper,—it is all the same; there is no help for it. And really, to look around the world and see the people that are its fathers and mothers is appalling,—the narrow-minded, prejudiced, ignorant, ill-tempered, fretful, peevish, passionate, careworn, harassed men and women. Even we grown people, independent of them and capable of self-defence, have as much as we can do to keep the peace. Where is there a city, or a town, or a village, in which are no bickerings, no jealousies, no angers, no petty or swollen spites? Then fancy

yourself, instead of the neighbor and occasional visitor of these poor human beings, their children, subject to their absolute control, with no power of protest against their folly, no refuge from their injustice, but living on through thick and thin right under their guns.

"Oh!" but you say, "this is a very one-sided view. You leave out entirely the natural tenderness that comes in to temper the matter. Without that, a child's situation would of course be intolerable; but the love that is born with him makes all things smooth."

No, it does not make all things smooth. It does wonders, to be sure, but it does not make cross people pleasant, nor violent people calm, nor fretful people easy, nor obstinate people reasonable, nor foolish people wise,—that is, it may do so spasmodically, but it does not hold them to it and keep them at it. A great deal of beautiful moonshine is written about the sanctities of home and the sacraments of marriage and birth. I do not mean to say that there is no sanctity and no sacrament. Moonshine is not nothing. It is light,—real, honest light,—just as truly as the sunshine. It is sunshine at second-hand. It illuminates, but indistinctly. It beautifies, but it does not vivify or fructify. It comes indeed from the sun, but in too roundabout a way to do the sun's work. So, if a woman is pretty nearly sanctified before she is married, wifehood and motherhood may accomplish the work; but there is not one man in ten thousand of the writers aforesaid who would marry a vixen, trusting to the sanctifying influences of marriage to tone her down to sweetness. A thoughtful, gentle, pure, and elevated woman, who has been accustomed to stand face to face with the eternities, will see in her child a soul. If the circumstances of her life leave her leisure and adequate repose, that soul will be to her a solemn trust, a sacred charge, for which she will give her own soul's life in pledge. But how many such women do you suppose there are in your village? Heaven forbid that I should even appear to be depreciating woman! Do I not know too well their strength, and their virtue which is their strength? But, stepping out of idyls and novels, and stepping into American kitchens, is it not true that the larger part of the mothers see in their babies, or act as if they saw, only babies? And if there are three or four or half a dozen of them, as there generally are, so much the more do they see babies whose bodies monopolize the mother's time to the disadvantage of their souls. She loves them, and she works for them day and night; but when they are ranting and ramping and quarrelling, and torturing her over-tense nerves, she forgets the infinite, and applies herself energetically to the finite, by sending Harry with a round scolding into one corner, and Susy into another, with no light thrown upon the point in dispute, no

principle settled as a guide in future difficulties, and little discrimination as to the relative guilt of the offenders. But there is no court of appeal before which Harry and Susy can lay their case, in these charming "happiest days"!

Then there are parents who love their children like wild beasts. It is a passionate, blind, instinctive, unreasoning love. They have no more intelligent discernment, when an outside difficulty arises with respect to their children, than a she-bear. They wax furious over the most richly deserved punishment, if inflicted by a teacher's hand; they take the part of their child against legal authority; but observe, this does not prevent them from laying their own hands heavily on their children. The same obstinate ignorance and narrowness that are exhibited without exist within also. Folly is folly, abroad or at home. A man does not play the fool out-doors and act the sage in the house. When the poor child becomes obnoxious, the same unreasoning rage falls upon him. The object of a ferocious love is the object of an equally ferocious anger. It is only he who loves wisely that loves well.

The manner in which children's tastes are disregarded, their feelings ignored, and their instincts violated, is enough to disaffect one with childhood. They are expected to kiss all flesh that asks them to do so. They are jerked up into the laps of people whom they abhor. They say, "Yes, ma'am," under pain of bread and water for a week, when their unerring nature prompts them to hurl out emphatically, "No." They are sent out of the room whenever a fascinating bit of scandal is to be rehearsed, packed off to bed just as everybody is settled down for a charming evening, bothered about their lessons when their play is but fairly under way, and hedged and hampered on every side. It is true, that all this may be for their good, but what of that? So everything is for the good of grown-up people; but does that make us contented? It is doubtless for our good in the long run that we lose our pocket-books, and break our arms, and catch a fever, and have our brothers defraud a bank, and our houses burn down, and people steal our umbrellas, and borrow our books and never return them. In fact, we know that upon certain conditions all things work together for our good, but, notwithstanding, we find some things very unpleasant; and we may talk to our children of discipline and health by the hour together, and it will never be anything but an intolerable nuisance to them to be swooped off to bed by a dingy old nurse just as the people are beginning to come, and shining silk, and floating lace, and odorous, faint flowers are taking their ecstatic young souls back into the golden days of the good Haroun al Raschid.

Even in this very point lies one of the miseries of childhood, that no philosophy comes to temper their sorrow. We do not know why we are troubled,

but we know there *is* some good, grand reason for it. The poor little children do not know even that. They find trouble utterly inconsequent and unreasonable. The problem of evil is to them absolutely incapable of solution. We know that beyond our horizon stretches the infinite universe. We grasp only one link of a chain whose beginning and end is eternity. So we readily adjust ourselves to mystery, and are content. We apply to everything inexplicable the test of partial view, and maintain our tranquillity. We fall into the ranks, and march on, acquiescent, if not jubilant. We hear the roar of cannon, and the rattle of musketry. Stalwart forms fall by our side, and brawny arms are stricken. Our own hopes bite the dust, our own hearts bury their dead; but we know that law is inexorable. Effect must follow cause, and there is no happening without causation. So, knowing ourselves to be only one small brigade of the army of the Lord, we defile through the passes of this narrow world, bearing aloft on our banner, and writing ever on our hearts, the divine consolation, "What thou knowest not now thou shalt know hereafter." This is an unspeakable tranquillizer and comforter, of which, woe is me! the little ones know nothing. They have no underlying generalities on which to stand. Law and logic and eternity are nothing to them. They only know that it rains, and they will have to wait another week before they go a-fishing; and why couldn't it have rained Friday just as well as Saturday? and it always does rain or something when I want to go anywhere,—so, there! And the frantic flood of tears comes up from outraged justice as well as from disappointed hope. It is the flimsiest of all possible arguments to say that their sorrows are trifling, to talk about their little cares and trials. These little things are great to little men and women. A pine bucket full is just as full as a hogshead. The ant has to tug just as hard to carry a grain of corn as the Irishman does to carry a hod of bricks. You can see the bran running out of Fanny's doll's arm, or the cat putting her foot through Tom's new kite, without losing your equanimity; but their hearts feel the pang of hopeless sorrow, or foiled ambition, or bitter disappointment,—and the emotion is the thing in question, not the event that caused it.

It is an additional disadvantage to children in their troubles, that they can never estimate the relations of things. They have no perspective. All things are at equal distances from the point of sight. Life presents to them neither foreground nor background, principal figure nor subordinates, but only a plain spread of canvas, on which one thing stands out just as big and just as black as another. You classify your *désagréments*. This is a mere temporary annoyance, and receives but a passing thought. This is a life-long sorrow, but it is superficial; it will drop off from you at the grave, be folded away with your cere-

ments, and leave no scar on your spirit. This thrusts its lancet into the secret place where your soul abideth, but you know that it tortures only to heal; it is recuperative, not destructive, and you will rise from it to newness of life. But when little ones see a ripple in the current of their joy, they do not know, they cannot tell, that it is only a pebble breaking softly in upon the summer flow, to toss a cool spray up into the white bosom of the lilies, or to bathe the bending violets upon the green and grateful bank. It seems to them as if the whole strong tide is thrust fiercely and violently back, and hurled into a new channel, chasmed in the rough, rent granite. It is impossible to calculate the waste of grief and pathos which this incapacity causes. Fanny's doll aforesaid is left too near the fire, and waxy tears roll down her ruddy cheeks, to the utter ruin of her pretty face and her gay frock; and anon poor Fanny breaks her little heart in moans and sobs and sore lamentations. It is Rachel weeping for her children. I went on a tramp one May morning to buy a tissue-paper wreath of flowers for a little girl to wear to a May-party, where all the other little girls were expected to appear similarly crowned. After a long and weary search, I was forced to return without it. Scarcely had I pulled the bell, when I heard the quick pattering of little feet in the entry. Never in all my life shall I lose the memory of those wistful eyes, that did not so much as look up to my face, but levelled themselves to my hand, and filmed with disappointment to find it empty. *I* could see that the wreath was a very insignificant matter. I knew that every little beggar in the street had garlanded herself with sixpenny roses, and I should have preferred that my darling should be content with her own silky brown hair; but my taste availed her nothing, and the iron entered into her soul. Once a little boy who could just stretch himself up as high as his papa's knee, climbed surreptitiously into the store-closet and upset the milk-pitcher. Terrified, he crept behind the flour-barrel, and there Nemesis found him, and he looked so charming and so guilty that two or three others were called to come and enjoy the sight. But he, unhappy midget, did not know that he looked charming; he did not know that his guilty consciousness only made him the more interesting; he did not know that he seemed an epitome of humanity, a Liliputian miniature of the great world; and his large, blue, solemn eyes were filled with remorse. As he stood there silent, with his grave, utterly mournful face, he had robbed a bank, he had forged a note, he had committed a murder, he was guilty of treason. All the horror of conscience, all the shame of discovery, all the unavailing regret of a detected, atrocious, but not utterly hardened pirate, tore his poor little innocent heart. Yet children are seeing their happiest days!

These people—the aforesaid three fourths of our acquaintance—lay great stress on the fact that children are free from care, as if freedom from care were one of the beatitudes of Paradise; but I should like to know if freedom from care is any blessing to beings who don't know what care is. You who are careful and troubled about many things may dwell on it with great satisfaction, but children don't find it delightful by any means. On the contrary, they are never so happy as when they can get a little care, or cheat themselves into the belief that they have it. You can make them proud for a day by sending them on some responsible errand. If you will not place care upon them, they will make it for themselves. You shall see a whole family of dolls stricken down simultaneously with malignant measles, or a restive horse evoked from a passive parlor-chair. They are a great deal more eager to assume care, than you are to throw it off. To be sure, they may be quite as eager to be rid of it after a while; but while this does not prove that care is delightful, it certainly does prove that freedom from care is not.

Now I should like, Herr Narr, to have you look at the other side for a moment: for there is a positive and a negative pole. Children not only have their full share of misery, but they do not have their full share of happiness; at least, they miss many sources of happiness to which we have access. They have no consciousness. They have sensations, but no perceptions. We look longingly upon them, because they are so graceful, and simple, and natural, and frank, and artless; but though this may make us happy, it does not make them happy, because they don't know anything about it. It never occurs to them that they are graceful. No child is ever artless to himself. The only difference he sees between you and himself is, that you are grown-up and he is little. Sometimes I think he does have a dim perception that when he is ill, it is because he has eaten too much, and he must take medicine, and feed on heartless dry toast, while, when you are ill, you have the dyspepsia, and go to Europe. But the beauty and sweetness of children are entirely wasted on themselves, and their frankness is a source of infinite annoyance to each other. A man enjoys *himself*. If he is handsome, or wise, or witty, he generally knows it, and takes great satisfaction in it; but a child does not. He loses half his happiness because he does not know that he is happy. If he ever has any consciousness, it is an isolated, momentary thing, with no relation to anything antecedent or subsequent. It lays hold on nothing. Not only have they no perception of themselves, but they have no perception of anything. They never recognize an exigency. They do not salute greatness. Has not the Autocrat told us of some lady who remembered a certain momentous event in our Revolutionary War, and remem-

bered it only by and because of the regret she experienced at leaving her doll behind when her family was forced to fly from home? What humiliation is this! What an utter failure to appreciate the issues of life! For her there was no revolution, no upheaval of world-old theories, no struggle for freedom, no great combat of the heroisms. All the passion and pain, the mortal throes of error, the glory of sacrifice, the victory of an idea, the triumph of right, the dawn of a new era,—all, all were hidden from her behind a lump of wax. And what was true of her is true of all her class. Having eyes, they see not; with their ears they do not hear. The din of arms, the waving of banners, the gleam of swords, fearful sights and great signs in the heavens, or the still, small voice that thrills when wind and fire and earthquake have swept by, may proclaim the coming of the Lord, and they stumble along, munching bread-and-butter. Out in the solitudes Nature speaks with her many-toned voices, and they are deaf. They have a blind sensational enjoyment, such as a squirrel or a chicken may have, but they can in no wise interpret the Mighty Mother, nor even hear her words. The ocean moans his secret to unheeding ears. The agony of the underworld finds no speech in the mountain-peaks, bare and grand. The old oaks stretch out their arms in vain. Grove whispers to grove, and the robin stops to listen, but the child plays on. He bruises the happy buttercups, he crushes the quivering anemone, and his cruel fingers are stained with the harebell's purple blood. Rippling waterfall and rolling river, the majesty of sombre woods, the wild waste of wilderness, the fairy spirits of sunshine, the sparkling wine of June, and the golden languor of October the child passes by, and a dipper of blackberries or a pocketful of chestnuts, fills and satisfies his horrible little soul. And in face of all this people say,—there are people who *dare* to say—that childhood's are the "happiest days."

I may have been peculiarly unfortunate in my surroundings, but the children of poetry and novels were very infrequent in my day. The innocent cherubs never studied in my school-house, nor played puss-in-the-corner in our back-yard. Childhood, when I was young, had rosy cheeks and bright eyes, as I remember, but it was also extremely given to quarrelling. It used frequently to "get mad." It made nothing of twitching away books and balls. It often pouted. Sometimes it would bite. If it wore a fine frock, it would strut. It told lies—"whoppers" at that. It took the larger half of the apple. It was not, as a general thing, magnanimous, but "aggravating." It may have been fun to you, who looked on, but it was death to us who were in the midst.

This whole way of viewing childhood, this regretful retrospect of its vanished joys, this infatuated apotheosis of doughiness and rank unfinish, this

fearful looking-for of dread old age, is low, gross, material, utterly unworthy of a sublime manhood, utterly false to Christian truth. Childhood is pre-eminently the animal stage of existence. The baby is a beast,—a very soft, tender, caressive beast,—beast full of promise,—a beast with the germ of an angel,—but a beast still. A week-old baby gives no more sign of intelligence, of love, or ambition, or hope, or fear, or passion, or purpose, than a week-old monkey, and is not half so frisky and funny. In fact, it is a puling, scowling, wretched, dismal, desperate-looking animal. It is only as it grows old that the beast gives way and the angel-wings bud, and all along through infancy and childhood the beast gives way and gives way and the angel-wings bud and bud; and yet we entertain our angel so unawares, that we look back regretfully to the time when the angel was in abeyance and the beast raved regnant.

The only advantage which childhood has over manhood is the absence of foreboding, and this indeed is much. A large part of our suffering is anticipatory, much of which children are spared. The present happiness is clouded for them by no shadowy possibility; but for this small indemnity, shall we offset the glory of our manly years? Because their narrowness cannot take in the contingencies that threaten peace, are they blessed above all others? Does not the same narrowness cut them off from the bright certainty that underlies all doubts and fears? If ignorance is bliss, man stands at the summit of mortal misery, and the scale of happiness is a descending one. We must go down into the ocean-depths, where, for the scintillant soul, a dim, twilight instinct lights up gelatinous lives. If childhood is indeed the happiest period, then the mysterious God-breathed breath was no boon, and the Deity is cruel. Immortality were well exchanged for the blank of annihilation.

We hear of the dissipated illusions of youth, the paling of bright, young dreams. Life, it is said, turns out to be different from what was pictured. The rosy-hued morning fades away into the gray and livid evening, the black and ghastly night. In especial cases it may be so, but I do not believe it is the general experience. It surely need not be. It should not be. I have found things a great deal better than I expected. I am but one; but with all my oneness, with all that there is of me, I protest against such generalities. I think they are slanderous of Him who ordained life, its processes and its vicissitudes. He never made our dreams to outstrip our realizations. Every conception, brain-born, has its execution, hand-wrought. Life is not a paltry tin cup which the child drains dry, leaving the man to go weary and hopeless, quaffing at it in vain with black, parched lips. It is a fountain ever springing. It is a great deep, which the wisest has never bounded, the grandest never fathomed.

It is not only idle, but stupid, to lament the departure of childhood's joys. It is as if something precious and valued had been forcibly torn from us, and we go sorrowing for lost treasure. But these things fall off from us naturally; we do not give them up. We are never called upon to give them up. There is no pang, no sorrow, no wrenching away of a part of our lives. The baby lies in his cradle and plays with his fingers and toes. There comes an hour when his fingers and toes no longer afford him amusement. He has attained to the dignity of a rattle, a whip, a ball. Has he suffered a loss? Has he not rather made a great gain? When he passed from his toes to his toys, did he do it mournfully? Does he look at his little feet and hands with a sigh for the joys that once loitered there, but are now forever gone? Does he not rather feel a little ashamed, when you remind him of those days? Does he not feel that it trenches somewhat on his dignity? Yet the regret of maturity for its past joys amounts to nothing less than this. Such regret is regret that we cannot lie in the sunshine and play with our toes,—that we are no longer but one remove, or but few removes, from the idiot. Away with such folly! Every season of life has its distinctive and appropriate enjoyments, which bud and blossom and ripen and fall off as the season glides on to its close, to be succeeded by others better and brighter. There is no consciousness of loss, for there is no loss. There is only a growing up, and out of, and beyond.

Life does turn out differently from what was anticipated. It is an infinitely higher and holier and nobler thing than our childhood fancied. The world that lay before us then was but a tinsel toy to the world which our firm feet tread. We have entered into the undiscovered land. We have explored its ways of pleasantness, its depths of dole, its mountains of difficulty, its valleys of delight, and, behold! it is very good. Storms have swept fiercely, but they swept to purify. We have heard in its thunders the Voice that woke once the echoes of the Garden. Its lightnings have riven a path for the Angel of Peace.

Manhood discovers what childhood can never divine,—that the sorrows of life are superficial, and the happiness of life structural; and this knowledge alone is enough to give a peace which passeth understanding.

Yes, the dreams of youth were dreams, but the waking was more glorious than they. They were only dreams,—fitful, flitting, fragmentary visions of the coming day. The shallow joys, the capricious pleasures, the wavering sunshine of infancy, have deepened into virtues, graces, heroisms. We have the bold outlook of calm, self-confident courage, the strong fortitude of endurance, the imperial magnificence of self-denial. Our hearts expand with benevolence, our lives broaden with beneficence. We cease our perpetual skirmishing at the out-

posts, and go inward to the citadel. Down into the secret places of life we descend. Down among the beautiful ones, in the cool and quiet shadows, on the sunny summer levels, we walk securely, and the hidden fountains are unsealed.

For those people who do nothing, for those to whom Christianity brings no revelation, for those who see no eternity in time, no infinity in life, for those to whom opportunity is but the handmaid of selfishness, to whom smallness is informed by no greatness, for whom the lowly is never lifted up by indwelling love to the heights of divine performance,—for them, indeed, each hurrying year may well be a King of Terrors. To pass out from the flooding light of the morning, to feel all the dewiness drunk up by the thirsty, insatiate sun, to see the shadows slowly and swiftly gathering, and no starlight to break the gloom, and no home beyond the gloom for the unhoused, startled, shivering soul,— ah! this indeed is terrible. The "confusions of a wasted youth" strew thick confusions of a dreary age. Where youth garners up only such power as beauty or strength may bestow, where youth is but the revel of physical or frivolous delight, where youth aspires only with paltry and ignoble ambitions, where youth presses the wine of life into the cup of variety, there indeed Age comes, a thrice unwelcome guest. Put him off. Thrust him back. Weep for the early days: you have found no happiness to replace their joys. Mourn for the trifles that were innocent, since the trifles of your manhood are heavy with guilt. Fight to the last. Retreat inch by inch. With every step you lose. Every day robs you of treasure. Every hour passes you over to insignificance; and at the end stands Death. The bare and desolate decline drops suddenly into the hopeless, dreadful grave, the black and yawning grave, the foul and loathsome grave.

But why those who are Christians and not Pagans, who believe that death is not an eternal sleep, who wrest from life its uses and gather from life its beauty,—why they should dally along the road, and cling frantically to the old landmarks, and shrink fearfully from the approaching future, I cannot tell. You are getting into years. True. But you are getting out again. The bowed frame, the tottering step, the unsteady hand, the failing eye, the heavy ear, the tremulous voice, they will all be yours. The grasshopper will become a burden, and desire shall fail. The fire shall be smothered in your heart, and for passion you shall have only peace. This is not pleasant. It is never pleasant to feel the inevitable passing away of priceless possessions. If this were to be the culmination of your fate, you might indeed take up the wail for your lost youth. But this is only for a moment. The infirmities of age come gradually. Gently we are led down into the valley. Slowly, and not without a soft loveliness, the shadows lengthen. At the worst these weaknesses are but the stepping-stones in the

river, passing over which you shall come to immortal vigor, immortal fire, immortal beauty. All along the western sky flames and glows the auroral light of another life. The banner of victory waves right over your dungeon of defeat. By the golden gateway of the sunsetting,

"Through the dear might of Him who walked the waves,"

you shall pass into the "cloud-land, gorgeous land," whose splendor is unveiled only to the eyes of the Immortals. Would you loiter to your inheritance?

You are "getting into years." Yes, but the years are getting into you,—the ripe, rich years, the genial, mellow years, the lusty, luscious years. One by one the crudities of your youth are falling off from you,—the vanity, the egotism, the isolation, the bewilderment, the uncertainty. Nearer and nearer you are approaching yourself. You are consolidating your forces. You are becoming master of the situation. Every wrong road into which you have wandered has brought you, by the knowledge of that mistake, so much closer to the truth. You no longer draw your bow at a venture, but shoot straight at the mark. Your purposes concentrate, and your path is cleared. On the ruins of shattered plans you find your vantage-ground. Your broken hopes, your thwarted purposes, your defeated aspirations, become a staff of strength with which you mount to sublimer heights. With self-possession and self-command return the possession and the command of all things. The title-deed of creation, forfeited, is reclaimed. The king has come to his own again. Earth and sea and sky pour out their largess of love. All the past crowds down to lay its treasures at your feet. Patriotism stands once more in the breach at Thermopylae,—bears down the serried hosts of Bannockburn,—lays its calm hand in the fire, still, as if it felt the pressure of a mother's lips,—gathers to its heart the points of opposing spears, to make a way for the avenging feet behind. All that the ages have of greatness and glory your hand may pluck, and every year adds to the purple vintage. Every year comes laden with the riches of the lives that were lavished on it. Every year brings to you softness and sweetness and strength. Every year evokes order from confusion, till all things find scope and adjustment. Every year sweeps a broader circle for your horizon, grooves a deeper channel for your experience. Through sun and shade and shower you ripen to a large and liberal life.

Yours is the deep joy, the unspoken fervor, the sacred fury of the fight. Yours is the power to redress wrong, to defend the weak, to succor the needy, to relieve the suffering, to confound the oppressor. While vigor leaps in great tidal pulses along your veins, you stand in the thickest of the fray, and broadsword

and battle-axe come crashing down through helmet and visor. When force has spent itself, you withdraw from the field, your weapons pass into younger hands, you rest under your laurels, and your works do follow you. Your badges are the scars of your honorable wounds. Your life finds its vindication in the deeds which you have wrought. The possible to-morrow has become the secure yesterday. Above the tumult and the turbulence, above the struggle and the doubt, you sit in the serene evening, awaiting your promotion.

Come, then, O dreaded years! Your brows are awful, but not with frowns. I hear your resonant tramp far off, but it is sweet as the May-maidens' song. In your grave prophetic eyes I read a golden promise. I know that you bear in your bosom the fulness of my life. Veiled monarchs of the future, shining dim and beautiful, you shall become my vassals, swift-footed to bear my messages, swift-handed to work my will. Nourished by the nectar which you will pour in passing from your crystal cups, Death shall have no dominion over me, but I shall go on from strength to strength and from glory to glory.

FRANCES POWER COBBE

(1822–1904)

Born at her Anglo-Irish father's estate in Dublin, Ireland, Frances Power Cobbe received only two years of formal education. Instead, she educated herself at home, honing views that eventually made life in her father's house intolerable. Due to her desire for intellectual, if not physical, independence, Cobbe's father threw her out of his house when she was in her twenties. She eventually returned when he ordered her back to serve as his housekeeper. So that her rationalist religious views and her support for women's autonomy did not humiliate her father, Cobbe did not sign her name to her first publication, *An Essay on Intuitive Morals, Being an Attempt to Popularize Ethical Science* (1855). When Cobbe's father died in 1857, she finally found the independence she had long sought.

In 1861 she published her first periodical essay, "Workhouse Sketches," detailing her experiences in Bristol, where she had gone to assist Mary Carpenter in running a reform school for delinquent girls. The treatment of workhouse inmates would become one of Cobbe's lifelong causes. At this time, she also began writing for the London daily newspaper *The Echo*, penning unsigned leaders that covered a broad range of subjects and infused commentary with personal experiences and observations. In her autobiography, *Life of Frances Power Cobbe, by Herself* (1894), Cobbe describes this period as one of the happiest in her life: "To be in touch with the most striking events of the whole world, and enjoy the privilege of giving your opinion on them to 50,000 to 100,000 readers within a few hours, this struck me, when I first recognized that such was my business as a leader-writer, as something for which many prophets and preachers of old would have given a house full of silver and gold. And I was to be *paid* for accepting it." Also contributing to Cobbe's happiness

was her relationship with Mary Lloyd; the two women were intimate companions until Lloyd's death in 1888. Cobbe wrote and published tirelessly until her own death in 1904.

Fat People

First appeared on September 16, 1869, in *The Echo* and reprinted in *Re-Echoes* (London, 1876), pp. 20–26.

Fat people cannot be exactly called the "salt of the earth," but they are fairly entitled to be considered its sugar. There is a certain sweetness, or, at least, mellowness, about healthful and cheerful obesity which spreads on all around the sense that life is, after all, not a bad thing. What optimism is to the intellect, the tendency to grow fat is to the body, and the mental and material characters mostly harmonize in the same individual. There is the same generous power of assimilation applicable alike to the food which the man eats and the facts he observes. He chooses of both what agrees with him, and does not swallow sour, indigestible fruit, nor notice the more bitter realities of human existence. He does not "quarrel with his bread and butter," in the literal or metaphorical sense of the words. Not for him is the theory that "nothing is new, and nothing is true, and it don't matter." He believes in the solid earth; else how could he tread on it? Gloomy doubts, dark suspicions, and evil fears, he throws off by the healthful action of his mental epidermis. According to his vocation in life, he is a "jolly tar;" a foxhunter with a "view halloo!" capable of wakening the dead; or a host as mellow as his ale. You will not find him writing saturnine reviews, or preaching after the manner of the Rev. Dr. Brimstone, or joining secret associations for the purpose of blowing up obnoxious workmen, or shooting superfluous emperors. The people who work for the female franchise complain that they can never induce a fat man seriously to entertain the subject of the wrongs of women. "Whatever is," he is inclined to think, "is right." His cruse of the oil of gladness is always moderately full, and it is not his specialty to pry into the empty vessels of his neighbours. He feels, like that grand optimist, Marcus Aurelius, who viewed the panorama of life from the rather advantageous position of the throne of the world, "that fate has done well by him and by everybody." The very faults of a fat man are less acerbate than those of other people. There is a certain jovial ease about him which makes it hard to view them with strict severity. As Falstaff said of himself, he has "more flesh

weakness in morals, or delicate?

than other men, therefore more frailty." It is to be expected there should be some relaxation of discipline for people who can never, figuratively or otherwise, gird up their loins very tightly. Then there is a notion, too, which is only common justice, that a fat man has a good deal to bear, and must not have needless burdens thrust upon him. Nobody could expect him to take the same sort of trouble for his neighbours which might be looked for from an active, fussy, little man; and if the fat man does get in a passion now and then, there is a certain fitness of things about his portentous wrath, a rotundity in his angry expressions, and a security that the mere force of gravitation will cause the disturbance shortly to subside, which almost reconcile us to the offence. No fear from him of long-cherished spite, and hidden bitterness, and vengeance nursed in the recesses of his capacious person. He could not be the man he is, were there any gall among his secretions; and every superfluous pound of flesh on his form is a public guarantee that he bears no rancour in his soul.

Generally the fat man is somewhat selfish. It is not by attending to other people's affairs that he has accumulated that abundance of adipose matter. He finds in himself always, as Rochefoucauld says, "sufficient force to endure the ills of other men." To the evils they suffer, his eyes have a tendency gently to close; and a maxim for which he has much favour is, that "Charity begins at home." He is fond of his wife and children—a fat man is generally married—and likes to see them looking cheerful, especially at meal-times; but he does not fret himself very grievously when things go wrong with them, unless they die, and of that evil the fat man has peculiar horror. He hates the idea of severance between the soul and the comfortable body. The epitaph on an obese gentleman—

> "Reader, whoe'er thou art, oh! tread not hard,
> For Tadlow lies all over this churchyard,"

might be appropriate to him, but shocks his feelings. No fat man ever committed suicide, nor yet, that ever we heard of, any crime liable to capital punishment. Look at the lean wretches in Madame Tussaud's Chamber of Horrors, and say if there be not inductive proof that to commit murder it is needful to have a bad complexion and no superfluous corpulence!

All these circumstances being taken into consideration, fat people may themselves think they have less than justice done them in the world. Ought they not to be looked on as the pillars of the commonwealth—the solid ballast of the ship of State, liable to no sudden shiftings? Is not their very presence in a country a credit to it, a sort of permanent itinerant human cattle-show, prov-

ing how plentiful is the food, how wholesome the air, how settled and digni-
fied all the conditions of existence, in that favoured land? When we look at
countries where fat men are rare, as in France or America, do we not see that
there the population must be seething in political discontent, or struggling
with unseemly haste for the possession of dollars? Revolutions and civil wars
are only natural occurrences amidst lean and lanky peoples. A nation whose
Registrar-general could announce that the average weight of adult manhood
had reached thirteen stone, would infallibly repose in eternal peace and pros-
perity, and sing the "Roast Beef of Old England" to the end of time, instead of
those thin and restless jigs, "Yankee Doodle" and "Partant pour la Syrie."

But, alas! instead of bestowing due honour and offering appropriate deco-
rations—such, for instance, as those which are hung on prize meat at Christ-
mas—to the few living representatives and forerunners of such a millennium,
they are treated too often amongst us with most unfitting irreverence. The lev-
ity so remote from their appearance is transferred by some inscrutable process
to the minds of those who contemplate them; and a man who has nothing
to do but to fall on his neighbour's neck to reduce him to a platitude, is yet
treated by that mere hollow mask of humanity as if his immensity of solid flesh
were the natural target of scorn. A joke is understood to be ten times a joke
when launched against a person more than forty inches in girth. To be obliged
to share a seat in a public conveyance with one of those calm and bland and
generally cleanly persons, is looked upon as an adventure to be hereafter nar-
rated among the titters of an audience unworthy—in point of weight—to tie
those shoes which Mr. Banting in his earlier and better days found it impossi-
ble to fasten for himself. Nothing really heroic, much less sentimental, is ac-
cepted from a fat person. As to the poetry of life, a man who happens to have a
tendency to superfluous flesh has nothing to do but to abjure it from the first.
Think how Gibbon, the most majestic of historians, has been laughed at for a
century for going down on his knees to make love, and finding it impossible to
get up till the lady rang for her footman to help him!

No! Among the neglected heroes, the misunderstood glories of our race,
fat people must certainly be reckoned. But, in spite of public ingratitude, they
have even now a measure of reward and a source of ineffable consolation.
Their rights cannot wholly be ignored even by the lightest and most frivolous
of mankind. When a fat man enters a drawing-room, there is no ignoring his
presence; he is never overlooked in the crowd. The mistress of the house must
perforce attend to the object which for the moment fills her doorway. Then,
as the obese "party" proceeds into the room, and seeks, perhaps modestly, to

seat himself or herself on a small ordinary chair, with what alacrity of courtesy does the hostess rush to prevent the hazardous experiment! "Oh, don't sit on that uncomfortable seat, Mrs. Adipose! Do, pray, try this large armchair by the fire!" Mrs. Adipose smiles sweetly at this version of "Friend, go up higher," knowing perfectly well that tender alarm for the cane article of furniture, rather than concern for her own ease, has prompted the removal. But she seats herself, necessarily with some stir and dignity, on the solid throne by the hearth, and the result is, that for the whole evening she occupies the place of honour, and is insensibly treated by everybody as the first lady in the room. After all, as Miss Thackeray confesses, "size has a dignity of its own," a claim to honour which it is vain to contest; and when the fat man rises to his proper and becoming eminence, and takes his seat on the Woolsack, the Bench of Bishops, or the Treasury Bench, then all mankind recognize the natural fitness of things, and greet the new dignitary with the Eastern benediction, "May your shadow never be less!"

ELIZA LYNN LINTON

(1822–98)

Eliza Lynn Linton is credited with inventing a popular nineteenth-century catchphrase, "girl of the period" or "G.O.P." This derogatory term referred to the new modern woman whom Linton frequently took to task in her essays, provoking the ire of women's rights supporters. Born in Keswick, England, Linton was the daughter of a learned Anglican preacher who ignored her education. In lieu of formal schooling, Linton took refuge in her father's well-stocked library, where she granted herself the education she believed she deserved. Her first publication, a poem titled "The National Convention of the Gods," appeared in *Ainsworth's Magazine* in 1845. Later that year, she moved to London to try her luck as a professional writer.

Linton's first two novels, *Azeth the Egyptian* (1847) and *Amymone* (1848), received favorable reviews, but it was her "Girl of the Period" essays in 1868 that put her on the literary map. In 1858 she had married William James Linton, a widower with seven children. The couple eventually separated on amicable terms, and Eliza Lynn Linton was left to support herself by writing. She continued doing what she had been doing while married—writing for the periodical press. During the course of her married life, she published more than three hundred articles. Her first major endeavor after her separation was a series of essays for the *Saturday Review* criticizing the modern Victorian woman for straying from the ideal woman of ages past and neglecting her primary duties as wife and mother. Linton published the essays anonymously, causing great consternation among readers who argued over her identity. For sixteen years, she kept her authorship a secret.

In 1883, with the reprint of the essays in *The Girl of the Period and Other Social Essays*, Linton at last identified herself as the author. In the preface to the

book, she writes, "The essays hit sharply enough at the time, and caused some ill-blood. The 'Girl of the Period' was especially obnoxious to many to whom women were the Sacred Sex above criticism and beyond rebuke; and I had to pay pretty smartly in private life." But she also welcomes the chance to claim authorship for her work, noting, "Whether for praise or blame, I am glad to be able at last to assume the full responsibility of my own work." Linton continued to publish essays and novels until her death from pneumonia in 1898. An incomplete autobiography, *My Literary Life*, appeared posthumously in 1899.

Old Ladies

First appeared on November 20, 1869, in the *Saturday Review* and reprinted in the second volume of *The Girl of the Period* (London, 1883), pp. 28–36.

The world is notoriously unjust to its veterans, and above all it is unjust to its ancient females. Everywhere, and from all time, an old woman has been taken to express the last stage of uselessness and exhaustion; and while a meeting of bearded dotards goes by the name of a council of sages, and its deliberations are respected accordingly, a congregation of grey-haired matrons is nothing but a congregation of old women, whose thoughts and opinions on any subject whatsoever have no more value than the chattering of so many magpies. In fact the poor old ladies have a hard time of it; and if we look at it in its right light, perhaps nothing proves more thoroughly the coarse flavour of the world's esteem respecting women than this disdain which they excite when they are old. And yet what charming old ladies one has known at times!— women quite as charming in their own way at seventy as their grand-daughters are at seventeen, and all the more so because they have no design now to be charming, because they have given up the attempt to please for the reaction of praise, and long since have consented to become old though they have never drifted into unpersonableness nor neglect. While retaining the intellectual vivacity and active sympathies of maturity, they have added the softness, the mellowness, the tempering got only from experience and advancing age. They are women who have seen and known and read a great deal; and who have suffered much; but whose sorrows have neither hardened nor soured them— but rather have made them even more sympathetic with the sorrows of others, and pitiful for all the young. They have lived through and lived down all their own trials, and have come out into peace on the other side; but they remember

the trials of the fiery passage, and they feel for those who have still to bear the pressure of the pain they have overcome. These are not women much met with in society; they are of the kind which mostly stays at home and lets the world come to them. They have done with the hurry and glitter of life, and they no longer care to carry their grey hairs abroad. They retain their hold on the affections of their kind; they take an interest in the history, the science, the progress of the day; but they rest tranquil and content by their own fireside, and they sit to receive, and do not go out to gather.

The fashionable old lady who haunts the theatres and drawing-rooms, bewigged, befrizzled, painted, ghastly in her vain attempts to appear young, hideous in her frenzied clutch at the pleasures melting from her grasp, desperate in her wild hold on a life that is passing away from her so rapidly, knows nothing of the quiet dignity and happiness of her ancient sister who has been wise enough to renounce before she lost. In her own house, where gather a small knot of men of mind and women of character, where the young bring their perplexities and the mature their deeper thoughts, the dear old lady of ripe experience, loving sympathies and cultivated intellect holds a better court than is known to any of those miserable old creatures who prowl about the gay places of the world, and wrestle with the young for their crowns and garlands—those wretched simulacra of womanhood who will not grow old and who cannot become wise. She is the best kind of old lady extant, answering to the matron of classic times—to the Mother in Israel before whom the tribes made obeisance in token of respect; the woman whose book of life has been well studied and closely read, and kept clean in all its pages. She has been no prude however, and no mere idealist. She must have been wife, mother and widow; that is, she must have known many things of joy and grief and have had the fountains of life unsealed. However wise and good she may be, as a spinster she has had only half a life; and it is the best half which has been denied her. How can she tell others, when they come to her in their troubles, how time and a healthy will have wrought with her, if she has never passed through the same circumstances? Theoretic comfort is all very well, but one word of experience goes beyond volumes of counsel based on general principles and a lively imagination.

One type of old lady, growing yearly scarcer, is the old lady whose religions and political theories are based on the doctrines of Voltaire and Paine's *Rights of Man*—the old lady who remembers Hunt and Thistlewood and the Birmingham riots; who talks of the French Revolution as if it were yesterday; and who has heard so often of the Porteus mob from poor papa that one would think she had assisted at the hanging herself. She is an infinitely old woman,

for the most part birdlike, chirrupy, and wonderfully alive. She has never gone beyond her early teaching, but is a fossil radical of the old school; and she thinks the Gods departed when Hunt and his set died out. She is an irreligious old creature, and scoffs with more cleverness than grace at everything new or earnest. She would as lief see Romanism rampant at once as this new fangled mummery they call Ritualism; and Romanism is her version of the unchaining of Satan. As for science—well, it is all very wonderful, but more wonderful she thinks than true; and she cannot quite make up her mind about the spectroscope or protoplasm. Of the two, protoplasm commends itself most to her imagination, for private reasons of her own connected with the Pentateuch; but these things are not so much in her way as Voltaire and Diderot, Volney and Tom Paine, and she is content to abide by her ancient cairns and to leave the leaping-poles of science to younger and stronger hands. This type of old lady is for the most part an ancient spinster, whose life has worn itself away in the arid deserts of mental doubt and emotional negation. If she ever loved it was in secret, some thin-lipped embodied Idea long years ago. Most likely she did not get even to this unsatisfactory length, but contented herself with books and discussions only. If she had ever honestly loved and been loved, perhaps she would have gone beyond Voltaire, and have learned something truer than a scoff.

The old lady of strong instinctive affections, who never reflects and never attempts to restrain her kindly weaknesses, stands at the other end of the scale. She is the grandmother *par excellence*, and spends her life in spoiling the little ones, cramming them with sugar-plums and rich cake whenever she has the chance, and nullifying mamma's punishments by surreptitious gifts and goodies. She is the dearly beloved of our childish recollections; and to the last days of our life we cherish the remembrance of the kind old lady with her beaming smile, taking out of her large black reticule, or the more mysterious recesses of her unfathomable pocket, wonderful little screws of paper which her withered hands thrust into our chubby fists; but we can understand now what all awful nuisance she must have been to the authorities, and how impossible she made it to preserve anything like discipline and the terrors of domestic law in the family.

The old lady who remains a mere child to the end; who looks very much like a faded old wax doll with her scanty hair blown out into transparent ringlets, and her jaunty cap bedecked with flowers and gay-coloured bows; who cannot rise into the dignity of true womanliness; who knows nothing useful; can give no wise advice; has no sentiment of protection, but on the contrary

demands all sorts of care and protection for herself—she, simpering and giggling as if she were fifteen, is by no means an old lady of the finest type. But she is better than the leering old lady who says coarse things, and who, like Béranger's immortal creation, passes her time in regretting her plump arms and her well-turned ankle and the lost time that can never be recalled, and who is altogether a most unedifying old person and by no means nice company for the young.

Then there is the irascible old lady, who rates her servants and is free with full-flavoured epithets against sluts in general; who is like a tigress over her last unmarried daughter, and, when crippled and disabled, still insists on keeping the keys, which she delivers up when wanted only with a snarl and a suspicious caution. She has been one of the race of active housekeepers, and has prided herself on her exceptional ability that way for so long that she cannot bear to yield, even when she can no longer do any good; so she sits in her easy chair, like old Pope and Pagan in *Pilgrim's Progress*, and gnaws her fingers at the younger world which passes her by. She is an infliction to her daughter for all the years of her life, and to the last keeps her in leading-strings, tied up as tight as the sinewy old hands can knot them; treating her always as an irresponsible young thing who needs both guidance and control, though the girl has passed into the middle-aged woman by now, shuffling through life a poor spiritless creature who has faded before she has fully blossomed, and who dies like a fruit that has dropped from the tree before it has ripened.

Twin sister to this kind is the grim female become ancient; the gaunt old lady with a stiff backbone, who sits upright and walks with a firm tread like a man; a leathery old lady, who despises all your weak slips of girls that have nerves and headaches and cannot walk their paltry mile without fatigue; a desiccated old lady, large-boned and lean, without an ounce of superfluous fat about her, with keen eyes yet, with which she boasts that she can thread a needle and read small print by candlelight; an indestructible old lady, who looks as if nothing short of an earthquake would put an end to her. The friend of her youth is now a stout, soft, helpless old lady, much bedraped in woollen shawls, given to frequent sippings of brandy and water, and ensconced in the chimney corner like a huge clay figure set to dry. For her the indestructible old lady has the supremest contempt, heightened in intensity by a vivid remembrance of the time when they were friends and rivals. Ah, poor Laura, she says, straightening herself; she was always a poor creature, and see what she is now! To those who wait long enough the wheel always comes round, she thinks; and the days when Laura bore away the bell from her for grace and sweetness

and loveableness generally are avenged now, when the one is a mere mollusc and the other has a serviceable backbone that will last for many a year yet.

Then there is the musical old lady, who is fond of playing small anonymous pieces of a jiggy character full of queer turns and shakes, music that seems all written in demi-semi-quavers, and that she gives in a tripping, catching way, as if the keys of the piano were hot. Sometimes she will sing, as a great favour, old-world songs which are almost pathetic for the thin and broken voice that chirrups out the sentiment with which they abound; and sometimes, as a still greater favour, she will stand up in the dance, and do the poor uncertain ghosts of what were once steps, in the days when dancing was dancing and not the graceless lounge it is now. But her dancing-days are over, she says, after half a-dozen turns; though, indeed, sometimes she takes a frisky fit and goes in for the whole quadrille:—and pays for it the next day.

The very dress of old ladies is in itself a study and a revelation of character. There are the beautiful old women who make themselves like old pictures by a profusion of soft lace and tender grays; and the stately old ladies who affect rich rustling silks and sombre velvet; and there are the original and individual old ladies, who dress themselves after their own kind, like Mrs. Basil Montagu, Miss Jane Porter, and dear Mrs. Duncan Stewart, and have a *cachet* of their own with which fashion has nothing to do. And there are the old women who wear rusty black stuffs and ugly helmet-like caps; and those who affect uniformity and going with the stream, when the fashion has become national— and these have been much exercised of late with the strait skirts and the new bonnets. But Providence is liberal and milliners are fertile in resources. In fact, in this as in all other sections of humanity, there are those who are beautiful and wise, and those who are foolish and unlovely; those who make the best of things as they are, and those who make the worst, by treating them as what they are not; those who extract honey, and those who find only poison. For in old age, as in youth, are to be found beauty, use, grace and value, but in different aspects and on another platform. And the folly is when this difference is not allowed for, or when the possibility of these graces is denied and their utility ignored.

FANNY FERN

(1811–72)

Born in Portland, Maine, Fanny Fern, whose given name was Sara Payson Wilson, was the daughter of a printer. Two of her brothers also went on to become successful editors in New York, but none of the men in Fern's family encouraged her writing. In fact, they actively discouraged it. Upon reading samples of Fern's early work, her brother Nathanial Willis told her in a letter, "I am sorry that any editor knows that a sister of mine wrote some of these which you sent me."

Fern married her first husband, Charles H. Eldredge, in 1837. The union was a happy one, culminating in the births of three children. When Eldredge died unexpectedly from typhoid fever in 1846, Fern was left to fend for herself and her then two surviving children. Her family provided her with little support and pushed her into marrying S. P. Farrington, who divorced her in 1852. In order to support herself and her children, the impoverished Fern turned to writing, first publishing essays under the pen name Fanny Fern in two Boston periodicals, the *Olive Branch* and the *True Flag*. Her essays proved so popular that they were soon reprinted in newspapers across the country. Readers were clamoring to know the true identity of the bitingly funny writer who flicked her pen at men's follies as much as at women's, and who was an ardent supporter of rights for women, children, and the disadvantaged.

Fern soon collected her early essays and published them in book form. The first collection, *Fern Leaves from Fanny's Port-folio*, appeared in 1853, and *Little Ferns for Fanny's Little Friends* and *Fern Leaves, Second Series* both appeared in 1854. The essays were an instant sensation—and a lucrative one. Fanny Fern became a household name, not to mention one of the best-selling authors of the nineteenth century. The following year, she published the autobiograph-

ical novel *Ruth Hall* (1855), a work that fueled the controversy over her relationship with her family, who had effectively disowned her.

In 1856, now living in New York, Fern married James Parton, former editor of her brother Nathanial Willis's *Home Journal*. Parton had resigned from the magazine after Willis refused to continue publishing Fern's work. That same year, editor Robert Bonner recruited Fern to his weekly newspaper, the *New York Ledger*, promising to pay her the incredible sum of one hundred dollars per installment for a serial novel. Although the novel never appeared in the pages of the newspaper, her essay column did, every week for the next seventeen years. Fern continued to publish additional volumes of essays, including *Fresh Leaves* (1857), *Folly As It Flies* (1859), *Ginger-Snaps* (1870), and *Caper-sauce* (1872). She died from cancer in 1872.

Men and Their Clothes

First appeared in Fern's regular column for the *New York Ledger* and
reprinted in *Ginger-Snaps* (New York, 1870), pp. 223–27.

The female fashions of to-day are absurd enough; but if anything more absurd than a man's "stove-pipe hat" was ever invented, I would like to see it. Mark its victims, when they remove it from their heads—which they seldom do, the gods know why, unless they are getting into bed; see the red rim across their foreheads, produced by its unwieldy weight, and unnecessary inches up in the air; see them occasionally in the street, giving it a cock backwards, when nobody but apple-women are looking, to observe how quickly a gentleman, by that action, may be made into a rowdy; then see them apply their handkerchiefs to their foreheads, to cool off the heat and the pain, and then with a stoicism worthy of one of Fox's martyrs, replace it, and bear the long agony till they get home. Then what garment that ever woman wore, is more ridiculous than a man's shirt, whether buttoning before or buttoning behind, or disfigured with puerile "studs;" whether the stiff collar stands up like a picket on guard, or lays over, with a necktie to tie it suffocatingly over the jugular vein.

Then mark that abomination—a swallow-tailed coat. Heavens! how ugly the handsomest man may look in it! and woe for the plain men, when they intensify their plainness with it!

Then see the knock-kneed and the crooked-legged advertising their deformity in tight pantaloons; and short, fat, barrel men wearing little boys' cloth

caps on their heads! Ah, for every female goose that Fashion makes, I will find you a male mate, even to the wearing of tight corsets!

But, my friends, on one point there's a difference. When a fashionable lady engages a female servant, she stipulates that she shall wear a cap on her head, and calico on her back, to mark the difference between herself and that servant—without which, I suppose, it would not often be recognizable. When her *husband* gives a dinner, the male waiters are dressed exactly like himself—in festal white neckties, white gloves, and hideous swallow-tailed coats.

How is this? It must be that the male creature is very secure of his position, socially, mentally, morally, and physically, to permit such presumption—nay, to demand it. Can any philosopher explain to me this mystery? I was "struck 'midships" with the idea at a festal gathering not long since; and turning to my male guide, philosopher, and friend, asked what it meant. His irritating answer to this most proper and natural question was, "Fanny, don't be silly."

I reiterate my remark that men's dress is to the full as absurd in its way as women's, and I am only reconciled to the idea that a man was intended for a human being when I see an athlete of a gymnast, of glorious chest and calves, and splendid muscular arms, skimming the air as gracefully as a bird, and as poetically; then I know how civilization has ruined him! I know, that man if he jumped, and ran, and wrestled, and walked, instead of sitting stupidly in a chair in the house, or creeping into an omnibus when out of it, and smoking and going to sleep in the intervals, would not be obliged to creep into these ugly tailor's padded fashions to hide his deficiencies, but could wear what he chose, knowing that the beautiful outlines of his form would glorify any decent vestment.

I walked several blocks out of my way behind a man, the other day, who positively "stepped off." What a chest he had! what a splendid poise of the head! what a free, jubilant swing of the arm! I hope he will come to New York again some day, for I'm sure he was a stranger to it, for he neither stopped anywhere to take a drink, buy a cigar, nor did he hail an omnibus!

Magnificent giant! I wonder what was his name, and had he a mother. If not—well, it was a pity he shouldn't have.

I wonder what *are* "good manners"? The question occured to me the other evening in a place of public amusement. I was one of a dozen or so of ladies, wedged in a row of the usual narrow seats. At every pause in the performance, three *gentlemen* stepped over the laps of the ladies in that seat, carrying off in their exit, or knocking upon the floor, opera-glasses, fans, scarfs, handkerchiefs, and, almost, the ladies themselves; returning each time wiping their

lips, and introducing with them a strong odious smell of tobacco. I respectfully submit to any *real* gentleman who reads this article, if that is "good manners."

Of course, I know it would be better if all seats at such places could be so arranged that *gentlemen* need not clean their boots on ladies' laps in order to pass out. But also it would be well if gentlemen took all the sustenance in the way of wine which they needed before starting from home; and if they *could* also bring their godlike minds, to defer smoking till they could annoy only the one lady, whom they have a legal right to annoy, it would add to the general comfort, as well as their *public* reputation for gallantry and politeness. Men generally object to going out evenings, "because they are so tired." Why, then, they never embrace the opportunity to sit still when they get there, is an inconsistency which we must place unsolved, on the shelf already so well labelled with them. I might suggest also, that if they will persist in cleaning their boots on our laps, in order to get out these narrow sets of seats, and if they will carry off in their exit our gloves and fans and opera-glasses, and if they will keep on repeating this little pastime all the evening, to say nothing of occasionally crushing our feet out of all shape, I would venture to suggest that they should mitigate the suffering by saying, occasionally, "I beg pardon," or, "Pray excuse me," or by some such little deference acknowledge the infinite bore of their presence.

Failing in this, I propose that each *gentleman*, on his return, should bring in his hand a peace-offering to the ladies in the seat, of a glass of lemonade and a bit of cake. Why shouldn't *we* be thirsty too? Mr. Beecher says a woman has a right to—no, I believe he *didn't* say that, but he ought to have done so; and if he didn't, "fair play is a jewel."

Mr. Smith exclaims, on reading this, "Horrible woman!" because, though a handsome man, he sees himself looking selfish and ugly in the glass I hold up to him. Now, Mr. Smith wouldn't say that, if he should sit down beside me and let me talk to him five minutes. Not he! You see I have him at a great disadvantage, away off at the other end of the city or over to Brooklyn. I could say the very same things to him I have just said on paper, sitting here on my sofa beside me, and that man would go on lying, as men will, to other men's wives' faces, and be *so* polite and smiling, that his own wife never would know him, if she happened in; and he'd tell me that "what I said was all true, and that men *were* selfish animals," meaning Tom Jones and Sam Jenkins, and every other man but just himself. Don't I know them?

LOUISE IMOGEN GUINEY

(1861–1920)

Born in the Boston suburb of Roxbury, Massachusetts, Guiney was the daughter of Jeanette Doyle and Patrick Guiney, an Irish immigrant who became a prosperous lawyer and served as a Union general in the Civil War. In 1879 Guiney graduated from the Elmhurst Academy, a school the Sisters of the Sacred Heart ran in Providence, Rhode Island. After her father died in 1877 from wounds he had suffered in the war, Guiney began supporting herself and her mother by writing. In 1884 she published her first book, *Songs at the Start*, a collection of poetry. *Goose-Quill Papers*, a book of essays, appeared in 1885. She continued publishing poetry, essays, and biographical sketches for the next two decades, earning praise from critics and her place as an influential writer of her time. Guiney increased the income for her family—which included her mother and an aunt—while also working as a postmistress in Auburndale, Massachusetts, and then in the Boston Public Library Catalogue Room. In 1893 she published her most successful volume of poetry, *A Roadside Harp*.

In addition to several biographies, including a volume of biographical sketches titled *A Little English Gallery* (1895), Guiney published a second volume of essays, *Patrins* (1897). In 1901 Guiney moved to Oxford, England, where she continued to write and publish, primarily poems and criticism related to her lifelong interest in seventeenth-century English poetry. She returned to the United States several times after her move to England in order to care for her mother, aunt, and three orphaned relatives who had joined the household. She never married. Often in poor health herself, Guiney died of a stroke at age fifty-nine in England. In the preface to a collection of Guiney's letters, published posthumously in 1926, essayist Agnes Repplier remarks that Guiney "worked hard," declaring, "So great was the prodigality of her pen that

time and fatigue seem equally out of reckoning." Guiney wrote prodigiously in part because she had to. She seemed to have few regrets, however, as evidenced in a "Point of View" essay she wrote in 1911 for *Scribner's Magazine* under the byline "a 'Well-known' Author": "I have no quarrel with deprivation and discipline. I have toiled mightily for years. Honor itself is profit."

On a Pleasing Encounter with a Pickpocket

Written in 1892 and published in *Patrins* (Boston, 1897), pp. 131–36.

I was in town the other evening, walking by myself, at my usual rapid pace, and ruminating, in all likelihood, on the military affairs of the Scythians, when, at a lonely street corner not adorned by a gas-lamp, I suddenly felt a delicate stir in my upper pocket. There is a sort of mechanical intelligence in a well-drilled and well-treated body, which can act, in an emergency, without orders from headquarters. My mind, certainly, was a thousand years away, and is at best drowsy and indifferent. It had besides, no experience, nor even hearsay, which would have directed it what to do at this thrilling little crisis. Before it was aware what had happened, and in the beat of a swallow's wing, my fingers had brushed the flying thief, my eyes saw him, and my legs (retired race-horses, but still great at a spurt) flew madly after him. I protest that from the first, though I knew he had under his wicked thumb the hard-earned wealth of a notoriously poor poet (let the double-faced phrase, which I did not mean to write, stand there, under my hand, to all posterity), yet I never felt one yearning towards it, nor conceived the hope of revenge. No: I was fired by the exquisite dramatic situation; I felt my blood up, like a charger

"that sees
The battle over distances."

I was in for the chase in the keen winter air, with the moon just rising over the city roofs, as rapturously as if I were a very young dog again. My able bandit, clearly viewed the instant of his assault, was a tiger-lily of the genus "tough": short, pallid, sullen, with coat-collar up and hat-brim down, and a general air of mute and violent executive ability. My business in devoting this chapter to reminiscences of my only enemy, is to relate frankly what were my contemporaneous sensations. As I wheeled about, neatly losing the chance of confront-

ing him, and favored with a hasty survey, in the dark, of his strategic mouth and chin, the one sentiment in me, if translated into English, would have uttered itself in this wise: "After years of dulness and decorum, O soul, here is some one come to play with thee; here is Fun, sent of the immortal gods!"

This divine emissary, it was evident, had studied his ground, and awaited no activity on the part of the preoccupied victim, in a hostile and unfamiliar neighborhood. He suffered a shock when, remembering my ancient prowess in the fields of E—, I took up a gallop within an inch of his nimble heels. Silently, as he ran, he lifted his right arm. We were soon in the blackness of an empty lot across the road, among coal-sheds and broken tins, with the far lights of the thoroughfare full in our faces. Quick as kobolds summoned up from earth, air, and nowhere, four fellows, about twenty years old, swarmed at my side, as like the first in every detail as foresight and art could make them; and these darting, dodging, criss-crossing, quadrilling, and incessantly interchanging as they advanced, covering the expert one's flight, and multiplying his identity, shot separately down a labyrinth of narrow alleys, leaving me confused and checkmated, after a brief and unequal game, but overcome, nay, transported with admiration and unholy sympathy! It was the prettiest trick imaginable.

It was near Christmas; and, brought to bay, and still alone, I conjured up a vision of a roaring cellar-fire, and the snow whistling at the bulkhead, as the elect press in, with great slapping of hands and stamping of shoes, to a superfine night-long and month-long bowl of grog, MY grog, dealt out by Master Villon, with an ironic toast to the generous founder. I might have followed the trail, as I was neither breathless nor afraid, but it struck me that the sweet symmetry of the thing ought not to be spoiled; that I was serving a new use and approximating a new experience; that it would be a stroke of genius, in short, almost equal to the king pickpocket's own, to make love to the inevitable. Whereupon, bolstered against an aged fence, I laughed the laugh of Dr. Johnson, "heard, in the silence of the night, from Fleet Ditch to Temple Bar." I thought of the good greenbacks won by my siren singing in the *Hodgepodge Monthly*; I thought of my family, who would harbor in their memories the inexplicable date when the munificent church-mouse waxed stingy. I thought even of the commandment broken and of the social pact defied, gave my collapsed pocket a friendly dig, and laughed again. The police arrived, with queries, and ineffective note-books. I went home, a shorn lamb, conscious of my exalted financial standing; for had I not been robbed? All the way I walked with Marcus Aurelius Antoninus, who came to mind promptly as my cor-

poreal blessings departed. He intoned no requiem for the lost, but poured a known philosophy, in which I had now taken my degree, into my liberal ear:—

"Why shouldst thou vex thyself, that never willingly vexed anybody?"

"A man has but two concerns in life: to be honorable in what he does, and resigned under what happens to him."

"If any one misconduct himself towards thee, what is that to thee? The deed is his; and therefore let him look to it."

"Welcome everything that happens as necessary and familiar."

Marry, a glow of honest self-satisfaction is cheaply traded for a wad of current specie, and an inkling into the ways of a bold and thirsty world. Methinks I have "arrived"; I have attained a courteous composure proof against mortal hurricanes. Life is no longer a rude and trivial comedy with the Beautifully Bulldozed, who feels able to warm to his own catastrophe, and even to cry, "Pray, madam, don't mention it," to an apologizing lady in a gig, who drives over him and kills him, and does so, moreover, in the most bungling manner in the world.

GERTRUDE BUSTILL MOSSELL

(1855–1948)

Gertrude E. H. Bustill Mossell was born in Philadelphia to a prominent African American family. Her mother died when she was young, and her father, Charles, who was active in the Underground Railroad, raised her and her sister. Later in Mossell's life, her nephew Paul Robeson would become a well-known Broadway singer, actor, and civil rights activist. Mossell attended the elite Robert Vaux Grammar School, which had an all-black faculty and student body, and the Institute for Colored Youth. At age sixteen, she delivered her high school's graduation speech, "Influence." Her remarks so impressed Henry McNeal Turner, editor of the *Christian Recorder*, that he published them in the paper and invited her to contribute additional essays and poetry.

After her graduation, Mossell taught school and continued to write, contributing to a number of local and national publications in the course of her lifetime. In 1893 she married the physician Nathan Mossell, with whom she had two daughters (two other children died in infancy). One year later, Mossell published *The Work of the Afro-American Woman* (1894), a compilation of her own essays and poetry as well as the poetry of other African American women, including Phillis Wheatley and Frances E. W. Harper. This volume appeared when there was a dearth of collections of African American writers. It was significant not only for its inclusion of other African American authors, but also for its attempts to catalogue a history of African American women's literature. Mossell's title essay in this volume celebrates the work of African American women in a number of fields, ranging from journalism to medicine to music. She also lauds humble church workers and "those uncrowned queens of the fireside who have been simply home-keepers." That black women have risen to such achievements, despite "their past condition and its consequent

poverty" and the "blasting influence of caste prejudice," is remarkable, Mossell writes.

In 1855 Mossell became the editor of the women's department for the *New York Age*. That same year, she also became one of the first African American women to write a newspaper column—and to write it for other African American girls and women. Her biweekly advice column in the *New York Freeman*, "Our Woman's Department," encourages girls and women to get their education and provides tips on how to engage safely in the workplace. Mossell's position at the *New York Freeman* made her the highest-paid black newspaperwoman at the time. She later served as the woman's editor for the *Indianapolis World* from 1891 to 1892. Mossell died on January 21, 1948, in Philadelphia's Frederick Douglass Memorial Hospital, the very hospital that she and her husband helped to found. The title of her January 24 obituary in the *Philadelphia Tribune* only mentions the name of her husband: "Widow of Dr. Mossell Succumbs at 92 Years."

A Lofty Study

From *The Work of the Afro-American Woman*, 1894. This version is
from the second edition, *The Work of the Afro-American Woman*
(Philadelphia: George S. Ferguson, 1908), pp. 126–29.

In these days of universal scribbling, when almost every one writes for fame or money, many people who are not reaping large pecuniary profits from their work do not feel justified in making any outlay to gratify the necessities of their labors in literature.

Every one engaged in literary work, even if but to a limited extent, feels greatly the need of a quiet nook to write in. Each portion of the home seems to have its clearly defined use, that will prevent their achieving the desired result. A few weeks ago, in the course of my travels, I came across an excellent idea carried into practical operation, that had accomplished the much-desired result of a quiet spot for literary work, without the disarrangement of a single portion of the household economy. In calling at the house of a member of the Society of Friends, I was ushered first into the main library on the first floor. Not finding in it the article sought, the owner invited me to walk upstairs to an upper library. I continued my ascent until we reached the attic. This had been utilized in such a way that it formed a comfortable and acceptable study.

I made a mental note of my surroundings. The room was a large sloping attic chamber. It contained two windows, one opening on a roof; another faced the door: a skylight had been cut directly overhead, in the middle of the room. Around the ceiling on the side that was not sloping ran a line of tiny closets with glass doors. Another side had open shelves. On the sloping side, drawers rose from the floor a convenient distance. The remaining corner had a desk built in the wall; it was large and substantial, containing many drawers. Two small portable tables were close at hand near the centre.

An easy chair, an old-fashioned sofa with a large square cushion for a pillow, completed the furniture of this unassuming study. Neatness, order, comfort reigned supreme. Not a sound from the busy street reached us. It was so quiet, so peaceful, the air was so fresh and pure, it seemed like living in a new atmosphere.

I just sat down and wondered why I had never thought of this very room for a study. Almost every family has an unused attic, dark, sloping, given up to odds and ends. Now let it be papered with a creamy paper, with narrow stripes, giving the impression of height; a crimson velvety border. Paint the woodwork a darker shade of yellow, hang a buff and crimson portière at the door. Put in an open grate; next widen the windowsills, and place on them boxes of flowering plants. Get an easy chair, a desk that suits your height, and place by its side a revolving bookcase, with the books most used in it. Let an adjustable lamp stand by its side, and with a nice old-fashioned sofa, well supplied with cushions, you will have a study that a queen might envy you. Bright, airy, cheerful, and almost noiseless, not easy of access to those who would come only to disturb, and far enough away to be cosy and inviting, conferring a certain privilege on the invited guest.

These suggestions can be improved upon, but the one central idea, a place to one's self without disturbing the household economy, would be gained.

Even when there is a library in the home, it is used by the whole family, and if the husband is literary in his tastes, he often desires to occupy it exclusively at the very time you have leisure, perhaps. Men are so often educated to work alone that even sympathetic companionship annoys. Very selfish, we say, but we often find it so—and therefore the necessity of a study of one's own.

If even this odd room cannot be utilized for your purposes, have at least your own corner in some cheerful room. A friend who edits a special department in a *weekly* has in her own chamber a desk with plenty of drawers and small separate compartments. The desk just fits in an alcove of the room, with a revolving-chair in front. What a satisfaction to put everything in order, turn

the key, and feel that all is safe—no busy hands, no stray breeze can carry away or disarrange some choice idea kept for the future delectation of the public! Besides this, one who writes much generally finds that she can write best at some certain spot. Ideas come more rapidly, sentences take more lucid forms. Very often the least change from that position will break up the train of thought.

AGNES REPPLIER

(1855–1950)

While relatively unknown today, Agnes Repplier was one of the most promi-
nent women writers of her era. She was also one of the most prolific, publish-
ing dozens of books, the majority of them collections of familiar essays. Born
in Philadelphia, Pennsylvania, Repplier enjoyed a privileged childhood as the
daughter of a wealthy coal merchant. When her father lost the family's for-
tunes in 1871, however, she was forced to end her formal education and help
support her family by writing. Yet to a large extent, the patrician encultura-
tion of Repplier's youth never left her. It influenced her largely conservative
views on politics and social change, and it particularly influenced her critique
of feminism and the suffragette movement.

Repplier's first publications, sketches and short stories, appeared in the
Philadelphia Sunday Times and *Young Catholic*. As a pupil at an area convent
school, she had become a devout Catholic, a decision that informed her writ-
ing for the rest of her life. Unsuccessful as a fiction writer, Repplier turned to
nonfiction, publishing her first essay, "Ruskin as a Teacher," in 1884. Another
essay appeared in 1886, this time in one of the most prominent periodicals of
the day, *Atlantic Monthly*. Repplier contributed more than forty essays to *At-
lantic Monthly* over the next fifty years. Written in the style of the genteel tra-
dition, these essays were popular among turn-of-the-century editors and read-
ers who favored the voice of the bookish, laid-back English gentleman. Even
as a woman, Repplier could imitate this voice in order to succeed as an essay-
ist. And succeed she did, straddling both sides of the century with popular es-
say volumes such as *Essays in Miniature* (1892), *Books and Men* (1893), *Essays
in Idleness* (1893), *In the Dozy Hours and other Papers* (1894), *Compromises*
(1904), *A Happy Half Century and Other Essays* (1908), *Americans and Others*
(1912), *Counter-Currents* (1916), and *Times and Tendencies* (1931).

While the genteel essayist generally avoided the harsh world of politics, Repplier fully supported the Allies' involvement in the First World War and wrote numerous essays to that effect. Her view of the war, however, was largely a romantic one, and she lamented the impact of the war upon the genteel essay form in a 1918 essay titled "The American Essay in War Time": "The personal essay, the little bit of sentiment or observation, the lightly offered commentary which aims to appear the artless thing it isn't,—this exotic, of which Lamb was a rare exponent, has withered in the blasts of war." As that war, and the new century, wore on, genteel essayists like Repplier began to lose touch with the emerging modern world and its readers. Yet at the turn of the century, she was the familiar voice that the public readily turned to, both in essays and on the lecture circuit, where she was a popular speaker. Repplier died of heart failure in 1950.

Lectures

From *In the Dozy Hours* (Boston, 1894), pp. 123–36.

"Few of us," says Mr. Walter Bagehot in one of his most cynical moods, "can bear the theory of our amusements. It is essential to the pride of man to believe that he is industrious."

Now, is it industry or a love of sport which makes us sit in long and solemn rows in an oppressively hot room, blinking at glaring lights, breathing a vitiated air, wriggling on straight and narrow chairs, and listening, as well as heat and fatigue and discomfort will permit, to a lecture which might just as well have been read peacefully by our own firesides? Do we do this thing for amusement, or for intellectual gain? Outside, the winter sun is setting clearly in a blue-green sky. People are chatting gayly in the streets. Friends are drinking cups of fragrant tea in pleasant lamp-lit rooms. There are concerts, perhaps, or *matinées*, where the deft comedian provokes continuous laughter. No; it is not amusement that we seek in the lecture-hall. Too many really amusing things may be done on a winter afternoon. Too many possible pleasures lie in wait for every spare half-hour. We can harbor no delusions on that score.

Is it industry, then, that packs us side by side in serried Amazonian ranks, broken here and there by a stray and downcast man? But on the library shelves stand thick as autumn leaves the unread books. Hidden away in obscure corners are the ripe old authors whom we know by name alone. The mist of an

unspoken tongue veils from us the splendid treasures of antiquity, and we comfort ourselves with glib commonplaces about "the sympathetic study of translations." No; it can hardly be the keen desire of culture which makes us patient listeners to endless lectures. Culture is not so easy of access. It is not a thing passed lightly from hand to hand. It is the reward of an intelligent quest, of delicate intuitions, of a broad and generous sympathy with all that is best in the world. It has been nobly defined by Mr. Symonds as "the raising of the intellectual faculties to their highest potency by means of conscious training." We cannot gain this fine mastery over ourselves by absorbing—or forgetting—a mass of details upon disconnected subjects,—"a thousand particulars," says Addison, "which I would not have my mind burdened with for a Vatican." If we will sit down and seriously try to reckon up our winnings in years of lecture-going, we may yet find ourselves reluctant converts to Mr. Bagehot's cruel conclusions. It is the old, old search for a royal road to learning. It is the old, old effort at a compromise which cheats us out of both pleasure and profit. It is the old, old determination to seek some short cut to acquirements, which, like "conversing with ingenious men," may save us, says Bishop Berkeley, from "the drudgery of reading and thinking."

The necessity of knowing a little about a great many things is the most grievous burden of our day. It deprives us of leisure on the one hand, and of scholarship on the other. At times we envy the happy Hermit of Prague, who never saw pen or ink; at times we think somewhat wistfully of the sedate and dignified methods of the past, when students, to use Sir Walter Scott's illustration, paid their tickets at the door, instead of scrambling over the walls to distinction. It shows a good deal of agility and self-reliance to scale the walls; and such athletic interlopers, albeit a trifle disordered in appearance, are apt to boast of their unaided prowess: how with "little Latin and less Greek" they have become—not Shakespeares indeed, nor even Scotts—but prominent, very prominent citizens indeed. The notion is gradually gaining ground that common-school education is as good as college education; that extension lectures and summer classes are acceptable substitutes for continuous study and mental discipline; that reading translations of the classics is better, because easier, than reading the classics themselves; and that attending a "Congress" of specialists gives us, in some mysterious fashion, a very respectable knowledge of their specialties. It is after this manner that we enjoy, in all its varied aspects, that energetic idleness which Mr. Bagehot recommends as a deliberate sedative for our restless self-esteem.

Yet the sacrifice of time alone is worth some sorrowful consideration. We

laugh at the droning pedants of the old German universities who, in the sixteenth and seventeenth centuries, had well-nigh drowned the world with words. The Tübingen chancellor, Penziger, gave, it is said, four hundred and fifty-nine lectures on the prophet Jeremiah, and over fifteen hundred lectures on Isaiah; while the Viennese theologian, Hazelbach, lectured for twenty-two consecutive years on the first chapter of Isaiah, and was cruelly cut off by death before he had finished with his theme. But the bright side of this picture is that only students—and theological students at that—attended these limitless dissertations. Theology was then a battle-field, and the heavy weapons forged for the combat were presumed to be as deadly as they were cumbersome. During all those twenty-two years in which Herr Hazelbach held forth so mercilessly, German maidens and German matrons formed no part of his audience. They at least had other and better things to do. German artisans and German tradesmen troubled themselves little about Isaiah. German ploughmen went about their daily toil as placidly as if Herr Hazelbach had been born a mute. The sleepy world had not then awakened to its duty of disseminating knowledge broadcast and in small doses, so that our education, as Dr. Johnson discontentedly observed of the education of the Scotch, is like bread in a besieged town,—"every man gets a little, but no man gets a full meal."

What we lack in quantity, however, we are pleased to make up in variety. We range freely over a mass of subjects from the religion of the Phœnicians to the poets of Australia, and from the Song of Solomon to the latest electrical invention. We have lectures in the morning upon Plato and Aristotle, and in the afternoon upon Emerson and Arthur Hugh Clough. We take a short course of German metaphysics,—which is supposed to be easily compressed into six lectures,—and follow it up immediately with another on French art, or the folk-lore of the North American Indians. No topic is too vast to be handled deftly, and finished up in a few afternoons. A fortnight for the Renaissance, a week for Greek architecture, ten days for Chaucer, three weeks for anthropology. It is amazing how far we can go in a winter, when we travel at this rate of speed. "What under the sun is bringing all the women after Hegel?" asked a puzzled librarian not very long ago. "There isn't one of his books left in the library, and twenty women come in a day to ask for him." It was explained to this custodian that a popular lecturer had been dwelling with some enthusiasm upon Hegel, and that the sudden demand for the philosopher was a result of his contagious eloquence. It seemed for the nonce like a revival of pantheism; but in two weeks every volume was back in its place, and the gray dust of neglect was settling down as of yore upon each hoary head. The women, fickle

as in the days of the troubadours, had wandered far from German erudition, and were by that time wrestling with the Elizabethan poets, or the constitutional history of republics. The sun of philosophy had set.

One rather dismal result of this rapid transit is the amount of material which each lecture is required to hold, and which each lecture-goer is expected to remember. A few centuries of Egyptian history or of Mediæval song are packed down by some system of mental hydraulic pressure into a single hour's discourse; and, when they escape, they seem vast enough to fill our lives for a week. "When Macaulay talks," complained Lady Ashburton tartly, "I am not only overflowed with learning, but I stand in the slops." We have much the same uncomfortable sensation at an afternoon lecture, when the tide of information, of dry, formidable, relentless facts, rises higher and higher, and our spirits sink lower and lower with every fresh development. "The need of limit, the feasibility of performance," has not yet dawned upon the new educators who have taken the world in hand; and, as a consequence, we, the students, have never learned to survey our own intellectual boundaries. We assume in the first place that we have an intelligent interest in literature, science, and history, art, architecture, and archæology; and, in the second, that it is possible for us to learn a moderate amount about all these things without any unreasonable exertion. This double delusion lures us feebly on until we have listened to so much, and remembered so little, that we are a good deal like the infant Paul Dombey wondering in pathetic perplexity whether a verb always agreed with an ancient Briton, or three times four was Taurus a bull.

"When all can read, and books are plentiful, lectures are unnecessary," says Dr. Johnson, who hated "by-roads in education," and novel devices—or devices which were novel a hundred and thirty years ago—for softening and abridging hard study. He hated also to be asked the kind of questions which we are now so fond of answering in the columns of our journals and magazines. What should a child learn first? How should a boy be taught? What course of study would he recommend an intelligent youth to pursue? "Let him take a course of chemistry, or a course of rope-dancing, or a course of anything to which he is inclined," was the great scholar's petulant reply to one of these repeated inquiries; and, though it sounds ill-natured, we have some human sympathy for the pardonable irritation which prompted it. Dr. Johnson, I am well aware, is not a popular authority to quote in behalf of any cause one wishes to advance; but his heterodoxy in the matter of lectures is supported openly by Charles Lamb, and furtively by some living men of letters, who strive, though with no great show of temerity, to stem the ever-increasing current of popular instruc-

tion. One eminent scholar, being entreated to deliver a course of lectures on a somewhat abstruse theme, replied that if people really desired information on that subject, and if they could read, he begged to refer them to two books he had written several years before. By perusing these volumes, which were easy of access, they would know all that he once knew, and a great deal more than he knew at the present time, as he had unhappily forgotten much that was in them. It would be simpler, he deemed, and it would be cheaper, than bringing him across the ocean to repeat the same matter in lectures.

As for Lamb, we have not only his frankly stated opinion, but—what is much more diverting—we have also the unconscious confession of a purely human weakness with which it is pleasant to sympathize. Like all the rest of us, this charming and fallible genius found that heroic efforts in the future cost less than very moderate exertions in the present. He was warmly attached to Coleridge, and he held him in sincere veneration. When the poet came to London in 1816, we find Lamb writing to Wordsworth very enthusiastically, and yet with a vague undercurrent of apprehension:—

"Coleridge is absent but four miles, and the neighborhood of such a man is as exciting as the presence of fifty ordinary persons. 'Tis enough to be within the whiff and wind of his genius for us not to possess our souls in quiet. If I lived with him, or with the author of 'The Excursion,' I should in a very little time lose my own identity, and be dragged along in the currents of other people's thoughts, hampered in a net."

This is well enough by way of anticipation, but later on, when Coleridge is a fixed star in the London skies, and is preparing to give his lectures on Shakespeare and English poetry, Lamb's kind heart warms to his perpetually impecunious friend. He writes now to Payne Collier, with little enthusiasm, but with great earnestness, bespeaking his interest and assistance. He reminds Collier of his friendship and admiration for Coleridge, and bids him remember that he and all his family attended the poet's lectures five years before. He tells him alluringly that this is a brand-new course, with nothing metaphysical about it, and adds: "There are particular reasons just now, and have been for the last twenty years, why he [Coleridge] should succeed. He will do so with a little encouragement."

Doubtless; but it is worthy of note that the next time the subject is mentioned is in a letter to Mrs. Wordsworth, written more than two months later. The lectures are now in progress; very successful, we hear; but—Lamb has been to none of them. He intends to go soon, of course,—so do we always; but, in the mean while, he is treating resolution with a good deal of zest,

and making the best plea he can for his defalcation. With desperate candor he writes:—

"I mean to hear some of the course, but lectures are not much to my taste, whatever the lecturer may be. If read, they are dismal flat, and you can't think why you are brought together to hear a man read his works, which you could read so much better at leisure yourself. If delivered extempore, I am always in pain lest the gift of utterance should suddenly fail the orator in the middle, as it did me at the dinner given in honor of me at the London Tavern. 'Gentlemen,' said I, and there I stopped; the rest my feelings were under the necessity of supplying."

We can judge pretty well from this letter just how many of those lectures on Shakespeare Lamb was likely to hear; and all doubts are set at rest when we find Coleridge, the following winter, endeavoring to lure his reluctant friend to another course by the presentation of a complimentary ticket. Even this device fails of its wonted success. Lamb is eloquent in thanks, and lame in excuses. He has been in an "incessant hurry." He was unable to go on the evening he was expected because it was the night of Kenney's new comedy, "which has utterly failed,"—this is mentioned as soothing to Coleridge's wounded feelings. He has mistaken his dates, and supposed there would be no lecture in Christmas week. He is as eager to vindicate himself as Miss Edgeworth's Rosamond, and he is as sanguine as ever about the future. "I trust," he writes, "to hear many a course yet;" and with this splendid resolution, which is made without a pang, he wanders brightly off to a more engaging topic.

It is a charming little bit of comedy, and has, withal, such a distinctly modern touch, that we might fancy it enacted in this year of grace eighteen hundred and ninety-four by any of our weak and erring friends.

THE *Twentieth* CENTURY

ZITKALA-SA

(1876–1938)

Born in South Dakota to a full-blood Dakota Indian and a white man who abandoned her family before her birth, Gertrude Simmons (Bonnin) later adopted the nom de plume Zitkala-Sa, which means "Red Bird." When she was a young girl, Zitkala-Sa was recruited by missionaries to attend a Quaker-run school for Indians in Indiana. She studied there for six years before attending Earlham College, also in Indiana. In 1899 Zitkala-Sa accepted a teaching job at the Carlisle Indian Industrial School in Pennsylvania. The following year, she began publishing autobiographical essays in the *Atlantic Monthly*, one of the most prestigious periodicals of the age. Controversial for their criticism of white society and its impact on Native American culture, particularly its pressure on Native Americans to assimilate, these essays explored her own life as an Indian woman amid such demands.

Ultimately, though, Zitkala-Sa's criticism led to her dismissal from Carlisle. After leaving her teaching post, she studied at the New England Conservatory in Boston, and in 1901 she published her first book, the popular *Old Indian Legends*. One year later, Zitkala-Sa ended her engagement to a Yavapai doctor who believed that assimilation successfully proved to white people the great potential of American Indians. She instead married Raymond Talesfase Bonnin, a Yankton Sioux, and moved with him to a Utah reservation, where she gave birth to a son in 1903. After being elected secretary of the Society for the American Indian in 1916, Zitkala-Sa moved with her family to Washington, D.C., where she edited the society's journal, the *American Indian Magazine*. In 1921 she published her *Atlantic Monthly* essays as *American Indian Stories*, the book for which she is best known today. Zitkala-Sa worked as an advocate for Indian rights for the rest of her life. She founded the National Council of American Indians in 1926 and served as its president until her death in 1938.

Why I Am a Pagan

First appeared in the December 1902 issue of *Atlantic Monthly* as "Why I Am a Pagan" and reprinted, with a revised ending paragraph, as "The Great Spirit" in *American Indian Stories* (Washington, D.C.: Hayworth, 1921), pp. 101–7.

When the spirit swells my breast I love to roam leisurely among the green hills; or sometimes, sitting on the brink of the murmuring Missouri, I marvel at the great blue overhead. With half-closed eyes I watch the huge cloud shadows in their noiseless play upon the high bluffs opposite me, while into my ear ripple the sweet, soft cadences of the river's song. Folded hands lie in my lap, for the time forgot. My heart and I lie small upon the earth like a grain of throbbing sand. Drifting clouds and tinkling waters, together with the warmth of a genial summer day, bespeak with eloquence the loving Mystery round about us. During the idle while I sat upon the sunny river brink, I grew somewhat, though my response be not so clearly manifest as in the green grass fringing the edge of the high bluff back of me.

At length retracing the uncertain footpath scaling the precipitous embankment, I seek the level lands where grow the wild prairie flowers. And they, the lovely little folk, soothe my soul with their perfumed breath.

Their quaint round faces of varied hue convince the heart which leaps with glad surprise that they, too, are living symbols of omnipotent thought. With a child's eager eye I drink in the myriad star shapes wrought in luxuriant color upon the green. Beautiful is the spiritual essence they embody.

I leave them nodding in the breeze, but take along with me their impress upon my heart. I pause to rest me upon a rock embedded on the side of a foothill facing the low river bottom. Here the Stone-Boy, of whom the American aborigine tells, frolics about, shooting his baby arrows and shouting aloud with glee at the tiny shafts of lightning that flash from the flying arrow-beaks. What an ideal warrior he became, baffling the siege of the pests of all the land till he triumphed over their united attack. And here he lay,—Inyan our great-great-grandfather, older than the hill he rested on, older than the race of men who love to tell of his wonderful career.

Interwoven with the thread of this Indian legend of the rock, I fain would trace a subtle knowledge of the native folk which enabled them to recognize a kinship to any and all parts of this vast universe. By the leading of an ancient trail I move toward the Indian village.

With the strong, happy sense that both great and small are so surely enfolded in His magnitude that, without a miss, each has his allotted individual ground of opportunities, I am buoyant with good nature.

Yellow Breast, swaying upon the slender stem of a wild sunflower, warbles a sweet assurance of this as I pass near by. Breaking off the clear crystal song, he turns his wee head from side to side eyeing me wisely as slowly I plod with moccasined feet. Then again he yields himself to his song of joy. Flit, flit hither and yon, he fills the summer sky with his swift, sweet melody. And truly does it seem his vigorous freedom lies more in his little spirit than in his wing.

With these thoughts I reach the log cabin whither I am strongly drawn by the tie of a child to an aged mother. Out bounds my four-footed friend to meet me, frisking about my path with unmistakable delight. Chän is a black shaggy dog, "a thoroughbred little mongrel" of whom I am very fond. Chän seems to understand many words in Sioux, and will go to her mat even when I whisper the word, though generally I think she is guided by the tone of the voice. Often she tries to imitate the sliding inflection and long-drawn-out voice to the amusement of our guests, but her articulation is quite beyond my ear. In both my hands I hold her shaggy head and gaze into her large brown eyes. At once the dilated pupils contract into tiny black dots, as if the roguish spirit within would evade my questioning.

Finally resuming the chair at my desk I feel in keen sympathy with my fellow-creatures, for I seem to see clearly again that all are akin. The racial lines, which once were bitterly real, now serve nothing more than marking out a living mosaic of human beings. And even here men of the same color are like the ivory keys of one instrument where each resembles all the rest, yet varies from them in pitch and quality of voice. And those creatures who are for a time mere echoes of another's note are not unlike the fable of the thin sick man whose distorted shadow, dressed like a real creature, came to the old master to make him follow as a shadow. Thus with a compassion for all echoes in human guise, I greet the solemn-faced "native preacher" whom I find awaiting me. I listen with respect for God's creature, though he mouth most strangely the jangling phrases of a bigoted creed.

As our tribe is one large family, where every person is related to all the others, he addressed me:—

"Cousin, I came from the morning church service to talk with you."

"Yes?" I said interrogatively, as he paused for some word from me.

. Shifting uneasily about in the straight-backed chair he sat upon, he began: "Every holy day (Sunday) I look about our little God's house, and not seeing

you there, I am disappointed. This is why I come today. Cousin, as I watch you from afar, I see no unbecoming behavior and hear only good reports of you, which all the more burns me with the wish that you were a church member. Cousin, I was taught long years ago by kind missionaries to read the holy book. These godly men taught me also the folly of our old beliefs.

"There is one God who gives reward or punishment to the race of dead men. In the upper region the Christian dead are gathered in unceasing song and prayer. In the deep pit below, the sinful ones dance in torturing flames.

"Think upon these things, my cousin, and choose now to avoid the after-doom of hell fire!" Then followed a long silence in which he clasped tighter and unclasped again his interlocked fingers.

Like instantaneous lightning flashes came pictures of my own mother's making, for she, too, is now a follower of the new superstition.

"Knocking out the chinking of our log cabin, some evil hand thrust in a burning taper of braided dry grass, but failed of his intent, for the fire died out and the half-burned brand fell inward to the floor. Directly above it, on a shelf, lay the holy book. This is what we found after our return from a several days' visit. Surely some great power is hid in the sacred book!"

Brushing away from my eyes many like pictures, I offered midday meal to the converted Indian sitting wordless and with downcast face. No sooner had he risen from the table with "Cousin, I have relished it," than the church bell rang.

Thither he hurried forth with his afternoon sermon. I watched him as he hastened along, his eyes bent fast upon the dusty road till he disappeared at the end of a quarter of a mile.

The little incident recalled to mind the copy of a missionary paper brought to my notice a few days ago, in which a "Christian" pugilist commented upon a recent article of mine, grossly perverting the spirit of my pen. Still I would not forget that the pale-faced missionary and the hoodooed aborigine are both God's creatures, though small indeed their own conceptions of Infinite Love. A wee child toddling in a wonder world, I prefer to their dogma my excursions into the natural gardens where the voice of the Great Spirit is heard in the twittering of birds, the rippling of mighty waters, and the sweet breathing of flowers.

Here, in a fleeting quiet, I am awakened by the fluttering robe of the Great Spirit. To my innermost consciousness the phenomenal universe is a royal mantle, vibrating with His divine breath. Caught in its flowing fringes are the spangles and oscillating brilliants of sun, moon, and stars.

THE TWENTIETH CENTURY

VERNON LEE

(1865–1935)

Born in France, Violet Paget, who published under the nom de plume Vernon Lee, traveled widely with her British-born parents. From France, her family moved to Germany and then to Italy, where they eventually settled in Florence. Lee continued to reside in Italy for the rest of her life, with the exception of her travels, which included numerous trips to England. To some extent, Lee's nomadic childhood proved to be good preparation for the many travel essays she later produced. Her formative years also impacted her developing aesthetic sense, which later acquaintances, including artist John Singer Sargent and writer and critic Walter Pater, greatly influenced.

Not only did Lee master each country's language, but she also studied its history, its literature, and, in particular, its art. At thirteen, she published her first essay, in French. In 1880 her first book appeared, *Studies of the Eighteenth Century in Italy*, a collection of essays on Italian music and literature. In an 1855 review of Lee's works for the *Atlantic Monthly*, American essayist Harriet Waters Preston offers Lee as proof of "how far the emancipated, encouraged, and enlightened women of the now rising literary generation are beginning to find places among this excellent stock company of [male] writers."

Lee had as many detractors as she had fans, however, both as a writer and as a person. Novelist Henry James, for one, acknowledged Lee's intellectual gifts but, in a letter to his brother William dated January 20, 1893, James dismissed Lee's style as "*insupportable*" and referred to her as a "tiger-cat." Lee's aggressive, opinionated nature, which must have been all the more unseemly in a woman, disturbed him. Critics, too, often voiced mixed opinions regarding her work. Lee's writing included stylistic glitches and a logorrhea of philosophy, history, politics, and aesthetics, all amid flashes of genius and mo-

ments of stunning locution. In addition to numerous other books, the prolific Lee published seven volumes of travel essays, the first of which, *Limbo, and Other Essays*, appeared in 1897, followed by *Genius Loci* (1899), *The Enchanted Woods* (1905), *The Spirit of Rome* (1906), *The Sentimental Traveler* (1908), *The Tower of Mirrors* (1914), and *The Golden Keys* (1925). Lee never married, but she had two intimate relationships with women artists—Mary Robinson and Kit Anstruther-Thomson—both of which ended in heartbreak. Her pacifist stance against the First World War further alienated Lee from her critics and readers, many of whom also began to find the style and matter of her Victorian essays out of touch with the modern world. Lee died in 1935 in San Gervasio, Italy.

Going Away

From *Hortus Vitae: Essays on Gardening and Life*, 1903. This version
is from a reprinted edition, *Hortus Vitae: Essays on Gardening
and Life* (London: John Lane, 1904), pp. 211–17.

We stood on the steps of the old Scotch house as the carriage rolled her away. A last greeting from that delightful, unflagging voice; the misty flare of the lanterns round a corner; and then nothing but the darkness of the damp autumn night. There is to some foolish persons—myself especially—a strange and almost supernatural quality about the fact of departure, one's own or that of others, which constant repetition seems, if anything, merely to strengthen. I cannot become familiar with the fact that a moment, the time necessary for a carriage, as in this case, to turn a corner, or for those two steel muscles of the engine to play upon each other, can do so complete and wonderful a thing as to break the continuity of intercourse, to remove a living presence. The substitution of an image for a reality, the present broken off short and replaced by the past; enumerating this by no means gives the equivalent of that odd and unnatural word GONE. And the terror of death itself lies surely in its being the most sudden and utter act of *going away*.

I suppose there must be people who do not feel like this, as there are people also who do not feel, apparently, the mystery of change of place, of watching the familiar lines of hill or valley transform themselves, and the very sense of one's bearings, what was in front or to the other side, east or west, getting lost or hopelessly altered. Such people's lives must be (save for misfortune) fun-

nily undramatic; and, trying to realize them, I understand why such enormous crowds require to go and see plays.

It is usually said that in such partings as these—partings with definite hope of meeting and with nothing humanly tragic about them, so that the last interchange of voice is expected to be a laugh or a joke—the sadder part is for those who stay. But I think this is mistaken. There is indeed a little sense of flatness—almost of something in one's chest—when the train is gone or the carriage rolled off; and one goes back into one's house or into the just-left room, throwing a glance all round as if to measure the emptiness. But the accustomed details—the book we left open, the order we had to give, the answer brought to the message, and breakfast and lunch and dinner and the postman, all the great eternities—gather round and close up the gap: close the gone one, and that piece of past, not merely *up*, but, alas! *out*.

It is the sense of this, secret even in the most fatuous breast, which makes things sadder for the goer. He knows from experience, and, if he have imagination, he feels, this process of closing him out, this rapid adaptation to doing without him. And meanwhile he, in his carriage or train, is being hurled into the void; for even the richest man and he of the most numerous clients, is turned adrift without possessions or friends, a mere poor nameless orphan, when on a solitary journey. There is, moreover, a sadder feeling than this in the heart of the more sentimental traveller, who has engaged the hospitality of friends. *He knows it is extended equally to others*; that this room, which he may have made peculiarly his own, filling it, perhaps, in proportion to the briefness of sojourn, with his own most personal experience; the landscape made his own through this window, the crucial conversation, receiving unexpected sympathies, held or (more potent still) thought over afterwards in that chair; he knows that this room will become, perhaps, O horror, within a few hours, another's!

The extraordinary hospitality of England, becoming, like all English things, rather too well done materially, rather systematic, and therefore heartless, inflicts, I have been told, some painful blows on sentimental aliens, particularly of Latin origin. There is a pang in finding on the hospitable door a label-holder with one's name in it: it saves losing one's way, but suggests that one is apt to lose it, is a stranger in the house; and it tells of other strangers, past and future, each with his name slipped in. Similarly the guest-book, imitated from nefarious foreign inns, so fearfully suggestive of human instability, with its close-packed signatures, and dates of arrival and departure. And then the cruelty of housekeepers, and the ruthlessness of housemaids! Take heed, O Thestylis,

dear Latin guardian of my hearth, take heed and imprint my urgent wishes in thy faithful heart: never, never, never, in my small southern home (not unlike, I sometimes fondly fancy, the Poet's *parva domus*), never let me surprise thee depositing thy freshly-whitened linen in heaps outside the door of the departing guest; and never, I conjure thee, offend his eye or nostril with mops, or *frotteur's* rollers, or resinous scent of furniture-polish near his small chamber! For that chamber, kindly Handmaiden, is *his*. He is the Prophet it was made for; and the only Prophet conceivable as long as present. And when he takes departure, why, the void must follow, a long hiatus, darkness, and stacked-up furniture, and the scent of varnish within tight-closed shutters. . . .

But, alas! alas! not all kind Thestylis's doing and refraining is able to dispel the natural sense of coming and going: one's bed re-made, one's self replaced, new boxes brought and unpacked, metaphorically as well as literally; fresh adjustments, new subjects of discourse, new sympathies: and the poor previous occupant meanwhile *rolling*, as the French put it. Rolling! how well the word expresses that sense of smooth and empty nowhere, with nothing to catch on or keep, which plays so large a part in all our earthly experience; as, for the rest, is natural, seeing that the earth is only a ball, at least the astronomers say so.

But let us turn from this painful side of *going away*; and insist rather on certain charming impressions sometimes connected with it. For there is something charming and almost romantic, when, as in the case I mentioned, the friend leaves friends late in the evening. There is the whole pleasant day intact, with leisurely afternoon stroll when all is packed and ready: watching the sunset up the estuary, picking some flowers in the garden; sometimes even seeing the first stars prick themselves upon the sky, and mild sheet-lightnings, auguring good, play round the house, disclosing distant hills and villages. And the orderly dinner, seeming more swept and garnished for the anticipation of bustle, the light on the cloth, the sheen on the silver, the grace and fragrance of fruit and flowers, and the gracious faces above it, remains a wide and steady luminous vision on the black background of midnight travel, of the train rushing through nothingness. Most charming of all, when after the early evening on the balcony, the traveller leaves the south, to hurtle by night, conscious only of the last impression of supper with kind friends at Milan or the lakes, and the glimpse, in the station light, of heads covered with veils, and flowers in the hands, and southern evening dresses. These are the occasional gracious compensations for that bad thing called going away.

VIRGINIA WOOLF

(1882–1941)

One of the most influential writers of the twentieth century, Virginia Stephen Woolf was born in London to Julia Jackson Duckworth Stephen and distinguished literary critic Sir Leslie Stephen. Woolf's parents were committed to her education, and she read voraciously as a child, devouring books and languages. From her infancy, Woolf was surrounded by intellectuals and writers. Family friends included such well-known writers as Henry James, James Russell Lowell, and George Meredith. Woolf knew that she wanted to be a writer from an early age. Her happy childhood came to a quick end in 1895 upon the death of her mother, however. Woolf then suffered her first mental collapse.

In subject matter Woolf ranged more widely than many women essayists of her time, addressing multifarious literary subjects with intellectual rigor. Unlike popular male essayists of the period, she also ventured into the realm of gender politics. She tackled the subject of women themselves in arguments for their political, social, personal, and sexual freedoms. But the voice of Woolf-the-essayist was one of controlled effusiveness, exuberance for subject and argument that never went too far, a strategy she urged other essayists to employ. In 1905 Woolf had begun writing reviews for the *Times Literary Supplement*, and this relationship would continue for the next thirty years.

Virginia Woolf married Leonard Woolf in 1912, and her first suicide attempt followed within six months. Devoted to his wife and anxious to restore her to health, Leonard Woolf conceived of a strategy to occupy her mind. In 1917 he founded Hogarth Press, which the Woolfs operated from their home. By then, Virginia Woolf had begun publishing fiction. Her first novel, *The Voyage Out*, appeared in 1913, and *Night and Day* followed it in 1919. She continued to build her literary reputation with the critical success of subsequent novels such as *Jacob's Room* (1922), *Mrs. Dalloway* (1925), *To the Lighthouse* (1927), *Orlando* (1928) and *The Waves* (1931). But Woolf also remained a prolific essayist, collecting her literary reviews in *The Common Reader* (1925) and

The Second Common Reader (1932) and her now-famous essays and lectures in
A Room of One's Own (1929). In 1941 Woolf committed suicide by drowning
herself in a river near her home. Many of her best-known autobiographical es-
says, collected in The Death of the Moth, and Other Essays (1942) and The Mo-
ment, and Other Essays (1947), appeared after her death. In 1966–67, Leonard
Woolf published a substantial four-volume edition of Woolf's Collected Essays,
which Andrew McNeillie edited and republished in 1986 as The Essays of Vir-
ginia Woolf.

Street Music

First appeared in the National Review in March 1905 and reprinted in volume
1 of The Essays of Virginia Woolf, edited by Andrew McNeillie, which was
published in 1986. This version is from the National Review, pp. 144–48.

"Street musicians are counted a nuisance" by the candid dwellers in most Lon-
don squares, and they have taken the trouble to emblazon this terse bit of mu-
sical criticism upon a board which bears other regulations for the peace and
propriety of the square. No artist, however, pays the least attention to criti-
cism, and the artist of the streets is properly scornful of the judgment of the
British public. It is remarkable that in spite of such discouragement as I have
noted—enforced on occasion by a British policeman—the vagrant musician
is if anything on the increase. The German band gives a weekly concert as reg-
ularly as the Queen's Hall orchestra; the Italian organ grinders are as faithful
to their audience and reappear punctually on the same platform, and in ad-
dition to these recognized masters every street has an occasional visit from
some wandering star. The stout Teuton and the swarthy Italian certainly live
on something more substantial than the artistic satisfaction of their own souls;
and it is therefore probable that the coins, which it is beneath the dignity of
the true lover of music to throw from the drawing-room window, are tendered
at the area steps. There is an audience, in short, who is willing to pay for even
such crude melody as this.

Music, to be successful in a street, must be loud before it is beautiful, and
for this reason brass is the favourite instrument, and one may conclude that
the street musician who uses his own voice or a violin has a genuine reason for
his choice. I have seen violinists who were obviously using their instrument
to express something in their own hearts as they swayed by the kerb in Fleet

Street; and the copper, though rags make it acceptable, was, as it is to all who love their work, a perfectly incongruous payment. Indeed, I once followed a disreputable old man who, with eyes shut so that he might the better perceive the melodies of his soul, literally played himself from Kensington to Knightsbridge in a trance of musical ecstasy, from which a coin would have been a disagreeable awakening. It is, indeed, impossible not to respect any one who has a god like this within them; for music that takes possession of the soul so that nakedness and hunger are forgotten must be divine in its nature. It is true that the melodies that issued from his laboring violin were in themselves laughable, but he, certainly, was not. Whatever the accomplishment, we must always treat with tenderness the efforts of those who strive honestly to express the music that is in them; for the gift of conception is certainly superior to the gift of expression, and it is not unreasonable to suppose that the men and women who scrape for the harmonies that never come while the traffic goes thundering by have as great a possession, though fated never to impart it, as the masters whose facile eloquence enchants thousands to listen.

There is more than one reason perhaps why the dwellers in squares look upon the street musician as a nuisance; his music disturbs the householder at his legitimate employment, and the vagrant and unorthodox nature of such a trade irritates a well-ordered mind. Artists of all kinds have invariably been looked on with disfavour, especially by English people, not solely because of the eccentricities of the artistic temperament, but because we have trained ourselves to such perfection of civilisation that expression of any kind has something almost indecent—certainly irreticent—about it. Few parents, we observe, are willing that their sons should become painters or poets or musicians, not only for worldly reasons, but because in their own hearts they consider that it is unmanly to give expression to the thoughts and emotions which the arts express and which it should be the endeavour of the good citizen to repress. Art in this way is certainly not encouraged; and it is probably easier for an artist than for a member of any other profession to descend to the pavement. The artist is not only looked upon with contempt but with a suspicion that has not a little of fear in it. He is possessed by a spirit which the ordinary person cannot understand, but which is clearly very potent, and exercises so great a sway over him that when he hears its voice he must always rise and follow.

Nowadays we are not credulous, and though we are not comfortable in the presence of artists we do our best to domesticate them. Never was such respect paid to the successful artist as there is to-day; and perhaps we may see in this

a sign of what many people have foretold, and that the gods who went into exile when the first Christian altars rose will come back to enjoy their own again. Many writers have tried to trace these old pagans, and have professed to find them in the disguise of animals and in the shelter of far-away woods and mountains; but it is not fantastic to suppose that while every one is searching for them they are working their charms in the midst of us, and that those strange heathens who do the bidding of no man are inspired by a voice that is other than human in their ears and not really as other people, but are either the very gods themselves or their priests and prophets upon earth. Certainly I should be inclined to ascribe some such divine origin to musicians at any rate, and it is probably some suspicion of this kind that drives us to persecute them as we do. For if the stringing together of words which nevertheless may convey some useful information to the mind, or the laying on of colours which may represent some tangible object, are employments which can be but tolerated at best, how are we to regard the man who spends his time in making tunes? Is not his occupation the least respectable—the least useful and necessary—of the three? It is certain that you can carry away nothing that can be of service to you in your day's work from listening to music; but a musician is not merely a useful creature, to many, I believe, he is the most dangerous of the whole tribe of artists. He is the minister of the wildest of all the gods, who has not yet learnt to speak with human voice, or to convey to the mind the likeness of human things. It is because music incites within us something that is wild and inhuman like itself—a spirit that we would willingly stamp out and forget—that we are distrustful of musicians and loath to put ourselves under their power.

To be civilised is to have taken the measure of our own capabilities and to hold them in a perfect state of discipline; but one of our gifts has, as we conceive, so slight a power of beneficence, so unmeasured a power of harm, that far from cultivating it we have done our best to cripple and stifle it. We look upon those who have given up their lives to the service of this god as Christians regard the fanatic worshippers of some Eastern idol. This arises perhaps from an uneasy foreknowledge that when the Pagan gods come back the god we have never worshipped will have his revenge upon us. It will be the god of music who will breathe madness into our brains, crack the walls of our temples, and drive us in loathing of our rhythmless lives to dance and circle for ever in obedience to his voice.

The number of those that declare, as though confessing their immunity from some common weakness, that they have no ear for music is increasing, though such a confession ought to be as serious as the confession that one is

colour blind. The way in which music is taught and presented by its ministers must to some extent be held answerable for this. Music is dangerous as we know, and those that teach it have not the courage to impart it in its strength, from fear of what would happen to the child who should drink so intoxicating a draught. The whole of rhythm and harmony have been pressed, like dried flowers, into the neatly divided scales, the tones and semitones of the pianoforte. The safest and easiest attribute of music—its tune—is taught, but rhythm, which is its soul, is allowed to escape like the winged creature it is. Thus educated people who have been taught what it is safe for them to know of music are those who oftenest boast of their want of ear, and the uneducated, whose sense of rhythm has never been divorced or made subsidiary to their sense of tune, are those who cherish the greatest love of music and are oftenest heard producing it.

It may be indeed that the sense of rhythm is stronger in people whose minds are not elaborately trained to other pursuits, as it is true that savages who have none of the arts of civilisation are very sensitive to rhythm, before they are awake to music proper. The beat of rhythm in the mind is akin to the beat of the pulse in the body; and thus though many are deaf to tune hardly any one is so coarsely organised as not to hear the rhythm of his own heart in words and music and movement. It is because it is thus inborn in us that we can never silence music, any more than we can stop our heart from beating; and it is for this reason too that music is so universal and has the strange and illimitable power of a natural force.

In spite of all that we have done to repress music it has a power over us still whenever we give ourselves up to its sway that no picture, however fair, or words however stately, can approach. The strange sight of a room full of civilised people moving in rhythmic motion at the command of a band of musicians is one to which we have grown accustomed, but it may be that some day it will suggest the vast possibilities that lie within the power of rhythm, and the whole of our life will be revolutionised as it was when man first realised the power of steam. The barrel-organ, for instance, by reason of its crude and emphatic rhythm, sets all the legs of the passers by walking in time; a band in the centre of the wild discord of cabs and carriages would be more effectual than any policeman; not only cabman but horse would find himself constrained to keep time in the dance, and to follow whatever measure of trot or canter the trumpets dictated. This principle has been in some degree recognised in the army, where troops are inspired to march into battle to the rhythm of music. And when the sense of rhythm was thoroughly alive in every mind we should

if I mistake not, notice a great improvement not only in the ordering of all the affairs of daily life, but also in the art of writing, which is nearly allied to the art of music, and is chiefly degenerate because it has forgotten its allegiance. We should invent—or rather remember—the innumerable metres which we have so long outraged, and which would restore both prose and poetry to the harmonies that the ancients heard and observed.

Rhythm alone might easily lead to excesses; but when the ear possessed its secret, tune and harmony would be united with it, and those actions which by means of rhythm were performed punctually and in time, would now be done with whatever of melody is natural to each. Conversation, for instance, would not only obey its proper laws of metre as dictated by our sense of rhythm, but would be inspired by charity, love and wisdom, and ill-temper or sarcasm would sound to the bodily ear as terrible discords and false notes. We all know that the voices of friends are discordant after listening to beautiful music because they disturb the echo of rhythmic harmony, which for the moment makes of life a united and musical whole; and it seems probable considering this that there is a music in the air for which we are always straining our ears and which is only partially made audible to us by the transcripts which the great musicians are able to preserve. In forests and solitary places an attentive ear can detect something very like a vast pulsation, and if our ears were educated we might hear the music also which accompanies this. Though this is not a human voice it is yet a voice which some part of us can, if we let it, understand, and music perhaps because it is not human is the only thing made by men that can never be mean or ugly.

If, therefore, instead of libraries, philanthropists would bestow free music upon the poor, so that at each street corner the melodies of Beethoven and Brahms and Mozart could be heard, it is probable that all crime and quarrelling would soon be unknown, and the work of the hand and the thoughts of the mind would flow melodiously in obedience to the laws of music. It would then be a crime to account street musicians or any one who interprets the voice of the god as other than a holy man, and our lives would pass from dawn to sunset to the sound of music.

ELISABETH WOODBRIDGE MORRIS

(1870–1964)

A descendant of the Puritan theologian and preacher Jonathan Edwards, Elisabeth Woodbridge Morris was born in Brooklyn, New York. Her maternal grandfather, David Cartwright, was a Quaker and a firm believer in education for women. He helped to found the Packer Collegiate Institute in Brooklyn, an all-girls school that Morris, and her mother before her, attended. In 1892 Morris graduated from Vassar College, then returned to Packer to teach English and history. In 1898 she earned a PhD in English from Yale University, just four years after the first women had received their doctorates from the school.

In 1899 Elizabeth Woodbridge Morris married Charles Gould Morris, also a Yale University graduate. By then she was already a published author. She also would become a mother of six children while she continued to write books and articles for such periodicals as *The Outlook, Scribner's Magazine,* and *Atlantic Monthly.* In *The Jonathan Papers* (1912) and *More Jonathan Papers* (1915), Morris gives a nod to her famous ancestor, for whom the husband in her sketches is named. The books' narrator writes about the pleasures she and Jonathan experience together on and about their New England farm. In 1917 Morris published *Days Out and Other Papers,* a wide-ranging collection of essays on life, literature, and questions of faith. In her later years, Morris suffered from macular degeneration and learned to read Braille. She would pore over books in Braille for hours, her grandson Charles G. Morris II recounts in a family history. In 1964, following a stroke, Morris died in her winter home in Globe, Arizona.

The Embarrassment of Finality

First appeared in a 1912 "Contributors' Club" column for the
Atlantic Monthly and reprinted in *Days Out and Other Papers*
(Boston: Houghton Mifflin, 1917), pp. 53–60.

"Live as if each moment were your last." How often I used to come across such advice in the books that I read! At least it seemed often to me—too often. For while I accepted it as being probably good advice if one could follow it, yet follow it I couldn't.

For one thing, I could never bring myself to feel this "last"-ness of each moment. I tried and failed. I was good at make-believe too, but this was out of all reason.

I still fail. The probability that each moment is really my last is, I suppose, growing theoretically greater as the clock ticks, yet I am no more able to realize it than I used to be. I no longer try to; and, what is more, I hope I never shall. I hope that when my last moment really comes, it may slip by unrecognized. If it doesn't, I am sure I don't know what I shall do.

For I find that this sense of finality is not a spur, but an embarrassment. Only consider: suppose this moment, or let us say the next five minutes, is really my last—what shall I do? Bless me, I can't think! I really cannot hit upon anything important enough to do at such a time. Clearly, it ought to be important, something having about it this peculiar quality of finality. It should have finish, it should in some way be expressive of something—I wonder what? It should leave a good taste in one's mouth. If I consulted my own savage instincts I should probably pick up a child and kiss it; that would at all events leave a good taste. But, suppose there were no child about, or suppose the child kicked because he was playing and didn't want to be interrupted—what a fiasco!

Moreover, one must consider the matter from the child's standpoint: he, of course, ought also to be acting as if each moment were *his* last. And in that case, ought he to spend it in being kissed by me? Not necessarily. At any rate, I should be selfish to assume this. Perhaps he ought to wash his hands, or tell his little sister that he is sorry he slapped her. Perhaps I ought to tell my little sister something of that sort—if it wasn't slapping, it was probably something else. But no, five minutes are precious. If they are my last, she will forgive me

anyway—*de mortuis*, etc.; it would be much more necessary to do this if I were sure of going on living and meeting her at meals; then, indeed—

Yet there must be something that one ought to do in these five minutes. There is enough that needs doing,—at least there would be if they were *not* my last. There is the dusting, and the marketing, and letter-writing, and sewing, and reading, and seeing one's friends. But under the peculiar circumstances, none of these things seems suitable. I give it up. The fact must be that very early in life—before I can remember—I formed a habit of going on living, and of expecting to go on, which became incorrigible. And the contrary assumption produces hopeless paralysis. As to these last five minutes that I have been trying to plan for, I think I will cut them out, and stop right here. It will do as well as anywhere. Though I still have a hankering to kiss that baby! *life has no perfect ending*

I might think the trouble entirely with myself, but that I have noticed indications of the same thing in others. Have you ever been met by an old friend at a railroad station where one can stop only a few moments? I have. She comes down for a glimpse of me; good of her, too! We have not met for years, and it will be years before we can meet again. It is almost like those fatal last moments of life. I stand on the car-platform and wave, and she dashes out of the crowd. "Oh, there you are! Well—*how* are you? Come over here where we can talk.—Why,—you're looking well—yes, I am, too, only I've been having a horrid time with the dentist." (Pause.) "Are you having a pleasant journey?— Yes, of course, those vestibule trains are always hideously close. I've been in a hot car, too.—I thought I'd *never* get here, the cars were blocked—you know they're tearing up the streets again—they always are." (Pause.) "How's Alice?—That's nice.—And how's Egbert?—Yes, you wrote me about his eyes. What a good-looking hat you have! I hated to come down in this old thing, but my new one didn't come home—she promised, too—and I just *had* to see you.—*Do* look at those two over there! How *can* people do such things on a public platform, do you see? I'll move round so you can look.—Why, it isn't time yet, is it? Oh, dear! And we haven't really *begun* to talk. Well, stand on the step and then you won't get left.—Yes, I'll write. So glad to have seen you.—Going to be gone all winter?—Oh, yes, I remember, you wrote me. Well, good-bye! good-bye!"

The train pulls out a few feet, then pauses—one more precious moment for epochal conversation—we laugh. "Why, I thought it had started—Well, give my love to Alice—and I hope Bert's eyes will be better—I said, I hoped his *eyes—Egbert's eyes—*will be *better—will improve.*"

The train starts again. "Good-bye once more!" I stand clutching the car

door, holding my breath lest the train change its mind a second time. But it moves smoothly out, I give a last wave, and reënter my car, trying to erase the fatuous smile of farewell from my features, that I may not feel too foolish before my fellow passengers. I sink into my seat, feeling rather worn and frazzled. No more five-minute meetings for me if I can help it! Give me a leisurely letter, or my own thoughts and memories, until I can spend with my friend at least a half day. Then, perhaps, when we are not oppressed by the importance of the speeding moments, we may be able to talk together with the unconscious nonchalance that makes talk precious.

I have never heard a death-bed conversation, but I fancy it must be something like this, only worse, and my suspicions are so far corroborated by what I am able to glean from those who have witnessed such scenes—in hospitals, for instance. Friends come to visit the dying man; they sit down, hug one knee, make an embarrassed remark, drop that knee and pick up the other ankle. They rise, walk to the foot of the bed, then tiptoe back uneasily. Hang it, what is there to say! If he wasn't dying there would be plenty, but that sort of talk doesn't seem appropriate. What *is* appropriate—except hymns?

When my time comes, defend me from this! I shall not repine at going, but if my friends can't talk to me just as they always have, I shall be really exasperated. And if they offer me hymns—!

No—last minutes, or hours, for me might better be discounted at once—dropped out. I have a friend who thinks otherwise, at least about visits. She says that it makes no difference how you behave on a visit, so long as you act prettily during the last day or two. People will remember that, and forget the rest. Perhaps; but I doubt it. I think we are much more apt to remember the middles of things, and their beginnings, than their endings. Almost all the great pieces of music have commonplace endings; well enough, of course, but what one remembers are bits here and there in the middle, or some wonderful beginning. If one is saying good-bye to a beloved spot, and goes for a last glimpse, does one really take that away to cherish? No, I venture to say, one forgets that, and remembers the place as one saw it on some other day, some time when one had no thought of finality, and was not consciously storing up its beauty to be kept against the time of famine.

One makes a last visit to a friend, and all one remembers about it is its painful "last"-ness. The friend herself one recalls rather as one has known her in other, happy, thoughtless moments, which were neither last nor first, and therefore most rich because most unconscious.

closure not always needed
live authentically

Live as if each moment were my last? Not at all! I know better now. I choose to live as if each moment were my first, as if life had just come to me fresh. Or perhaps, better yet, to live as if each moment were, not last, for that gives up the future, nor first, for that would relinquish the past, but in the midst of things, enriched by memory, lighted by anticipation, aware of no trivialities, because acknowledging no finality.

life every moment as the first not the last

ALICE MEYNELL

(1847–1922)

One of the most popular and frequently anthologized women poets and es-
sayists at the turn of the twentieth century, Alice Thompson Meynell enjoyed
a privileged childhood. Her wealthy and artistically talented family counted
novelist Charles Dickens among its friends. Meynell's father, a graduate of
Cambridge, oversaw her education, which included a move to Italy. There, she
learned both Italian and French. From an early age, Meynell had decided that
she would be a poet, and when she was a teenager, she met Alfred Lord Tenny-
son, who encouraged her to publish her verses. In 1875 Meynell did just that;
her *Preludes* enjoyed critical success, as did subsequent volumes throughout
her life.

In 1877 Alice Meynell married editor and writer Wilfrid Meynell. The cou-
ple had seven children, and her earnings as a poet could not support such a
large family. Meynell reluctantly turned to nonfiction writing to supplement
the family's income. During the 1880s and 1890s, she wrote scores of articles
and essays for her husband's periodical, the *Weekly Register*, as well as for nu-
merous other publications, including *The Observer*, the *Pall Mall Gazette*, the
Saturday Review, and *The Spectator*. Meynell collected many of her essays,
written primarily in the style of the genteel essayists popular at the turn of the
twentieth century, in volumes such as *The Rhythm of Life and Other Essays*
(1893), *The Colour of Life and Other Essays on Things Seen and Heard* (1896),
The Spirit of Place and Other Essays (1899), *Ceres' Runaway and Other Essays*
(1909), and *The Second Person Singular and Other Essays* (1921). She died in
London in 1922.

The Rhythm of Life

From *Essays* (London: Burns, Oates, and Washbourne, 1923), pp. 78–81.

If life is not always poetical, it is at least metrical. Periodicity rules over the mental experience of man, according to the path of the orbit of his thoughts. Distances are not gauged, ellipses not measured, velocities not ascertained, times not known. Nevertheless, the recurrence is sure. What the mind suffered last week, or last year, it does not suffer now; but it will suffer again next week or next year. Happiness is not a matter of events; it depends upon the tides of the mind. Disease is metrical, closing in at shorter and shorter periods towards death, sweeping abroad at longer and longer intervals towards recovery. Sorrow for one cause was intolerable yesterday, and will be intolerable to-morrow; to-day it is easy to bear, but the cause has not passed. Even the burden of a spiritual distress unsolved is bound to leave the heart to a temporary peace; and remorse itself does not remain—it returns. Gaiety takes us by a dear surprise. If we had made a course of notes of its visits, we might have been on the watch, and would have had an expectation instead of a discovery. No one makes such observations; in all the diaries of students of the interior world, there have never come to light the records of the Kepler of such cycles. But Thomas à Kempis knew of the recurrences, if he did not measure them. In his cell alone with the elements—"What wouldst thou more than these? for out of these were all things made"—he learnt the stay to be found in the depth of the hour of bitterness, and the remembrance that restrains the soul at the coming of the moment of delight, giving it a more conscious welcome, but presaging for it an inexorable flight. And "rarely, rarely comest thou," sighed Shelley, not to Delight merely, but to the Spirit of Delight. Delight can be compelled beforehand, called, and constrained to our service—Ariel can be bound to a daily task; but such artificial violence throws life out of metre, and it is not the spirit that is thus compelled. *That* flits upon an orbit elliptically or parabolically or hyperbolically curved, keeping no man knows what trysts with Time. ·

It seems fit that Shelley and the author of the "Imitation" should both have been keen and simple enough to perceive these flights, and to guess at the order of this periodicity. Both souls were in close touch with the spirits of their several worlds, and no deliberate human rules, no infractions of the liberty and law of the universal movement, kept from them the knowledge of recurrences. *Eppur si muove.* They knew that presence does not exist without absence; they

knew that what is just upon its flight of farewell is already on its long path of return. They knew that what is approaching to the very touch is hastening towards departure. "O wind," cried Shelley, in autumn,

> O wind,
> If winter comes can spring be far behind?

They knew that the flux is equal to the reflux; that to interrupt with unlawful recurrences, out of time, is to weaken the impulse of onset and retreat; the sweep and impetus of movement. To live in constant efforts after an equal life, whether the equality be sought in mental production, or in spiritual sweetness, or in the joy of the senses, is to live without either rest or full activity. The souls of certain of the saints, being singularly simple and single, have been in the most complete subjection to the law of periodicity. Ecstasy and desolation visited them by seasons. They endured, during spaces of vacant time, the interior loss of all for which they had sacrificed the world. They rejoiced in the uncovenanted beatitude of sweetness alighting in their hearts. Like them are the poets whom, three times or ten times in the course of a long life, the Muse has approached, touched, and forsaken. And yet hardly like them; not always so docile, nor so wholly prepared for the departure, the brevity, of the golden and irrevocable hour. Few poets have fully recognized the metrical absence of their Muse. For full recognition is expressed in one only way—silence.

It has been found that several tribes in Africa and in America worship the moon, and not the sun; a great number worship both; but no tribes are known to adore the sun, and not the moon. On her depend the tides; and she is Selene, mother of Herse, bringer of the dews that recurrently irrigate lands where rain is rare. More than any other companion of earth is she the Measurer. Early Indo-Germanic languages knew her by that name. Her metrical phases are the symbol of the order of recurrence. Constancy in approach and in departure is the reason of her inconstancies. Juliet will not receive a vow spoken in invocation of the moon; but Juliet did not live to know that love itself has tidal times—lapses and ebbs which are due to the metrical rule of the interior heart, but which the lover vainly and unkindly attributes to some outward alteration in the beloved. For man—except those elect already named—is hardly aware of periodicity. The individual man either never learns it fully, or learns it late. And he learns it so late, because it is a matter of cumulative experience upon which cumulative evidence is long lacking. It is in the after-part of each life that the law is learnt so definitely as to do away with the hope or fear of continuance. That young sorrow comes so near to despair is a result of this young ig-

norance. So is the early hope of great achievement. Life seems so long, and its capacity so great, to one who knows nothing of all the intervals it needs must hold—intervals between aspirations, between actions, pauses as inevitable as the pauses of sleep. And life looks impossible to the young unfortunate, unaware of the inevitable and unfailing refreshment. It would be for their peace to learn that there is a tide in the affairs of men, in a sense more subtle—if it is not too audacious to add a meaning to Shakespeare—than the phrase was meant to contain. Their joy is flying away from them on its way home; their life will wax and wane; and if they would be wise, they must wake and rest in its phases, knowing that they are ruled by the law that commands all things—a sun's revolutions and the rhythmic pangs of maternity.

ZORA NEALE HURSTON

(1891–1960)

Born in Alabama, Zora Neale Hurston moved as a toddler to Eatonville, Florida, the first incorporated all-black town in the United States. Hurston used both Eatonville and the stories she heard as a child as the basis for much of her fiction. One of her earliest publications, *Mules and Men* (1935), is a collection of southern black folklore. At age thirteen, upon the death of her mother, Hurston left school and bounced among family members, eventually moving to Nashville to care for her brother Robert's children. At age sixteen, she joined a traveling theater troupe and worked as a maid in Baltimore, where she attended high school. Hurston later studied anthropology at Howard University and at Barnard College, where she graduated in 1928. She also completed two years of graduate studies in anthropology at Columbia University. While in college, Hurston began publishing short stories and, along with Langston Hughes, founded the short-lived literary magazine *Fire!* in 1927.

Hurston worked as a writer and teacher for much of her life, publishing both fiction and nonfiction. Her notable works include the novel *Their Eyes Were Watching God* (1937) and her autobiography *Dust Tracks on a Road* (1942). Additionally, she published numerous articles and essays for such periodicals as the *American Mercury*, the *Negro Digest*, the *Saturday Evening Post*, and the *World Tomorrow*.

Heralded as a promising young writer of the Harlem Renaissance, Hurston received a considerable amount of attention during the early years of her career. But she faded into obscurity in the latter years of her life, dying virtually penniless in a welfare home in Florida. Robert Hemenway's acclaimed 1977 biography of Hurston, based on years of research tracking down information about her life, did much to restore her to the attention of critics and readers.

Hurston's grave in Florida remained unmarked until Alice Walker, another contemporary African American writer, discovered it.

How It Feels to Be Colored Me

From the May 1928 issue of the *World Tomorrow*. Republished in
I Love Myself When I Am Laughing: A Zora Neale Hurston Reader,
1979. This version is from the *World Tomorrow*, pp. 215–16.

I am colored but I offer nothing in the way of extenuating circumstances except the fact that I am the only Negro in the United States whose grandfather on the mother's side was *not* an Indian chief.

I remember the very day that I became colored. Up to my thirteenth year I lived in the little Negro town of Eatonville, Florida. It is exclusively a colored town. The only white people I knew passed through the town going to or coming from Orlando. The native whites rode dusty horses, the Northern tourists chugged down the sandy village road in automobiles. The town knew the Southerners and never stopped cane chewing when they passed. But the Northerners were something else again. They were peered at cautiously from behind curtains by the timid. The more venturesome would come out on the porch to watch them go past and got just as much pleasure out of the tourists as the tourists got out of the village.

The front porch might seem a daring place for the rest of the town, but it was a gallery seat to me. My favorite place was atop the gate-post. Proscenium box for a born first-nighter. Not only did I enjoy the show, but I didn't mind the actors knowing that I liked it. I usually spoke to them in passing. I'd wave at them and when they returned my salute, I would say something like this: "Howdy-do-well-I-thank-you-where-you-goin'?" Usually automobile or the horse paused at this, and after a queer exchange of compliments, I would probably "go a piece of the way" with them, as we say in farthest Florida. If one of my family happened to come to the front in time to see me, of course negotiations would be rudely broken off. But even so, it is clear that I was the first "welcome-to-our-state" Floridian, and I hope the Miami Chamber of Commerce will please take notice.

During this period, white people differed from colored to me only in that they rode through town and never lived there. They liked to hear me "speak pieces" and sing and wanted to see me dance the parse-me-la, and gave me gen-

erously of their small silver for doing these things, which seemed strange to me for I wanted to do them so much that I needed bribing to stop. Only they didn't know it. The colored people gave no dimes. They deplored any joyful tendencies in me, but I was their Zora nevertheless. I belonged to them, to the nearby hotels, to the county—everybody's Zora.

But changes came in the family when I was thirteen, and I was sent to school in Jacksonville. I left Eatonville, the town of the oleanders, as Zora. When I disembarked from the river-boat at Jacksonville, she was no more. It seemed that I had suffered a sea change. I was not Zora of Orange County any more, I was now a little colored girl. I found it out in certain ways. In my heart as well as in the mirror, I became a fast brown—warranted not to rub nor run.

But I am not tragically colored. There is no great sorrow dammed up in my soul, nor lurking behind my eyes. I do not mind at all. I do not belong to the sobbing school of Negrohood who hold that nature somehow has given them a lowdown dirty deal and whose feelings are all hurt about it. Even in the helter-skelter skirmish that is my life, I have seen that the world is to the strong regardless of a little pigmentation more or less. No, I do not weep at the world—I am too busy sharpening my oyster knife.

Someone is always at my elbow reminding me that I am the granddaughter of slaves. It fails to register depression with me. Slavery is sixty years in the past. The operation was successful and the patient is doing well, thank you. The terrible struggle that made me an American out of a potential slave said "On the line!" The Reconstruction said "Get set!"; and the generation before said "Go!" I am off to a flying start and I must not halt in the stretch to look behind and weep. Slavery is the price I paid for civilization, and the choice was not with me. It is a bully adventure and worth all that I have paid through my ancestors for it. No one on earth ever had a greater chance for glory. The world to be won and nothing to be lost. It is thrilling to think—to know that for any act of mine, I shall get twice as much praise or twice as much blame. It is quite exciting to hold the center of the national stage, with the spectators not knowing whether to laugh or to weep.

The position of my white neighbor is much more difficult. No brown specter pulls up a chair beside me when I sit down to eat. No dark ghost thrusts its leg against mine in bed. The game of keeping what one has is never so exciting as the game of getting.

I do not always feel colored. Even now I often achieve the unconscious Zora of Eatonville before the Hegira. I feel most colored when I am thrown against a sharp white background.

For instance at Barnard. "Beside the waters of the Hudson" I feel my race. Among the thousand white persons, I am a dark rock surged upon, overswept by a creamy sea. I am surged upon and overswept, but through it all, I remain myself. When covered by the waters, I am; and the ebb but reveals me again.

Sometimes it is the other way around. A white person is set down in our midst, but the contrast is just as sharp for me. For instance, when I sit in the drafty basement that is The New World Cabaret with a white person, my color comes. We enter chatting about any little nothing that we have in common and are seated by the jazz waiters. In the abrupt way that jazz orchestras have, this one plunges into a number. It loses no time in circumlocutions, but gets right down to business. It constricts the thorax and splits the heart with its tempo and narcotic harmonies. This orchestra grows rambunctious, rears on its hind legs and attacks the tonal veil with primitive fury, rending it, clawing it until it breaks through to the jungle beyond. I follow those heathen—follow them exultingly. I dance wildly inside myself; I yell within, I whoop; I shake my assegai above my head, I hurl it true to the mark *yeeeeooww*! I am in the jungle and living in the jungle way. My face is painted red and yellow and my body is painted blue. My pulse is throbbing like a war drum. I want to slaughter something—give pain, give death to what, I do not know. But the piece ends. The men of the orchestra wipe their lips and rest their fingers. I creep back slowly to the veneer we call civilization with the last tone and find the white friend sitting motionless in his seat, smoking calmly.

"Good music they have here," he remarks, drumming the table with his fingertips.

 Music! The great blobs of purple and red emotion have not touched him. He has only heard what I felt. He is far away and I see him but dimly across the ocean and the continent that have fallen between us. He is so pale with his whiteness then and I am *so* colored.

At certain times I have no race, I am *me*. When I set my hat at a certain angle and saunter down Seventh Avenue, Harlem City, feeling as snooty as the lions in front of the Forty-Second Street Library, for instance. So far as my feelings

are concerned, Peggy Hopkins Joyce on the Boule Mich with her gorgeous raiment, stately carriage, knees knocking together in a most aristocratic manner, has nothing on me. The cosmic Zora emerges. I belong to no race nor time. I am the eternal feminine with its string of beads.

I have no separate feeling about being an American citizen and colored. I am merely a fragment of the Great Soul that surges within the boundaries. My country, right or wrong.

Sometimes, I feel discriminated against, but it does not make me angry. It merely astonishes me. How *can* any deny themselves the pleasure of my company! It's beyond me.

But in the main, I feel like a brown bag of miscellany propped against a wall. Against a wall in company with other bags, white, red and yellow. Pour out the contents, and there is discovered a jumble of small things priceless and worthless. A first-water diamond, an empty spool, bits of broken glass, lengths of string, a key to a door long since crumbled away, a rusty knife-blade, old shoes saved for a road that never was and never will be, a nail bent under the weight of things too heavy for any nail, a dried flower or two, still a little fragrant. In your hand is the brown bag. On the ground before you is the jumble it held—so much like the jumble in the bags, could they be emptied, that all might be dumped in a single heap and the bags refilled without altering the content of any greatly. A bit of colored glass more or less would not matter. Perhaps that is how the Great Stuffer of Bags filled them in the first place—who knows?

REBECCA WEST

(1892–1983)

Born Cicily Fairfield to intellectual, artistically talented, but often impover-ished parents, Rebecca West became one of the most colorful women writers of the twentieth century. She fashioned her nom de plume after a character in Henrik Ibsen's dark play *Rosmersholm*. West began her career in 1911 as a columnist for the weekly suffragist newspaper *The Freewoman*. Her early arti-cles and columns are collected in *The Young Rebecca: Writings of Rebecca West, 1911–1917* (1982). West later contributed essays to the socialist newspaper *The Clarion*, before moving on to, among others, *The Bookman*, the *London Daily News*, the *New Statesman*, the *Time and Tide*, the *New York Herald Tribune*, and the *Sunday Telegraph*, for which she was a regular reviewer. West's first book-length publication, *Henry James*, appeared in 1916.

Popular both in Britain and the United States, West embarked on an Amer-ican lecture tour in 1923. By then her affair with H. G. Wells, the father of her child, Anthony, was well known, even though it was coming to an end. The scandal followed West to America and, indeed, for the rest of her life. In 1930, she married Henry Andrews.

The persona West developed in her essays, the best of which she collected in two volumes, *The Strange Necessity* (1928) and *Ending in Earnest* (1931), was witty and often biting. Although influential in the modernist movement, West differed from male critics like T. S. Eliot and Ezra Pound in her praise of previous literary traditions. She particularly admired the romantic movement of the past century that had produced so many familiar essayists. In 1941 West published one of her most important books, *Black Lamb and Great Falcon*, an eclectic travelogue based on visits to Yugoslavia in 1937 and 1938. She died of pneumonia in 1983.

Notes on the Effect of Women Writers
on Mr. Max Beerbohm

First appeared as "Mr. Beerbohm and the Literary Ladies" in the
June 1929 issue of *The Bookman* and reprinted in *Ending in Ernest:
A Literary Log* (New York: Doubleday, Doran, 1931), pp. 66–74.

The dinner was being given by Mr. Theodore Byard (of Heinemann's) and Mr.
Russell Doubleday in honour of Mr. and Mrs. Du Bose Heyward, whose *Porgy*
is the admiration of London. Charming as they were (and Mrs. Heyward was
looking very beautiful indeed, like a picture by Alfred Stevens, the Belgian,
with her dark curling hair which restrains itself from curling too much, lest
that should spoil the shape of her head, and her pallor which is like an exqui-
site physical form of reserve), they were displaced in my mind by the more poi-
gnant figure of Mr. Max Beerbohm. He presented himself at the party, look-
ing extraordinarily like one of those little Chinese dragons which are made in
the porcelain known as *blanc de Chine*. Like them he has a rounded forehead
and eyes that press forward in their eagerness; and his small hands and feet
have the neat compactness of paws. His white hair, which sweeps back in trim
convolutions like one of these little dragon's manes, his blue eyes, and his skin,
which is as clear as a child's, have the gloss of newly washed china. He is, more-
over, obviously precious, and not of this world, though relevant to its admira-
tion: a museum piece, if ever there was one.

This evening it could be seen at once that he was not at ease, that he wished
himself back again in his rightful home in the Ceramics Department of the
South Kensington Museum. He was looking round with surprise, with dis-
taste—and I perceived that his eye was lighting on members of my own sex,
on members of my own profession. Yes! He confessed it, in his gentle cour-
teous voice, which has about it something of a Chinese calm, he did not like
literary ladies. He did not mind saying as much to me, since I was of course an
exceptional woman. One could see the little dragon reflecting that since I was
a literary lady I might possibly believe him when he said that. Yes, he repeated,
having ventured the bland proviso, he did not like literary ladies. And he had
thought he had seen two. Or even three.

At that moment the party really began to arrive. Miss G. B. Stern and Miss
Sheila Kaye-Smith came together, followed by Lady Russell (the author of

Elizabeth and Her German Garden), whose fragile and innocent aspect falsely promises the world that butter will not melt in her mouth. Then came that dark Renaissance beauty, Viola Garvin. Then came Mrs. Belloc Lowndes, the writer of detective stories, who looks (if you can get the idea) like a pretty Queen Victoria. Then came Mrs. C. N. Williamson, who seemed to be holding romance firmly to its place in modern life by a large Juliet cap of diamonds; and that superb Roman matron, the author of *Serena Blandish*. They were, I noticed nervously, coming larger now. The sculptural splendours of Miss Clemence Dane, darkly draped, gave the doorway for an instant the air of being a really handsome memorial to somebody who had died in a noble cause.

I perceived that on this tide Mr. Beerbohm was beginning to bob like a cork. It seemed a pity that he had come. He had no doubt been encouraged to form other dreams of the evening's personnel by the invitation cards which had bidden us dine in the Charles II suite of the Carlton Hotel. I had thought myself that, in view of the notorious fact that King Charles's dinner companions were far other than women writers, this was not too suitable for a literary dinner. When we rose to go to the table, still more of the dangerous breed pressed in on us. The average woman writer, I was suddenly conscious, runs to height and force and mass. More and more did Mr. Beerbohm seem minute, perilously fragile, enormously precious. Finally we sat down in our appointed places, which was at the very end of the immensely long table. But though we were now out of the crowd Mr. Beerbohm was not relieved. Up the long vista travelled the clear blue eye, and remained protruded in horror; for no one, save the All-seeing Eye of Providence, can ever have seen so many women writers at once.

Were we literary women, I inquired of him, like the violets that had been strewn on the tablecloth with prodigality but no very successful decorative effect?—rived from our right place in secluded dells to pursue an aesthetic aim that we never could quite realize? In the faintest of moans he assented. So hypnotic an effect is exerted by the delicate, fixed perfection of his personality, and so single-minded is he in his concentration on the thing which seems to him most beautiful—and that is the society which died with the 'nineties—that I had by now entirely passed over to his state of mind. I found myself lachrymosely remembering the appearance of my father and mother, as I had seen them from my nursery window some time about the beginning of the century, when they walked down the path to a hansom cab that waited to take them to a garden party. Magnificent the hansom cab with its jingling bells; magnificent

its driver with his black top hat, his carnation buttonhole, and his beribboned whip. Magnificent my father, as he waved his silver-gray top hat towards the horse. But most magnificent of all was my mother, in her complete dedication to beauty and uselessness.

On a waved plethora of hair, I remember, a large hat rode like a boat, with a bird's wing for its sail; an immense snake of feathers floated round her neck, which was encased in white net supported by invisible whalebones; on her pouched silken bodice she wore a huge bunch of Parma violets upside down; her minute waist was clipped in by a petersham belt; her sleeves were vast bells and her skirts were a vaster bell under which flounces and flounces of stiff silk rattled like silver shrapnel. Her whole appearance, seen in opposition to the soldierly bearing of my father and his relatively simple clothing, cried out, "See how completely ornamental I am. How utterly divorced I am from the idea of the useful! Look, I prove myself by shackling and embellishing myself with this arsenal of garments!" Entrancing world that has departed, entrancing woman! Tears came into my eyes. I could almost smell the hawthorn that had bloomed in our garden that long distant day. I was very willing to admit that, for one accustomed to such hobbled elegancies as my mother's, we women writers must look an uninviting company. Our nearest equivalent in charm was, perhaps, a group of factory chimneys in a northern dawn; or an assembly of Fords at a parking place.

It was just at this point that I suddenly caught sight of Lady—, the wife of a sporting baronet. I felt as if my life—for so strongly had my sympathetic nature identified myself with Mr. Beerbohm's suffering that my life was practically his—were saved. For she is beautiful, but not a beauty of to-day. She does not belong to a past as remote as that which Mr. Beerbohm insists on making his present, but the morning of her flowering was in King Edward VII's reign. Her silver hair springs and curls and coils, unrestrained by that sense of sleek loyalty to the scalp which makes us, her juniors, look so all alike. I am sure that somewhere about her slender form she has concealed a waist which will be brought out in perfect order, should the fashion change. She has that air which only women who were young before the war can achieve, of not understanding machinery and of being able to get on quite well without the knowledge. This enables one to feel that the universe can be, and indeed ought to be, conducted with all the works hidden out of sight round the corner, being looked after by someone else. It indicates a fantasy that the universe need have no works at all, but can just beautifully be projected, the image of a few nice people's minds.

Obviously she was exactly what I—that is, what Mr. Beerbohm wanted. "Look," I said, "there's Lady—." "Oh, where?" asked Mr. Beerbohm. "She is so charming—oh, there!" He sighed. There were perhaps twenty female poets and novelists between them. But at length the dinner came to an end. Mr. Beerbohm stood up hopefully, and Lady— saw his hope and presently bore down on him with outstretched hand. Alas, the errors we commit, the images of ourselves we smash on the altars in other people's souls, through not knowing precisely what kinds of deities they have chosen to make of us! She approached him with a confidence that came of her belief that at last she had bridged a certain gulf between them, and cried out in her deliciously fresh and jubilant voice, "Mr. Beerbohm, do you know that since I last saw you I have written and published a book?"

Of course the spirit of the age always wins. But since it had won, I thought Mr. Beerbohm might as well make the best of it, so I introduced him to G. B. Stern. With glowing eyes she sat down beside the author whom she admires perhaps more than any other of the living. His courtesy was perfect, his response to her adoration exquisitely gracious; yet the sense that he was not happy in this atmosphere made itself apparent. Impossible for his sensitive interlocutor not to feel guilt at being part of the atmosphere, at belonging so bleakly to to-day. Casting about for a subject to talk about she looked down the immensely long table at Mr. Russell Doubleday, whose extreme slenderness, seen from that distance, appeared almost as a vertical straight line. It reminded her of the exercise in perspective one is set in the art class, when one draws lines that stretch away to the vanishing point. Thus it was she came to turn to the most famous living caricaturist and asked him in accents so clear that there could be no possible mistake about what she said, "Did you ever learn to draw, Mr. Beerbohm?" The next day at a lunch party, Mr. John van Druten heard a still, small voice complaining that gooseberries were not so good as they had been when he was a young man; bigger they might be nowadays, but they had not the delicate flavour . . . I need not tell you, ladies and gentlemen, to whom that voice belonged.

In Georges d'Agay's book *Les Aventures d'un Jeune Homme Bien Elevé*, the hero goes for a short space to live in Hell, which he finds indistinguishable from a tenement in Montmartre. On the same storey lives an elderly female demon whom he encounters when she comes in a striped gray flannel dressing gown to draw water from the tap on the landing. Remembering that the saint kept his sainthood, the hero does not quite know what to say; and the demon, reading his silence, says shortly, "There is a dignity attached to history as well

as to success, you know, monsieur." Such a dignity, I feel, attaches (in the matter at least of Mr. Max Beerbohm) to myself, Lady—, Miss G. B. Stern, Miss Sheila Kaye-Smith, Mrs. Belloc Lowndes, and the rest of the women writers who so inappropriately gathered in the Charles II suite to meet Mr. and Mrs. Du Bose Heyward.

KATHARINE FULLERTON GEROULD

(1879–1944)

Katharine Fullerton Gerould was born in Brockton, Massachusetts, where she was adopted by her uncle and aunt, the Reverend Bradford Fullerton and Julia Fullerton. It was not until she was in her twenties, however, that Gerould learned of her adoption; she had believed until that point that her uncle and aunt were her biological parents. The Fullertons encouraged their daughter to pursue her education, and she received bachelor's and master's degrees from Radcliffe College. While Gerould was still an undergraduate at Radcliffe, *Century Magazine* handed her the first public acknowledgement of her writing talent, awarding her first prize in a short story contest.

In 1901 she began teaching English composition at Bryn Mawr College, a position she held until 1910. In 1907 Gerould took a leave of absence from Bryn Mawr and traveled to Paris with her cousin and fiancé, William Morton Fullerton. At the very least, knowing that she was adopted allowed Gerould to pursue a relationship with Fullerton, whom she had previously understood to be her biological brother. In 1910, however, Fullerton broke off the engagement. Katharine Gerould promptly married Gordon Hall Gerould, a medievalist at Princeton University with whom she had two children. She continued to write fiction, completing her first book of short stories, *Vain Obligations*, published in 1914. In addition to a book of travel essays, *Hawaii: Scenes and Impressions* (1916), Gerould published her first book of essays, *Modes and Morals*. Another travel book, *The Aristocratic West* (1925), and a second book of essays, *Ringside Seats* (1937), followed.

The increasingly cool critical reception to Gerould's growing oeuvre of fiction matches the reception she would later receive for her essays—though a reviewer of *Ringside Seats* insists in an October 1937 notice in the *Saturday*

Review that the book is free of "'prissy' detachment." This charge, the reviewer notes, was one the "literary left" often made against Gerould's work. By the 1930s, the careful, genteel prose of writers like Gerould had begun to lose favor in a world reeling from war and intent on welcoming the modern age. Gerould herself would complain about this modernism, particularly the modern reader's insatiable appetite for information. "The preoccupation with facts to the exclusion of what can be done with them, and the incapacity for logical thinking, are both savage," she writes in a 1935 article titled "An Essay on Essays." Gerould died of lung cancer in 1944.

"Ringside Seats"

First appeared in the December 1926 issue of *Harper's Monthly* and reprinted in *Ringside Seats* (New York: Dodd, Mead, 1937), pp. 208–26.

At the funeral games of Anchises the Trojan Dares was about to claim the heavyweight championship of the world by default when the aged Entellus, throwing into the ring the brains-and-gore-stained boxing-gloves of Eryx, challenged him. Lovers of the *Æneid* will recall how Entellus fell, to rise again and buffet the Trojan with such murderous rights and lefts that pious Æneas, as referee, stopped the bout. Dares, spitting out teeth and unable to stand, was dragged away by his friends. Both contestants presumably wore regulation bull-hide gloves well knobbed and studded with metal. They must have weighed considerably more than five pounds; and, indeed, the cauliflower ear, I understand, was even more common in classical times than now. There was, moreover, no adrenalin at hand.

An impression is made of many memories. Perhaps it was Dares and Entellus, perhaps the vast half-lit reaches of the Stadium, curbed to the familiar classic shape, perhaps the concentration of a hundred and forty thousand souls on the beautiful bared bodies of athletes—with jumbled memories of the terrible cestus, of the "pancratist's ear," of matrons barred from the Olympic games on pain of death, of the Circus Maximus, of "Reds" and "Greens" and *"habet"* and turned-down imperial thumbs: perhaps it was all these and more that pulled me so authentically back through time. Those white faces, massed tier above tier, beyond all counting, until the topmost parapet of the arena cut them sharply off from the lowering starless sky—surely, they dumbly affirmed, the spirit of this scene was a very ancient one. In spite of electric lights, and

American slang, and hot-dogs, and field-glasses, and monotonous dark male clothing, I had but to turn my eyes away from the brilliant ring itself, half close them on that ordered multitude, to imagine that we were all the guests of Julius Cæsar. No, I have never felt, potentially, so much a part of the Imperial world. Except that this was far quieter—so quiet that it just might have been (between bouts) not the gladiators, but a new play of Sophocles that we were waiting for. A jumble, yes; but all a classic jumble.

There are a great many people who have a prejudice against prize fighting. I number them largely among my friends and kin. Such folk might overlook a man's going to a fight, because—as women all seem to know, especially the older women—there is, in the normal man, a residuum of brutality that no amount of association with perfect ladies (male or female) can quite reduce out of existence. A woman's going to a fight is another matter. They would quite agree with the old ruling about the Olympic games—no ladies except priestesses of Demeter (of whom, fortunately, there are none left upon earth) should be admitted. Accordingly, I took care not to tell most of my friends beforehand that I was going to the Dempsey-Tunney fight. Some of them would have felt like accessories before the fact in a criminal case. If I had mentioned Dares and Entellus or the *pancratium*, they would have thought I was pretending. It was better they should be presented with a *fait accompli*. Perhaps I could come home and placate them by announcing that I had been quite sick.

I knew better, of course. Though I had never seen a prize fight, I knew better. If I had seen no fights, myself, I had talked with those who had. I suspected that this would be a great, grave spectacle, intensely interesting to the amateur, and presenting aspects of serious beauty to the tyro. The very tickets were grave—with their size, their stamped enormous price, their pictures of Dempsey and Tunney, their printed grandiloquence about "the heavyweight championship of the world" ("the world" settles it: you can't be bigger than that), the faint blue signatures of Tex Rickard all over them, as though to guarantee that every inch of this pasteboard was sacred. A cloud of governors, a bevy of millionaires, the Pennsylvania Boxing Commission, and the Liberty Bell would all see to it that there was no "rough stuff" or foul play. You do not offer rough stuff or foul play to a two-million dollar gate—to private trains, and proud specials from Pittsburgh, Chicago, South Dakota, and points west, puffing staidly on the West Philadelphia tracks. Through what brutal hells of blood-lust, what sordid treacheries of dope and fouls and "framing," in furtive sporting clubs and obscure bouts in the desert, a pugilist may have to lift himself (and lucky to survive) before he gets out into the Sesquicentennial Sta-

dium and up to the big promoters, I am probably not aware. But one felt sure that the air would blow clean on this fight.

The tensity of a championship bout, as of any occasion that draws to itself, for its own sake, a vast crowd converging from great distances on the one event, begins long before the bout itself begins. Those human beings bring their own excitement with them, from east, west, north, and south; and as they clot together and the streams grow thick in the main avenues of approach, their own excitement is reinforced and multiplied. The nearer the fight, the more you feel it. At North Philadelphia the industry of America seemed to have stopped. The windows and doors of factories were crowded with faces; the station platforms uneasy and staring. I never made out just what it was, though I did hear porters saying "Tunney." Perhaps, we thought, his train had passed through from Stroudsburg. Later, we wondered if the challenger's airplane had flown over; perhaps he was even then being historically sick above the North Philadelphia station. Perhaps it was only a rumor of champion or challenger. Perhaps it was nothing—only a vague expectancy raying out from the ring itself and hypnotizing everyone on the direct route to it. The nearer you are the more you feel it, is true of any spot that is focusing the passion of scores of thousands. Things happen, even to you—even if you are only at North Philadelphia (in a factory window) watching the world channel itself in one direction.

Preconceived ideas are a general infection of middle age. Though by six o'clock the station and City Hall Square were crowded, the crowds—except that they were male, in very large proportion—failed to bear out any of my expectations. There was a total dearth of conspicuous clothing and fancy waistcoats; an almost total dearth of fat black cigars. Instead, there were binoculars, binoculars enough to supply every officer in the A.E.F. The hawkers in front of the station who urged you to buy seven-dollar glasses for fifty cents, as well as those who offered ringside tickets under the shadow of William Penn, may have done some business; but it looked as if everyone had brought his own field glass and his own ticket, and had left his flask, his Havanas, and his emotions at home. It was a perfectly unremarkable crowd. You were shouldered and shoved by quietly active thousands. You were one of a multitude so drab and dignified that it lost all quality of multitude except sheer physical weight. Almost any crowd shows higher lights than this one. It lacked color, it lacked noise, it lacked even emphasis, and your nerves had to feel for its secret purpose. Except that it was moving relentlessly, unwaveringly southward, no purpose was visible or audible. Its very force was latent, tacit; you realized only

that nothing short of an act of God would deflect that stream from its objective. In the Sesquicentennial grounds it flowed thickly on through the appointed gates (there was a spaced series of them) and you walked in the midst, compassed closely round with softly treading shadows that never turned to right or left to stare or shout or dally. The poor little lights of the Exhibition buildings were inadequate to illumine this mass, to pick out individuals here or there. Almost every crowd has "humors," diversities, to catch the eye. This crowd had none. Pouring through the darkness, it had no time for byplay. It was only going to the fight.

To one who from early youth has experienced "sport" chiefly in the form of Big Three football games, those hours from six P.M. to three A.M. were an amazing demonstration. I had come to believe that rowdiness, drunkenness, bad manners, maudlin emotionalism were inseparable from great crowds at a sporting event in the open air. Adverse critics, whether of college football or of professional baseball, usually attribute the vulgarity of the spectacle to the commercializing of the game. I had always helplessly supposed that commercialization was partly responsible, as well as the animalism latent even in respectable people when they have once turned into a mob. Yet there were three times as many human beings in the Stadium that night as I have ever seen at a football game—three times as much excuse for the loosing of herd-excitement. Nor was Mr. Rickard exactly giving tickets away, nor were champion and challenger—to put it delicately—fighting for nothing. Something like one hundred and forty thousand people present; two hundred thousand dollars for Mr. Tunney and something like seven hundred thousand for Mr. Dempsey— you really could not say either that the crowd was safely small or that no money was involved.

The argument that in "ringside" seats we were separated from the proletariat amounts to nothing; for we spent only two hours and a half out of some nine or ten in that privileged position. Taxis seemed to have disappeared from Philadelphia. We went from the station to the Stadium in a bus, and after the fight we milled in the rain with thousands, for an hour and a half, before we could even achieve a bus to return on. The station doors at one A.M. were shut against the crowd and the storm. We dribbled in, a few at a time; after half an hour, inside, of pressing against other gates, the compact mass of which we were a part catapulted us through into the train shed, the police protesting vainly. Sodden, we stood for another half hour before we could get on a train and, sodden, we fell into our seats. Sodden, among the sodden, we hitched along the obstructed tracks for an hour and a half. We were, for many hours,

soaking, unsegregated, massed with the lesser and poorer fight fans, those cheap and brutal addicts to the sport over whom other people shake their heads. Just once (in the station) between six o'clock and quarter to four— nearly ten hours—I saw a man take a drink; never did I see anyone who had obviously had a drink; not once did I hear a bet so much as mentioned; not once did I hear an oath or any questionable language. Yet I have never experienced, or watched other people experiencing, a tenser excitement than during the big bout; nor have I ever been in a crowd that was suffering greater physical discomfort than the crowd was suffering during the hours after it. In the Stadium itself the quality of the excitement might explain it; but what about the letdown afterwards? My husband and I confessed to each other that it would be a long time before we could again endure the vulgarity and rowdiness of a football crowd, since now we had clear proof that they were unnecessary.

"The quality of the excitement" . . . Even now, a week later—a week during which the memory of the whole occasion has hardly once left me—I am unable quite to define that quality. During the preliminary bouts, only one or two of which were keenly interesting, I turned my eyes frequently from the ring to the vast stretches of the arena, serried and stippled with faces. I have said that it stirred all sorts of incoherent memories and imaginings of classic scenes. As a spectacle, the high-piled, densely peopled Stadium, with its gamuts of light and darkness—shadowy where vagueness was needed, brilliant where strength and skill, terribly compressed into human form, were emphatically contending—was impressive and beautiful beyond foreknowledge. Yet by being other than they were, differently possessed, those thousands could have turned the place into a spiritual shambles, a great mortar in which you were brayed with unspeakable ingredients. Crowds are not beautiful . . . unless they are animated by a literally respectable emotion, unified by an intellectual as well as a physical interest. Hysteria, even in a noble cause, is a horrid thing. Perhaps the elaborate ritual of announcement and preparation helped—dignity, after all, is dignity wherever it be met. Perhaps people were awed by a superlative—the heavyweight championship of the world does imply a superlative. Certainly the absence of sentimental partisanships helped: it was a cooler, more reasoned interest. Professional sport has the advantage over amateur sport that people are more apt to be looking for excellence, unswayed by prejudice. (At least, it should have this advantage—I believe professional baseball does not bear me out, in practice.) There need be no Red Mist of Anger hovering over the benches.

It is hard to determine the nature of other people's excitement except

through its physical manifestations. I know only that they were immensely and quietly concentrated; that ushers had no trouble in getting people to keep their seats and take their hats off; that any necessary shift of position was made as quickly and apologetically as possible; that everyone (it seemed) would rather die than shove; that ushers and vendors passed down the aisles crouched double, so as not to interfere; and that, while the big bout was on, the murmur of multitude did not prevent your hearing the occasional low speech of a man some rows away. People who have attended crowded athletic events will know what I mean when I say that no one made noises in his throat—there were not even those familiar guttural beginnings of emotional lapse. As no one, I fancy, has ever seen a hundred and forty thousand Lord Chesterfields assembled to-gether—and certainly not at a prize fight—I could account for the manners, the quietness, the considerateness, the general decorum not by the quality of the people, but only by the quality of the interest that dominated them. Though there were plenty of thugs present, as the crowds afterwards bore witness, they were not illustrating thuggishness just then.

Keen concentration was no doubt part of it: it was all happening in a ring twenty-four feet square, and there was no possible dispersal of "effects"; there were only two men to watch; it was personal combat in its intensest form. For the initiate—presumably the majority—it was an entrancing display of "science" and speed which claimed all their vision, all their mental faculties; they could not afford to be distracted for a second from those lightninglike sequences.

Beauty also was part of it; to the tyro, a very great part. A year or two ago, I saw Dempsey do some exhibition boxing in a Broadway theater, and I remember being amazed then to realize that I had seen no such grace of motion since Nijinsky was dancing here with the Russian ballet. Shadow-boxing and the mere illustration of hooks and jabs and swings are of course not to be compared with the real contest with a real antagonist, when there is force behind the speed, and constant counterplay of gestures. There is no plastic beauty in football, none in baseball. There is beauty in lacrosse and in hurdling and pole-vaulting. But in none of these is there plastic beauty comparable with that of good boxing: two perfect bodies matched against each other, melting from attitude to attitude, grouping to grouping, a hundred poses succeeding one another with incredible speed—and the ultimate purpose of it, triumph and the lifted arm. They dance, they spar, they clinch . . . and every instant reveals to the eye some new aspect of art or strength. I have ever preferred statues to pictures; there is something in the validity of three dimensions that com-

forts my soul. And infinitely better is the statue released to motion, its poses incalculably varied and multiplied.

Impossible to explain *that* to people preconceived that boxing is all physical brutality and—therefore—physical ugliness. "But how could you stand it?" wailed one friend of mine; "didn't you have to see *blood*?" I knew then that I could never explain. "Do you know how long a round lasts?" I asked. "No," she shuddered. "Well, it only lasts three minutes, and they wash 'em off in between." To such evasive crudity I was reduced.

The Battle of the Century appears to be the mystery of the ages. It is not for me, in my ignorance, to sustain or to challenge anything said by any sporting editor in the land. I do not know what "happened"; or why Gene Tunney was able to beat Jack Dempsey. I keep, unperturbed, my own deep sense of the spectacle; and no hashing over of the fight, in talk or in print, can alter one jot of the impression which was, that night, forced upon me. Of necessity, my own reactions to the bout were only æsthetic and psychological. If it was, for me, a great experience, that was simply because I had never before been a tiny assisting unit in so impressive a spectacle. Someone once told me, concerning the Dempsey-Carpentier fight, that it was like watching a Greek tragedy. His words came back to me in the arena, where I was duplicating his internal comment. So subtly are we wrought upon by the rest of any audience of which we are a part that, unless we are in open and deliberate revolt against our fellow-witnesses, we partake in the common spirit of the occasion. I do not know if anyone else was saying to himself that it was like watching a Greek tragedy; but there was nothing in the surrounding atmosphere to contradict my own mood. In feeling the event to be like that, I seemed to be agreeing with a hundred thousand people around me.

I do not for an instant mean that to those spectators the defeat of Dempsey was a personal distress. The newspapers, I believe, said it was a Tunney crowd. Around us sympathy was evenly divided. If it was like a Greek tragedy, that was precisely because messy partisanships seemed to be absent. As round succeeded round, and Dempsey came no nearer landing a knockout blow, incredulity seemed to be swallowed up in impersonal awe. One could do nothing; one's muscles made no attempt to stir in sympathy with either athlete (which of us has not impotently tried to help a halfback down the field?); one's throat was dumb. The event was beyond all petty worrying, beyond all impulse to change or forestall it. There were no tears in it except the universal "tears of things." Whatever was happening had to happen: you were only watching. You might as well protest an Æschylean catastrophe. It was like seeing a doom

fall from the very hands of the Parcæ. That, in part, is why I confirm again the Greek tragedy comparison.

The protagonist, too, was a symbol, or the event would not have been tragic in the impersonal, classic sense. No matter what they say of Dempsey now, the majority of sporting writers and boxing fans said earlier that he was the greatest heavyweight fighter of our times. I have no means of knowing whether this is a true estimate or not, and for my own purpose it does not matter. True or not, the crowd believed it. The Dempsey legend hung heavy over the whole arena. Whatever they hoped, they believed him invincible. The moments just before the champion entered the ring were almost intolerable in their weight of expectancy. They were the only moments in the Stadium I would not willingly live through again. Tunney climbed through the ropes, debonair in his gaudy bathrobe, and there were cheers a-plenty, but the general tension did not slacken. I heard a young man, some distance away from us, murmur to his companion—low and painfully, as if breath came hard, "You just watch—when Dempsey comes—he'll come into the ring looking just like a gorilla." If you had to wait much longer for Dempsey, blood vessels would crack, everything would go dark. . . . Not quite for eagerness to see the fight; rather, because Dempsey himself was, to most of them, a superlative, something that had nothing to do with human averages. No one had seen him in the ring for three long years: he *was* a legend and had taken on legendary proportions and gifts; the exaggeration of myth was about him. They might call him in words the "Manassa Mauler," but the tone said "Achilles." It is ill waiting for lightning or earthquake, a portent or a revelation. He came, at last,—at the proper moment, no doubt; and if Shakespeare had been writing it, he would have made the rain begin—as it did—when Dempsey entered the ring.

For a person with no technical knowledge to describe a fight, even a single round of a fight, would be more than folly. It would resemble the insolence of the local vet's wife who analyzes Shakespeare's *Sonnets* for her woman's club. Experts pronounced themselves on both subjects, too copiously, too long ago. What, then, was the spectacle that transcended one's ignorance and fed one's intuitions for forty fleeting minutes? For one had no sense of not knowing what was going on; and if one was bewildered, so were all the gentlemen who had no time to smoke. I have read, I think, square miles of "dope" about the fight, yet I am precisely where I was, that night, in the dripping Stadium.

What one saw, with one's unenlightened eyes, was Tunney, infinitely tall, his half-inch advantage expanded to a cubit; Tunney and his long arms swinging right and left to Dempsey's ducked head; Tunney wide-mouthed and pant-

ing, but perpetually dancing round the champion, forcing the pace, and only once (or so it looked) clearly frightened. Tunney's tall ugliness (as Henry James would have put it) and his flailing arms. And Dempsey? Dempsey, whose face, lowered at Tunney's breast, you seldom saw; Dempsey with his bull-necked crouch, weaving, bobbing, closing in—but always the shade too slow, his half-inch longer reach not counting; Dempsey "flat-footed" and dancing not at all, robbed somehow of the speed that makes strength fatal; Dempsey ineffectual, but terrifying, portentous, to the last gong-stroke, so that, for thirty counted minutes, you were expecting him, the next instant, to explode from that crouch, and kill. If ever human figure looked invincible, that figure was Jack Dempsey's; and in the later rounds (prolonging themselves incredibly beyond the fifth, which most people had taken for the ultimate) one felt that invisible burdens must be laid upon him, great weights that no scales could register, no officials detect.

I have been accused of being a Dempsey fan; though just why it is an accusation, I do not know. Certainly, if I felt any pallid partisan desires, they were all for Dempsey's victory; but I have never had the opportunity to become a fight fan, and my pugilistic sympathies are, veritably, neither keen nor profound. I felt during the fight, no more than, and no differently from, the Tunney supporters at my right hand. The same bewilderment paralyzed us all. Every man and woman there must have been asking the tacit question, "What has slowed Dempsey down?" I believe anyone who had never heard of Dempsey would have asked, that night, the same question. Dempsey, in the ring, spoke for himself, defined himself, illustrated, to any eye that watched him, the quintessential gladiator. *Numen inest.* You might know nothing about it, be less than the least reporter, but you felt, with every internal muscle, a classic strength deprived of speed, a perfect engine somehow ill-fired. "A great ox stood upon my tongue," says the Herald in the *Agamemnon.* A great ox seemed to be checking Dempsey with unseen hoofs and breath. For he looked, each moment, as if he would co-ordinate that strength with one tremendous impulse and knock out the challenger. If, after the fifth round, you no longer quite expected it, that was from a dim, *a fortiori* logic—if Tunney had stuck it as long as that, he might go on sticking it; and, clearly, he was hitting home far oftener than Dempsey. Even to the last round, one looked for the natural fulfilment of the strength and science that were Dempsey. But the speed never came back.

If I shut my eyes, regarding the hour once more with the simplifying, fore-shortening gaze of memory, I see three things—Tunney, standing clear of Dempsey from the chest up, swinging rights and lefts to Dempsey's head;

Dempsey, crouched and ferine, weaving, weaving, searching Tunney's body vainly for the appointed, vulnerable spot; and Dempsey, coming from his corner, those last times, dripping with rain and looking as blind as the Cyclops. I am no expert; but that is what I seemed—eternally, yet so briefly—to see. That is how, to the untrained eye, it looked. And no one believed any of it—any more than I did.

Vachel Lindsay has long since, refused to read in public his poem called "Boston." You may remember the constant refrain of the uneven stanzas:

> And John L. Sullivan
> The strong boy of Boston
> Broke-every-single-rib-of-Jake-Kilrain.

(Was that the fight that went forty-five rounds? I do not remember.) I used to think that poem was quite as near as I cared to get to a prize fight. Though the rhythm carries you, in spite of yourself, they are reeking lines. And no doubt their suggestion is right. Boxing, very likely, *is* a brutal business. Referees stopped two of the preliminary bouts, on this occasion, because one of the fighters was so clearly outclassed that to continue it would have been like letting John L. Sullivan break every single rib of Jake Kilrain. Perhaps, among other things, it was the more perfect matching of champion and challenger, the greater science displayed, that permitted one to forget Vachel Lindsay and hark back to Atropos. Certainly, as I have reiterated, the setting helped. But I believe that the classic quality, the awe, the tension, the helplessness derived from a deeper, more personal source. If Dempsey's defeat was like, as I have so tediously repeated, a Greek tragedy, it was neither because Dempsey was passionately beloved nor because all fights are like that. None of the preliminary bouts was in the least like a Greek tragedy. That the quality of inescapable doom, the suggestion that the Fates themselves were mixing in this matter, the curious enlarging of the fight from "sport" into a more poetic issue, the injection of symbolism into the effect produced were directly due to Dempsey, I think none could deny. If, for example, Gene Tunney, later, should fight Jack Sharkey, these graver and nobler elements, I feel sure, would be lacking. I watched Dempsey, round after round, a crouching, ducking, terribly weaving figure, battered about the head, forced to the ropes, recovering, following, pursuing, swollen-faced, bleeding; and in the teeth of defeat I could see why he had been a legend. Someone behind us was whispering at intervals, as if in a private agony of prayer, "Just one blow, Jack—only one blow— it's *all* you, need, Jack—only one." Some Tunney fans directly in front of us

checked up each round with stammering amazement. When the announcement of the decision finally belled over the Stadium, they clasped one another in delight—with just a touch of boyish consternation. No man is invincible, the Manassa Mauler or another, and seven years is, I suppose, a fair length of time to hold the heavyweight title, which is, in these days, a property of youth. Even Dempsey had to be defeated sometime, and all these people had sense enough to know it. Many of them, no doubt, hoped to see him lose his title that very night—by a knockout. All champions go through the Arician cycle:

> The priest who slew the slayer.
> And shall himself be slain.

If this was different, there was a reason; and that reason lay, I believe, in Dempsey himself, as I have said.

For the world likes (though it seldom gets) its types complete. Dempsey was, to the eye of contemplation, the Platonic idea of a heavyweight fighter, the perfection of a type, one thing supremely and nothing else. Apart from being a beautiful boxer, Tunney was, to the common vision, a thug like another. Several times, psychology prevailing, in my interest, over sport, I focussed the present champion's "fighting face" through my good German glass. No man's fighting face is pretty, I need hardly say, and I was not looking for beauty. I was looking for some quality, some emphasis, that always evaded me: it was not there. Tunney was what the French call *quelconque*. "He might be a gasoline salesman," I sighed to my husband as I gave over the search. But not Dempsey, whose ferocious face and beautiful body alike suggested nothing but the great gladiator. He was, you would say, engined, created, fashioned to be that, in its perfection; it was the original purpose of him from the beginning of the world. Not one element of him betrayed it. There was nothing *quelconque*— vague, indeterminate, drably indefinable—about him. The prize fighter may not be one's pet type—it certainly is not mine—but, as I say, the world likes its types, whatever they are, perfect. Dempsey might have been the primal matrix from which all great fighters are struck. He was complete enough to be a symbol; and when a symbol ceases to symbolize, it is like a death. The man who told me that the Carpentier fight was like a Greek tragedy—youth, grace, beauty, gallantry going down before brute strength—added, "And it was *right*. If Carpentier had won, it would have been logically wrong; you would have been happier, but your intellect would have been outraged." This time the case was other. I have noticed that, even now, when everyone knows that Tunney did beat Dempsey, there seem to be comparatively few people who believe that

Tunney can beat Dempsey. It was a decision according to fact, but contrary to nature. One must square facts with nature somehow, or the brain reels; and this fact could be thus squared only by the law of the Arician doom. Whether Tunney or someone else, it did not matter; sometime or other, that symbol of strength, because he was only a man, had to be proved mortal and subject to the processes of decay. Therefore, one had the sense that, as I say, the Fates themselves were mixing in the matter. Perhaps the boxing fans are right, and Tunney cannot beat Dempsey—only did beat him, for the high cosmic reason that legends are weaker than laws, and the Immortals concern themselves periodically with proving it to us.

It may be that I poetize it too much. As we surged slowly, thousands of us, out of the Stadium, we saw a single fan seated among acres of empty benches, watching the last bout going on in the downpour. He was fat and genial, and the rain slid down him on every side in shining arcs. "Want your money's worth, don't you?" someone sang out to him across the wet expanse of bleachers. "Sure," he chuckled; "I've been here all night and haven't seen a knockout yet." He obviously did not consider that he had witnessed a Greek tragedy.

Yet something, for hours to come, laid a finger on foolish lips. Something kept the crowd in general from swearing, during that night of discomfort, when the rain was searching their very bones. Something kept the packed, motionless crowd in the train, from any discussion of the fight; kept them from protest or vaunting or comparing of notes or exchange of "dope." I incline to think that it was what kept us, until at five in the morning we achieved dryness, warmth, and comfortable beds, exalted, tense, and silent. I think that they had seen a classic drama, though they knew only that they had seen a fight.

M. F. K. FISHER

(1908–92)

Mary Frances Kennedy Fisher understood that her literary achievements suffered critical neglect and dismissal because of their chief subject matter: food. But from the time she was a young girl, growing up in Whittier, California, food and cooking had been Fisher's passions. She later wrote in the foreword to her book *The Gastronomical Me* (1943), "It seems to me that our three basic needs, for food and security and love, are so mixed and mingled and entwined that we cannot straightly think of one without the others." Fisher's parents encouraged her to develop her literary talents, and in 1937 she published her first book, *Serve It Forth*, a work that combined recipes with autobiographical anecdotes and discussions of food. This feature would mark nearly all of her subsequent food writing.

In 1929 Fisher had married Alfred Young Fisher, but she divorced him in 1938 and married the painter Dillwyn Parrish two years later. After Parrish died in 1942, Fisher married again, this time to Donald Friede. They had two children and divorced in 1951. In Fisher's early books, her trials and tribulations during her three marriages feature alongside memories of her girlhood and her travels as an adult. She collected her first five food books in the critically acclaimed *The Art of Eating* (1954). In addition to *Serve It Forth*, those early books include *Consider the Oyster* (1941); *How to Cook a Wolf* (1942), a wartime cookbook with advice for dealing with rations and hunger; *The Gastronomical Me* (1943), a collection of autobiographical sketches; and *An Alphabet for Gourmets* (1949). Fisher continued to write and publish until her death in 1992 from Parkinson's disease.

H *is for* Happy

From *An Alphabet for Gourmets*
(New York: Viking, 1949), pp. 71–75.

. . . and for what kind of dinner is most often just that evanescent, unpredictable, and purely heaven-sent thing.

In general, I think, human beings are happiest at table when they are very young, very much in love, or very lone. It is rare to be happy in a group: a man can be merry, gay, keenly excited, but not happy in the sense of being free— free from life's cluttering and clutching.

When I was a child my Aunt Gwen (who was not an aunt at all but a large-boned and enormous-hearted woman who, thank God, lived next door to us) used to walk my little sister Anne and me up into the hills at sundown. She insisted on pockets. We had to have at least two apiece when we were with her. In one of them, on these twilight promenades, would be some cookies. In the other, oh, deep sensuous delight! would be a fried egg sandwich!

Nobody but Aunt Gwen ever made fried egg sandwiches for us. Grandmother was carefully protected from the fact that we had ever even heard of them, and as for Mother, preoccupied with a second set of children, she shuddered at the thought of such grease-bound proteins with a thoroughness which should have made us chary but instead succeeded only in satisfying our human need for secrets.

The three of us, Aunt Gwen weighing a good four times what Anne and I did put together, would sneak out of the family ken whenever we could, into the blue-ing air, our pockets sagging and our spirits spiraling in a kind of intoxication of freedom, breathlessness, fatigue, and delicious anticipation. We would climb high above other mortals, onto a far rock or a fallen eucalyptus tree, and sit there, sometimes close as burrs and sometimes apart, singing straight through *Pinafore* and the Episcopal Hymn Book (Aunt Gwen was British and everything from contralto to basso profundo in the Whittier church choir), and biting voluptuously into our tough, soggy, indigestible, and luscious suppers. We flourished on them, both physically and in our tenacious spirits.

Lone meals, which can be happy too, are perhaps the hardest to put on paper, with a drop of cyanide on their noses and a pin through their guts. They

are the fleetingest of the gastronomical butterflies. I have known some. We all have. They are compounded in almost equal parts of peace, nostalgia, and good digestion, with sometimes an amenable touch of alcohol thrown in.

As for dining-in-love, I think of a lunch at the Lafayette in New York, in the front café with the glass pushed back and the May air flowing almost visibly over the marble tabletops, and a waiter named Pons, and a bottle of Louis Martini's Folle Blanche and moules-more-or-less-marinières but delicious, and then a walk in new black high-heeled shoes with white stitching on them beside a man I had just met and a week later was to marry, in spite of my obdurate resolve never to marry again and my cynical recognition of his super-salesmanship. Anyone in the world could dream as well . . . being blessed . . .

Group happiness is another thing. Few of us can think with honesty of a time when we were indeed happy at table with more than our own selves or one other. And if we succeed in it, our thinking is dictated no matter how mysteriously by the wind, the wine, and the wish of that particular moment.

Now, for no reason that I consciously know of, I remember a lunch at the Casino at Berne, in Switzerland. I was with my father and mother, my husband, and a friend deep in his own murky moods but still attainable socially. We had driven there from Vevey, and we sat in the glass-enclosed bourgeois sparkle of the main dining-room with a fine combination of tired bones and bottoms, thirst, hunger, and the effect of altitude.

I do not recall that we drank anything stronger than sherry before lunch, but we may have; my father, a forthright man who had edited a paper in the hard-liquor days when his Midwest village had fifteen saloons and three churches or thereabouts, may have downed a drink or two of Scotch, or the Bernese play on words, *ein Gift*, aptly called "poison" and made of half sweet vermouth and half any alcohol from vodka to gin.

Then, and this is the part I best remember, we had carafes of a rosé wine that was believed to be at its peak, its consummateness, in Berne, and indeed in that very room. Zizerser it was called. It came in the open café pitchers with the federal mark at the top, naming the liquid content. It was a gay, frivolous color. It was poured into fine glasses (they were one of the many good things about that casino) from a height of two feet or so, and miracle! it foamed! It bubbled! It was full of a magic gas, that wine, which melted out of it with every inch of altitude it lost, so that when I took down a case of it and proudly poured it lake-side, in Vevey, it was merely a pink pretty drink, flat as flat. In Berne it was champagne. We drank deep.

So did our driver, François, and later when a frenzied-looking mountain-

eer waved back our car, we drove on with nonchalance along a cliff road above fabulous gorges, singing "Covered all over with Sweet Violets" and "Der Heimat" (ensemble) and "Rover Was Blind but Brave" (my mother), until finally a rock about half as big as our enormous old Daimler sailed lazily down in front of us and settled a few feet from the engine.

We stopped in time.

Another mountaineer, with tiny stars of gold in his ear lobes to make him hear better, dropped into sight from the pine forest. Go back, go back, he cried. We are blasting a new road. You might have been killed. All right, all right, we said.

He lingered, under the obvious spell of our happiness. We talked. My father introduced my mother as the sweetest singer in Onawa-iowa, which once she was. My husband breathed deeply, as if in sleep. My friend looked out over the plumy treetops and sighed for a lost love. François blinked in a surfeit of content. We all sat about, on felled branches and running boards, and drank some superlative cognac from an unlabeled bottle which my father had bought secretly from a Vevey wine merchant and brought along for just this important moment.

A couple more boulders drifted down and settled, dustily and noisily but without active danger, within a few feet of us.

The mountaineer sang three or four songs of his canton. Then, because of the Zizerser and mostly and mainly because we were for that one moment in all time a group of truly happy people, we began to yodel. My father, as a small-town editor, had the edge on us: he had practiced for years at the more unbridled of the local service-club luncheons and banquets. My mother found herself shooting off only too easily into *Aïda* and the more probable sections of *Parsifal*. My husband and even my friend hummed and buzzed, and I too buzzed and hummed. And François? He really yodeled, right along with the man from the mountains.

It was a fine thing. Whatever we had eaten at lunch, trout I think, went properly with the Zizerser, and we were full and we were happy, beyond the wine and the brandy, beyond the immediate danger of blasted boulders and cascading slides, beyond any feeling of foolishness. If we had lunched on milk and pap, that noontime in the Casino, we still would have felt the outer-world bliss that was ours, winy and full, on the Oberland mountainside that summer day.

It happened more than ten years ago, but if I should live a hundred and ten more I would still feel the freedom of it.

AUNT GWEN'S FRIEND EGG SANDWICHES

INGREDIENTS (*Physical*)

½ to 1 cup drippings

6 fresh eggs

12 slices bread

waxed paper

The drippings are very English, the kind poured off an unidentified succession of beef, mutton, and bacon pans, melted gradually into one dark puddle of thick unappetizing grease, which immediately upon being dabbed into a thick hot iron skillet sends out rendingly appetizing smells.

The eggs must be fresh, preferably brown ones, best of all freckled brown ones.

The bread must be good bread, no puffy, blanched, uniform blotters from a paper cocoon.

The waxed paper must be of honest quality, since at the corners where it will leak a little some of it will stick to the sandwich and in a way merge with it and be eaten.

INGREDIENTS (*Spiritual*)

These have been amply indicated in the text, and their prime requisite—Aunt Gwen herself would be the first to cry no to any further exposition of them. Suffice it that they were equal parts of hunger and happiness.

METHOD

Heat the drippings in a wide flat-bottomed skillet until they spit and smoke. Break in the eggs, which will immediately bubble around the edges, making them crisp and indigestible, and break their yolks with a fork and swirl them around, so that they are scattered fairly evenly through the whites. This will cook very quickly, and the eggs should be tough as leather.

Either push them to one side of the pan or remove them, and fry bread in the drippings for each sandwich, two slices to an egg. It too will send off a blue smoke. Fry it on one side only, so that when the sandwiches are slapped together their insides will turn soggy at once. Add to this sogginess by pressing them firmly together. Wrap them well in the waxed paper, where they will steam comfortably.

These sandwiches, if properly made and wrapped, are guaranteed, if properly carried in sweater or pinafore pockets, to make large oily stains around them.

Seasoning depends on the state of the drippings. As I remember Aunt Gwen's, they were such a "fruity" blend of last week's roast, last month's gammon, that salt and pepper would have been an insult to their fine flavor.

PRESCRIPTION

To be eaten on top of a hill at sunset, between trios of "A Wandering Minstrel I" and "Onward Christian Soldiers," preferably before adolescence and its priggish queasiness set in.

ELIZABETH BOWEN

(1899–1973)

Although Britain claims her as one of its most significant writers of the twentieth century, Elizabeth Bowen, born Elizabeth Dorothea Cole Bowen, spent her early childhood near Dublin, Ireland, on the estate of her Anglo-Irish family. When her father suffered a mental breakdown, Bowen moved with her mother to England. In 1912, when Bowen was just thirteen, her mother died suddenly from cancer, leaving her in the care of relatives and with the legacy of a troubling adolescence. The latter found its way into a number of the novels and short stories for which Bowen is best known.

In 1923, the twenty-four-year-old Bowen published her first book of short stories, *Encounters*. Another short story collection and a first novel, *The Hotel* (1927), followed this book. Critics generally consider Bowen's novels *The Death of the Heart* (1938) and *The Heat of the Day* (1949) to be her best works, but Bowen also wrote nonfiction as moving and as vivid as many of her better-known works of fiction. She published her first nonfiction book, *Bowen's Court*, a family history, in 1942. She subsequently released nearly a dozen others, including *Collected Impressions* (1950), *Afterthought: Pieces about Writing* (1962), the autobiographical *Seven Winters* (1942), and her posthumous memoirs *Pictures and Conversations* (1975). In 1923 Bowen had married Alan Cameron, a World War I veteran. When Cameron died in 1952, after twenty-nine years of marriage, Bowen settled at Bowen Court, which she had inherited upon her father's death. She lived there for eight years before returning to England, where she died of lung cancer in 1973.

London, 1940

From *Collected Impressions*
(New York: Longmans Green, 1950), pp. 217–20.

Early September morning in Oxford Street. The smell of charred dust hangs on what should be crystal pure air. Sun, just up, floods the once more innocent sky, strikes silver balloons and the intact building-tops. The whole length of Oxford Street, west to east, is empty, looks polished like a ballroom, glitters with smashed glass. Down the distances, natural mists of morning are brown with the last of smoke. Fumes still come from the shell of a shop. At this corner where the burst gas main flaming floors high made a scene like a hell in the night, you still feel heat. The silence is now the enormous thing—it appears to amaze the street. Sections and blocks have been roped off; there is no traffic; the men in the helmets say not a person may pass (but some sneak through). Besides the high explosives that did the work, this quarter has been seeded with timebombs—so we are herded, waiting for those to go off. This is the top of Oxford Street, near where it joins the corner of Hyde Park at Marble Arch.

We people have come up out of the ground, or out from the bottom floors of the damaged houses: we now see what we heard happen throughout the night. Roped away from the rest of London we seem to be on an island—when shall we be taken off? Standing, as might the risen dead in the doors of tombs, in the mouths of shelters, we have nothing to do but yawn at each other or down the void of streets, meanwhile rubbing the smoke-smart deeper into our eyes with our dirty fists. . . . It has been a dirty night. The side has been ripped off one near block—the open gash is nothing but dusty, colourless. (As bodies shed blood, buildings shed mousey dust.) Up there the sun strikes a mirror over a mantelpiece; shreds of a carpet sag out over the void. An A.R.P. man, like a chamois, already runs up the debris; we stare. The charred taint thickens everyone's lips and tongues—what we want is bacon and eggs, coffee. We attempt little sorties—"Keep BACK, please! Keep OFF the street!" The hungry try to slake down with smoking. "PLEASE—that cigarette *out*! Main gone—gas all over the place—d'*you* want to blow up London?" Cigarette trodden guiltily into the trodden glass. We loaf on and on in our cavemouths; the sun goes on and on up. Some of us are dressed, some of us are not: pyjama-legs show below overcoats. There are some Poles, who having lost everything all over again sit down whenever and wherever they can. They are

our seniors in this experience: we cannot but watch them. There are two or three unmistakable pairs of disturbed lovers—making one think 'Oh yes, how odd—love.' There are squads of ageless 'residents' from aquarium-like private hotels just round the corner. There are the nomads of two or three nights ago who, having been bombed out of where they were, pitched on this part, to be bombed out again. There is the very old gentleman wrapped up in the blanket, who had been heard to say, humbly, between the blasts in the night, 'The truth is, I have outlived my generation. . . .' We are none of us—except perhaps the Poles?—the very very poor: our predicament is not a great predicament. The lady in the fur coat has hair in two stiff little bedroomy grey plaits. She appeals for hair-pins: most of us have short hair—pins for her are extracted from one of the Poles' heads. Girls stepping further into the light look into pocket mirrors. 'Gosh,' they say remotely. Two or three people have, somehow, begun walking when one time-bomb goes off at Marble Arch. The street puffs itself empty; more glass splinters. Everyone laughs.

It is a fine morning and we are still alive.

This is the buoyant view of it—the theatrical sense of safety, the steady breath drawn. We shall be due, at to-night's siren, to feel our hearts once more tighten and sink. Soon after black-out we keep that date with fear. The howling ramping over the darkness, the lurch of the barrage opening, the obscure throb in the air. We *can* go underground—but for this to be any good you have to go very deep, and a number of us, fearful of being buried, prefer not to. Our own 'things'—tables, chairs, lamps—give one kind of confidence to us who stay in our own paper rooms. But when to-night the throb gathers over the roof we must not remember what we looked at this morning—these fuming utter glissades of ruin. No, these nights in September nowhere is pleasant. Where you stay is your own choice, how you feel is your fight.

However many people have crowded together, each has, while air whistles and solids rock, his or her accesses of solitude. We can do much for each other, but not all. Between bomb and bomb we are all together again: we all guess, more or less, what has been happening to all the others. Chatter bubbles up; or there is a cosy slumping sideways, to doze. Fear is not cumulative: each night it starts from scratch. On the other hand, resistance becomes a habit. And, better, it builds up a general fund.

Autumn seems a funny time to be bombed. By nature it is the hopeful start of the home year. The colours burning in the trees and weed-fires burning in the gardens ought to be enough. Autumn used to be a slow sentimental fête, with

an edge of melancholy—the children going back to school, the evenings drawing in. Windows lit up earlier. Lanes in the country, squares in the city crisp with leaves. (This year, leaves are swept up with glass in them.) In autumn, where you live touches the heart—it is the worst time not to be living anywhere. This is the season in which to honour safety.

London feels all this this year most. To save something, she contracts round her wounds. Transport stoppages, roped-off districts, cut-off communications and 'dirty' nights now make her a city of villages—almost of village communes. Marylebone is my village. Friends who live outside it I think about but seldom see: *they* are sunk in the life of their own villages. We all have new friends: our neighbours. In Marylebone, shopping just before the black-out or making for home before the bombers begin to fill up the sky, we say, 'Well, good luck!' to each other. And every morning after the storm we go out to talk. News comes filtering through from the other villages. They say St. John's Wood had it worse than we did. Camden Town, on the other hand, got off light. Chelsea, it seems, was hot again. They say they brought 'one' down on Paddington Green. Has anybody been over to Piccadilly? A man from Hampstead was here a minute ago; he said . . . Mrs. X is a Pimlico woman; she's quite upset. Anybody know how it was in Kilburn? Somebody had a letter from Finsbury Park.

For one bad week, we were all turned out on account of timebombs: exiled. We camped about London in other villages. (That was how I happened to be in Oxford Street, only to be once more dislodged from there.) When we were let home again we were full of stories, spent another morning picking up all the threads. The fishmonger said he had caught sight of me buying milk in Paddington. 'What, you were there too?' I asked. 'No,' he replied, 'I've got Finchley people; I was only over in Paddington looking after a friend.' We had all detested our week away: for instance, I had been worrying about my typewriter left uncovered in the dust blowing through our suddenly-emptied house; the fishmonger had been worrying about all that fish of his in the frig. with the power off. It had been necessary for several of us to slip through the barricades from time to time in order to feed cats.

Regent's Park where I live is still, at the time of writing, closed: officially, that is to say, we are not here. Just inside the gates an unexploded bomb makes a boil in the tarmac road. Around three sides of the Park, the Regency terraces look like scenery in an empty theatre: in the silence under the shut façades a week's drift of leaves flitters up and down. At nights, at my end of my terrace, I feel as though I were sleeping in one corner of a deserted palace. I had always

placed this Park among the most civilized scenes on earth; the Nash pillars look as brittle as sugar—actually, which is wonderful, they have not cracked; though several of the terraces are gutted—blown-in shutters swing loose, ceilings lie on floors and a premature decay-smell comes from the rooms. A pediment has fallen on to a lawn. Illicitly, leading the existence of ghosts, we overlook the locked park.

Through the railings I watch dahlias blaze out their colour. Leaves fill the empty deck-chairs; in the sunshine water-fowl, used to so much attention, mope round the unpeopled rim of the lake. One morning a boy on a bicycle somehow got inside and bicycled round and round the silence, whistling 'It's a Happy, Happy Day.' The tune was taken up by six soldiers digging out a bomb. Now and then everything rips across; a detonation rattles remaining windows. The R.E. 'suicide squad' detonate, somewhere in the hinterland of this park, bombs dug up elsewhere.

We have no feeling to spare.

ELIZABETH DAVID

(1913–92)

British cooks and food critics claim Elizabeth David as one of the most influential food writers of the twentieth century, crediting her for having an indelible, and delectable, effect on English cooking. Born at her family's seventeenth-century home in Sussex, England, David studied at the Sorbonne in Paris, where she first developed an appreciation of French cuisine. In fact, a good deal of her influence on British fare emerged from her introduction to the foods of other countries during her extensive travels as an adult. Yet David also wrote about the traditions of her homeland's cooking in *Spices, Salt and Aromatics in the English Kitchen* (1970) and *English Bread and Yeast Cookery* (1977).

David's personal life was as colorful as her cooking. After a scandalous departure from Britain in 1939 with married actor Charles Gibson Cowan, David eventually settled with Cowan on the Greek island of Syros. When the Germans invaded Greece in 1941, David and Cowan were evacuated to Cairo, Egypt. There, Elizabeth David eventually married Tony David, an officer in the Indian Army, and she secured a job in the library at the Ministry of Information. The marriage was unhappy, and in 1946 an ill Elizabeth David left India, where the couple had moved after marrying. She returned to London and began publishing essays based on her research into local foods while she was abroad. Those essays appeared in periodicals such as *The Spectator, Vogue,* and *Nova.* David's first publication, *A Book of Mediterranean Food,* appeared in 1950. Other hugely successful and meticulously researched books soon followed, including *French Country Cooking* (1951), *Italian Food* (1954), *Summer Cooking* (1955), and *French Provincial Cooking* (1960). David's periodical essays, written between 1955 and 1984, are collected in *An Omelette and a Glass*

of Wine (1984). David died in England in 1992. A second collection containing previously unpublished material, *Is there a Nutmeg in the House?*, appeared posthumously in 2000.

Para Navidad

First appeared on November 27, 1964, in *The Spectator* and reprinted
in *An Omelette and a Glass of Wine*, 1984. This version is from the sixth
printing of Lyons Press edition published in 1997, pp. 94–97.

It is the last day of October. Here in the south-eastern corner of Spain the afternoon is hazy and the sun is warm, although not quite what it was a week ago. Then we were eating out-of-doors at midday, and were baked even in our cotton sweaters. The colours of the land are still those of late summer—roan, silver, lilac, and ochre. In the soft light the formation of the rock and the ancient terracing of the hills become clearly visible. In the summer the sun on the limestone-white soil dazzles the eyes, and the greens of June obscure the shapes of the ravines and craggy outcroppings. Now there are signs of autumn on the leaves of some of the almond trees. They have turned a frail, transparent auburn, and this morning when I awoke I devoured two of the very first tangerines of the season. In the dawn their scent was piercing and their taste was sharp. During the night it had rained—not much, nothing like enough to affect the parched soil—but all the same there was a sheen on the rose bricks and grey stones of the courtyard. The immense old terra-cotta oil jar in the centre was freshly washed, and over the mountains a half-rainbow gave a pretty performance as we drank our breakfast coffee.

At midday we picked small figs, dusty purple and pale jade green. On the skins is a bloom not to be seen on midsummer figs. The taste, too, is quite different. The flesh is a clear garnet red, less rich and more subtle than that of the main-crop fruit, which is of the *vernal* variety, brilliant green. Some of the figs have split open and are half dried by the sun. In the north we can never taste fruit like this, fruit midway between fresh and dried. It has the same poignancy as the black Valencia grapes still hanging in heavy bunches on the vines. These, too, are in the process of transforming themselves—from fresh grapes to raisins on the stalk as we know them. Here the bunches have been tied up in cotton bags.

The two ancients who tend the almond trees (this is Valencia almond coun-

try, and it has been a bad season. If the rain fails, next year's crop may prove to be another disaster) and who have known the estate of La Alfarella all their lives, were hoping that the grapes could be cut late and hung in the storeroom until Christmas. Their plans have been foiled by the wasps. This year there has been a fearsome plague of the persistent and destructive brutes. They have bitten their way through the protecting cotton, sucked out the juice of the fruit, and left nothing but husks. Here and there where a bunch has escaped the marauders, we have cut one and brought it back to the house in a basket with the green lemons and some of the wild thyme that has an almost overpowering scent, one that seems to be peculiar to Spanish thyme. It is perhaps fanciful, but it seems to have undertones of aniseed, chamomile, hyssop, lavender.

My English host, who has re-created this property of La Alfarella out of a ruin and is bringing its land back to life after twenty years of neglect, is at the cooking pots. He seizes on the green lemons and grates the skins of two of them into the meat mixture he is stirring up. He throws in a little of the sun-dried thyme and makes us a beguiling dish of *albóndigas*, little *rissoles* fried in olive oil. He fries them skilfully and they emerge with a caramel-brown and gold coating reflecting the glaze of the shallow earthenware *sartén*, the frying dish in which they have been cooked and brought to the table. All the cooking here is done in the local earthenware pots. Even the water is boiled in them. They are very thick and sturdy, unglazed on the outside, and are used directly over the Butagaz flame, or sometimes on the wood fire in the open hearth. As yet there is no oven. That is one of next year's projects.

Surprisingly, in an isolated farmhouse in a country believed by so many people to produce the worst and most repetitive food in Europe, our diet has a good deal of variety, and some of the produce is of a very high quality. I have never eaten such delicate and fine-grained pork meat, and the cured fillet, *lomo de cerdo*, is by any standard a luxury worth paying for. The chicken and the rabbit that go into the ritual paella cooked in a vast burnished iron pan (only for paella on a big scale and for the frying of *tortillas* are metal pans used) over a crackling fire are tender, possessed of their true flavours. We have had little red mullet and fresh sardines *a la plancha*, grilled on primitive round tin grill plates made sizzling hot on the fire. This is the utensil, common to France, Italy, Spain, and Greece, that also produces the best toast in the world—brittle and black-barred with the marks of the grill.

To start our midday meal we have, invariably, a tomato and onion salad, a few slices of fresh white cheese, and a dish of olives. The tomatoes are the Mediterranean ridged variety of which I never tire. They are huge, sweet,

fleshy, richly red. Here they cut out and discard the central wedge, almost as we core apples, then slice the tomatoes into rough sections. They need no dressing, nothing but salt. With the roughly cut raw onions, sweet as all the vegetables grown in this limestone and clay soil, they make a wonderfully refreshing salad. It has no catchy name. It is just *ensalada*, and it cannot be reproduced without these sweet Spanish onions and Mediterranean tomatoes.

In the summer, seventeen-year-old Juanita asked for empty wine bottles to take to her married sister in the village, who would, she explained, preserve the tomatoes for the winter by slicing them, packing them in bottles, and sealing them with olive oil. They would keep for a year or more, Juanita said. Had her sister a bottle we could try? No. There were only two of last year's vintage left. They were to be kept *para Navidad*, for Christmas.

Yesterday in the market there were fresh dates from Elche, the first of the season. They are rather small, treacle-sticky, and come in tortoiseshell-cat colours: black, acorn brown, peeled-chestnut beige; like the lengths of Barcelona corduroy I have bought in the village shop. Inevitably, we were told that the best dates would not be ready until *Navidad*. That applies to the oranges and the muscatel raisins; and presumably also to the little rosy copper meddlers now on sale in the market. They are not yet ripe enough to eat, so I suppose they are to be kept, like Juanita's sister's tomatoes, and the yellow and green Elche melons stored in an *esparto* basket in the house, for *Navidad*. We nibble at the candied melon peel in sugar-frosted and lemon-ice-coloured wedges we have bought in the market, and we have already torn open the Christmas-wrapped *mazapan* (it bears the trade name of El Alce, 'the elk'; a sad-faced moose with tired hooves and snow on its antlers decorates the paper), which is of a kind I have not before encountered. It is not at all like marzipan. It is very white, in bricks, with a consistency reminiscent of frozen sherbet. It is made of almonds and egg whites, and studded with crystallized fruit. There is the new season's quince cheese, the *carne de membrillo*, which we ought to be keeping to take to England for *Navidad* presents, and with it there is also a peach cheese. How is it that one never hears mention of this beautiful and delicious clear amber sweetmeat?

There are many more Mediterranean treats, cheap treats of autumn, like the newly brined green olives that the people of all olive-growing countries rightly regard as a delicacy. In Rome, one late October, I remember buying-new green olives from a woman who was selling them straight from the barrel she had set up at a street corner. That was twelve years ago. I have never forgotten the fresh flavour of the Roman green olives. The *manzanilla* variety we have bought

here come from Andalucía. They are neither green nor black, but purple, rose, lavender, and brown, picked at varying stages of maturity, and intended for quick home consumption rather than for export. It is the tasting of familiar products at their point of origin (before they are graded, classified, prinked up, and imprisoned in bottles, tins, jars, and packets) that makes them memorable; forever changes their aspect.

By chance, saffron is another commodity that has acquired a new dimension. It was somewhere on the way up to Córdoba that we saw the first purple patches of autumn-flowering saffron crocuses in bloom. On our return we called on Mercedes, the second village girl who works at La Alfarella, to tell her that we were back. Her father was preparing saffron—picking the orange stigmas one by one from the iridescent mauve flowers heaped up in a shoe box by his side and spreading them carefully on a piece of brown paper to dry. The heap of discarded crocus petals made a splash of intense and pure colour, shining like a pool of quicksilver in the cavernous shadows of the village living room. Every night, during the six-odd weeks that the season lasts, he prepares a boxful of flowers, so his wife told us. The bundle of saffron that she took out of a battered tin, wrapped in a square of paper, and gave to us must represent a fortnight's work. It is last year's vintage because there is not yet enough of the new season's batch to make a respectable offering. It appears to have lost nothing of its penetrating, quite violently acrid-sweet and pungent scent. It is certainly a handsome present that Mercedes' mother has given us, a rare present, straight from the source, and appropriate for us to take home to England for *Navidad*.

An even better one is the rain. At last, now it is real rain that is falling. The ancient have stopped work for the day, and most of the population of the village is gathered in the café. The day the rain comes the village votes its own fiesta day.

JOAN DIDION

(1934–)

Born in Sacramento, California, Joan Didion graduated from the University of California at Berkeley in 1956 and headed to New York City to take a job as a copywriter for *Vogue* magazine. She remained in New York for eight years, eventually becoming associate feature editor of the magazine and establishing herself as an acclaimed journalist and writer in her own right. In 1963 she published her first novel, *Run River*. The following year, she married writer John Gregory Dunne, with whom she had one daughter. When Didion and Dunne married, they returned to the West Coast, where Didion began a successful career as a columnist and freelance writer. Her work appeared in such periodicals as *Esquire*, the *Saturday Evening Post*, the *New Yorker*, the *New York Times Book Review*, and the *New York Review of Books*. As an essayist and journalist, Didion, along with writers like Tom Wolfe and Hunter S. Thompson, established herself as one of the shaping forces behind New Journalism, which combined techniques from fiction writing and reportage.

In addition to screenplays and novels, Didion has published over a dozen works of nonfiction. *Slouching towards Bethlehem*, a highly praised collection of essays about California originally written for the *Saturday Evening Post*, appeared in 1968. A second collection of essays, *The White Album*, followed in 1979. Didion went on to publish *Salvador* (1983), *Miami* (1987), *After Henry* (1992), *Political Fictions* (2001), and *Where I Was From* (2003). In 2006 these seven essay collections were published together as *We Tell Ourselves Stories in Order to Live*. Two memoirs, *The Year of Magical Thinking* (2005) and *Blue Nights* (2011), chronicle the devastating deaths of Didion's husband in 2003 and their daughter, Quintana, in 2005. In one of Didion's most oft-reprinted essays, "On Keeping a Notebook," Didion discusses the compulsion for writ-

ing in notebooks she has had since she was five years old. In 2017 she published excerpts from her notebooks as *South and West: From a Notebook*.

On Going Home

First appeared as "Going Home" on June 3, 1967, in *Saturday Evening Post* and reprinted in *Slouching Towards Bethlehem*, 1968. This version is from the fifth Noonday Press printing published in 1993, pp. 164–68.

→ concept of home

I am home for my daughter's first birthday. By "home" I do not mean the house in Los Angeles where my husband and I and the baby live, but the place where my family is, in the Central Valley of California. It is a vital although troublesome distinction. My husband likes my family but is uneasy in their house, because once there I fall into their ways, which are difficult, oblique, deliberately inarticulate, not my husband's ways. We live in dusty houses ("D-U-S-T," he once wrote with his finger on surfaces all over the house, but no one noticed it) filled with mementos quite without value to him (what could the Canton dessert plates mean to him? how could he have known about the assay scales, why should he care if he did know?), and we appear to talk exclusively about people we know who have been committed to mental hospitals, about people we know who have been booked on drunk-driving charges, and about property, particularly about property, land, price per acre and C-2 zoning and assessments and freeway access. My brother does not understand my husband's inability to perceive the advantage in the rather common real-estate transaction known as "saleleaseback," and my husband in turn does not understand why so many of the people he hears about in my father's house have recently been committed to mental hospitals or booked on drunk-driving charges. Nor does he understand that when we talk about sale-leasebacks and right-of-way condemnations we are talking in code about the things we like best, the yellow fields and the cottonwoods and the rivers rising and falling and the mountain roads closing when the heavy snow comes in. We miss each other's points, have another drink and regard the fire. My brother refers to my husband, in his presence, as "Joan's husband." Marriage is the classic betrayal.

Or perhaps it is not any more. Sometimes I think that those of us who are now in our thirties were born into the last generation to carry the burden of "home," to find in family life the source of all tension and drama. I had by all objective accounts a "normal" and a "happy" family situation, and yet I was al-

most thirty years old before I could talk to my family on the telephone without crying after I had hung up. We did not fight. Nothing was wrong. And yet some nameless anxiety colored the emotional charges between me and the place that I came from. The question of whether or not you could go home again was a very real part of the sentimental and largely literary baggage with which we left home in the fifties; I suspect that it is irrelevant to the children born of the fragmentation after World War II. A few weeks ago in a San Francisco bar I saw a pretty young girl on crystal take off her clothes and dance for the cash prize in an "amateur-topless" contest. There was no particular sense of moment about this, none of the effect of romantic degradation, of "dark journey," for which my generation strived so assiduously. What sense could that girl possibly make of, say, *Long Day's Journey into Night?* Who is beside the point?

That I am trapped in this particular irrelevancy is never more apparent to me than when I am home. Paralyzed by the neurotic lassitude engendered by meeting one's past at every turn, around every corner, inside every cupboard, I go aimlessly from room to room. I decide to meet it head-on and clean out a drawer, and I spread the contents on the bed. A bathing suit I wore the summer I was seventeen. A letter of rejection from *The Nation*, an aerial photograph of the site for a shopping center my father did not build in 1954. Three teacups hand-painted with cabbage roses and signed "E. M.," my grandmother's initials. There is no final solution for letters of rejection from *The Nation* and teacups hand-painted in 1900. Nor is there any answer to snapshots of one's grandfather as a young man on skis, surveying around Donner Pass in the year 1910. I smooth out the snapshot and look into his face, and do and do not see my own. I close the drawer, and have another cup of coffee with my mother. We get along very well, veterans of a guerrilla war we never understood.

Days pass. I see no one. I come to dread my husband's evening call, not only because he is full of news of what by now seems to me our remote life in Los Angeles, people he has seen, letters which require attention, but because he asks what I have been doing, suggests uneasily that I get out, drive to San Francisco or Berkeley. Instead I drive across the river to a family graveyard. It has been vandalized since my last visit and the monuments are broken, overturned in the dry grass. Because I once saw a rattlesnake in the grass I stay in the car and listen to a country-and-Western station. Later I drive with my father to a ranch he has in the foothills. The man who runs his cattle on it asks us to the roundup, a week from Sunday, and although I know that I will be in Los An-

geles I say, in the oblique way my family talks, that I will come. Once home I mention the broken monuments in the graveyard. My mother shrugs.

I go to visit my great-aunts. A few of them think now that I am my cousin, or their daughter who died young. We recall an anecdote about a relative last seen in 1948, and they ask if I still like living in New York City. I have lived in Los Angeles for three years, but I say that I do. The baby is offered a horehound drop, and I am slipped a dollar bill "to buy a treat." Questions trail off, answers are abandoned, the baby plays with the dust motes in a shaft of afternoon sun.

It is time for the baby's birthday party: a white cake, strawberry-marshmallow ice cream, a bottle of champagne saved from another party. In the evening, after she has gone to sleep, I kneel beside the crib and touch her face, where it is pressed against the slats, with mine. She is an open and trusting child, unprepared for and unaccustomed to the ambushes of family life, and perhaps it is just as well that I can offer her little of that life. I would like to give her more. I would like to promise her that she will grow up with a sense of her cousins and of rivers and of her great-grandmother's teacups, would like to pledge her a picnic on a river with fried chicken and her hair uncombed, would like to give her home for her birthday, but we live differently now and I can promise her nothing like that. I give her a xylophone and a sundress from Madeira, and promise to tell her a funny story.

ANNIE DILLARD

(1945–)

One of the most popular nature writers of the late twentieth century, Annie Doak Dillard grew up in Pittsburgh, Pennsylvania. Books and language and creative energy marked her youth, which she chronicles in her best-selling *An American Childhood* (1987). In 1964 Annie Dillard married Richard Dillard, her writing professor at Hollins College in Virginia. She graduated from Hollins in 1968 with bachelor's and master's degrees. In 1971 a near-fatal case of pneumonia forced Dillard to reexamine her life, and she took to the woods, as had Henry David Thoreau, the subject of her master's thesis. The year Dillard spent at Tinker Creek contemplating life and the natural world became the subject of *Pilgrim at Tinker Creek* (1974), a book that won a Pulitzer Prize. She and Richard Dillard divorced in 1975. From 1973 to 1975, she contributed columns to *Living Wilderness* magazine, and from 1973 to 1985, she worked as an editor for *Harper's Magazine*. In 1979, Dillard began teaching at Wesleyan University in Connecticut, where she remained for twenty-one years.

In 1980 Dillard married writer Gary Clevidence, with whom she had a daughter. When Dillard and Clevidence later divorced, she married writer and professor Robert D. Richardson. Although Dillard's first published book, *Tickets for a Prayer Wheel* (1974), was a collection of poems, she has made a name for herself primarily as an award-winning essayist and nonfiction writer. In 1978 she published *Holy the Firm*, a meditation on life and suffering inspired by a plane accident that badly burned a neighbor's child. Other nonfiction works followed, including *Living By Fiction* (1982), *Teaching a Stone to Talk: Expeditions and Encounters* (1982), *The Writing Life* (1989), and *For the Time Being* (1999). She has also published two novels and another book of poems. In 1988 Dillard served as guest editor of the annual *The Best Amer-*

ican Essays anthology, the series editor of which is Robert Atwan. In 2016 she published a collection of previously published and unpublished essays titled *The Abundance: Narrative Essays Old and New.* That same year, Dillard told an NPR interviewer that she had stopped writing, outside of emails and occasional entries in her journal. "I wrote for thirty-eight years at the top of my form, and I wanted to quit on a high note," she said.

Living Like Weasels

An early version of this essay appeared in the Summer 1974 issue of *Living Wilderness.* It was later published in *Teaching a Stone to Talk,* 1982. Dillard made revisions to the essay before reprinting it in *The Annie Dillard Reader* (New York: Harper Perennial), 1994. This version is from the latter edition.

A weasel is wild. Who knows what he thinks? He sleeps in his underground den, his tail draped over his nose. Sometimes he lives in his den for two days without leaving. Outside, he stalks rabbits, mice, muskrats, and birds, killing more bodies than he can eat warm, and often dragging the carcasses home. Obedient to instinct, he bites his prey at the neck, either splitting the jugular vein at the throat or crunching the brain at the base of the skull, and he does not let go. One naturalist refused to kill a weasel who was socketed into his hand deeply as a rattlesnake. The man could in no way pry the tiny weasel off, and he had to walk half a mile to water, the weasel dangling from his palm, and soak him off like a stubborn label.

And once, says Ernest Thompson Seton—once, a man shot an eagle out of the sky. He examined the eagle and found the dry skull of a weasel fixed by the jaws to his throat. The supposition is that the eagle had pounced on the weasel and the weasel swiveled and bit as instinct taught him, tooth to neck, and nearly won. I would like to have seen that eagle from the air a few weeks or months before he was shot: was the whole weasel still attached to his feathered throat, a fur pendant? Or did the eagle eat what he could reach, gutting the living weasel with his talons before his breast, bending his beak, cleaning the beautiful airborne bones?

I have been thinking about weasels because I saw one last week. I startled a weasel who startled me, and we exchanged a long glance.

Near my house in Virginia is a pond—Hollins Pond. It covers two acres of

bottomland near Tinker Creek with six inches of water and six thousand lily pads. There is a fifty-five mph highway at one end of the pond, and a nesting pair of wood ducks at the other. Under every bush is a muskrat hole or a beer can. The far end is an alternating series of fields and woods, fields and woods, threaded everywhere with motorcycle tracks—in whose bare clay wild turtles lay eggs.

One evening last week at sunset, I walked to the pond and sat on a downed log near the shore. I was watching the lily pads at my feet tremble and part over the thrusting path of a carp. A yellow warbler appeared to my right and flew behind me. It caught my eye; I swiveled around—and the next instant, inexplicably, I was looking down at a weasel, who was looking up at me.

Weasel! I had never seen one wild before. He was ten inches long, thin as a curve, a muscled ribbon, brown as fruitwood, soft-furred, alert. His face was fierce, small and pointed as a lizard's; he would have made a good arrowhead. There was just a dot of chin, maybe two brown hairs' worth, and then the pure white fur began that spread down his underside. He had two black eyes I did not see, any more than you see a window.

The weasel was stunned into stillness as he was emerging from beneath an enormous shaggy wild-rose bush four feet away. I was stunned into stillness, twisted backward on the tree trunk. Our eyes locked, and someone threw away the key.

Our look was as if two lovers, or deadly enemies, met unexpectedly on an overgrown path when each had been thinking of something else: a clearing blow to the gut. It was also a bright blow to the brain, or a sudden beating of brains, with all the charge and intimate grate of rubbed balloons. It emptied our lungs. It felled the forest, moved the fields, and drained the pond; the world dismantled and tumbled into that black hole of eyes. If you and I looked at each other that way, our skulls would split and drop to our shoulders. But we don't. We keep our skulls.

He disappeared. This was only last week, and already I don't remember what shattered the enchantment. I think I blinked, I think I retrieved my brain from the weasel's brain, and tried to memorize what I was seeing, and the weasel felt the yank of separation, the careening splashdown into real life and the urgent current of instinct. He vanished under the wild rose. I waited motionless, my mind suddenly full of data and my spirit with pleadings, but he didn't return.

Please do not tell me about "approach-avoidance conflicts." I tell you I've

been in that weasel's brain for sixty seconds, and he was in mine. Brains are private places, muttering through unique and secret tapes—but the weasel and I both plugged into another tape simultaneously, for a sweet and shocking time. Can I help it if it was a blank?

What goes on in his brain the rest of the time? What does a weasel think about? He won't say. His journal is tracks in clay, a spray of feathers, mouse blood and bone: uncollected, unconnected, loose-leaf, and blown.

I would like to learn, or remember, how to live. I come to Hollins Pond not so much to learn how to live as, frankly, to forget about it. That is, I don't think I can learn from a wild animal how to live in particular—shall I suck warm blood, hold my tail high, walk with my footprints precisely over the prints of my hands?—but I might learn something of mindlessness, something of the purity of living in the physical senses and the dignity of living without bias or motive. The weasel lives in necessity and we live in choice, hating necessity and dying at the last ignobly in its talons. I would like to live as I should, as the weasel lives as he should. And I suspect that for me the way is like the weasel's: open to time and death painlessly, noticing everything, remembering nothing, choosing the given with a fierce and pointed will.

I missed my chance. I should have gone for the throat. I should have lunged for that streak of white under the weasel's chin and held on, held on through mud and into the wild rose, held on for a dearer life. We could live under the wild rose wild as weasels, mute and uncomprehending. I could very calmly go wild. I could live two days in the den, curled, leaning on mouse fur, sniffing bird bones, blinking, licking, breathing musk, my hair tangled in the roots of grasses. Down is a good place to go, where the mind is single. Down is out, out of your ever-loving mind and back to your careless senses. I remember muteness as a prolonged and giddy fast, where every moment is a feast of utterance received. Time and events are merely poured, unremarked, and ingested directly, like blood pulsed into my gut through a jugular vein. Could two live that way? Could two live under the wild rose, and explore by the pond, so that the smooth mind of each is as everywhere present to the other, and as received and as unchallenged, as falling snow?

We could, you know. We can live any way we want. People take vows of poverty, chastity, and obedience—even of silence—by choice. The thing is to stalk your calling in a certain skilled and supple way, to locate the most tender and live spot and plug into that pulse. This is yielding, not fighting. A weasel

doesn't "attack" anything; a weasel lives as he's meant to, yielding at every moment to the perfect freedom of single necessity.

I think it would be well, and proper, and obedient, and pure, to grasp your one necessity and not let it go, to dangle from it limp wherever it takes you. Then even death, where you're going no matter how you live, cannot you part. Seize it and let it seize you up aloft even, till your eyes burn out and drop; let your musky flesh fall off in shreds, and let your very bones unhinge and scatter, loosened over fields, over fields and woods, lightly, thoughtless, from any height at all, from as high as eagles.

SUSAN SONTAG

(1933– 2004)

Born in New York City, Susan Sontag graduated in 1951 from the University of Chicago, where she had enrolled at the age of sixteen, and later received master's degrees in English and philosophy from Harvard University. Her most recognized works on contemporary and cultural aesthetics unite these fields of study. In addition to numerous works of nonfiction, Sontag published novels and plays. However, it is for her often controversial and divisive critical essays that she is best known. In 1950 Sontag had married Philip Rieff, with whom she had one son. Five years after divorcing Rieff in 1958, she published her first book, a novel titled *The Benefactor*. Sontag subsequently released *Against Interpretation, and Other Essays* (1966), the first of several groundbreaking nonfiction collections. In the mid-1970s, Sontag learned she had cancer. That diagnosis resulted in an important book, *Illness as Metaphor* (1978). During that same period, she published *On Photography* (1977), another one of her better-known works.

In 2000 Sontag won the National Book Award for her novel *In America*. In 2001 she published another collection of critical essays, *Where the Stress Falls*, in which she continues to address familiar subjects such as film, literature, photography, and theater. *Regarding the Pain of Others* (2003) was her last major work of nonfiction before her death in 2004 due to complications from leukemia. Since her death, Sontag's son David Rieff has edited a collection of her letters, *As Consciousness Is Harnessed to Flesh: Journals and Notebooks, 1964–1980* (2012), and two collections of essays, *Susan Sontag: Essays of the 1960s & 70s* (2013) and *Susan Sontag: Later Essays* (2017).

A Woman's Beauty:
Put-Down or Power Source?

Written in 1975. From *Essays of the 1960s & 70s*, edited by David
Rieff (New York: Library of America, 2013), pp. 803–5.

For the Greeks, beauty was a virtue: a kind of excellence. Persons then were
assumed to be what we now have to call—lamely, enviously—*whole* persons.
If it did occur to the Greeks to distinguish between a person's "inside" and
"outside," they still expected that inner beauty would be matched by beauty of
the other kind. The well-born young Athenians who gathered around Socrates
found it quite paradoxical that their hero was so intelligent, so brave, so honor-
able, so seductive—and so ugly. One of Socrates' main pedagogical acts was to
be ugly—and teach those innocent, no doubt splendid-looking disciples of his
how full of paradoxes life really was.

They may have resisted Socrates' lesson. We do not. Several thousand years
later, we are more wary of the enchantments of beauty. Being beautiful no lon-
ger speaks, presumptively, for the worth of a whole person. We not only split
off—with the greatest facility—the "inside" (character, intellect) from the
"outside" (looks); but we are actually surprised when someone who is beauti-
ful is also intelligent, talented, good.

It was principally the influence of Christianity that deprived beauty of the
central place it had in classical ideals of human excellence. By limited excel-
lence (*virtus* in Latin) to *moral* virtue only, Christianity set beauty adrift—as
an alienated, arbitrary, superficial enchantment. And beauty has continued to
lose prestige. For close to two centuries it has become a convention to attribute
beauty to only one of the two sexes: the sex which, however Fair, is always Sec-
ond. Associating beauty with women has put beauty even further on the de-
fensive, morally.

A beautiful woman, we say in English. But a handsome man. "Handsome"
is the masculine equivalent of—and refusal of—a compliment which has ac-
cumulated certain demeaning overtones, by being reserved for women only.
That one can call a man "beautiful" in French and in Italian suggests that
Catholic countries—unlike those countries shaped by the Protestant version
of Christianity—still retain some vestiges of the pagan admiration for beauty.
But the difference, if one exists, is of degree only. In every modern country that

is Christian or post-Christian, women *are* the beautiful sex—to the detriment of the notion of beauty as well as of women.

To be called beautiful is thought to name something essential to women's character and concerns. (In contrast to men—whose essence is to be strong, or effective, or competent.) It does not take someone in the throes of advanced feminist awareness to perceive that the way women are taught to be involved with beauty encourages narcissism, reinforces dependence and immaturity. Everybody (women and men) knows that. For it is "everybody," a whole society, that has identified being feminine with caring about how one *looks*. (In contrast to being masculine—which is identified with caring about what one *is* and *does* and only secondarily, if at all, about how one looks.) Given these stereotypes, it is no wonder that beauty enjoys, at best, a rather mixed reputation.

It is not, of course, the desire to be beautiful that is wrong but the obligation to be—or to try. What is accepted by most women as a flattering idealization of their sex is a way of making women feel inferior to what they actually are—or normally grow to be. For the ideal of beauty is administered as a form of self-oppression. Women are taught to see their bodies in *parts*, and to evaluate each part separately. Breasts, feet, hips, waistline, neck, eyes, nose, complexion, hair, and so on—each in turn is submitted to an anxious, fretful, often despairing scrutiny. Even if some pass muster, some will always be found wanting. Nothing less than perfection will do.

In men, good looks is a whole, something taken in at a glance. It does not need to be confirmed by giving measurements of different regions of the body, nobody encourages a man to dissect his appearance, feature by feature. As for perfection, that is considered trivial—almost unmanly. Indeed, in the ideally good-looking man a small imperfection or blemish is considered positively desirable. According to one movie critic (a woman) who is a declared Robert Redford fan, it is having that cluster of skin-colored moles on one cheek that saves Redford from being merely a "pretty face." Think of the depreciation of women—as well as of beauty—that is implied in that judgment.

"The privileges of beauty are immense," said Cocteau. To be sure, beauty is a form of power. And deservedly so. What is lamentable is that it is the only form of power that most women are encouraged to seek. This power is always conceived in relation to men; it is not the power to do but the power to attract. It is a power that negates itself. For this power is not one that can be chosen freely—at least, not by women—or renounced without social censure.

To preen, for a woman, can never be just a pleasure. It is also a duty. It is her

work. If a woman does real work—and even if she has clambered up to a leading position in politics, law, medicine, business, or whatever—she is always under pressure to confess that she still works at being attractive. But in so far as she is keeping up as one of the Fair Sex, she brings under suspicion her very capacity to be objective, professional, authoritative, thoughtful. Damned if they do—women are. And damned if they don't.

One could hardly ask for more important evidence of the dangers of considering persons as split between what is "inside" and what is "outside" than that interminable half-comic half-tragic tale, the oppression of women. How easy it is to start off by defining women as caretakers of their surfaces, and then to disparage them (or find them adorable) for being "superficial." It is a crude trap, and it has worked for too long. But to get out of the trap requires that women get some critical distance from that excellence and privilege which is beauty, enough distance to see how much beauty itself has been abridged in order to prop up the mythology of the "feminine." There should be a way of saving beauty *from* women—and *for* them.

GRETEL EHRLICH

(1946–)

Born on a horse ranch in California, Gretel Ehrlich attended Bennington College in Vermont and the University of California at Los Angeles. Her first work was *Geode/Rock Body*, a volume of poems published in 1970. After the 1978 death of a coworker and lover, Ehrlich settled in Wyoming, where she had been filming a documentary. She grieved and wrote for the next several years, producing the critically acclaimed collection of essays *The Solace of Open Spaces* (1985), her first work of nonfiction. A second collection of essays, *Islands, the Universe, Home*, appeared in 1991. That same year, Ehrlich was struck by lightning while on her ranch. She spent the next few years recovering from the debilitating accident, which she chronicles in *A Match to the Heart* (1994). Most of her subsequent nonfiction publications concern her travels. Ehrlich's trip to China in 1993 resulted in *Questions of Heaven: The Chinese Journey of an American Buddhist* (1997). Her 1994 journey to Greenland produced *This Cold Heaven: Seven Seasons in Greenland* (2001). Ehrlich's additional nonfiction books include the essay collection *The Future of Ice: A Journey to Cold* (2004), as well as *In the Empire of Ice: Encounters in a Changing Landscape* (2010) and *Facing the Wave: A Journey in the Wake of the Tsunami* (2013).

The Solace of Open Spaces

First appeared as "Wyoming: The Solace of Open Spaces" in the May 1981 issue of *Atlantic Monthly* and reprinted in *The Solace of Open Spaces*, 1985. This version is from *The Solace of Open Spaces* (New York: Penguin Books, 1986), pp. 1–15.

It's May and I've just awakened from a nap, curled against sagebrush the way my dog taught me to sleep—sheltered from wind. A front is pulling the huge sky over me, and from the dark a hailstone has hit me on the head. I'm trailing a band of two thousand sheep across a stretch of Wyoming badlands, a fifty-mile trip that takes five days because sheep shade up in hot sun and won't budge until it's cool. Bunched together now, and excited into a run by the storm, they drift across dry land, tumbling into draws like water and surge out again onto the rugged, choppy plateaus that are the building blocks of this state.

The name Wyoming comes from an Indian word meaning "at the great plains," but the plains are really valleys, great arid valleys, sixteen hundred square miles, with the horizon bending up on all sides into mountain ranges. This gives the vastness a sheltering look.

Winter lasts six months here. Prevailing winds spill snowdrifts to the east, and new storms from the northwest replenish them. This white bulk is sometimes dizzying, even nauseating, to look at. At twenty, thirty, and forty degrees below zero, not only does your car not work, but neither do your mind and body. The landscape hardens into a dungeon of space. During the winter, while I was riding to find a new calf, my jeans froze to the saddle, and in the silence that such cold creates I felt like the first person on earth, or the last.

Today the sun is out—only a few clouds billowing. In the east, where the sheep have started off without me, the bench-land tilts up in a series of eroded red-earthed mesas, planed flat on top by a million years of water; behind them, a bold line of muscular scarps rears up ten thousand feet to become the Big Horn Mountains. A tidal pattern is engraved into the ground, as if left by the sea that once covered this state. Canyons curve down like galaxies to meet the oncoming rush of flat land.

To live and work in this kind of open country, with its hundred-mile views, is to lose the distinction between background and foreground. When I asked an older ranch hand to describe Wyoming's openness, he said, "It's all a bunch of nothing—wind and rattlesnakes—and so much of it you can't tell where you're going or where you've been and it don't make much difference." John,

a sheepman I know, is tall and handsome and has an explosive temperament. He has a perfect intuition about people and sheep. They call him "Highpockets," because he's so long-legged; his graceful stride matches the distances he has to cover. He says, "Open space hasn't affected me at all. It's all the people moving in on it." The huge ranch he was born on takes up much of one county and spreads into another state; to put 100,000 miles on his pickup in three years and never leave home is not unusual. A friend of mine has an aunt who ranched on Powder River and didn't go off her place for eleven years. When her husband died, she quickly moved to town, bought a car, and drove around the States to see what she'd been missing.

Most people tell me they've simply driven through Wyoming, as if there were nothing to stop for. Or else they've skied in Jackson Hole, a place Wyomingites acknowledge uncomfortably because its green beauty and chic affluence are mismatched with the rest of the state. Most of Wyoming has a "lean-to" look. Instead of big, roomy barns and Victorian houses, there are dugouts, low sheds, log cabins, sheep camps, and fence lines that look like driftwood blown haphazardly into place. People here still feel pride because they live in such a harsh place, part of the glamorous cowboy past, and they are determined not to be the victims of a mining-dominated future.

Most characteristic of the state's landscape is what a developer euphemistically describes as "indigenous growth right up to your front door"—a reference to waterless stands of salt sage, snakes, jack rabbits, deerflies, red dust, a brief respite of wildflowers, dry washes, and no trees. In the Great Plains the vistas look like music, like Kyries of grass, but Wyoming seems to be the doing of a mad architect—tumbled and twisted, ribboned with faded, deathbed colors, thrust up and pulled down as if the place had been startled out of a deep sleep and thrown into a pure light.

I came here four years ago. I had not planned to stay, but I couldn't make myself leave. John, the sheepman, put me to work immediately. It was spring, and shearing time. For fourteen days of fourteen hours each, we moved thousands of sheep through sorting corrals to be sheared, branded, and deloused. I suspect that my original motive for coming here was to "lose myself" in new and unpopulated territory. Instead of producing the numbness I thought I wanted, life on the sheep ranch woke me up. The vitality of the people I was working with flushed out what had become a hallucinatory rawness inside me. I threw away my clothes and bought new ones; I cut my hair. The arid country was a clean slate. Its absolute indifference steadied me.

Sagebrush covers 58,000 square miles of Wyoming. The biggest city has a population of fifty thousand, and there are only five settlements that could be called cities in the whole state. The rest are towns, scattered across the expanse with as much as sixty miles between them, their populations two thousand, fifty, or ten. They are fugitive-looking, perched on a barren, windblown bench, or tagged onto a river or a railroad, or laid out straight in a farming valley with implement stores and a block-long Mormon church. In the eastern part of the state, which slides down into the Great Plains, the new mining settlements are boomtowns, trailer cities, metal knots on flat land.

Despite the desolate look, there's a coziness to living in this state. There are so few people (only 470,000) that ranchers who buy and sell cattle know one another statewide; the kids who choose to go to college usually go to the state's one university, in Laramie; hired hands work their way around Wyoming in a lifetime of hirings and firings. And despite the physical separation, people stay in touch, often driving two or three hours to another ranch for dinner.

Seventy-five years ago, when travel was by buckboard or horseback, cowboys who were temporarily out of work rode the grub line—drifting from ranch to ranch, mending fences or milking cows, and receiving in exchange a bed and meals. Gossip and messages traveled this slow circuit with them, creating an intimacy between ranchers who were three and four weeks' ride apart. One old-time couple I know, whose turn-of-the-century homestead was used by an outlaw gang as a relay station for stolen horses, recall that if you were traveling, desperado or not, any lighted ranch house was a welcome sign. Even now, for someone who lives in a remote spot, arriving at a ranch or coming to town for supplies is cause for celebration. To emerge from isolation can be disorienting. Everything looks bright, new, vivid. After I had been herding sheep for only three days, the sound of the camp tender's pickup flustered me. Longing for human company, I felt a foolish grin take over my face; yet I had to resist an urgent temptation to run and hide.

Things happen suddenly in Wyoming, the change of seasons and weather; for people, the violent swings in and out of isolation. But good-naturedness is concomitant with severity. Friendliness is a tradition. Strangers passing on the road wave hello. A common sight is two pickups stopped side by side far out on a range, on a dirt track winding through the sage. The drivers will share a cigarette, uncap their thermos bottles, and pass a battered cup, steaming with coffee, between windows. These meetings summon up the details of several generations, because, in Wyoming, private histories are largely public knowledge.

Because ranch work is a physical and, these days, economic strain, being "at home on the range" is a matter of vigor, self-reliance, and common sense. A person's life is not a series of dramatic events for which he or she is applauded or exiled but a slow accumulation of days, seasons, years, fleshed out by the generational weight of one's family and anchored by a land-bound sense of place.

In most parts of Wyoming, the human population is visibly outnumbered by the animal. Not far from my town of fifty, I rode into a narrow valley and startled a herd of two hundred elk. Eagles look like small people as they eat car-killed deer by the road. Antelope, moving in small, graceful bands, travel at sixty miles an hour, their mouths open as if drinking in the space.

The solitude in which westerners live makes them quiet. They telegraph thoughts and feelings by the way they tilt their heads and listen; pulling their Stetsons into a steep dive over their eyes, or pigeon-toeing one boot over the other, they lean against a fence with a fat wedge of Copenhagen beneath their lower lips and take in the whole scene. These detached looks of quiet amusement are sometimes cynical, but they can also come from a dry-eyed humility as lucid as the air is clear.

Conversation goes on in what sounds like a private code; a few phrases imply a complex of meanings. Asking directions, you get a curious list of details. While trailing sheep I was told to "ride up to that kinda upturned rock, follow the pink wash, turn left at the dump, and then you'll see the water hole." One friend told his wife on roundup to "turn at the salt lick and the dead cow," which turned out to be a scattering of bones and no salt lick at all.

Sentence structure is shortened to the skin and bones of a thought. Descriptive words are dropped, even verbs; a cowboy looking over a corral full of horses will say to a wrangler, "Which one needs rode?" People hold back their thoughts in what seems to be a dumbfounded silence, then erupt with an excoriating perceptive remark. Language, so compressed, becomes metaphorical. A rancher ended a relationship with one remark: "You're a bad check," meaning bouncing in and out was intolerable, and even coming back would be no good.

What's behind this laconic style is shyness. There is no vocabulary for the subject of feelings. It's not a hangdog shyness, or anything coy—always there's a robust spirit in evidence behind the restraint, as if the earth-dredging wind that pulls across Wyoming had carried its people's voices away but everything else in them had shouldered confidently into the breeze.

I've spent hours riding to sheep camp at dawn in a pickup when nothing

was said; eaten meals in the cookhouse when the only words spoken were a mumbled "Thank you, ma'am" at the end of dinner. The silence is profound. Instead of talking we seem to share one eye. Keenly observed, the world is transformed. The landscape is engorged with detail, every movement on it chillingly sharp. The air between people is charged. Days unfold, bathed in their own music. Nights become hallucinatory; dreams, prescient.

Spring weather is capricious and mean. It snows, then blisters with heat. There have been tornadoes. They lay their elephant trunks out in the sage until they find houses, then slurp everything up and leave. I've noticed that melting snowbanks hiss and rot, viperous, then drip into calm pools where ducklings hatch and livestock, being trailed to summer range, drink. With the ice cover gone, rivers churn a milkshake brown, taking culverts and small bridges with them. Water in such an arid place (the average annual rainfall where I live is less than eight inches) is like blood. It festoons drab land with green veins; a line of cottonwoods following a stream; a strip of alfalfa; and, on ditch banks, wild asparagus growing.

I've moved to a small cattle ranch owned by friends. It's at the foot of the Big Horn Mountains. A few weeks ago, I helped them deliver a calf who was stuck halfway out of his mother's body. By the time he was freed, we could see a heartbeat, but he was straining against a swollen tongue for air. Mary and I held him upside down by his back feet, while Stan, on his hands and knees in the blood, gave the calf mouth-to-mouth resuscitation. I have a vague memory of being pneumonia-choked as a child, my mother giving me her air, which may account for my romance with this windswept state.

If anything is endemic to Wyoming, it is wind. This big room of space is swept out daily, leaving a bone yard of fossils, agates, and carcasses in every stage of decay. Though it was water that initially shaped the state, wind is the meticulous gardener, raising dust and pruning the sage.

I try to imagine a world in which I could ride my horse across uncharted land. There is no wilderness left; wildness, yes, but true wilderness has been gone on this continent since the time of Lewis and Clark's overland journey.

Two hundred years ago, the Crow, Shoshone, Arapaho, Cheyenne, and Sioux roamed the intermountain West, orchestrating their movements according to hunger, season, and warfare. Once they acquired horses, they traversed the spines of all the big Wyoming ranges—the Absarokas, the Wind

Rivers, the Tetons, the Big Horns—and wintered on the unprotected plains that fan out from them. Space was life. The world was their home.

What was life-giving to Native Americans was often nightmarish to sod-busters who had arrived encumbered with families and ethnic pasts to be transplanted in nearly uninhabitable land. The great distances, the shortage of water and trees, and the loneliness created unexpected hardships for them. In her book *O Pioneers!*, Willa Cather gives a settler's version of the bleak landscape:

> The little town behind them had vanished as if it had never been, had fallen behind the swell of the prairie, and the stern frozen country received them into its bosom. The homesteads were few and far apart; here and there a windmill gaunt against the sky, a sod house crouching in a hollow.

The emptiness of the West was for others a geography of possibility. Men and women who amassed great chunks of land and struggled to preserve unfenced empires were, despite their self-serving motives, unwitting geographers. They understood the lay of the land. But by the 1850s the Oregon and Mormon trails sported bumper-to-bumper traffic. Wealthy landowners, many of them aristocratic absentee landlords, known as remittance men because they were paid to come West and get out of their families' hair, overstocked the range with more than a million head of cattle. By 1885 the feed and water were desperately short, and the winter of 1886 laid out the gaunt bodies of dead animals so closely together that when the thaw came, one rancher from Kaycee claimed to have walked on cowhide all the way to Crazy Woman Creek, twenty miles away.

Territorial Wyoming was a boy's world. The land was generous with everything but water. At first there was room enough, food enough, for everyone. And, as with all beginnings, an expansive mood set in. The young cowboys, drifters, shopkeepers, schoolteachers, were heroic, lawless, generous, rowdy, and tenacious. The individualism and optimism generated during those times have endured.

John Tisdale rode north with the trail herds from Texas. He was a college-educated man with enough money to buy a small outfit near the Powder River. While driving home from the town of Buffalo with a buckboard full of Christmas toys for his family and a winter's supply of food, he was shot in the back by an agent of the cattle barons who resented the encroachment of small-time stockmen like him. The wealthy cattlemen tried to control all the public graz-

ing land by restricting membership in the Wyoming Stock Growers Association, as if it were a country club. They ostracized from roundups and brandings cowboys and ranchers who were not members, then denounced them as rustlers. Tisdale's death, the second such cold-blooded murder, kicked off the Johnson County cattle war, which was no simple good-guy-bad-guy shoot-out but a complicated class struggle between landed gentry and less affluent settlers—a shocking reminder that the West was not an egalitarian sanctuary after all.

Fencing ultimately enforced boundaries, but barbed wire abrogated space. It was stretched across the beautiful valleys, into the mountains, over desert badlands, through buffalo grass. The "anything is possible" fever—the lure of any new place—was constricted. The integrity of the land as a geographical body, and the freedom to ride anywhere on it, were lost.

I punched cows with a young man named Martin, who is the great-grandson of John Tisdale. His inheritance is not the open land that Tisdale knew and prematurely lost but a rage against restraint.

Wyoming tips down as you head northeast; the highest ground—the Laramie Plains—is on the Colorado border. Up where I live, the Big Horn River leaks into difficult, arid terrain. In the basin where it's dammed, sandhill cranes gather and, with delicate legwork, slice through the stilled water. I was driving by with a rancher one morning when he commented that cranes are "old-fashioned." When I asked why, he said, "Because they mate for life." Then he looked at me with a twinkle in his eyes, as if to say he really did believe in such things but also understood why we break our own rules.

In all this open space, values crystalize quickly. People are strong on scruples but tenderhearted about quirky behavior. A friend and I found one ranch hand, who's "not quite right in the head," sitting in front of the badly decayed carcass of a cow, shaking his finger and saying, "Now, I don't want you to do this ever again!" When I asked what was wrong with him, I was told, "He's goofier than hell, just like the rest of us." Perhaps because the West is historically new, conventional morality is still felt to be less important than rock-bottom truths. Though there's always a lot of teasing and sparring, people are blunt with one another, sometimes even cruel, believing honesty is stronger medicine than sympathy, which may console but often conceals.

The formality that goes hand in hand with the rowdiness is known as the Western Code. It's a list of practical do's and don'ts, faithfully observed. A friend, Cliff, who runs a trap-line in the winter, cut off half his foot while

chopping a hole in the ice. Alone, he dragged himself to his pickup and headed for town, stopping to open the ranch gate as he left, and getting out to close it again, thus losing, in his observance of rules, precious time and blood. Later, he commented, "How would it look, them having to come to the hospital to tell me their cows had gotten out?"

Accustomed to emergencies, my friends doctor each other from the vet's bag with relish. When one old-timer suffered a heart attack in hunting camp, his partner quickly stirred up a brew of red horse liniment and hot water and made the half-conscious victim drink it, then tied him onto a horse and led him twenty miles to town. He regained consciousness and lived.

The roominess of the state has affected political attitudes as well. Ranchers keep up with world politics and the convulsions of the economy but are basically isolationists. Being used to running their own small empires of land and livestock, they're suspicious of big government. It's a "don't fence me in" holdover from a century ago. They still want the elbow room their grandfathers had, so they're strongly conservative, but with a populist twist.

Summer is the season when we get our "cowboy tans"—on the lower parts of our faces and on three fourths of our arms. Excessive heat, in the nineties and higher, sends us outside with the mosquitoes. In winter we're tucked inside our houses, and the white wasteland outside appears to be expanding, but in summer all the greenery abridges space. Summer is a go-ahead season. Every living thing is off the block and in the race: battalions of bugs in flight and biting; bats swinging around my log cabin as if the bases were loaded and someone had hit a home run. Some of summer's high-speed growth is ominous: larkspur, death camas, and green greasewood can kill sheep—an ironic idea, dying in this desert from eating what is too verdant. With sixteen hours of daylight, farmers and ranchers irrigate feverishly. There are first, second, and third cuttings of hay, some crews averaging only four hours of sleep a night for weeks. And, like the cowboys who in summer ride the night rodeo circuit, nighthawks make daredevil dives at dusk with an eerie whirring sound like a plane going down on the shimmering horizon.

In the town where I live, they've had to board up the dance-hall windows because there have been so many fights. There's so little to do except work that people wind up in a state of idle agitation that becomes fatalistic, as if there were nothing to be done about all this untapped energy. So the dark side to the grandeur of these spaces is the small-mindedness that seals people in. Men become hermits; women go mad. Cabin fever explodes into suicides, or into

grudges and lifelong family feuds. Two sisters in my area inherited a ranch but found they couldn't get along. They fenced the place in half. When one's cows got out and mixed with the other's, the women went at each other with shovels. They ended up in the same hospital room but never spoke a word to each other for the rest of their lives.

After the brief lushness of summer, the sun moves south. The range grass is brown. Livestock is trailed back down from the mountains. Water holes begin to frost over at night. Last fall Martin asked me to accompany him on a pack trip. With five horses, we followed a river into the mountains behind the tiny Wyoming town of Meeteetse. Groves of aspen, red and orange, gave off a light that made us look toasted. Our hunting camp was so high that clouds skidded across our foreheads, then slowed to sail out across the warm valleys. Except for a bull moose who wandered into our camp and mistook our black gelding for a rival, we shot at nothing.

One of our evening entertainments was to watch the night sky. My dog, a dingo bred to herd sheep, also came on the trip. He is so used to the silence and empty skies that when an airplane flies over he always looks up and eyes the distant intruder quizzically. The sky, lately, seems to be much more crowded than it used to be. Satellites make their silent passes in the dark with great regularity. We counted eighteen in one hour's viewing. How odd to think that while they circumnavigated the planet, Martin and I had moved only six miles into our local wilderness and had seen no other human for the two weeks we stayed there.

At night, by moonlight, the land is whittled to slivers—a ridge, a river, a strip of grassland stretching to the mountains, then the huge sky. One morning a full moon was setting in the west just as the sun was rising. I felt precariously balanced between the two as I loped across a meadow. For a moment, I could believe that the stars, which were still visible, work like cooper's bands, holding together everything above Wyoming.

Space has a spiritual equivalent and can heal what is divided and burdensome in us. My grandchildren will probably use space shuttles for a honeymoon trip or to recover from heart attacks, but closer to home we might also learn how to carry space inside ourselves in the effortless way we carry our skins. Space represents sanity, not a life purified, dull, or "spaced out" but one that might accommodate intelligently any idea or situation.

From the clayey soil of northern Wyoming is mined bentonite, which is used as a filler in candy, gum, and lipstick. We Americans are great on fillers, as if what we have, what we are, is not enough. We have a cultural tendency toward denial, but, being affluent, we strangle ourselves with what we can buy. We have only to look at the houses we build to see how we build *against* space, the way we drink against pain and loneliness. We fill up space as if it were a pie shell, with things whose opacity further obstructs our ability to see what is already there.

JOYCE CAROL OATES

(1938–)

Born in Lockport, New York, Joyce Carol Oates attended Syracuse University as an undergraduate, writing a novel each semester while there. Her discipline and productivity during those years set the stage for an illustrious and prolific career as a writer. Oates has over one hundred publications to her name, mainly novels and short stories, but also poetry, nonfiction, and drama. One year after her graduation from Syracuse in 1960, she received a master's degree from the University of Wisconsin. In 1961 Oates also married Raymond Joseph Smith.

Oates taught at a number of schools before arriving at Princeton University in 1978. She is now a distinguished professor emeritus at Princeton, where she continues to teach creative writing. Oates's first novel, *With Shuddering Fall*, appeared in 1964. Several of her works have been Pulitzer Prize finalists: *The Wheel of Love and Other Stories* (1970); *Black Water* (1992); *What I Lived For* (1994); *Blonde* (2000); and *Lovely, Dark, Deep: Stories* (2014). Oates has also published several significant volumes of essays, including *Contraries: Essays* (1981), *The Profane Art* (1983), and *Where I've Been, and Where I'm Going: Essays, Reviews, and Prose* (1999).

Not only a writer of essays, Oates is also recognized as a critic and editor of the genre. In 1991 she served as guest editor of Robert Atwan's *The Best American Essays* series, and in 2000 she again teamed with Atwan to produce the massive anthology *The Best American Essays of the Century*. In 2008 Oates's husband, Raymond Smith, died suddenly, and in 2009 she married Charles Gross, a Princeton colleague. In 2011 she published *A Widow's Story*, a memoir about her marriage to Smith and the debilitating impact of his death. Another memoir, *The Lost Landscape*, followed in 2015.

Notes on Failure

First appeared in the Summer 1982 issue of the *Hudson Review*
and reprinted in *The Profane Art*, 1983. This version is from
The Profane Art (New York: Persea Books, 1985), pp. 106–20.

To Whom the Mornings stand for Nights,
What must the Midnights—be!

—EMILY DICKINSON

If writing quickens one's sense of life, like falling in love, like being precariously in love, it is not because one has any confidence in achieving *success*, but because one is most painfully and constantly made aware of *mortality*: the persistent question being, Is this the work I fail to complete, is this the "posthumous" work that can only make an appeal to pity . . . ?

The practicing writer, the writer-at-work, the writer immersed in his or her project, is not an entity at all, let alone a person, but a curious mélange of wildly varying states of mind, clustered toward what might be called the darker end of the spectrum: indecision, frustration, pain, dismay, despair, remorse, impatience, outright failure. To be honored in midstream for one's labor would be ideal, but impossible; to be honored after the fact is always too late, for by then another project has been begun, another concatenation of indefinable states. Perhaps one must contend with vaguely warring personalities, in some sort of sequential arrangement?—perhaps premonitions of failure are but the soul's wise economy, in not risking hubris?—it cannot matter, for, in any case, the writer, however battered a veteran, can't have any real faith, any absolute faith, in his stamina (let alone his theoretical "gift") to get him through the ordeal of *creating*, to the plateau of *creation*. One is frequently asked whether the process becomes easier, with the passage of time, and the reply is obvious: *Nothing gets easier with the passage of time, not even the passing of time.*

The artist, perhaps more than most people, inhabits failure, degrees of failure and accommodation and compromise; but the terms of his failure are generally secret. It seems reasonable to believe that failure may be a truth, or at any rate a negotiable fact, while success is a temporary illusion of some intoxicating sort, a bubble soon to be pricked, a flower whose petals will quickly drop. If despair is—as I believe it to be—as absurd a state of the soul as euphoria, who can protest that it feels more substantial, more reliable, less out of scale with

the human environment? When it was observed to T. S. Eliot that most critics are failed writers, Eliot replied: "But so are most writers."

Though most of us inhabit degrees of failure or the anticipation of it, very few persons are willing to acknowledge the fact, out of a vague but surely correct sense that it is not altogether American to do so. *Your standards are unreasonably high, you must be exaggerating, you must be of a naturally melancholy and saturnine temperament.* . . . From this pragmatic vantage point "success" itself is but a form of "failure," a compromise between what is desired and what is attained. One must be stoic, one must develop a sense of humor. And, after all, there is the example of William Faulkner, who considered himself a failed poet; Henry James returning to prose fiction after the conspicuous failure of his play-writing career; Ring Lardner writing his impeccable American prose because he despaired of writing sentimental popular songs; Hans Christian Andersen perfecting his fairy tales since his was clearly a failure in other genres—poetry, play writing, life. One has only to glance at *Chamber Music* to see why James Joyce specialized in prose.

Whoever battles with monsters had better see that it does not turn him into a monster. And if you gaze too long into an abyss—the abyss will gaze back into you. So Nietzsche cryptically warns us: and it is not implausible to surmise that he knew, so far as his own battles, his own monsters, and his own imminent abyss were concerned, much that lay before him: though he could not have guessed its attendant ironies, or the ignoble shallowness of the abyss. Neither does he suggest an alternative.

The specter of failure haunts us less than the specter of failing—the process, the activity, the absorbing delusionary stratagems. The battle lost, in retrospect, is, after all, a battle necessarily lost to time: and, won or lost, it belongs to another person. But the battle in the process of being lost, each gesture, each pulse beat . . . This is the true abyss of dread, the unspeakable predicament. *To Whom the Mornings stand for Nights, / What must the Midnights—be*!

But how graceful, how extraordinary these pitiless lines, written by Emily Dickinson some four years earlier, in 1862:

> The first Day's Night had come—
> And grateful that a thing
> So terrible—had been endured—
> I told my Soul to sing—
>
> She said her Strings were snapt—
> Her bow—to Atoms blown

And so to mend her—gave me work
Until another Morn—

And then—a Day as huge
As Yesterdays in pairs,
Unrolled its horror in my face—
Until it blocked my eyes—

My Brain—begun to laugh—
I mumbled—like a fool—
And tho' 'tis Years ago—that Day—
My Brain keeps giggling—still.

And Something's odd—within—
That person that I was—
And this One—do not feel the same—
Could it be Madness—this?

Here the poet communicates, in the most succinct and compelling imagery, the phenomenon of the ceaseless process of *creating*: the instruction by what one might call the ego that the Soul "sing," despite the nightmare of "Yesterdays in pairs"—the valiant effort of keeping language, forging language, though the conviction is overwhelming that "the person that I was— / And this One—do not feel the same." (For how, a scant poem later, *can* they be the same?) And again, in the same year:

The Brain, within its Groove
Runs evenly—and true—
But let a Splinter swerve—
'Twere easier for You—

To put a Current back—
When Floods have slit the Hills—
And scooped a Turnpike for Themselves—
And trodden out the Mills—

The Flood that is the source of creativity, and the source of self-oblivion: sweeping away, among other things, the very Soul that would sing. And is it possible to forgive Joseph Conrad for saying, in the midst of his slough of despair while writing *Nostromo*, surely one of the prodigious feats of the imagination in our time, that writing is but the "conversion of nervous force" into language?—so profoundly bleak an utterance that it must be true. For, after all,

as the busily productive Charles Gould remarks to his wife, a man must apply himself to *some* activity.

Even that self-proclaimed "teacher of athletes," that vehement rejector of "down-hearted doubters . . . / Frivolous, sullen, moping, angry, affected, dishearten'd, atheistical," that Bard of the American roadway who so wears us out with his yawp of barbaric optimism, and his ebullient energy, even the great Whitman himself confesses in "As I Ebb'd with the Ocean of Life," that things are often quite different, quite different indeed. When one is alone, walking at the edge of the ocean, at autumn, "held by this electric self out of the pride of which I utter poems"—

> O baffled, balk'd, bent to the very earth,
> Oppressed with myself that I have dared to open my mouth,
> Aware now that amid all that blab whose echoes recoil upon me I have not
> once had the least idea who or what I am,
> But that before all my arrogant poems the real Me stands yet untouch'd,
> untold, altogether unreach'd,
> Withdrawn far, mocking me with self-congratulatory signs and bows,
> With peals of distant ironical laughter at every word I have written,
> Pointing in silence to these songs, and then to the sand beneath.

Interesting to note that these lines were published in the same year, 1860, as such tirelessly exuberant and more "Whitmanesque" poems as "For You O Democracy," "Myself and Mine" ("Myself and mine gymnastic ever, / To stand the cold or heat, to take good aim with a gun, to sail a / boat, to manage horses, to beget superb children"), and "I Hear America Singing." More subdued and more eloquent is the short poem, "A Clear Midnight," of 1881, which allows us to overhear the poet in his solitude, the poet no longer in the blaze of noon on a public platform:

> This is thy hour O Soul, thy free flight into the wordless,
> Away from books, away from art, the day erased, the lesson done,
> Thee fully forth emerging, silent, gazing, pondering the themes thou lovest
> best,
> Night, sleep, death and the stars.

One feels distinctly honored, to have the privilege of such moments: to venture around behind the tapestry, to see the threads in their untidy knots, the loose ends hanging frayed.

Why certain individuals appear to devote their lives to the phenomenon of

interpreting experience in terms of structure, and of language, must remain a mystery. It is not an alternative to life, still less an escape from life, it *is* life: yet overlaid with a peculiar sort of luminosity, as if one were, and were not, fully inhabiting the present tense. Freud's supposition—which must have been his own secret compulsion, his sounding of his own depths—that the artist labors at his art to win fame, power, riches, and the love of women, hardly addresses itself to the fact that, such booty being won, the artist often intensifies his effort: and finds much of life, apart from that effort, unrewarding. Why, then, this instinct to interpret; to transpose flickering and transient thoughts into the relative permanence of language; to give oneself over to decades of obsessive labor, in the service of an elusive "transcendental" ideal, that, in any case, will surely be misunderstood or scarcely valued at all? Assuming that all art is metaphor, or metaphorical, what really *is* the motive for metaphor? Is there a motive? Or, in fact, metaphor? Can one say anything finally, with unqualified confidence, about any work of art—why it strikes a profound, irresistible, and occasionally life-altering response in some individuals, yet means very little to others? In this, the art of reading hardly differs from the art of writing, in that its most intense pleasures and pains must remain private, and cannot be communicated to others. Our secret affinities remain secret even to ourselves. . . . We fall in love with certain works of art, as we fall in love with certain individuals, for no very clear motive.

In 1955, in the final year of his life, as profusely honored as any writer in history, Thomas Mann wryly observed in a letter that he had always admired Hans Christian Andersen's fairy tale, "The Steadfast Tin Soldier." "Fundamentally," says Mann, "it is the symbol of my life." (And what is the "symbol" of Mann's life? Andersen's toy soldier is futilely in love with a pretty dancer, a paper cutout; his fate is to be cruelly, if casually, tossed into the fire by a child, and melted down to the shape "of a small tin heart.") Like most of Andersen's tales the story of the steadfast tin soldier is scarcely a children's story, though couched in the mock-simple language of childhood; and one can see why Thomas Mann felt such kinship with it, for it begins: "There were once five and twenty tin soldiers, all brothers, for they were the offspring of the same old tin spoon. Each man shouldered his gun, kept his eyes well to the front, and wore the smartest red and blue uniform imaginable. . . . All the soldiers were exactly alike with one exception, and he differed from the rest in having only one leg. For he was made last, and there was not quite enough tin left to finish

him. However, he stood just as well on his one leg as the others did on two. In fact he was the very one who became famous."

Is the artist secretly in love with failure? one might ask.

Is there something dangerous about "success," something finite and limited and, in a sense, historical: the passing over from *striving*, and *strife*, to *achievement*? One thinks again of Nietzsche, that most profound of psychologists, who tasted the poisonous euphoria of success, however brief, however unsatisfying: beware the danger in happiness! *Now everything I touch turns out to be wonderful. Now I love any fate that comes along. Who would like to be my fate?*

Yet it is perhaps not failure the writer loves, so much as the addictive nature of incompletion and risk. A work of art acquires, and then demands, its own singular "voice"; it insists upon its integrity; as Gide in his *Notebook* observed, the artist needs "a special world of which he alone has the key." That the fear of dying or becoming seriously ill in midstream is very real, cannot be doubted: and if there is an obvious contradiction here (one dreads completion; one dreads the possibility of a "posthumous" and therefore uncompleted work), that contradiction is very likely at the heart of the artistic enterprise. The writer carries himself as he would carry a precarious pyramid of eggs, because he is, in fact, a precarious pyramid of eggs, in danger of falling at any moment, and shattering on the floor in an ignoble mess. And he understands beforehand that no one, not even his most "sympathetic" fellow writers, will acknowledge his brilliant intentions, and see, for themselves, the great work he would surely have completed, had he lived.

An affinity for risk, danger, mystery, a certain derangement of the soul; a craving for distress, the pinching of the nerves, the not-yet-voiced; the predilection for insomnia; an impatience with past selves and past creations that must be hidden from one's admirers—why is the artist drawn to such extremes, why are we drawn along with him? Here, a forthright and passionate voice, from a source many would think unlikely:

> There are few of us who have not sometimes wakened before dawn, either after one of those dreamless nights that make us almost enamoured of death, or one of those nights of horror and misshapen joy, when through the chambers of the brain sweep phantoms more terrible than reality itself, and instinct with that vivid life that lurks in all grotesques, and that lends to Gothic art its enduring vitality. . . . Veil after veil of thin dusky gauze is lifted, and by degrees the forms and colors of things are restored to them, and we watch the dawn remaking the world in its antique pattern. The wan mirrors get back their mimic life. . . .

Nothing seems to us changed. Out of the unreal shadows of the night comes back the real life that we had known. We have to resume it where we had left off, and there steals over us a terrible sense of the necessity for the continuance of energy in the same wearisome round of stereotyped habits, or a wild longing, it may be, that our eyelids might open some morning upon a world that had been refashioned anew in the darkness . . . a world in which the past would have little or no place, or survive, at any rate, in no conscious form of obligation and re-gret. . . . It was the creation of such worlds as these that seemed to Dorian Gray to be the true object . . . of life.

That this unmistakably heartfelt observation should be bracketed, in Wil-de's great novel, by chapters of near-numbing cleverness, and moralizing of a Bunyanesque nature, does not detract from its peculiar poignancy: for here, one feels, Wilde is speaking without artifice or posturing; and that Dorian Gray, freed for the moment from his somewhat mechanical role in the alle-gory Wilde has assembled, to explain himself to himself, has in fact acquired the transparency—the invisibility—of a mask of our own.

Will one fail is a question less apposite, finally, then *can one succeed?*—granted the psychic predicament, the addiction to a worldly skepticism that contrasts (perhaps comically) with the artist's private system of customs, hab-its, and superstitious routines that constitutes his "working life." (A study should really be done of artists' private systems, that cluster of stratagems, both voluntary and involuntary, that make daily life navigable. Here we would find, I think, a bizarre and ingenious assortment of Great Religions in embryo—a system of checks and balances, rewards, and taboos, fastidious as a work of art. *What is your work schedule*, one writer asks another, never *What are the great themes of your books?*—for the question is, of course, in code, and really implies *Are you perhaps crazier than I?—and will you elaborate?*)

How to attain a destination is always more intriguing (involving, as it does, both ingenuity and labor) than *what* the destination finally is. It has always been the tedious argument of moralists that artists appear to value their art above what is called "morality"; but is not the artist by definition an individ-ual who has grown to care more about the interior dimensions of his art than about its public aspect, simply because—can this be doubted?—he spends all his waking hours, and many of his sleeping hours, in that landscape?

The curious blend of the visionary and the pragmatic that characterizes most novelists is exemplified by Joyce's attitude toward the various styles of *Ulysses*, those remarkable exuberant self-parodying voices: "From my point of view it

hardly matters whether the technique is 'veracious' or not; it has served me as a bridge over which to march my eighteen episodes, and, once I have got my troops across, the opposing forces can, for all I care, blow the bridge sky-high." And though critics generally focus upon the ingenious relationship of *Ulysses* to the *Odyssey*, the classical structure was one Joyce chose with a certain degree of arbitrariness, as he might have chosen another—*Peer Gynt*, for instance; or *Faust*. That the writer labors to discover the secret of his work is perhaps the writer's most baffling predicament, about which he cannot easily speak: for he cannot write the fiction without becoming, beforehand, the person who *must* write that fiction: and he cannot be that person, without first subordinating himself to the process, the labor, of creating that fiction. . . . Which is why one becomes addicted to insomnia itself, to a perpetual sense of things about to fail, the pyramid of eggs about to tumble, the house of cards about to be blown away. Deadpan, Stanislaus Joyce noted in his diary, in 1907: "Jim says that . . . when he writes, his mind is as nearly normal as possible."

But my position, as elaborated, is, after all, only the reverse of the tapestry.

Let us reconsider. Isn't there, perhaps, a very literal advantage, now and then, to failure? —a way of turning even the most melancholy of experiences inside out, until they resemble experiences of *value*, of *growth*, of *profound significance*? That Henry James so spectacularly failed as a playwright had at least two consequences: it contributed to a nervous collapse; and it diverted him from a career for which he was unsuited (not because he had a too grandly "literary" and ambitious conception of the theater but because, in fact, his theatrical aspirations were so conventional, so trivial), thereby allowing him the spaciousness of relative failure. The public catastrophe of *Guy Domville* behind him, James wrote in his notebook: "I take up my *own* old pen again—the pen of all my old unforgettable efforts and sacred struggles. To myself—today—I need say no more. Large and full and high the future still opens. It is now indeed that I may do the work of my life. And I will." *What Maisie Knew, The Awkward Age, The Ambassadors, The Wings of the Dove, The Golden Bowl*—the work of James's life. Which success in the London theater would have supplanted, or would have made unnecessary.

Alice James, the younger sister of William and Henry, was born into a family in which, by Henry's admission, "girls seem scarcely to have had a chance." As her brilliant *Diary* acknowledges, Alice made a career of various kinds of failure: the failure to become an adult; the failure to become a "woman" in

conventional terms; the failure—which strikes us as magnificently stubborn—to survive. (When Alice discovered that she had cancer of the breast, at the age of forty-three, she wrote rhapsodically in her diary of her great good fortune: for now her long and questionable career of invalidism had its concrete, incontestable, deathly vindication.)

Alice lies on her couch forever. Alice, the "innocent" victim of fainting spells, convulsions, fits of hysteria, mysterious paralyzing pains, and such nineteenth-century female maladies as nervous hyperesthesia, spinal neurosis, cardiac complications, and rheumatic gout. Alice, the focus of a great deal of familial attention; yet the focus of no one's interest. Lying on her couch she does not matter in the public world, in the world of men, of history. She does not count; she is nothing. Yet the *Diary*, revealed to her brothers only after her death, exhibits a merciless eye, an unfailing accurate ear, a talent that rivals "Harry's" (that is, Henry's) for its astuteness, and far surpasses his for its satirical and sometimes cruel humor. Alice James's career-invalidism deprives her of everything; yet, paradoxically, of nothing. The triumph of the *Diary* is the triumph of a distinct literary voice, as valuable as the voice of Virginia Woolf's celebrated diaries.

> I think if I get into the habit of writing a bit about what happens, or rather what doesn't happen, I may lose a little of the sense of loneliness and isolation which abides with me. . . . Scribbling my notes and reading [in order to clarify] the density and shape the formless mass within. Life seems inconceivably rich.

Life seems inconceivably rich—the sudden exclamation of the writer, the artist, in defiance of external circumstances.

The invalid remains an invalid. She dies triumphantly young. When a nurse wished to commiserate with her about her predicament, Alice notes in her diary that destiny—any destiny—because it *is* destiny—is fascinating: thus pity is unnecessary. One is born not to suffer but to negotiate with suffering, to choose or invent forms to accommodate it.

Every commentator feels puritanically obliged to pass judgment on Alice. As if the *Diary* were not a document of literary worth; as if it doesn't surpass in literary and historical interest most of the publications of Alice's contemporaries, male or female. This "failure" to realize one's gifts may look like something very different from within. One must remember that, in the James family, "an interesting failure had more value than too-obvious success"—as it does to most observers.

In any case Alice James creates "Alice," a possibly fictitious person, a marvel-

ous unforgettable voice. It is Alice who sinks unprotesting into death; it is Alice who says: "I shall proclaim that anyone who spends her life as an appendage to five cushions and three shawls is justified in committing the sloppiest kind of suicide at a moment's notice."

In Cyril Connolly's elegiac "war-book" *The Unquiet Grave: A Word Cycle by Palinurus,* the shadowy doomed figure of Palinurus broods upon the melancholic but strengthening wisdom of the ages, as a means of "contemplating" (never has the force of that word been more justified), and eventually rejecting, his own suicide. Palinurus, the legendary pilot of Aeneas, becomes for the thirty-nine-year-old Connolly an image of his own ambivalence, which might be called "neurotic" and self-destructive, unless one recalls the specific historical context in which the idiosyncratic "word cycle" was written, between the autumn of 1942 and the autumn of 1943, in London. *The Unquiet Grave* is a journal in perpetual metamorphosis; a lyric assemblage of epigrams, reflections, paradoxes, and descriptive passages; a commonplace book in which the masters of European literature from Horace and Virgil to Goethe, Schopenhauer, Flaubert, and beyond, are employed, as voices in Palinurus's meditation. In "Lemprière," Palinurus suffered a fate that, in abbreviated form, would appear to cry out for retribution, as well as pity:

> Palinurus, a skillful pilot of the ship of Aeneas,
> fell into the sea in his sleep, was three days exposed
> to the tempests and waves of the sea, and at last came
> to the sea shore near Velia, where the cruel inhabitants
> of the place murdered him to obtain his clothes: his
> body was left unburied on the seashore.

Connolly's meditation upon the temptations of death takes the formal structure of an initiation, a descent into hell, a purification, a cure—for "the ghost of Palinurus must be appeased." Approaching forty, Connolly prepares to "heave his carcass of vanity, boredom, guilt and remorse into another decade." His marriage has failed; the France he has loved is cut off from him, as a consequence of the war; it may well be that the world as he has known it will not endure. He considers the rewards of opium-smoking, he broods upon the recent suicides of four friends, he surrenders his lost Eden and accommodates himself to a changed but evidently enduring world. The word cycle ends with an understated defense of the virtues of happiness, by way of a close analysis of Palinurus's complicity in his fate.

As a myth . . . with a valuable psychological interpretation, Palinurus clearly stands for a certain will-to-failure or repugnance-to-success, a desire to give up at the last moment, an urge toward loneliness, isolation, and obscurity. Palinurus, in spite of his great ability and his conspicuous public position, deserted his post in the moment of victory and opted for the unknown shore.

Connolly rejects his own predilection for failure and self-willed death only by this systematic immersion in "Palinurus's" desire for the unknown shore: *The Unquiet Grave* achieves its success as a unique work by way of its sympathy with failure.

Early failure, "success" in being published of so minimal a nature it might be termed failure, repeated frustrations, may have made James Joyce possible: these factors did not, at any rate, humble him.

Consider the example of his first attempt at a novel, *Stephen Hero*, a fragmented work that reads precisely like a "first novel"—ambitious, youthful, flawed with the energies and naïve insights of youth, altogether conventional in outline and style, but, one would say, "promising." (Though conspicuously less promising than D. H. Lawrence's first novel, *The White Peacock*.) Had Joyce found himself in a position to publish *Stephen Hero*, had his other publishing experiences been less disheartening, he would have used the material that constitutes *A Portrait of the Artist as a Young Man*; and that great novel would not have been written. As things evolved, Joyce retreated, and allowed himself ten years to write a masterpiece: and so he rewrote *Stephen Hero* totally, using the first draft as raw material upon which language makes a gloss. *Stephen Hero* presents characters and ideas, tells a story: *A Portrait of the Artist* is about language, *is* language, a portrait-in-progress of the creator, as he discovers the range and depth of his genius. The "soul in gestation" of Stephen Dedalus gains its individuality and its defiant strength as the novel proceeds; at the novel's conclusion it has even gained a kind of autonomy, wresting from the author a *first-person* voice, supplanting the novel's strategy of narration with Stephen's own journal. Out of unexceptional and perhaps even banal material Joyce created one of the most original works in our language. If the publication of *Dubliners* had been less catastrophic, however, and a clamor had arisen for the first novel by this "promising" young Irishman, one might imagine a version of *Stephen Hero* published the following year: for, if the verse of *Chamber Music* (Joyce's first book) is any measure, Joyce was surely not a competent critic of his own work at this time; and, in any case, as always, he needed

money. If *Stephen Hero* had been published, *Portrait* could not have been written; without *Portrait*, its conclusion in particular, it is difficult to imagine the genesis of *Ulysses* . . . So one speculates; so it seems likely, in retrospect. But James Joyce was protected by the unpopularity of his work. He enjoyed, as his brother Stanislaus observed, "that inflexibility firmly rooted in failure."

The possibilities are countless. Can one imagine a D. H. Lawrence whose great novel *The Rainbow* had enjoyed a routine popular fate, instead of arousing the most extraordinary sort of vituperation ("There is no form of viciousness, of suggestiveness, that is not reflected in these pages," said a reviewer for one publication; the novel, said another reviewer, "had no right to exist"); how then could *Women in Love*, fueled by Lawrence's rage and loathing, have been written? And what of the evangelical *Lady Chatterly's Lover*, in its several versions? In an alternative universe there is a William Faulkner whose poetry (variously, and ineptly, modeled on Swinburne, Eliot, and others) was "successful"; there is a Faulkner whose early, derivative novels gained him a substantial public and commercial success—imitation Hemingway in *Soldiers Pay*, imitation Huxley in *Mosquitoes*—with the consequence that Faulkner's own voice might never have developed. (For when Faulkner needed money—and he always needed money—he wrote as rapidly and as pragmatically as possible.) That his great, idiosyncratic, difficult novels (*The Sound and the Fury, As I Lay Dying, Light in August, Absalom, Absalom!*) held so little commercial promise allowed him the freedom, the spaciousness, one might even say the privacy, to experiment with language as radically as he wished: for it is the "inflexibility" of which Stanislaus Joyce spoke that genius most requires.

But the genius cannot know that he is a genius—not really: he has hopes, he has premonitions, he suffers raging paranoid doubts, but he can have, in the end, only himself for measurement. Success is distant and illusory, failure one's loyal companion, one's stimulus for imagining that the next book will be better, for, otherwise, why write? The impulse can be made to sound theoretical, and even philosophical, but it is, no doubt, as physical as our blood and marrow. *This insatiable desire to write something before I die, this ravaging sense of the shortness and feverishness of life make me cling . . . to my one anchor*—so Virginia Woolf, in her diary, speaks for us all.

ALICE WALKER

(1944–)

Alice Walker was born in Eatonville, Georgia, an African American tenant farming community. When she was eight years old, she was injured after one of her brothers accidentally shot her in the eye with a BB gun. By the time her parents managed to locate transportation to the doctor, Walker's sight in her right eye was gone, and she was left with a disfiguring scar that caused her to retreat into herself for many years. Despite her impoverished childhood, Walker won a scholarship to Spelman College, which she attended for two years before completing her degree at Sarah Lawrence College. Following her graduation, Walker returned to Mississippi, where she worked as an activist for civil rights. In 1967 she married civil rights attorney Melvyn Leventhal, and they had one child, Rebecca Walker, who would also become a writer. Alice Walker's first publication was a collection of poems, *Once: Poems* (1968), but it is her critically acclaimed fiction for which she is best known. Her third novel, *The Color Purple* (1982), won a Pulitzer Prize and inspired a blockbuster film released in 1985.

In addition to her poetry and fiction, Walker authored numerous successful and important volumes of essays. Many of these works embody her "womanist" perspective, a term she originated to define her woman-centered, multicultural approach to literature and writing. Walker's first collection of essays, *In Search of Our Mothers' Gardens: Womanist Prose*, appeared in 1983, and *Living by the Word: Selected Writings, 1973–1987* followed it in 1988. One of the African American "mothers," or literary ancestors, that Walker unearthed is Zora Neale Hurston. Along with scholar Robert Hemenway, Walker is credited with rescuing Hurston from literary neglect. In 1979 Walker edited *I Love Myself When I'm Laughing . . . and Then Again When I Am Looking Mean*

and Impressive: A Zora Neale Hurston Reader. During her prolific literary career, Walker has also contributed essays to numerous periodicals, including the *Negro Digest, Harper's*, and the *New York Times*. In addition, she served as a contributing editor to *Ms.* magazine. Subsequent collections of Walker's essays include *We Are the Ones We Have Been Waiting For* (2006) and *The Cushion in the Road* (2013).

Beauty: When the Other Dancer Is the Self

First appeared in the May 1983 issue of *Ms.* and reprinted in *In Search of Our Mothers' Gardens*, 1983. This version is from the first Harvest/ Harcourt Brace Jovanovich edition, published in 1984, pp. 361–70.

It is a bright summer day in 1947. My father, a fat, funny man with beautiful eyes and a subversive wit, is trying to decide which of his eight children he will take with him to the county fair. My mother, of course, will not go. She is knocked out from getting most of us ready: I hold my neck stiff against the pressure of her knuckles as she hastily completes the braiding and then beribboning of my hair.

My father is the driver for the rich old white lady up the road. Her name is Miss Mey. She owns all the land for miles around, as well as the house in which we live. All I remember about her is that she once offered to pay my mother thirty-five cents for cleaning her house, raking up piles of her magnolia leaves, and washing her family's clothes, and that my mother—she of no money, eight children, and a chronic earache—refused it. But I do not think of this in 1947. I am two and a half years old. I want to go everywhere my daddy goes. I am excited at the prospect of riding in a car. Someone has told me fairs are fun. That there is room in the car for only three of us doesn't faze me at all. Whirling happily in my starchy frock, showing off my biscuit-polished patent-leather shoes and lavender socks, tossing my head in a way that makes my ribbons bounce, I stand, hands on hips, before my father. "Take me, Daddy," I say with assurance; "I'm the prettiest!"

Later, it does not surprise me to find myself in Miss Mey's shiny black car, sharing the back seat with the other lucky ones. Does not surprise me that I thoroughly enjoy the fair. At home that night I tell the unlucky ones all I can remember about the merry-go-round, the man who eats live chickens, and the

teddy bears, until they say: that's enough, baby Alice. Shut up now, and go to sleep.

It is Easter Sunday, 1950. I am dressed in a green, flocked, scalloped-hem dress (handmade by my adoring sister, Ruth) that has its own smooth satin petticoat and tiny hot-pink roses tucked into each scallop. My shoes, new T-strap patent leather, again highly biscuit-polished. I am six years old and have learned one of the longest Easter speeches to be heard that day, totally unlike the speech I said when I was two: "Easter lilies / pure and white / blossom in / the morning light." When I rise to give my speech I do so on a great wave of love and pride and expectation. People in the church stop rustling their new crinolines. They seem to hold their breath. I can tell they admire my dress, but it is my spirit, bordering on sassiness (womanishness), they secretly applaud.

"That girl's a little *mess*," they whisper to each other, pleased.

Naturally I say my speech without stammer or pause, unlike those who stutter, stammer, or, worst of all, forget. This is before the word "beautiful" exists in people's vocabulary, but "Oh, isn't she the *cutest* thing!" frequently floats my way. "And got so much sense!" they gratefully add . . . for which thoughtful addition I thank them to this day.

It was great fun being cute. But then, one day, it ended.

I am eight years old and a tomboy. I have a cowboy hat, cowboy boots, checkered shirt and pants, all red. My playmates are my brothers, two and four years older than I. Their colors are black and green, the only difference in the way we are dressed. On Saturday nights we all go to the picture show, even my mother; Westerns are her favorite kind of movie. Back home, "on the ranch," we pretend we are Tom Mix, Hopalong Cassidy, Lash LaRue (we've even named one of our dogs Lash LaRue); we chase each other for hours rustling cattle, being outlaws, delivering damsels from distress. Then my parents decide to buy my brothers guns. These are not "real" guns. They shoot "BBs," copper pellets my brothers say will kill birds. Because I am a girl, I do not get a gun. Instantly I am relegated to the position of Indian. Now there appears a great distance between us. They shoot and shoot at everything with their new guns. I try to keep up with my bow and arrows.

One day while I am standing on top of our makeshift "garage"—pieces of tin nailed across some poles—holding my bow and arrow and looking out to-

ward the fields, I feel an incredible blow in my right eye. I look down just in time to see my brother lower his gun.

Both brothers rush to my side. My eye stings, and I cover it with my hand. "If you tell," they say, "we will get a whipping. You don't want that to happen, do you?" I do not. "Here is a piece of wire," says the older brother, picking it up from the roof; "say you stepped on one end of it and the other flew up and hit you." The pain is beginning to start. "Yes," I say. "Yes, I will say that is what happened." If I do not say this is what happened, I know my brothers will find ways to make me wish I had. But now I will say anything that gets me to my mother.

Confronted by our parents we stick to the lie agreed upon. They place me on a bench on the porch and I close my left eye while they examine the right. There is a tree growing from underneath the porch that climbs past the railing to the roof. It is the last thing my right eye sees. I watch as its trunk, its branches, and then its leaves are blotted out by the rising blood.

I am in shock. First there is intense fever, which my father tries to break using lily leaves bound around my head. Then there are chills: my mother tries to get me to eat soup. Eventually, I do not know how, my parents learn what has happened. A week after the "accident" they take me to see a doctor. "Why did you wait so long to come?" he asks, looking into my eye and shaking his head. "Eyes are sympathetic," he says. "If one is blind, the other will likely become blind too."

This comment of the doctor's terrifies me. But it is really how I look that bothers me most. Where the BB pellet struck there is a glob of whitish scar tissue, a hideous cataract, on my eye. Now when I stare at people—a favorite pastime, up to now—they will stare back. Not at the "cute" little girl but at her scar. For six years I do not stare at anyone, because I do not raise my head.

Years later, in the throes of a mid-life crisis, I ask my mother and sister whether I changed after the "accident." "No," they say, puzzled. "What do you mean?"

What do I mean?

I am eight, and, for the first time, doing poorly in school, where I have been something of a whiz since I was four. We have just moved to the place where the "accident" occurred. We do not know any of the people around us because this is a different county. The only time I see the friends I knew is when we go back to our old church. The new school is the former state penitentiary. It is a large stone building, cold and drafty, crammed to overflowing with boisterous,

ill-disciplined children. On the third floor there is a huge circular imprint of some partition that has been torn out.

"What used to be here?" I ask a sullen girl next to me on our way past it to lunch.

"The electric chair," says she.

At night I have nightmares about the electric chair, and about all the people reputedly "fried" in it. I am afraid of the school, where all the students seem to be budding criminals.

"What's the matter with your eye?" they ask, critically.

When I don't answer (I cannot decide whether it was an "accident" or not), they shove me, insist on a fight.

My brother, the one who created the story about the wire, comes to my rescue. But then brags so much about "protecting" me, I become sick.

After months of torture at the school, my parents decide to send me back to our old community, to my old school. I live with my grandparents and the teacher they board. But there is no room for Phoebe, my cat. By the time my grandparents decide there *is* room, and I ask for my cat, she cannot be found. Miss Yarborough, the boarding teacher, takes me under her wing, and begins to teach me to play the piano. But soon she marries an African—a "prince," she says—and is whisked away to his continent.

At my old school there is at least one teacher who loves me. She is the teacher who "knew me before I was born" and bought my first baby clothes. It is she who makes life bearable. It is her presence that finally helps me turn on the one child at the school who continually calls me "one-eyed bitch." One day I simply grab him by his coat and beat him until I am satisfied. It is my teacher who tells me my mother is ill.

My mother is lying in bed in the middle of the day, something I have never seen. She is in too much pain to speak. She has an abscess in her ear. I stand looking down on her, knowing that if she dies, I cannot live. She is being treated with warm oils and hot bricks held against her cheek. Finally a doctor comes. But I must go back to my grandparents' house. The weeks pass but I am hardly aware of it. All I know is that my mother might die, my father is not so jolly, my brothers still have their guns, and I am the one sent away from home.

"You did not change," they say.

Did I imagine the anguish of never looking up?

———

I am twelve. When relatives come to visit I hide in my room. My cousin Brenda, just my age, whose father works in the post office and whose mother is a nurse, comes to find me. "Hello," she says. And then she asks, looking at my recent school picture, which I did not want taken, and on which the "glob," as I think of it, is clearly visible, "You still can't see out of that eye?"

"No," I say, and flop back on the bed over my book.

That night, as I do almost every night, I abuse my eye. I rant and rave at it, in front of the mirror. I plead with it to clear up before morning. I tell it I hate and despise it. I do not pray for sight. I pray for beauty.

"You did not change," they say.

I am fourteen and baby-sitting for my brother Bill, who lives in Boston. He is my favorite brother and there is a strong bond between us. Understanding my feelings of shame and ugliness he and his wife take me to a local hospital, where the "glob" is removed by a doctor named O. Henry. There is still a small bluish crater where the scar tissue was, but the ugly white stuff is gone. Almost immediately I become a different person from the girl who does not raise her head. Or so I think. Now that I've raised my head I win the boyfriend of my dreams. Now that I've raised my head I have plenty of friends. Now that I've raised my head classwork comes from my lips as faultlessly as Easter speeches did, and I leave high school as valedictorian, most popular student, and *queen*, hardly believing my luck. Ironically, the girl who was voted most beautiful in our class (and was) was later shot twice through the chest by a male companion, using a "real" gun, while she was pregnant. But that's another story in itself. Or is it?

"You did not change," they say.

It is now thirty years since the "accident." A beautiful journalist comes to visit and to interview me. She is going to write a cover story for her magazine that focuses on my latest book. "Decide how you want to look on the cover," she says. "Glamorous, or whatever."

Never mind "glamorous," it is the "whatever" that I hear. Suddenly all I can think of is whether I will get enough sleep the night before the photography session: if I don't, my eye will be tired and wander, as blind eyes will.

At night in bed with my lover I think up reasons why I should not appear on the cover of a magazine. "My meanest critics will say I've sold out," I say. "My family will now realize I write scandalous books."

"But what's the real reason you don't want to do this?" he asks.

"Because in all probability," I say in a rush, "my eye won't be straight."

"It will be straight enough," he says. Then, "Besides, I thought you'd made your peace with that."

And I suddenly remember that I have.

I remember:

I am talking to my brother Jimmy, asking if he remembers anything unusual about the day I was shot. He does not know I consider that day the last time my father, with his sweet home remedy of cool lily leaves, chose me, and that I suffered and raged inside because of this. "Well," he says, "all I remember is standing by the side of the highway with Daddy, trying to flag down a car. A white man stopped, but when Daddy said he needed somebody to take his little girl to the doctor, he drove off."

I remember:

I am in the desert for the first time. I fall totally in love with it. I am so overwhelmed by its beauty, I confront for the first time, consciously, the meaning of the doctor's words years ago: "Eyes are sympathetic. If one is blind, the other will likely become blind too." I realize I have dashed about the world madly, looking at this, looking at that, storing up images against the fading of the light. *But I might have missed seeing the desert!* The shock of that possibility—and gratitude for over twenty-five years of sight—sends me literally to my knees. Poem after poem comes—which is perhaps how poets pray.

ON SIGHT

I am so thankful I have seen
The Desert
And the creatures in the desert
And the desert Itself.

The desert has its own moon
Which I have seen
With my own eye.
There is no flag on it.

Trees of the desert have arms
All of which are always up
That is because the moon is up
The sun is up
Also the sky
The stars

Clouds
None with flags.

If there *were* flags, I doubt
the trees would point.
Would you?

But mostly, I remember this:
I am twenty-seven, and my baby daughter is almost three. Since her birth I have worried about her discovery that her mother's eyes are different from other people's. Will she be embarrassed? I think. What will she say? Every day she watches a television program called "Big Blue Marble." It begins with a picture of the earth as it appears from the moon. It is bluish, a little battered-looking, but full of light, with whitish clouds swirling around it. Every time I see it I weep with love, as if it is a picture of Grandma's house. One day when I am putting Rebecca down for her nap, she suddenly focuses on my eye. Something inside me cringes, gets ready to try to protect myself. All children are cruel about physical differences, I know from experience, and that they don't always mean to be is another matter. I assume Rebecca will be the same.

But no-o-o-o. She studies my face intently as we stand, her inside and me outside her crib. She even holds my face maternally between her dimpled little hands. Then, looking every bit as serious and lawyerlike as her father, she says, as if it may just possibly have slipped my attention: "Mommy, there's a *world* in your eye." (As in, "Don't be alarmed, or do anything crazy.") And then, gently, but with great interest: "Mommy, where did you *get* that world in your eye?"

For the most part, the pain left then. (So what, if my brothers grew up to buy even more powerful pellet guns for their sons and to carry real guns themselves. So what, if a young "Morehouse man" once nearly fell off the steps of Trevor Arnett Library because he thought my eyes were blue.) Crying and laughing I ran to the bathroom, while Rebecca mumbled and sang herself off to sleep. Yes indeed, I realized, looking into the mirror. There *was* a world in my eye. And I saw that it was possible to love it: that in fact, for all it had taught me of shame and anger and inner vision, I *did* love it. Even to see it drifting out of orbit in boredom, or rolling up out of fatigue, not to mention floating back at attention in excitement (bearing witness, a friend has called it), deeply suitable to my personality, and even characteristic of me.

That night I dream I am dancing to Stevie Wonder's song "Always" (the name of the song is really "As," but I hear it as "Always"). As I dance, whirling

and joyous, happier than I've ever been in my life, another bright-faced dancer joins me. We dance and kiss each other and hold each other through the night. The other dancer has obviously come through all right, as I have done. She is beautiful, whole and free. And she is also me.

SARA SULERI

(1953–)

The daughter of a Pakistani journalist and a Welsh professor of English, Sara Suleri was born in Karachi, Pakistan. After receiving bachelor's and master's degrees from universities in Pakistan, Suleri traveled to England and the United States, completing a doctorate at Indiana University in 1980. In 1981, she accepted a job as a professor of English at Yale University. Suleri's first book, *Meatless Days*, was published in 1989, and it subsequently won a Pushcart Prize. The work contains autobiographical essays about Suleri's childhood in Pakistan as well as her immigration to England and the United States. In 1991 she published a second book, *The Rhetoric of English India*. In 1993, Suleri married Austin Goodyear. They remained married until Goodyear's death in 2005. In 2003 Suleri returned to the subject of her childhood and early adulthood with the autobiographical *Boys Will Be Boys: A Daughter's Elegy*.

Excellent Things in Women

First appeared in the Winter 1987 issue of *Raritan* and reprinted in
Meatless Days (Chicago: University of Chicago Press, 1989), pp. 1–20.

Leaving Pakistan was, of course, tantamount to giving up the company of women. I can tell this only to someone like Anita, in all the faith that she will understand, as we go perambulating through the grimness of New Haven and feeding on the pleasures of our conversational way. Dale, who lives in Boston, would also understand. She will one day write a book about the stern and secretive life of breastfeeding and is partial to fantasies that culminate in an

abundance of resolution. And Fawzi, with a grimace of recognition, knows because she knows the impulse to forget.

To a stranger or an acquaintance, however, some vestigial remoteness obliges me to explain that my reference is to a place where the concept of woman was not really part of an available vocabulary: we were too busy for that, just living, and conducting precise negotiations with what it meant to be a sister or a child or a wife or a mother or a servant. By this point admittedly I am damned by my own discourse, and doubly damned when I add that yes, once in a while we naturally thought of ourselves as women, but only in some perfunctory biological way that we happened on perchance. Or else it was a hugely practical joke, we thought, hidden somewhere among our clothes. But formulating that definition is about as impossible as attempting to locate the luminous qualities of an Islamic landscape, which can on occasion generate such aesthetically pleasing moments of life. My audience is lost, and angry to be lost, and both of us must find some token of exchange for this failed conversation. I try to lay the subject down and change its clothes, but before I know it, it has sprinted off evilly in the direction of ocular evidence. It goads me into saying, with the defiance of a plea, "You did not deal with Dadi."

Dadi, my father's mother, was born in Meerut toward the end of the last century. She was married at sixteen and widowed in her thirties, and by her latter decades could never exactly recall how many children she had borne. When India was partitioned, in August of 1947, she moved her thin pure Urdu into the Punjab of Pakistan and waited for the return of her eldest son, my father. He had gone careening off to a place called Inglestan, or England, fired by one of the several enthusiasms made available by the proliferating talk of independence. Dadi was peeved. She had long since dispensed with any loyalties larger than the pitiless give-and-take of people who are forced to live together in the same place, and she resented independence for the distances it made. She was not among those who, on the fourteenth of August, unfurled flags and festivities against the backdrop of people running and cities burning. About that era she would only say, looking up sour and cryptic over the edge of her Quran, "And I was also burned." She was, but that came years later.

By the time I knew her, Dadi with her flair for drama had allowed life to sit so heavily upon her back that her spine wilted and froze into a perfect curve, and so it was in the posture of a shrimp that she went scuttling through the day. She either scuttled or did not: it all depended on the nature of her fight with the Devil. There were days when she so hated him that all she could do was stretch herself out straight and tiny on her bed, uttering most awful im-

precation. Sometimes, to my mother's great distress, Dadi could berate Satan in full eloquence only after she had clambered on top of the dining-room table and lain there like a little moving centerpiece. Satan was to blame: he had after all made her older son linger long enough in Inglestan to give up his rightful wife, a cousin, and take up instead with a white-legged woman. Satan had stolen away her only daughter Ayesha when Ayesha lay in childbirth. And he'd sent her youngest son to Swaziland, or Switzerland; her thin hand waved away such sophistries of name.

God she loved, and she understood him better than anyone. Her favorite days were those when she could circumnavigate both the gardener and my father, all in solemn service of her God. With a pilfered knife, she'd weedle her way to the nearest sapling in the garden, some sprightly poplar or a newly planted eucalyptus. She'd squat, she'd hack it down, and then she'd peel its bark away until she had a walking stick, all white and virgin and her own. It drove my father into tears of rage. He must have bought her a dozen walking sticks, one for each of our trips to the mountains, but it was like assembling a row of briar pipes for one who will not smoke: Dadi had different aims. Armed with implements of her own creation, she would creep down the driveway unperceived to stop cars and people on the street and give them all the gossip that she had on God.

Food, too, could move her to intensities. Her eyesight always took a sharp turn for the worse over meals—she could point hazily at a perfectly ordinary potato and murmur with Adamic reverence "What *is* it, what *is* it called?" With some shortness of manner, one of us would describe and catalog the items on the table. "*Alu ka bhartha*," Dadi repeated with wonderment and joy; "Yes, Saira Begum, you can put some here." "Not too much," she'd add pleadingly. For ritual had it that the more she demurred, the more she expected her plate to be piled with an amplitude her own politeness would never allow. The ritual happened three times a day.

We pondered it but never quite determined whether food or God constituted her most profound delight. Obvious problems, however, occurred whenever the two converged. One such occasion was the Muslim festival called Eid—not the one that ends the month of fasting, but the second Eid, which celebrates the seductions of the Abraham story in a remarkably literal way. In Pakistan, at least, people buy sheep or goats beforehand and fatten them up for weeks with delectables. Then, on the appointed day, the animals are chopped, in place of sons, and neighbors graciously exchange silver trays heaped with raw and quivering meat. Following Eid prayers the men come home, and the

animal is killed, and shortly thereafter rush out of the kitchen steaming plates of grilled lung and liver, of a freshness quite superlative.

It was a freshness to which my Welsh mother did not immediately take. She observed the custom but discerned in it a conundrum that allowed no ready solution. Liberal to an extravagant degree on thoughts abstract, she found herself to be remarkably squeamish about particular things. Chopping up animals for God was one. She could not quite locate the metaphor and was uneasy when obeisance played such a truant to the metaphoric realm. My father the writer quite agreed: he was so civilized in those days.

Dadi didn't agree. She pined for choppable things. Once she made the mistake of buying a baby goat and bringing him home months in advance of Eid. She wanted to guarantee the texture of his festive flesh by a daily feeding of tender peas and clarified butter. Ifat, Shahid and I greeted a goat into the family with boisterous rapture, and soon after he ravished us completely when we found him at the washingline nonchalantly eating Shahid's pajamas. Of course there was no argument: the little goat was our delight, and even Dadi knew there was no killing him. He became my brother's and my sister's and my first pet, and he grew huge, a big and grinning thing.

Years after, Dadi had her will. We were all old enough, she must have thought, to set the house sprawling, abstracted, into a multitude of secrets. This was true, but still we all noticed one another's secretive ways. When the day before Eid, our Dadi disappeared, my brothers and sisters and I just shook our heads. We hid the fact from my father, who at this time of life had begun to equate petulance with extreme vociferation. So we went about our jobs and tried to be Islamic for a day. We waited to sight moons on the wrong occasion, and watched the food come into lavishment. Dried dates change shape when they are soaked in milk, and carrots rich and strange turn magically sweet when deftly covered with green nutty shavings and smatterings of silver. Dusk was sweet as we sat out, the day's work done, in an evening garden. Lahore spread like peace around us. My father spoke, and when Papa talked, it was of Pakistan. But we were glad, then, at being audience to that familiar conversation, till his voice looked up, and failed. There was Dadi making her return, and she was prodigal. Like a question mark interested only in its own conclusions, her body crawled through the gates. Our guests were spellbound, then they looked away. Dadi, moving in her eerie crab formations, ignored the hangman's rope she firmly held as behind her in the gloaming minced, hugely affable, a goat.

That goat was still smiling the following day when Dadi's victory brought

the butcher, who came and went just as he should on Eid. The goat was killed and cooked: a scrawny beast that required much cooking and never melted into succulence, he winked and glistened on our plates as we sat eating him on Eid. Dadi ate, that is: Papa had taken his mortification to some distant corner of the house; Ifat refused to chew on hemp; Tillat and Irfan gulped their baby sobs over such a slaughter. "Honestly," said Mamma, "honestly." For Dadi had successfully cut through tissues of festivity just as the butcher slit the goat, but there was something else that she was eating with that meat. I saw it in her concentration; I know that she was making God talk to her as to Abraham and was showing him what she could do—for him—to sons. God didn't dare, and she ate on alone.

Of those middle years it is hard to say whether Dadi was literally left alone or whether her bodily presence always emanated a quality of being apart and absorbed. In the winter I see her alone, painstakingly dragging her straw mat out to the courtyard at the back of the house and following the rich course of the afternoon sun. With her would go her Quran, a metal basin in which she could wash her hands, and her ridiculously heavy spouted waterpot, that was made of brass. None of us, according to Dadi, was quite pure enough to transport these particular items, but the rest of her paraphernalia we were allowed to carry out. These were baskets of her writing and sewing materials and her bottle of pungent and Dadi-like bitter oils, with which she'd coat the papery skin that held her brittle bones. And in the summer, when the night created an illusion of possible coolness and everyone held their breath while waiting for a thin and intermittent breeze, Dadi would be on the roof, alone. Her summer bed was a wooden frame latticed with a sweet-smelling rope, much aerated at its foot. She'd lie there all night until the wild monsoons would wake the lightest and the soundest sleeper into a rapturous welcome of rain.

In Pakistan, of course, there is no spring but only a rapid elision from winter into summer, which is analogous to the absence of a recognizable loneliness from the behavior of that climate. In a similar fashion it was hard to distinguish between Dadi with people and Dadi alone; she was merely impossibly unable to remain unnoticed. In the winter, when she was not writing or reading, she would sew for her delight tiny and magical reticules out of old silks and fragments she had saved, palm-sized cloth bags that would unravel into the precision of secret and more secret pockets. But none such pockets did she ever need hide, since something of Dadi always remained intact, however much we sought to open her. Her discourse, for example, was impervious to penetration, so that when one or two of us remonstrated with her in a

single hour, she never bothered to distinguish her replies. Instead she would pronounce generically and prophetically, "The world takes on a single face." "Must you, Dadi . . . ," I'd begin, to be halted then by her great complaint: "The world takes on a single face."

It did. And often it was a countenance of some delight, for Dadi also loved the accidental jostle with things belligerent. As she went perambulating through the house, suddenly she'd hear Shahid, her first grandson, telling me or one of my sisters we were vile, we were disgusting women. And Dadi, who never addressed any one of us girls without first conferring the title of lady—so we were "Teellat Begum," "Nuzhat Begum," "Iffat Begum," "Saira Begum"— would halt in reprimand and tell her grandson never to call her granddaughters women. "What else shall I call them, men?" Shahid yelled. "Men!" said Dadi, "Men! There is more goodness in a woman's little finger than in the benighted mind of man." "Hear, hear, Dadi! *Hanh hanh*, Dadi!" my sisters cried. "For men," said Dadi, shaking the name off her fingertips like some unwanted water, "live as though they were unsuckled things." "And heaven," she grimly added, "is the thing Mohammed says (peace be upon him) lies beneath the feet of women!" "But he was a man," Shahid still would rage, if he weren't laughing, as all of us were laughing, while Dadi sat among us as a belle or a May queen.

Toward the end of the middle years my father stopped speaking to his mother, and the atmosphere at home appreciably improved. They secretly hit upon a novel histrionics that took the place of their daily battle. They chose the curious way of silent things: twice a day Dadi would leave her room and walk the long length of the corridor to my father's room. There she merely peered round the door, as though to see if he were real. Each time she peered, my father would interrupt whatever adult thing he might be doing in order to enact a silent paroxysm, an elaborate facial pantomime of revulsion and affront. At teatime in particular, when Papa would want the world to congregate in his room, Dadi came to peer her ghostly peer. Shortly thereafter conversation was bound to fracture, for we could not drown the fact that Dadi, invigorated by an outcast's strength, was sitting alone in the dining room, chanting an appeal: "God give me tea, God give me tea."

At about this time Dadi stopped smelling old and smelled instead of something equivalent to death. It would have been easy to notice if she had been dying, but instead she conducted the change as a refinement, a subtle gradation, just as her annoying little stove could shift its hanging odors away from smoke and into ash. During the middle years there had been something more defined

about her being, which sat in the world as solely its own context. But Pakistan increasingly complicated the question of context, as though history, like a pestilence, forbid any definition outside relations to its fevered sleep. So it was simple for my father to ignore the letters that Dadi had begun to write to him every other day in her fine wavering script, letters of advice about the house or the children or the servants. Or she transcribed her complaint: "Oh my son, Zia. Do you think your son, Shahid, upon whom God bestow a thousand blessings, should be permitted to lift up his grandmother's chair and carry it into the courtyard when his grandmother is seated in it?" She had cackled in a combination of delight and virgin joy when Shahid had so transported her, but that little crackling sound she omitted from her letter. She ended it, and all her notes, with her single endearment. It was a phrase to halt and arrest when Dadi actually uttered it: her solitary piece of tenderness was an injunction, really, to her world—"Keep on living," she would say.

Between that phrase and the great Dadi conflagration comes the era of the trying times. They began in the winter war of 1971, when East Pakistan became Bangladesh and Indira Gandhi hailed the demise of the two-nation theory. Ifat's husband was off fighting and we spent the war together with her father-in-law, the brigadier, in the pink house on the hill. It was an ideal location for antiaircraft guns, so there was a bevy of soldiers and weaponry installed upon our roof. During each air raid the brigadier would stride purposefully into the garden and bark commands at them, as though the crux of the war rested upon his stiff upper lip. Then Dacca fell, and General Yahya came on television to resign the presidency and concede defeat. "Drunk, by God!" barked the brigadier as we sat watching, "Drunk!"

The following morning General Yahya's mistress came to mourn with us over breakfast, lumbering in draped with swathes of overscented silk. The brigadier lit an English cigarette—he was frequently known to avow that Pakistani cigarettes gave him a cuff—and bit on his moustache. "Yes," he barked, "these are trying times." "Oh yes, Gul," Yahya's mistress wailed, "these are such trying times." She gulped on her own eloquence, her breakfast bosom quaked, and then resumed authority over that dangling sentence: "It is so trying," she continued, "I find it so trying, it is trying to us all, to live in these trying, trying times." Ifat's eyes met mine in complete accord: mistress transmogrified to muse; Bhutto returned from the UN to put Yahya under house arrest and become the first elected president of Pakistan; Ifat's husband went to India as a prisoner of war for two years; my father lost his newspaper. We had entered the era of the trying times.

Dadi didn't notice the war, just as she didn't really notice the proliferation of her great-grandchildren, for Ifat and Nuzzi conceived at the drop of a hat and kept popping babies out for our delight. Tillat and I felt favored at this vicarious taste of motherhood: we learned to become that enviable personage, a *khala*, mother's sister, and when our married sisters came to visit with their entourage, we reveled in the exercise of *khala*-love. I once asked Dadi how many sisters she had had. She looked up through the oceanic grey of her cataracted eyes and answered, "I forget."

The children helped, because we needed distraction, there being then in Pakistan a musty taste of defeat to all our activities. The children gave us something, but they also took something away—they initiated a slight displacement of my mother. Because her grandchildren would not speak any English, she could not read stories of old. Urdu always remained a shyness on her tongue, and as the babies came and went she let something of her influence imperceptibly recede, as though she occupied an increasingly private space. Her eldest son was in England by then, so Mamma found herself assuming the classic posture of an Indian woman who sends away her sons and runs the risk of seeing them then succumb to the great alternatives represented by the West. It was a position that preoccupied her; and without my really noticing what was happening, she quietly handed over many of her wifely duties to her two remaining daughters—to Tillat and to me. In the summer, once the ferocity of the afternoon sun had died down, it was her pleasure to go out into the garden on her own. There she would stand, absorbed and abstracted, watering the driveway and breathing in the heady smell of water on hot dust. I'd watch her often, from my room upstairs. She looked like a girl.

We were aware of something, of a reconfiguration in the air, but could not exactly tell where it would lead us. Dadi now spoke mainly to herself; even the audience provided by the deity had dropped away. Somehow there wasn't a proper balance between the way things came and the way they went, as Halima the cleaning woman knew full well when she looked at me intently, asking a question that had no question in it: "Do I grieve, or do I celebrate?" Halima had given birth to her latest son the night her older child died in screams of meningitis once heard, never to be forgotten. She came back to work a week later, and we were talking as we put away the family's winter clothes into vast metal trunks. For in England, they would call it spring.

We felt a quickening urgency of change drown our sense of regular direction, as though something were bound to happen soon but not knowing what

it would be was making history nervous. And so we were not really that surprised then, to find ourselves living through the summer of the trials by fire. It climaxed when Dadi went up in a little ball of flames, but somehow sequentially related were my mother's trip to England to tend to her dying mother, and the night I beat up Tillat, and the evening I nearly castrated my little brother, runt of the litter, serious-eyed Irfan.

It was an accident on both our parts. I was in the kitchen, so it must have been a Sunday, when Allah Ditta the cook took the evenings off. He was a mean-spirited man with an incongruously delicate touch when it came to making food. On Sunday at midday he would bluster one of us into the kitchen and show us what he had prepared for the evening meal, leaving strict and belligerent instructions about what would happen if we overheated this or dared brown that. So I was in the kitchen heating up some food when Farni came back from playing hockey, an ominous asthmatic rattle in his throat. He, the youngest, had been my parents' gravest infant: in adolescence he remained a gentle invalid. Of course he pretended otherwise, and was loud and raucous, but it never worked.

Tillat and I immediately turned on him with the bullying litany that actually can be quite soothing, the invariable female reproach to the returning male. He was to do what he hated—stave off his disease by sitting over a bowl of camphor and boiling water and inhaling its acrid fumes. I insisted that he sit on the cook's little stool in the kitchen, holding the bowl of medicated water on his lap, so that I could cook, and Farni could not cheat, and I could time each minute he should sit there thus confined. We seated him and flounced a towel on his reluctant head. The kitchen reeked jointly of cumin and camphor, and he sat skinny and penitent and swathed for half a minute, and then was begging to be done. I slammed down the carving knife and screamed "Irfan!" with such ferocity that he jumped, figuratively and literally, right out of his skin. The bowl of water emptied onto him, and with a gurgling cry Irfan leapt up, tearing at his steaming clothes. He clutched at his groin, and everywhere he touched, the skin slid off, so that between his fingers his penis easily unsheathed, a blanched and fiery grape. "What's happening?" screamed Papa from his room. "What's happening?" echoed Dadi's wail from the opposite end of the house. What was happening was that I was holding Farni's shoulders, trying to stop him jumping up and down, but I was jumping too, while Tillat just stood there frozen, frowning at his poor ravaged grapes.

This was June, and the white heat of summer. We spent the next few days laying ice on Farni's wounds: half the time I was allowed to stay with him, un-

til the doctors suddenly remembered I was a woman and hurried me out when his body made crazy spastic reactions to its burns. Once things grew calmer and we were alone, Irfan looked away and said, "I hope I didn't shock you, Sara." I was so taken by tenderness for his bony convalescent body that it took me years to realize yes, something female in me had been deeply shocked.

Mamma knew nothing of this, of course. We kept it from her so that she could concentrate on what took her back to the rocky coastline of Wales, to places she had not really revisited since she was a girl. She sat waiting with her mother, who was blind now and of a fine translucency, and both of them knew that they were waiting for her death. It was a peculiar posture for Mamma to maintain, but her quiet letters spoke mainly of the sharp astringent light that made the sea wind feel so brisk in Wales and so many worlds away from the daily omnipresent weight of a summer in Lahore. There in Wales one afternoon, walking childless among the brambles and the furze, Mamma realized that her childhood was distinctly lost. "It was not that I wanted to feel more familiar," she later told me, "or that I was more used to feeling unfamiliar in Lahore. It's just that familiarity isn't important, really," she murmured absently, "it really doesn't matter at all."

When Mamma was ready to return, she wired us her plans, and my father read the cable, kissed it, then put it in his pocket. I watched him and felt startled, as we all did on the occasions when our parents' lives seemed to drop away before our eyes, leaving them youthfully engrossed in the illusion of knowledge conferred by love. We were so used to conceiving of them as parents moving in and out of hectic days that it always amused us, and touched us secretly, when they made quaint and punctilious returns to the amorous bond that had initiated the unlikely life together.

That summer while my mother was away, Tillat and I experienced a new bond of powerlessness, the white and shaking rage of sexual jealousy in parenthood. I had always behaved toward her as a contentious surrogate parent, but she had been growing beyond that scope and in her girlhood asking me for a formal acknowledgment of equality that I was loath to give. My reluctance was rooted in a helpless fear of what the world might do to her, for I was young and ignorant enough not to see that what I might do was worse. She went out one evening when my father was off on one of his many trips. The house was gaping emptily, and Tillat was very late. Allah Ditta had gone home, and Dadi and Irfan were sleeping; I read, and thought, and walked up and down the garden, and Tillat was very, very late. When she came back she wore that strange sheath of complacency and guilt which pleasure puts on faces very

young. It smote an outrage in my heart until despite all resolutions to the contrary I heard myself hiss: "And where were you?" Her returning look was both fearful and preening at the same time, and the next thing to be smitten was her face. "Don't, Sara," Tillat said in her superior way, "physical violence is so degrading." "To you, maybe," I answered, and hit her once again.

It made a sorrowful bond between us, for we both felt complicit in the shamefulness that had made me seem righteous whereas I had felt simply jealous, which we tacitly agreed was a more legitimate thing to be. But we had lost something, a certain protective aura, some unspoken myth asserting that love between sisters at least was sexually innocent. Now we had to fold that vain belief away and stand in slightly more naked relation to our affection. Till then we had associated such violence with all that was outside us, as though somehow the more history fractured, the more whole we would be. But we began to lose that sense of the differentiated identities of history and ourselves and became guiltily aware that we had known it all along, our part in the construction of unreality.

By this time, Dadi's burns were slowly learning how to heal. It was she who had given the summer its strange pace by nearly burning herself alive at its inception. On an early April night Dadi awoke, seized by a desperate need for tea. It was three in the morning, the household was asleep, so she was free to do the great forbidden thing of creeping into Allah Ditta's kitchen and taking charge, like a pixie in the night. As all of us had grown bored of predicting, one of her many cotton garments took to fire that truant night. Dadi, however, deserves credit for her resourceful voice, which wavered out for witness to her burning death. By the time Tillat awoke and found her, she was a little flaming ball: "Dadi!" cried Tillat in the reproach of sleep, and beat her quiet with a blanket. In the morning we discovered Dadi's torso had been almost consumed and little recognizable remained from collarbone to groin. The doctors bade us to some decent mourning.

But Dadi had different plans. She lived through her sojourn at the hospital; she weathered her return. Then, after six weeks at home, she angrily refused to be lugged like a chunk of meat to the doctor's for her daily change of dressings. "Saira Begum will do it," she announced. Thus developed my great intimacy with the fluid properties of human flesh. By the time Mamma left for England, Dadi's left breast was still coagulate and raw. Later, when Irfan got his burns, Dadi was growing pink and livid tightropes, strung from hip to hip in a flaming advertisement of life. And in the days when Tillat and I were wrestling,

Dadi's vanished nipples started to congeal and convex their cavities into triumphant little love knots.

I learned about the specialization of beauty through that body. There were times, as with love, when I felt only disappointment, carefully easing the dressings off and finding again a piece of flesh that would not knit, happier in the texture of a stubborn glue. But then on more exhilarating days I'd peel like an onion all her bandages away and suddenly discover I was looking down at some literal tenacity and was bemused at all the freshly withered shapes she could create. Each new striation was a victory to itself, and when Dadi's hairless groin solidified again, and sent firm signals that her abdomen must do the same, I could have wept with glee.

After her immolation, Dadi's diet underwent some curious changes. At first her consciousness teetered too much for her to pray, but then as she grew stronger it took us a while to notice what was missing: she had forgotten prayer. It left her life as firmly as tobacco can leave the lives of only the most passionate smokers, and I don't know if she ever prayed again. At about this time, however, with the heavy-handed inevitability that characterized his relation to his mother, my father took to prayer. I came home one afternoon and looked for him in all the usual places, but he wasn't to be found. Finally I came across Tillat and asked her where Papa was. "Praying," she said. "*Praying?*" I said. "Praying," she said, and I felt most embarrassed. For us it was rather as though we had come upon the children playing some forbidden, titillating game and decided it was wisest to ignore it calmly. In an unspoken way, though, I think we dimly knew we were about to witness Islam's departure from the land of Pakistan. The men would take it to the streets and make it vociferate, but the great romance between religion and the populace, the embrace that engendered Pakistan, was done. So Papa prayed, with the desperate ardor of a lover trying to converse life back into a finished love.

That was a change, when Dadi patched herself together again and forgot to put back prayer into its proper pocket, for God could now leave the home and soon would join the government. Papa prayed and fasted and went on pilgrimage and read the Quran aloud with the most peculiar locutions. Occasionally we also caught him in nocturnal altercations that made him sound suspiciously like Dadi: we looked askance, but didn't say a thing. My mother was altogether admirable; she behaved as though she'd always known that she'd wed a swaying, chanting thing and that to register surprise now would be an impoliteness to existence. Her expression reminded me somewhat of the time when Ifat was eight and Mamma was urging her recalcitrance into some

goodly task. Ifat postponed, and Mamma, always nifty with appropriate fables, quoted meaningfully: "'I'll do it myself,' said the little red hen." Ifat looked up with bright affection. "Good little red hen," she murmured. Then a glance crossed my mother's face, a look between a slight smile and a quick rejection of eloquent response, like a woman looking down and then away.

She looked like that at my father's sudden hungering for God, which was added to the growing number of subjects about which we, my mother and her daughters, silently decided we had no conversation. We knew that there was something other than trying times ahead and would far rather hold our breath than speculate about what other surprises the era held up its capacious sleeve. Tillat and I decided to quash our dread of waiting around for change by changing for ourselves, before destiny took the time to come our way. I would move to America, and Tillat to Kuwait and marriage. To both declarations of intention my mother said, "I see," and helped us in our preparations: she knew by then her elder son would not return, and was prepared to extend the courtesy of change to her daughters, too. We left, and Islam predictably took to the streets, shaking Bhutto's empire. Mamma and Dadi remained the only women in the house, the one untalking, the other unpraying.

Dadi behaved abysmally at my mother's funeral, they told me, and made them all annoyed. She set up loud and unnecessary lamentations in the dining room, somewhat like an heir apparent, as though this death had reinstated her as mother of the house. While Ifat and Nuzzi and Tillat wandered frozen-eyed, dealing with the roses and the ice, Dadi demanded an irritating amount of attention, stretching out supine and crying out, "Your mother has betrayed your father; she has left him; she has gone." Food from respectful mourners poured in, cauldron after cauldron, and Dadi relocated a voracious appetite.

Years later, I was somewhat sorry that I heard this tale because it made me take affront. When I went returned to Pakistan, I was too peeved with Dadi to find out how she was. Instead I listened to Ifat tell me about standing there in the hospital, watching the doctors suddenly pump upon my mother's heart— "I'd seen it on television," she gravely said, "I knew it was the end." Mamma's students from the university had tracked down the rickshaw driver who had knocked her down; they'd pummeled him nearly to death and then camped out in our garden, sobbing wildly, all in hordes.

By this time Bhutto was in prison and awaiting trial, and General Zulu was presiding over the Islamization of Pakistan. But we had no time to notice. My mother was buried at the nerve center of Lahore, an unruly and dusty place, and my father immediately made arrangements to buy the plot of land next

to her grave. "We're ready when you are," Shahid sang. Her tombstone bore some pretty Urdu poetry and a completely fictitious place of birth, because some details my father tended to forget. "Honestly," it would have moved his wife to say.

So I was angry with Dadi at that time and didn't stop to see her. I saw my mother's grave and then came back to America, hardly noticing when, six months later, my father called from London and mentioned Dadi was now dead. It happened in the same week that Bhutto finally was hanged, and our imaginations were consumed by that public and historical dying. Pakistan made rapid provisions not to talk about the thing that had been done, and somehow, accidentally, Dadi must have been mislaid into that larger decision, because she too ceased to be a mentioned thing. My father tried to get back in time for the funeral, but he was so busy talking Bhutto-talk in England that he missed his flight and thus did not return. Luckily, Irfani was at home, and saw Dadi to her grave.

Bhutto's hanging had the effect of making Pakistan feel unreliable, particularly to itself. Its landscape learned a new secretiveness, unusual for a formerly loquacious place. This may account for the fact that I have never seen my grandmother's grave and neither have my sisters. I think we would have tried, had we been together, despite the free-floating anarchy in the air that—like the heroin trade—made the world suspicious and afraid. There was no longer any need to wait for change because change was all there was, and we had quite forgotten the flavor of an era that stayed in place long enough to gain a name. One morning I awoke to find that, during the course of the night, my mind had completely ejected the names of all the streets in Pakistan, as though to assure that I could not return, or that if I did, it would be returning to a loss. Overnight the country had grown absentminded, and patches of amnesia hung over the hollows of the land like fog.

I think we would have mourned Dadi in our belated way, but the coming year saw Ifat killed in the consuming rush of change and disbanded the company of women for all times. It was a curious day in March, two years after my mother died, when the weight of that anniversary made us all disconsolate for her quietude. "I'll speak to Ifat, though," I thought to myself in America. But in Pakistan someone had different ideas for that sister of mine and thwarted all my plans. When she went walking out that warm March night, a car came by and trampeled her into the ground, and then it vanished strangely. By the time I reached Lahore, a tall and slender mound had usurped the grave space

where my father hoped to lie, next to the more moderate shape that was his wife. Children take over everything.

So, worn by repetition we stood by Ifat's grave, and took note of the narcissi, still alive, that she must have placed upon my mother on the day that she was killed. It made us impatient, in a way, as though we had to decide that there was nothing so farcical as grief and that it had to be eliminated from our diets for good. It cut away, of course, our intimacy with Pakistan, where history is synonymous with grief and always most at home in the attitudes of grieving. Our congregation in Lahore was brief, and then we swiftly returned to a more geographic reality. "We are lost, Sara," Shahid said to me on the phone from England. "Yes, Shahid," I firmly said, "We're lost."

Today, I'd be less emphatic. Ifat and Mamma must have honeycombed and crumbled now, in the comfortable way that overtakes bedfellows. And somehow it seems apt and heartening that Dadi, being what she was, never suffered the pomposities that enter the most well-meaning of farewells and seeped instead into the nooks and crannies of our forgetfulness. She fell between two stools of grief, which is appropriate, since she was greatest when her life was at its most unreal. Anyway she was always outside our ken, an anecdotal thing, neither more nor less. So some sweet reassurance of reality accompanies my discourse when I claim that when Dadi died, we all forgot to grieve.

For to be lost is just a minute's respite, after all, like a train that cannot help but stop between the stations of its proper destinations in order to stage a pretend version of the end. Dying, we saw, was simply change taken to points of mocking extremity, and wasn't a thing to lose us but to find us out, to catch us where we least wanted to be caught. In Pakistan, Bhutto became obsolete after a succession of bumper harvests, and none of us can fight the ways that the names Mamma and Ifat have become archaisms, quaintnesses on our lips.

Now I live in New Haven and feel quite happy with my life. I miss, of course, the absence of women and grow increasingly nostalgic for a world where the modulations of age are as recognized and welcomed as the shift from season into season. But that's a hazard that has to come along, since I have made myself inhabitant of a population which democratically insists that everyone from twenty-nine to fifty-six occupies roughly the same space of age. When I teach topics in third world literature, much time is lost in trying to explain that the third world is locatable only as a discourse of convenience. Trying to find it is like pretending that history or home is real and not located precisely where you're sitting, I hear my voice quite idiotically say. And then it happens. A face, puzzled and attentive and belonging to my gender, raises its

intelligence to ask why, since I am teaching third world writing, I haven't given equal space to women writers on my syllabus. I look up, the horse's mouth, a foolish thing to be. Unequal images battle in my mind for precedence—there's imperial Ifat, there's Mamma in the garden, and Halima the cleaning woman is there too, there's uncanny Dadi with her goat. Against all my own odds I know what I must say. Because, I'll answer slowly, there are no women in the third world.

LINDA HOGAN

(1947–)

A member of the Chickasaw tribe, Linda Hogan was born in Denver, Colorado, and spent much of her childhood in Colorado and Oklahoma, moving around with her military family. In 1978 she earned a master's degree from the University of Colorado at Boulder. Before reducing her professorial duties and devoting more time to her writing, Hogan taught English at several universities, including the University of Colorado and the University of Oklahoma. Her first publication, a collection of poems titled *Calling Myself Home*, appeared in 1979. Hogan subsequently published five additional volumes of poetry as well as works of fiction and nonfiction. Published in 1995, *Dwellings: A Spiritual History of the Living World* is a collection of essays that continues a familiar theme of Hogan's, preservation of the natural world and Native American culture. *The Woman Who Watches Over the World: A Native Memoir* followed in 2001. Since then, Hogan has published two books of poetry and a novel. In 2007 she was inducted into the Chickasaw Nation Hall of Fame for her writing. Hogan lives in Tishomingo, Oklahoma, the first capital of the Chickasaw Nation, and she has two children with her former husband, Pat Hogan. She remarked in an 1998 interview for *The Bloomsbury Review*, "I feel like I owe the future to my children and grandchildren, that the work I do, I hope, will help sustain them in the future."

The Bats

First appeared in the Winter 1989 issue of *American Voice* and reprinted in *Dwellings*, 1995. This version is from the Touchstone paperback edition, *Dwellings: A Spiritual History of the Living World* (New York: Simon and Shuster, 1996), pp. 21–28.

The first time I was fortunate enough to catch a glimpse of mating bats was in the darkest corner of a zoo. I was held spellbound, seeing the fluid movement of the bats as they climbed each other softly and closed their wings together. They were an ink black world hanging from a rafter. The graceful angles of their dark wings opened and jutted out like an elbow or knee poking through a thin, dark sheet. A moment later it was a black, silky shawl pulled tight around them. Their turning was beautiful, a soundless motion of wind blowing great dark dunes into new configurations.

A few years later, in May, I was walking in a Minneapolis city park. The weather had been warm and humid. For days it had smelled of spring, but the morning grew into a sudden cold snap, the way Minnesota springs are struck to misery by a line of cold that travels in across the long, gray plains. The grass was crisp. It cracked beneath my feet. Chilled to the bone, and starting home, I noticed what looked like a brown piece of fur lying among the frosted blades of new grass. I walked toward it and saw the twiglike legs of a bat, wings folded like a black umbrella whose inner wires had been broken by a windstorm.

The bat was small and brown. It had the soft, furred body of a mouse with two lines of tiny black nipples exposed on the stomach. At first I thought it was dead, but as I reached toward it, it turned its dark, furrowed face to me and bared its sharp teeth. A fierce little mammal, it looked surprisingly like an angry human being. I jumped back. I would have pulled back even without the lightning fast memory of tales about rabid bats that tangle in a woman's hair.

In this park, I'd seen young boys shoot birds and turtles. Despite the bat's menacing face, my first thought was to protect it. Its fangs were still bared, warning me off. When I touched it lightly with a stick, it clamped down like it would never let go. I changed my mind; I decided it was the children who needed protection. Still, I didn't want to leave it lying alone and vulnerable in the wide spiny forest of grass blades that had turned sharp and brittle in the cold.

Rummaging through the trash can I found a lidded box and headed back toward the bat when I came across another bat. This bat, too, was lying brown and inert on the grass. That's when it occurred to me that the recent warm spell had been broken open by the cold and the bats, shocked back into hibernation, had stopped dead in flight, rendered inactive by the quick drop in temperature.

I placed both bats inside the box and carried them home. Now and then the weight would shift and there was the sound of scratching and clawing. I wondered if the warmth from my hands was enough heat to touch them back to life.

At home, I opened the box. The two bats were mating. They were joined together, their broken umbrella wings partly open, then moving, slumping, and opening again. These are the most beautiful turnings, the way these bodies curve and glide together, fold and open. It's elegant beyond compare, more beautiful than eels circling each other in the dark waters.

I put them in a warm corner outside, nestled safe in dry leaves and straw. I looked at them several times a day. Their fur, in the springtime, was misted with dewy rain. They mated for three days in the moldering leaves and fertile earth, moving together in that liquid way, then apart, like reflections on a mirror, a four-chambered black heart beating inside the closed tissue of wings. Between their long, starry finger bones were dark webbings of flesh, wings for sailing jagged across the evening sky. The black wing membranes were etched like the open palm of a human hand, stretched open, offering up a fortune for the reading. As I watched, the male stretched out, opened his small handlike claws to scratch his stomach, closed them again, and hid the future from my eyes.

By the fourth day, the male had become thin and exhausted. On that day he died and the female flew away with the new life inside her body.

For months after that, the local boys who terrorized the backyards of neighbors would not come near where I lived. I'd shown one the skeleton of the male and told them there were others. I could hear them talking in the alley late at night, saying, "Don't go in there. She has bats in her yard." So they'd smoke their cigarettes in a neighbor's yard while the neighbor watched them like a hawk from her kitchen window. My house escaped being vandalized.

My family lived in Germany once when I was a child. One day, exploring a forest with a friend, we came across a cave that went back into the earth. The dark air coming from inside the cave was cool, musty, and smelled damp as

spring, but the entryway itself was dark and forboding, the entrance to a world we didn't know. Gathering our courage, we returned the next day with flashlights and stolen matches. It was late afternoon, almost dusk, when we arrived back at the cave. We had no more than just sneaked inside and held up the light when suddenly there was a roaring tumult of sound. Bats began to fly. We ran outside to twilight just as the sky above us turned gray with a fast-moving cloud of their ragged wings, flying up, down, whipping air, the whole sky seething. Afraid, we ran off toward the safety of our homes, half-screaming, half-laughing through the path in the forest. Not even our skirts catching on the brambles slowed us down.

Later, when we mentioned the cave of bats, we were told that the cave itself had been an ammunition depot during World War II, and that bat guano was once used in place of gunpowder. During the war, in fact, the American military had experimented with bats carrying bombs. It was thought that they could be used to fly over enemy lines carrying explosives that would destroy the enemy. Unfortunately, one of them flew into the attic of the general's house and the bomb exploded. Another blew up a colonel's car. They realized that they could not control the direction a bat would fly and gave up on their strategy of using life to destroy life.

Recently I visited a cave outside of San Antonio with writer and friend Naomi Nye. It was only a small mouth of earth, but once inside it, the sanctuaries stretched out for long distances, a labyrinth of passageways. No bats have inhabited that cave since people began to intrude, but it was still full of guano. Some of it had been taken out in the 1940s to be used as gunpowder. Aside from that, all this time later, the perfect climate inside the cave preserved the guano in its original form, with thick gray layers, as fresh and moist as when the bats had lived there.

Bats hear their way through the world. They hear the sounds that exist at the edges of our lives. Leaping through blue twilight they cry out a thin language, then listen for its echo to return. It is a dusky world of songs a pitch above our own. For them, the world throws back a language, the empty space rising between hills speaks an open secret then lets the bats pass through, here or there, in the dark air. Everything answers, the corner of a house, the shaking leaves on a wind-blown tree, the solid voice of bricks. A fence post talks back. An insect is located. A wall sings out its presence. There are currents of air loud as ocean waves, a music of trees, stones, charred stovepipes. Even our noisy silences speak out in a dark dimension of sound that is undetected by our limited hearing in the loud, vibrant land in which we live.

Once, Tennessee writer Jo Carson stuck her hearing aid in my ear and said, "Listen to this." I could hear her speak, listening through the device. I could hear the sound of air, even the noise of cloth moving against our skin, and a place in the sky. All of it drowned out the voices of conversation. It was how a bat must hear the world, I thought, a world alive in its whispering songs, the currents of air loud as waves of an ocean, a place rich with the music of trees and stones.

It is no wonder that bats have been a key element in the medicine bundles of some southern tribes. Bats are people from the land of souls, land where moon dwells. They are listeners to our woes, hearers of changes in earth, predictors of earthquake and storm. They live with the goddess of night in the lusty mouth of earth.

Some of the older bundles, mistakenly opened by non-Indians, were found to contain the bones of a bat, wrapped carefully in brain-tanned rawhide. The skeletons were intact and had been found naturally rather than killed or trapped by people, which would have rendered them neutral; they would have withdrawn their assistance from people. Many Indian people must have waited years, searching caves and floors and the ground beneath trees where insects cluster, in order to find a small bony skull, spine, and the long finger bones of the folded wings. If a bat skeleton were found with meat still on it, it was placed beside an anthill, and the ants would pick the bones clean.

I believe it is the world-place bats occupy that allows them to be of help to people, not just because they live inside the passageways between earth and sunlight, but because they live in double worlds of many kinds. They are two animals merged into one, a milk-producing rodent that bears live young, and a flying bird. They are creatures of the dusk, which is the time between times, people of the threshold, dwelling at the open mouth of inner earth like guardians at the womb of creation.

The bat people are said to live in the first circle of holiness. Thus, they are intermediaries between our world and the next. Hearing the chants of life all around them, they are listeners who pass on the language and songs of many things to human beings who need wisdom, healing, and guidance through our lives, we who forget where we stand in the world. Bats know the world is constantly singing, know the world inside the turning and twisting of caves, places behind and beneath our own. As they scuttle across cave ceilings, they leave behind their scratch marks on the ceiling like an ancient alphabet written by diviners who traveled through and then were gone from the thirteen-month world of light and dark.

And what curing dwells at the center of this world of sounds above our own? Maybe it's as if earth's pole to the sky lives in a weightless cave, poking through a skin of dark and night and sleep.

At night, I see them out of the corner of my eye, like motes of dust, as secret as the way a neighbor hits a wife, a ghost cat slinks into a basement, or the world is eaten through by rust down to the very heart of nothing. What an enormous world. No wonder it holds our fears and desires. It is all so much larger than we are.

I see them through human eyes that turn around a vision, eyes that see the world upside down before memory rights it. I don't hear the high-pitched language of their living, don't know if they have sorrow or if they tell stories longer than a rainstorm's journey, but I see them. How can we get there from here, I wonder, to the center of the world, to the place where the universe carries down the song of night to our human lives. How can we listen or see to find our way by feel to the heart of every yes or no? How do we learn to trust ourselves enough to hear the chanting of earth? To know what's alive or absent around us, and penetrate the void behind our eyes, the old, slow pulse of things, until a wild flying wakes up in us, a new mercy climbs out and takes wing in the sky?

JUDITH ORTIZ COFER

(1952–2016)

Born in Hormigueros, Puerto Rico, Judith Ortiz Cofer shuttled back and forth between the United States and Puerto Rico as a child. Her father, Jesus Lugo, was a member of the U.S. Navy. Ortiz Cofer once remarked that her literary heritage was "nonintellectual in its beginnings," yet she credited her mother and grandmother for passing along their strong imaginations and story-telling skills. When Ortiz Cofer was fifteen, her father retired from the navy, and the family moved to Augusta, Georgia. In 1971 she married John Cofer, with whom she had one daughter. In 1974 she earned a bachelor's degree in English from Augusta College. Destined to be a teacher, Ortiz Cofer did not consider a writing career until she was a graduate student at Florida Atlantic University, where she received her master's degree in 1977. Faculty member Betty Owen, Ortiz Cofer's mentor, encouraged her to write and publish her poetry.

Ortiz Cofer's first full-length collection of poetry, *Terms of Survival*, appeared in 1987. Her first book of essays, *Silent Dancing: A Partial Remembrance of a Puerto Rican Childhood*, was published in 1990. *Silent Dancing* was awarded a Pushcart Prize, and the title essay in the collection was chosen for inclusion in *The Best American Essays 1991*. Ortiz Cofer went on to publish numerous books of poetry, novels, and essays, the latter of which appear in *The Latin Deli: Prose and Poetry* (1993) and *Woman in Front of the Sun: On Becoming a Writer* (2000). Her 2015 memoir, *The Cruel Country*, documents her return to Puerto Rico in 2011 to care for her dying mother.

In 1994 Ortiz Cofer told an interviewer for *Callaloo* that the most influential writer on her work was Virginia Woolf. "People smile when I say that I consider her one of my literary mothers," she acknowledged. Ortiz Cofer en-

countered Spanish and Latin American literary traditions only after she became a writer. In the otherwise male-dominated English literature that made up her education, Woolf was a model for Ortiz Cofer's own work. "I give credit to Virginia Woolf for having opened my eyes to the possibility of literary and artistic autonomy," Ortiz Cofer noted in that 1994 interview. A long-time writing professor at the University of Georgia in Athens, Ortiz Cofer died of cancer in 2016.

The Witch's Husband

First appeared in the Fall 1992 issue of *Kenyon Review*
and reprinted in *The Latin Deli*, 1993. This version is from the
The Latin Deli (New York: Norton, 1995), pp. 42–49.

My grandfather has misplaced his words again. He is trying to find my name in the kaleidoscope of images that his mind has become. His face brightens like a child's who has just remembered his lesson. He points to me and says my mother's name. I smile back and kiss him on the cheek. It doesn't matter what names he remembers anymore. Every day he is more confused, his memory slipping back a little further in time. Today he has no grandchildren yet. Tomorrow he will be a young man courting my grandmother again, quoting bits of poetry to her. In months to come, he will begin calling her Mamá.

I have traveled to Puerto Rico at my mother's request to help her deal with the old people. My grandfather is physically healthy, but his dementia is severe. My grandmother's heart is making odd sounds again in her chest. Yet she insists on taking care of the old man at home herself. She will not give up her house, though she has been warned that her heart might fail in her sleep without proper monitoring, that is, a nursing home or a relative's care. Her response is typical of her famous obstinacy: "*Bueno*," she says, "I will die in my own bed."

I am now at her house, waiting for my opportunity to talk "sense" into her. As a college teacher in the United States I am supposed to represent the voice of logic; I have been called in to convince *la abuela*, the family's proud matriarch, to step down—to allow her children to take care of her before she kills herself with work. I spent years at her house as a child but have lived in the U.S. for most of my adult life. I learned to love and respect this strong woman, who with five children of her own had found a way to help many others. She was a

legend in the pueblo for having more foster children than anyone else. I have spoken with people my mother's age who told me that they had spent up to a year at Abuela's house during emergencies and hard times. It seems extraordinary that a woman would willingly take on such obligations. And frankly, I am a bit appalled at what I have begun to think of as "the martyr complex" in Puerto Rican women, that is, the idea that self-sacrifice is a woman's lot and her privilege: a good woman is defined by how much suffering and mothering she can do in one lifetime. Abuela is the all-time champion in my eyes: her life has been entirely devoted to others. Not content to bring up two sons and three daughters as the Depression raged on, followed by the war that took one of her sons, she had also taken on other people's burdens. This had been the usual pattern with one exception that I knew of: the year that Abuela spent in New York, apparently undergoing some kind of treatment for her heart while she was still a young woman. My mother was five or six years old, and there were three other children who had been born by that time too. They were given into the care of Abuela's sister, Delia. The two women traded places for the year. Abuela went to live in her sister's apartment in New York City while the younger woman took over Abuela's duties at the house in Puerto Rico. Grandfather was a shadowy figure in the background during that period. My mother doesn't say much about what went on during that year, only that her mother was sick and away for months. Grandfather seemed absent too, since he worked all of the time. Though they missed Abuela, they were well taken care of.

I am sitting on a rocking chair on the porch of her house. She is facing me from a hammock she made when her first baby was born. My mother was rocked on that hammock. I was rocked on that hammock, and when I brought my daughter as a baby to Abuela's house, she was held in Abuela's sun-browned arms, my porcelain pink baby, and rocked to a peaceful sleep too. She sits there and smiles as the breeze of a tropical November brings the scent of her roses and her herbs to us. She is proud of her garden. In front of the house she grows flowers and lush trailing plants; in the back, where the mango tree gives shade, she has an herb garden. From this patch of weedy-looking plants came all the remedies of my childhood, for anything from a sore throat to menstrual cramps. Abuela had a recipe for every pain that a child could dream up, and she brought it to your bed in her own hands smelling of the earth. For a moment I am content to sit in her comforting presence. She is rotund now; a small-boned brown-skinned earth mother—with a big heart and a temper

to match. My grandfather comes to stand at the screen door. He has forgotten how the latch works. He pulls at the knob and moans softly, rattling it. With some effort Abuela gets down from the hammock. She opens the door, gently guiding the old man to a chair at the end of the porch. There he begins anew his constant search for the words he needs. He tries various combinations, but they don't work as language. Abuela pats his hand and motions for me to follow her into the house. We sit down at opposite ends of her sofa.

She apologizes to me as if for a misbehaving child.

"He'll quiet down," she says. "He does not like to be ignored."

I take a deep breath in preparation for my big lecture to Grandmother. This is the time to tell her that she has to give up trying to run this house and take care of others at her age. One of her daughters is prepared to take her in. Grandfather is to be sent to a nursing home. Before I can say anything, Abuela says: "Mi amor, would you like to hear a story?"

I smile, surprised at her offer. These are the same words that stopped me in my tracks as a child, even in the middle of a tantrum. Abuela could always entrance me with one of her tales. I nod. Yes, my sermon can wait a little longer, I thought.

"Let me tell you an old, old story I heard when I was a little girl.

"There was once a man who became worried and suspicious when he noticed that his wife disappeared from their bed every night for long periods of time. Wanting to find out what she was doing before confronting her, the man decided to stay awake at night and keep guard. For hours he watched her every movement through half-closed eyelids with his ears perked up like those of a burro.

"Then just about midnight, when the night was as dark as the bottom of a cauldron, he felt his wife slipping out of bed. He saw her go to the wardrobe and take out a jar and a little paintbrush. She stood naked by the window, and when the church bells struck twelve, she began to paint her entire body with the paintbrush, dipping it into the jar. As the bells tolled the hour, she whispered these words: *I don't believe in the church, or in God, or in the Virgin Mary*. As soon as this was spoken, she rose from the ground and flew into the night like a bird.

"Astounded, the man decided not to say anything to his wife the next day, but to try to find out where she went. The following night, the man pretended to sleep and waited until she had again performed her little ceremony and flown away, then he repeated her actions exactly. He soon found himself flying

after her. Approaching a palace, he saw many other women circling the roof, taking turns going down the chimney. After the last had descended, he slid down the dark hole that led to the castle's bodega, where food and wine were stored. He hid himself behind some casks of wine and watched the women greet each other.

"The witches, for that's what they were, were the wives of his neighbors and friends, but he at first had trouble recognizing them, for like his wife, they were all naked. With much merriment, they took the meats and cheeses that hung from the bodega's rafters and laid a table for a feast. They drank the fine wines right from the bottles, like men in a cantina, and danced wildly to eerie music from invisible instruments. They spoke to each other in a language that he did not understand, words that sounded like a cat whose tail has been stepped on. Still, horrible as their speech was, the food they prepared smelled delicious. Cautiously placing himself in the shadows near one of the witches, he extended his hand for a plate. He was given a steaming dish of stewed tongue. Hungrily, he took a bite: it was tasteless. The other witches had apparently noticed the same thing, because they sent one of the younger ones to find some salt. But when the young witch came back into the room with a saltshaker in her hand, the man forgot himself and exclaimed: 'Thank God the salt is here.'

"On hearing God's name, all the witches took flight immediately, leaving the man completely alone in the darkened cellar. He tried the spell for flight that had brought him there, but it did not work. It was no longer midnight, and it was obviously the wrong incantation for going *up* a chimney. He tried all night to get out of the place, which had been left in shambles by the witches, but it was locked up as tight as heaven is to a sinner. Finally, he fell asleep from exhaustion, and slept until dawn, when he heard footsteps approaching. When he saw the heavy door being pushed open, he hid himself behind a cask of wine.

"A man in rich clothes walked in, followed by several servants. They were all armed with heavy sticks as if out to kill someone. When the man lit his torch and saw the chaos in the cellar, broken bottles strewn on the floor, meats and cheeses half-eaten and tossed everywhere, he cried out in such a rage that the man hiding behind the wine cask closed his eyes and committed his soul to God. The owner of the castle ordered his servants to search the whole bodega, every inch of it, until they discovered how vandals had entered his home. It was a matter of minutes before they discovered the witch's husband, curled up

like a stray dog and, worse, painted the color of a vampire bat, without a stitch of clothing.

"They dragged him to the center of the room and beat him with their sticks until the poor man thought that his bones had been pulverized and he would have to be poured into his grave. When the castle's owner said that he thought the wretch had learned his lesson, the servants tossed him naked onto the road. The man was so sore that he slept right there on the public *camino*, oblivious to the stares and insults of all who passed him. When he awakened in the middle of the night and found himself naked, dirty, bloody, and miles from his home, he swore to himself right then and there that he would never, for anything in the world, follow his wife on her nightly journeys again."

"Colorín, colorado," Abuela claps her hands three times, chanting the childhood rhyme for ending a story, "Este cuento se ha acabado." She smiles at me, shifting her position on the sofa to be able to watch Grandfather muttering to himself on the porch. I remember those eyes on me when I was a small child. Their movements seemed to be triggered by a child's actions, like those holograms of the Holy Mother that were popular with Catholics a few years ago—you couldn't get away from their mesmerizing gaze.

"Will you tell me about your year in New York, Abuela?" I surprise myself with the question. But suddenly I need to know about Abuela's lost year. It has to be another good story.

She looks intently at me before she answers. Her eyes are my eyes, same dark brown color, almond shape, and the lids that droop a little: called by some "bedroom eyes"; to others they are a sign of a cunning nature. "Why are you looking at me that way?" is a question I am often asked.

"I wanted to leave home," she says calmly, as though she had been expecting the question from me all along.

"You mean abandon your family?" I am really taken aback by her words.

"Yes, Hija. That is exactly what I mean. Abandon them. Never to return."

"Why?"

"I was tired. I was young and pretty, full of energy and dreams." She smiles as Grandfather breaks into song standing by himself on the porch. A woman passing by with a baby in her arms waves at him. Grandfather sings louder, something about a man going to his exile because the woman he loves has rejected him. He finishes the song on a long note and continues to stand in the middle of the tiled porch as if listening for applause. He bows.

Abuela shakes her head, smiling a little, as if amused by his antics, then she

finishes her sentence, "Restless, bored. Four children and a husband all demanding more and more from me."

"So you left the children with your sister and went to New York?" I say, trying to keep the mixed emotions I feel out of my voice. I look at the serene old woman in front of me and cannot believe that she once left four children and a loving husband to go live alone in a faraway country.

"I had left him once before, but he found me. I came back home, but on the condition that he never follow me anywhere again. I told him the next time I would not return." She is silent, apparently falling deep into thought.

"You were never really sick," I say, though I am afraid that she will not resume her story. But I want to know more about this woman whose life I thought was an open book.

"I *was* sick. Sick at heart. And he knew it," she says, keeping her eyes on Grandfather, who is standing as still as a marble statue on the porch. He seems to be listening intently for something.

"The year in New York was his idea. He saw how unhappy I was. He knew I needed to taste freedom. He paid my sister Delia to come take care of the children. He also sublet her apartment for me, though he had to take a second job to do it. He gave me money and told me to go."

"What did you do that year in New York?" I am both stunned and fascinated by Abuela's revelation. "I worked as a seamstress in a fancy dress shop. And . . . y pues, Hija," she smiles at me as if I should know some things without being told, "I lived."

"Why did you come back?" I ask.

"Because I love him," she says, "and I missed my children."

He is scratching at the door. Like a small child he has traced the sound of Abuela's voice back to her. She lets him in, guiding him gently by the hand. Then she eases him down on his favorite rocking chair. He begins to nod; soon he will be sound asleep, comforted by her proximity, secure in his familiar surroundings. I wonder how long it will take him to revert to infantilism. The doctors say he is physically healthy and may live for many years, but his memory, verbal skills, and ability to control his biological functions will deteriorate rapidly. He may end his days bedridden, perhaps comatose. My eyes fill with tears as I look at the lined face of this beautiful and gentle old man. I am in awe of the generosity of spirit that allowed him to give a year of freedom to the woman he loved, not knowing whether she would ever return to him. Abuela has seen my tears and moves over on the sofa to sit near me. She slips an arm around my waist and pulls me close. She kisses my wet cheek. Then she whis-

pers softly into my ear, "and in time, the husband either began forgetting that he had seen her turn into a witch or believed that he had just dreamed it."

She takes my face into her hands. "I am going to take care of your grandfather until one of us dies. I promised him when I came back that I would never leave home again unless he asked me to: he never did. He never asked any questions."

I hear my mother's car pull up into the driveway. She will wait there for me. I will have to admit that I failed in my mission. I will argue Abuela's case without revealing her secret. As far as everyone is concerned she went away to recover from problems with her heart. That part is true in both versions of the story.

At the door she gives me the traditional blessing, adding with a wink, "Colorín, colorado." My grandfather, hearing her voice, smiles in his sleep.

CYNTHIA OZICK

(1928–)

Cynthia Ozick was born in New York City, where her father and mother, both
Russian immigrants, owned a drugstore. One year after her birth, she moved
with her parents and older brother to the Bronx, where her parents had pur-
chased a pharmacy. Determination and discrimination marked Ozick's early
education—because she was a girl and because she was Jewish. These two
themes appear in various forms in her later fiction and nonfiction. But Ozick
persevered, graduating from New York University with a bachelor's degree in
1949, and from Ohio State University with a master's degree in 1950. In 1952
she married Bernard Hallote, with whom she had a daughter. A novel titled
Trust (1966), her first book, appeared in 1966 and instantly attracted critical
notice. Much of Ozick's early work was in fiction. Her next three books, *The
Pagan Rabbi, and Other Stories* (1971), *Bloodshed and Three Novellas* (1976),
and *Levitation: Five Fictions* (1982), all won awards. A contributor to various
periodicals, Ozick published her first essay collection, *Art and Ardor: Essays*,
in 1983. She then published *Metaphor and Memory: Essays* (1989), *Fame and
Folly: Essays* (1996), and *Quarrel & Quandary* (2000), which was nominated
for a National Book Award. Ozick served as the guest editor of the 1998 *The
Best American Essays* anthology. Her most recent essay collections are *The Din
in the Head* (2006) and *Critics, Monsters, Fanatics, and Other Literary Essays*
(2016).

A Drug Store Eden

First appeared in the September 16, 1996, issue of the *New Yorker* and reprinted in *Quarrel & Quandary* (New York: Knopf, 2000), pp. 188–203.

In 1929 my parents sold their drug store in Yorkville—a neighborhood comprising Manhattan's East Eighties—and bought a pharmacy in Pelham Bay, in the northeast corner of the Bronx. It was a move from dense city to almost country. Pelham Bay was at the very end of a relatively new stretch of elevated train track that extended from the subway of the true city all the way out to the small-town feel of little houses and a single row of local shops: shoemaker's, greens store, grocery, drug store, bait store. There was even a miniature five-and-ten where you could buy pots, housedresses, and thick lisle stockings for winter. Three stops down the line was the more populous Westchester Square, with its bank and post office, which old-timers still called "the village"—Pelham Bay had once lain outside the city limits, in Westchester County.

This lost little finger of the borough was named for the broad but mild body of water that rippled across Long Island Sound to a blurry opposite shore. All the paths of Pelham Bay Park led down to a narrow beach of rough pebbles, and all the surrounding streets led, sooner or later, to the park, wild and generally deserted. Along many of these streets there were empty lots that resembled meadows, overgrown with Queen Anne's lace and waist-high weeds glistening with what the children termed "snake spit"; poison ivy crowded between the toes of clumps of sky-tall oaks. The snake spit was a sort of bubbly botanical excretion, but there were real snakes in those lots, with luminescent skins, brownish-greenish, crisscrossed with white lines. There were real meadows, too: acres of downhill grasses, in the middle of which you might suddenly come on a set of rusty old swings—wooden slats on chains—or a broken red-brick wall left over from some ruined and forgotten Westchester estate.

The Park View Pharmacy—the drug store my parents bought—stood on the corner of Colonial Avenue, between Continental and Burr: Burr for Aaron Burr, the Vice President who killed Alexander Hamilton in a duel. The neighborhood had a somewhat bloodthirsty Revolutionary flavor. Not far away you could still visit Spy Oak, the venerable tree on which captured Redcoats had once been hanged; and now and then Revolutionary bullets were churned up a foot or so beneath the front lawn of the old O'Keefe house, directly across the street from the Park View Pharmacy. George Washington

had watered his horses, it was believed, in the ancient sheds beyond Ye Olde Homestead, a local tavern that, well after Prohibition, was still referred to as the "speak-easy." All the same, there were no Daughters of the American Revolution here: instead, Pelham Bay was populated by the children of German, Irish, Swedish, Scottish, and Italian immigrants, and by a handful of the original immigrants themselves. The greenhorn Italians, from Naples and Sicily, kept goats and pigs in their back yards, and pigeons on their roofs. Pelham Bay's single Communist—you could tell from the election results that there was such a rare bird—was the Scotsman who lived around the corner, though only my parents knew this. They were privy to the neighborhood's opinions, ailments, and family secrets.

In those years a drug store seemed one of the world's permanent institutions. Who could have imagined that it would one day vanish into an aisle in the supermarket, or re-emerge as a kind of supermarket itself? What passes for a pharmacy nowadays is all open shelves and ceiling racks of brilliant white neon suggesting perpetual indoor sunshine. The Park View, by contrast, was a dark cavern lined with polished wood cabinets rubbed nearly black and equipped with sliding glass doors and mirrored backs. The counters were heaped with towering ziggurats of lotions, potions, and packets, and under them ran glassed-in showcases of the same sober wood. There was a post office (designated a "substation") that sold penny postcards and stamps and money orders. The prescription area was in the rear, closed off from view: here were scores of labeled drawers of all sizes, and rows of oddly shaped brown bottles. In one of those drawers traditional rock candy was stored, in two flavors, plain and maple, dangling on long strings. And finally there was the prescription desk itself, a sloping lecternlike affair on which the current prescription ledger always lay, like some sacred text.

There was also a soda fountain. A pull at a long black handle spurted out carbonated water; a push at a tiny silver spout drew out curly drifts of whipped cream. The air in this part of the drug store was steamy with a deep coffee fragrance, and on wintry Friday afternoons the librarians from the Traveling Library, a green truck that arrived once a week, would linger, sipping and gossiping on the high-backed fountain chairs, or else at the little glass-topped tables nearby, with their small three-cornered seats. Everything was fashioned of the same burnished chocolate-colored wood; but the fountain counters were heavy marble. Above the prescription area, sovereign over all, rose a symbolic pair of pharmacy globes, one filled with red fluid, the other with blue. My father's diploma, class of 1917, was mounted on a wall; next to it hung a picture

of the graduates. There was my very young father, with his round pale eyes and widow's peak—a fleck in a mass of black gowns.

Some time around 1937, my mother said to my father, "Willie, if we don't do it now, we'll never do it."

It was the trough of the Great Depression. In the comics, Pete the Tramp was swiping freshly baked pies set out to cool on windowsills; and in real life, tramps (as the homeless were then called) were turning up in the Park View nearly every day. Sometimes they were city drunks—"Bowery bums"—who had fallen asleep on the subway downtown and had ended up in Pelham Bay. Sometimes they were exhausted Midwesterners who had been riding the rails, and had rolled off into the obscuring cattails of the Baychester marsh. But always my father sat them down at the fountain and fed them a sandwich and soup. They smelled bad, these penniless tramps, and their eyes were red and rheumy; often they were very polite. They never left without a meal and a nickel for carfare.

No one was worse off than the tramps, or more desolate than the family who lived in an old freight car on the way to Westchester Square; but no one escaped the Depression. It stalked the country, it stalked Pelham Bay, it stalked the Park View. Drugstore hours were famously long—monstrously long: seven days a week the Park View opened at nine a.m. and closed at two the next morning. My mother scurried from counter to counter, tended the fountain, unpacked cartons, climbed ladders; her varicose veins oozed through their strappings. My father patiently ground powders, and folded the white dust into translucent paper squares with elegantly efficient motions. The drug store was, besides, a public resource: my father bandaged cuts, took specks out of strangers' eyes, and once removed a fishhook from a man's cheek—though he sent him off to the hospital, on the other side of the Bronx, immediately afterward. My quiet father had cronies and clients, grim women and voluble men who flooded his understanding ears with the stories of their sufferings, of flesh or psyche. My father murmured and comforted, and later my parents would whisper sadly about who had "the big C," or, with an ominous gleam, they would smile over a geezer certain to have a heart attack: the geezer would be newly married to a sweet young thing. (And usually they were right about the heart attack.)

Yet no matter how hard they toiled, they were always in peril. There were notes to pay off; they had bought the Park View from a pharmacist named Robbins, and every month, relentlessly, a note came due. They never fell behind, and never missed a payment (and, in fact, were eventually awarded a

certificate attesting to this feat); but the effort—the unremitting pressure, the endless anxiety—ground them down. "The note, the note," I would hear, a refrain that shadowed my childhood, though I had no notion of what it meant.

What it meant was that the Depression, which had already crushed so many, was about to crush my mother and father: suddenly their troubles intensified. The Park View was housed in a building owned by a catlike woman my parents habitually referred to, whether out of familiarity or resentment, only as Tessie. The pharmacy's lease was soon to expire, and at this moment, in the cruelest hour of the Depression, Tessie chose to raise the rent. Her tiger's eyes narrowed to slits: no appeal could soften her.

It was because of those adamant tiger's eyes that my mother said, "Willie, if we don't do it now, we'll never do it."

My mother was aflame with ambition, emotion, struggle. My father was reticent, and far more resigned to the world as given. Once, when the days of the Traveling Library were over, and a real library had been constructed at Westchester Square—you reached it by trolley—I came home elated, carrying a pair of books I had found side by side. One was called *My Mother Is a Violent Woman*; the other was *My Father Is a Timid Man*. These seemed a comic revelation of my parents' temperaments. My mother was all heat and enthusiasm. My father was all logic and reserve. My mother, unrestrained, could have run an empire of drug stores. My father was satisfied with one.

Together they decided to do something revolutionary; something virtually impossible in those raw and merciless times. One street over—past McCardle's sun-baked gas station, where there was always a Model-T Ford with its hood open for repair, and past the gloomy bait store, ruled over by Mr. Isaacs, a dour and reclusive veteran of the Spanish-American War who sat reading military histories all day under a mastless sailboat suspended from the ceiling—lay an empty lot in the shape of an elongated lozenge. My parents' daring plan—for young people without means it was beyond daring—was to buy that lot and build on it, from scratch, a brand-new Park View Pharmacy.

They might as well have been dreaming of taking off in Buck Rogers' twenty-fifth-century rocket ship. The cost of the lot was a stratospheric $13,500, unchanged from the Boom of 1928, just before the national wretchedness descended; and that figure was only for the land. After that would come the digging of a foundation and the construction of a building. What was needed was a miracle.

One sad winter afternoon my mother was standing on a ladder, concentrating on setting out some newly arrived drug items on a high shelf. (Although a

typical drug store stocked several thousand articles, the Park View's unit-by-unit inventory was never ample. At the end of every week I would hear my father's melodious, impecunious chant on the telephone, ordering goods from the jobber: "A sixth of a dozen, a twelfth of a dozen . . .") A stranger wearing a brown fedora and a long overcoat entered, looked around, and appeared not at all interested in making a purchase; instead he went wandering from case to case, picking things up and putting them down again, trying to be inconspicuous, asking an occasional question or two, all the while scrupulously observing my diligent and tireless parents. The stranger turned out to be a mortgage officer from the American Bible Society, and what he saw, he explained afterward, was a conscientious application of the work ethic; so it was the American Bible Society that supplied the financial foundation of my parents' Eden, the new Park View. They had entertained an angel unawares.

The actual foundation, the one to be dug out of the ground, ran into instant trouble. An unemployed civil engineer named Levinson presided over the excavation; he was unemployed partly because the Depression had dried up much of the job market, but mostly because engineering firms in those years were notorious for their unwillingness to hire Jews. Poor Levinson! The vast hole in the earth that was to become the Park View's cellar filled up overnight with water; the bay was near, and the water table was higher than the hapless Levinson had expected. The work halted. Along came Finnegan and rescued Levinson: Finnegan the plumber, who for a painful fee of fifty dollars (somehow squeezed out of Levinson's mainly empty pockets) pumped out the flood.

After the Park View's exultant move in 1939, the shell of Tessie's old place on Colonial Avenue remained vacant for years. No one took it over; the plate-glass windows grew murkier and murkier. Dead moths were heaped in decaying mounds on the inner sills. Tessie had lost more than the heartless increase she had demanded, and more than the monthly rent the renewed lease would have brought: there was something ignominious and luckless—tramp-like—about that fly-specked empty space, now dimmer than ever. But within its freshly risen walls, the Park View Redux gleamed. Overhead, fluorescent tubes—an indoor innovation—shed a steady white glow, and a big square skylight poured down shifting shafts of brilliance. Familiar objects appeared clarified in the new light: the chocolate-colored fixtures, arranged in unaccustomed configurations, were all at once thrillingly revivified. Nothing from the original Park View had been left behind—everything was just the same, yet zanily out of order: the two crystal urns with their magical red and blue fluids suggestive of alchemy; the entire stock of syrups, pills, tablets, powders,

pastes, capsules; tubes and bottles by the hundreds; all the contents of all the drawers and cases; the fountain with its marble top; the prescription desk and its sacrosanct ledger; the stacks of invaluable cigar boxes stuffed with masses of expired prescriptions; the locked and well-guarded narcotics cabinet; the post office, and the safe in which the post office receipts were kept. Even the great, weighty, monosyllabically blunt hanging sign—"DRUGS"—had been brought over and rehung, and it too looked different now. In the summer heat it dropped its black rectangular shadow over Mr. Isaacs' already shadowy head-quarters, where vials of live worms were crowded side by side with vials of nails and screws.

At around this time my mother's youngest brother, my uncle Rubin, had come to stay with us—no one knew for how long—in our little house on Saint Paul Avenue, a short walk from the Park View. Five of us lived in that house: my parents, my grandmother, my brother and I. Rubin, who was called Ruby, was now the sixth. He was a bachelor and something of a family enigma. He was both bitter and cheerful; effervescence would give way to lassitude. He taught me how to draw babies and bunnies, and could draw anything him-self; he wrote ingenious comic jingles, which he illustrated as adroitly, it struck me, as Edward Lear; he cooked up mouth-watering corn fritters, and designed fruit salads in the shape of ravishing unearthly blossoms. When now and then it fell to him to put me to bed, he always sang the same heartbreaking lullaby: "Sometimes I fee-eel like a motherless child, a long, long way-ay from ho-ome," in a deep and sweet quaver. In those days he was mostly jobless; on occasion he would crank up his Tin Lizzie and drive out to upper Westchester to prune trees. Once he was stopped at a police roadblock, under suspicion of being the Lindbergh baby kidnapper—the back seat of his messy old Ford was strewn with ropes, hooks, and my discarded baby bottles.

Ruby had been disappointed in love, and was somehow a disappointment to everyone around him. When he was melancholy or resentful, the melan-choly was irritable and the resentment acrid. As a very young man he had been single-minded in a way none of his immigrant relations, or the snobbish mother of the girlfriend who had been coerced into jilting him, could under-stand or sympathize with. In Czarist Russia's restricted Pale of Settlement, a pharmacist was the highest vocation a Jew could attain to. In a family of phar-macists, Ruby wanted to be a farmer. Against opposition, he had gone off to the National Farm School in New Jersey—one of several Jewish agricultural projects sponsored by the German philanthropist Baron Maurice de Hirsch. Ruby was always dreaming up one sort of horticultural improvement or an-

other, and sometimes took me with him to visit a certain Dr. McClain, at the Bronx Botanical Gardens, whom he was trying to interest in one of his inventions. He was kindly received, but nothing came of it. Despite his energy and originality, all of Ruby's hopes and strivings collapsed in futility.

All the same, he left an enduring mark on the Park View. It was a certain circle of stones—a mark more distinctive than his deserted bachelor's headstone in an overgrown cemetery on Staten Island.

Ruby assisted in the move from Tessie's place to the new location. His presence was fortuitous—but his ingenuity, it would soon develop, was benison from the goddess Flora. The Park View occupied all the width but not the entire depth of the lot on which it was built. It had, of course, a welcoming front door, through which customers passed; but there was also a back door, past a little aisle adjoining the prescription room in the rear of the store, and well out of sight. When you walked out this back door, you were confronted by an untamed patch of weeds and stones, some of them as thick as boulders. At the very end of it lay a large flat rock, in the center of which someone had scratched a mysterious X. The X, it turned out, was a surveyor's mark; it had been there long before my parents bought the lot. It meant that the property extended to that X and no farther.

I was no stranger either to the lot or its big rock. It was where the neighborhood children played—a sparse group in that sparsely populated place. Sometimes the rock was a pirate ship; sometimes it was a pretty room in a pretty house; in January it held a snow fort. But early one summer evening, when the red ball of the sun was very low, a little girl named Theresa, whose hair was as red as the sun's red ball, discovered the surveyor's X and warned me against stamping on it. If you stamp on a cross, she said, the devil's helpers climb right out from inside the earth and grab you and take you away to be tortured. "I don't believe that," I said, and stamped on the X as hard as I could. Instantly Theresa sent out a terrified shriek; chased by the red-gold zigzag of her hair, she fled. I stood there abandoned—suppose it was true? In the silence all around, the wavering green weeds seemed taller than ever before.

Looking out from the back door at those same high weeds stretching from the new red brick of the Park View's rear wall all the way to the flat rock and its X, my mother, like Theresa, saw hallucinatory shapes rising out of the ground. But it was not the devil's minions she imagined streaming upward; it was their very opposite—a vision of celestial growths and fragrances, brilliant botanical hues, golden pears and yellow sunflower-faces, fruitful vines and dreaming gourds. She imagined an enchanted garden. She imagined a secret Eden.

Ruby was angry at my mother; he was angry at everyone but me: I was too young to be held responsible for his lost loves and aspirations. But he could not be separated from his love of fecund dirt. Dirt—the brown dirt of the earth—inspired him; the feel and smell of dirt uplifted him; he took an artist's pleasure in the soil and all its generative properties. And though he claimed to scorn my mother, he became the subaltern of her passion. Like some wizard commander of the stones—they were scattered everywhere in a wild jumble— he swept them into orderliness. A pack of stones was marshaled into a low wall. Five stones were transformed into a perfect set of stairs. Seven stones surrounded what was to become a flower bed. Stones were borders, stones were pathways, stones—placed just so—were natural sculptures.

And finally Ruby commanded the stones to settle in a circle in the very center of the lot. Inside the circle there was to be a green serenity of grass, invaded only by the blunders of violets and wandering buttercups. Outside the circle the earth would be a fructifying engine. It was a dreamer's circle, like the moon or the sun; or a fairy ring; or a mystical small Stonehenge, miniaturized by a spell.

The back yard was cleared, but it was not yet a garden. Like a merman combing a mermaid's weedy hair, my uncle Ruby had unraveled primeval tangles and brambles. He had set up two tall metal poles to accommodate a rough canvas hammock, with a wire strung from the top of one pole to the other. Over this wire a rain-faded old shop-awning had been flung, so that the hammock became a tent or cave or darkened den. A backyard hammock! I had encountered such things only in storybooks.

And then my uncle was gone. German tanks were biting into Europe. Weeping, my grandmother pounded her breast with her fist: the British White Paper of 1939 had declared that ships packed with Jewish refugees would be barred from the beaches of Haifa and Tel Aviv and returned to a Nazi doom. In P.S. 71, our neighborhood school, the boys were drawing cannons and warplanes; the girls were drawing figure skaters in tutus; both boys and girls were drawing the Trylon and the Perisphere. The Trylon was a three-sided obelisk. The Perisphere was a shining globe. They were already as sublimely legendary as the Taj Mahal. The official colors of the 1939 World's Fair were orange and blue—everyone knew this; everyone had ridden in noiselessly moving armchairs into the Fair's World of Tomorrow, where the cloverleaf highways of the impossibly futuristic nineteen-sixties materialized among inconceivable suburbs. In the magical lanes of Flushing you could watch yourself grin on a television screen as round and small as the mouth of a teacup. My grandmother,

in that frail year of her dying, was taken to see the Palestine Pavilion, with its flickering films of Jewish pioneers.

Ruby was drafted before the garden could be dug. He sent a photograph of himself in Army uniform, and a muffled recording of his voice, all songs and jolly jingles, from a honky-tonk arcade in an unnamed Caribbean town.

So it was left to my mother to dig the garden. I have no inkling of when or how. I lived inside the hammock all that time, under the awning, enclosed; I read and read. Sometimes, for a treat, I would be given two nickels for carfare and a pair of quarters, and then I would climb the double staircase to the train and go all the way to Fifty-ninth Street: you could enter Bloomingdale's directly from the subway, without ever glimpsing daylight. I would run up the steps to the book department on the mezzanine, moon over the Nancy Drew series in an agony of choosing (*The Mystery of Larkspur Lane*, *The Mystery of the Whispering Statue*, each for fifty cents), and run down to the subway again, with my lucky treasure. An hour and a half later, I would be back in the hammock, under the awning, while the afternoon sun broiled on. But such a trip was rare. Mostly the books came from the Traveling Library; inside my hammock-cave the melting glue of new bindings sent out a blissful redolence. And now my mother would emerge from the back door of the Park View, carrying—because it was so hot under the awning—half a cantaloupe, with a hillock of vanilla ice cream in its scooped-out center. (Have I ever been so safe, so happy, since? Has consciousness ever felt so steady, so unimperiled, so immortal?)

Across the ocean, synagogues were being torched, refugees were in flight. On American movie screens Ginger Rogers and Fred Astaire whirled in and out of the March of Time's grim newsreels—Chamberlain with his defeatist umbrella, the Sudetenland devoured, Poland invaded. Meanwhile my mother's garden grew. The wild raw field Ruby had regimented was ripening now into a luxuriant and powerful fertility: all around my uncle's talismanic ring of stones the ground swelled with thick savory smells. Corn tassels hung down over the shut greenleaf lids of pearly young cobs. Fat tomatoes reddened on sticks. The bumpy scalps of cucumbers poked up. And flowers! First, as tall as the hammock poles, a flock of hunchbacked sunflowers, their heads too weighty for their shoulders—huge heavy heads of seeds, and a ruff of yellow petals. At their feet, rows of zinnias and marigolds, with tiny violets and the weedy pink buds of clover sidling between.

Now and then a praying mantis—a stiffly marching fake leaf—would rub its skinny forelegs together and stare at you with two stern black dots. And

butterflies! These were mostly white and mothlike; but sometimes a great black-veined monarch would alight on a stone, in perfect stillness. Year by year the shade of a trio of pear trees widened and deepened.

Did it rain? It must have rained—it must have thundered—in those successive summers of my mother's garden; but I remember a perpetual sunlight, hot and honeyed, and the airless boil under the awning, and the heart-piercing scalliony odor of library glue (so explicit that I can this minute re-create it in my very tear ducts, as a kind of mourning); and the fear of bees.

Though I was mostly alone there, I was never lonely in the garden. But on the other side of the door, inside the Park View, an unfamiliar churning had begun—a raucous teeming, the world turning on its hinge. In the aftermath of Pearl Harbor, there were all at once jobs for nearly everyone, and money to spend in any cranny of wartime leisure. The Depression was receding. On weekends the subway spilled out mobs of city picnickers into the green fields of Pelham Bay Park, bringing a tentative prosperity to the neighborhood—especially on Sundays. I dreaded and hated this new Sunday frenzy, when the Park View seemed less a pharmacy than a carnival stand, and my own isolation grew bleak. Open shelves sprouted in the aisles, laden with anomalous racks of sunglasses, ice coolers, tubes of mosquito repellent and suntan lotion, paper cups, colorful towers of hats—sailors' and fishermen's caps, celluloid visors, straw topis and sombreros, headgear of every conceivable shape. Thirsty picnickers stood three deep at the fountain, clamoring for ice-cream cones or sodas. The low, serious drug-store voices that accompanied the Park View's weekday decorum were swept away by revolving laughing crowds—carnival crowds. And at the close of these frenetic summer Sundays, my parents would anxiously count up the cash register in the worn night of their exhaustion, and I would hear their joyful disbelief: unimaginable riches, almost seventy-five dollars in a single day!

Then, when the safe was locked up, and the long cords of the fluorescent lights pulled, they would drift in the dimness into the garden, to breathe the cool fragrance. At this starry hour the katydids were screaming in chorus, and fireflies bleeped like errant semaphores. In the enigmatic dark, my mother and father, with their heads together in silhouette, looked just then as I pictured them looking on the Albany night boat, on June 19, 1921, their wedding day. There was a serial photo from that long-ago time I often gazed at—a strip taken in an automatic-photo booth in fabled, faraway Albany. It showed them leaning close, my young father quizzical, my young mother trying to smile, or else trying not to; the corners of her lips wandered toward one loveliness or the

other. They had brought back a honeymoon souvenir: three sandstone monkeys joined at the elbows: see no evil, hear no evil, speak no evil. And now, in their struggling forties, standing in Ruby's circle of stones, they breathed in the night smells of the garden, onion grass and honeysuckle, and felt their private triumph. Seventy-five dollars in eighteen hours!

No one knew the garden was there. It was utterly hidden. You could not see it, or suspect it, inside the Park View, and because it was nested in a wilderness of empty lots all around, it was altogether invisible from any surrounding street. It was a small secluded paradise.

And what vegetable chargings, what ferocities of growth, the turbulent earth pushed out! Buzzings and dapplings. Birds dipping their beaks in an orgy of seed-lust. It was as if the ground itself were crying peace, peace; and the war began. In Europe the German death factories were pumping out smoke and human ash from a poisoned orchard of chimneys. In Pelham Bay, among bees and white-wing flutterings, the sweet brown dirt pumped ears of corn.

Nearly all the drug stores—of the old kind—are gone, in Pelham Bay and elsewhere. The Park View Pharmacy lives only in a secret Eden behind my eyes. Gone are Bernardini, Pressman, Weiss, the rival druggists on the way to Westchester Square. They all, like my father, rolled suppositories on glass slabs and ground powders with brass pestles. My mother's garden has returned to its beginning: a wild patch, though enclosed now by brick house after brick house. The houses have high stoops; they are city houses. The meadows are striped with highways. Spy Oak gave up its many ghosts long ago.

But under a matting of decayed pear pits and thriving ragweed back of what used to be the Park View, Ruby's circle of stones stands frozen. The earth, I suppose, has covered them over, as—far off in Staten Island—it covers my dreaming mother, my father, my grandmother, my resourceful and embittered farmer uncle.

JENNY DISKI

(1947–2016)

Born in London, England, Jenny Diski endured a childhood that was marked by poverty, violence, and abuse. These experiences are chronicled in *Skating to the Antarctica* (1997), an autobiographical travelogue that weaves her past life with her adventures on an Antarctic cruise. Diski's father, who had previously left Diski and her mother to fend for themselves, died when Diski was a teenager. Novelist and future Nobel laureate Doris Lessing, the mother of one of Diski's boarding school classmates, took Diski in when she was fifteen. Diski lived with Lessing for almost four years, and the women maintained a complicated and fraught relationship until Lessing's death in 2013. Like her mother, Diski suffered from depression and spent her college years in mental hospitals rather than in classrooms. In 1976 Diski married Roger Diski, with whom she had a daughter. The couple divorced, and Diski eventually met Ian Patterson, her partner until her death.

At the age of thirty-four, Diski decided to fulfill her lifelong dream of being a writer. Her first book, the novel *Nothing Natural*, was published in 1986. She wrote several additional dark, and darkly humorous, novels, as well as two books that combine travel writing and memoir, *Skating to Antarctica* (1997) and *Stranger on a Train: Daydreaming and Smoking Around America without Interruptions* (2002). Moreover, Diski published two collections of essays, *Don't* (1998) and *A View from the Bed and Other Observations* (2003), largely culled from her book reviews for the *London Review of Books*. In 2009 she published a memoir, *The Sixties*, and in 2010 she published *What I Don't Know About Animals* (2010). In 2014 Diski was diagnosed with inoperable lung cancer. Shortly before her death in 2016, she published her last book, *In Gratitude*, a memoir about her time with Lessing.

Rhythm Method

First appeared on September 22, 1994, in the *London Review*
of Books and later reprinted in *Don't*, 1998. This version is
from *Don't* (London: Granta, 1999), pp. 231–41.

R. D. Laing: A Biography, by Adrian Laing (Peter Owen, London, 1994)

Not long ago a friend of mine was walking back to her car after the cinema
when, not unusually for the time and the place, a distraught man placed him-
self in her way. She was not frightened; he was easily identified as mad, not
bad. A shuffling walk, a drooping, defeated posture which required a special
effort to raise his head so he could address her, and eyes, when they lifted,
which were more distressed than aggressive. He put out a hand, as if the fact of
his body being in her path would not be enough to gain her attention. "Can
I talk to you?" he asked. My friend felt around in her handbag and came up
with some money which she pressed into his hand. It was a normal inner city
exchange. Except that the man shook his head, put the money back into my
friend's open bag, took some more from his own pocket and dropped that in
too. "No, I've got money. It's not money. I want to talk to you," he said, and
launched into a rambling tale of woe about being evicted from his hostel and
how it felt to have nowhere to go and no one to tell. He was not asking for
anything except what is most difficult to give: time and attention.

At its simplest, at least in the early days, what the existential psychiatrists
were advocating was careful listening. Their point, though, was never that sim-
ple: they were advocating listening *for*, not just listening *to*. Apart from the fact
that psychotics, like everyone else, would benefit from being heard, there was
the bold suggestion that they were actually saying something which their doc-
tors needed to be told in order to do their job. The mad monologue contained
real information, and psychiatrists would have to listen to their patients in the
way medical doctors had to take into account what physically distressed pa-
tients said about the nature of the symptoms.

In the early Sixties, R. D. Laing and others began to define psychosis in
terms of its relation to society, and psychotics as individuals who in their own
way were making sense of their social circumstances. The mad might be alien-
ated, but they were not aliens, and therefore their doctors must be, not alien-
ists, but interpreters of the language of the alienated. If that seems obvious

now, we have Laing and his fellow theorists to thank for it. At the time it came as something of a revelation, not least because there was an audience beyond the psychiatric community primed by the zeitgeist of the late Fifties and early Sixties to fall on their ideas and make much—too much, perhaps—of them.

I was a member of that wider audience. When Volume One of *Sanity, Madness and the Family* by R. D. Laing and his colleague Aaron Esterson, was published in 1964, I was 17 and living in the house of a woman who had rescued me a couple of years before, both from my disordered family and from the psychiatric hospital I was stuck in. The book took the form of case-histories of diagnosed schizophrenics, but what made it different from the usual run of psychiatric textbooks was that the views and voices of the patients and their families were presented side by side.

It was the case of the "Abbotts" that made an impact on me. "Maya Abbott" believed that her parents were trying to influence her by telepathy and thought-control, and showed clinical signs of "catatonia . . . affective impoverishment and autistic withdrawal." Laing and Esterson discovered on speaking to the parents of the girl who now experienced herself as a machine, that for many years they had indeed been trying to influence her thoughts, believing her to be telepathic; that for some time before she became "ill" they'd been experimenting with their daughter—sending each other signals which "Maya" was not supposed to perceive—in order to test their hypothesis and alter her attitudes and behaviour.

For Laing and Esterson, the "Abbotts" confirmed their thesis that madness could have a socially intelligible basis. For me, there was a starburst of recognition. At 13, I fled my emotionally erratic mother and went to stay with my father, with whom I'd had no contact for three years, and Pam, the woman he lived with. It wouldn't be anyone's idea of fun to have an angry adolescent arrive out of the blue, but the way Pam responded to me was, from the moment I arrived, mystifyingly aggressive. Nothing I did was right; everything was criticised or scorned. She ignored me when I tried to initiate or join in conversations, but called me idle and useless when she found me reading. She objected to me spending too much time in my room, but if I walked into the living room she'd go silent and turn her back on me. She complained that I didn't help out with the chores, but when, after that, I made a cup of tea after a meal, she poured it away and made a new pot. I wasted money by taking too many and too deep baths, but I was also "dirty." It seemed to me that she was viciously unkind even before I'd had a proper chance to make a nuisance of

myself. I withdrew into a sullen silence and relations became impossible. Gradually, I began to believe that Pam was trying to poison me.

My social worker was disbelieving, even though I left out my poisoning theory. Obviously I was having Oedipal (or Electral) difficulties and suffering delusions of persecution. In all honesty, it seemed a bit improbable even to me. But things were so bad in the house that the social worker got the council to send me away to boarding school. It was when the long summer holidays were imminent that I got a letter from Pam confessing that before I'd gone to live there, she had had a secret meeting with my mother whom she'd never met before, and together they had made a plan. Since (not unreasonably) Pam didn't fancy having a difficult adolescent around, and (very dubiously) my mother wanted me back, the pair of them decided that Pam was to treat me in such a way as to ensure I'd be miserable enough to want to return to my mother. Now that the plan had plainly failed, and alarmed, I suppose, at the prospect of six weeks' togetherness, Pam wrote to me at school to explain and apologise, and suggested we make a fresh start.

Sanity, Madness and the Family showed me how fortunate I was to get that letter which made it clear that it wasn't me who was behaving madly, and how fortunate, too, I had been to get away from them. What was extraordinary about the book to me then wasn't just the news that my family might have driven me mad—I already had an inkling of that—but that my family was not a unique quirk in a universe of normality. To have been a party to a cosmic irregularity left the answer to the "Why me?" question wide open—I might still, in some way I didn't understand, have deserved it—but if normality itself was under suspicion there was something wider and less personally reprehensible to be investigated.

What I—and I think quite a lot of other people who fell on this material—failed to notice was the word "sanity" in the title *Sanity, Madness and the Family*, and the fact that it was planned as the first of two projected volumes. The second book was to complement the first by studying the interaction of families in which no one had been diagnosed as schizophrenic, and was intended to investigate the theory that, while mad-making behaviour was always present in the families of schizophrenics, it was only sometimes present in families with no pathological members. Volume Two was never written, with the result that the key (and still unanswered) question which would explicitly have arisen as to why potentially mad-making behaviour only caused madness in some people was never addressed. The unwritten second volume on "normal"

families allowed both Laing and his admirers to skip the question and to suggest instead that there were no normal families, no normal society, and that the highest form of existential sanity was to be found in the individual who refused to conform to the madness of a demented civilisation. The autism of the mad became a heroic, hyper-sane response to an inauthentic world.

Well, it made sense to me, and I launched myself into the world of mental ill-health with all the fervour of a career move. I had a problem, though: I didn't have the right symptoms, the sort which might allow me (and the radical shrinks) to think of myself as a channel for social prophecy and higher truth. I was only a dull, inoperative depressive of the kind Laing showed not the slightest interest in. So far from liberating myself from the shackles of society's false diagnosis, I found, in my enthusiasm for existential psychiatry, a new logical framework in which to house and develop my free-flowing guilt: if I wasn't mad (properly mad, correctly mad, Laingian mad) then I was a miserable existential failure and as insubstantial as my depression insisted I must be. Laing, the clarifier of the concept of the double-bind, had invented a brand new version of his own. Exciting times? You bet.

Of course, I was young and flying without any background to keep me from floating away on the wings of misunderstanding, but judging by the practical results of Laing's theory and his own life's progress, my reasoning on the basis of what I read may not have been too far off the mark. It may even have been that Ronnie Laing, romancer of madness, suffered from the same problem as me. According to Charles Rycroft, who was his training analyst, he had "an extremely effective schizoid defence mechanism against exhibiting signs of depression." Laing was a depressive who needed drugs and drink to achieve what came naturally to his patients. He was more than capable of behaving badly, but perhaps behaving madly was beyond him. A tragedy of a kind, but, in retrospect, a massive irresponsibility towards those who were his concern. Like many at the time, he chose to overlook what is clear to anyone who has spent time with the mentally ill—the extraordinary pain involved. To find authenticity in the signs of madness is like finding a desirable simplicity in poverty; only those not obliged to experience either can afford such intellectual slackness.

Considering their relationship, Adrian Laing's account of his father's life and work is an astonishingly disciplined effort, which only occasionally betrays his private feelings ("Ronnie's nauseating desire to rationalise external events began at a very early age"). If anything, the controlled attempt not to allow personal judgment to colour his narrative results in a book that often reads

more like a curriculum vitae than a biography. But you can see why. Laing was the kind of father that would have given Papa Kronos indigestion. He made babies by the tribe (ten altogether) and deserted them in pursuit of his destiny with barely a glance back in their direction. He didn't see the five children of his first family for two years, and by the time he made a visit Adrian had forgotten what he looked like. When his daughter, Susie, was terminally ill in her early twenties, he made a special and exceedingly rare trip to Scotland to tell her, against the wishes of the rest of the family, her doctor and her fiancé, that she would be dead in six months. Then he returned to London almost immediately, leaving others to cope with the emotional aftermath of his searing honesty. Subsequently, his oldest child, Fiona, had a breakdown, and Laing failed to provide support. "It would not be fair to say that Fiona was callously abandoned," says his son, but it sounds as if some wording very close to that *would* be fair.

Perhaps none of that is our business. There are no end of families badly treated by self-obsessed individuals who have made great and lasting contributions to the wider world. The personal failures ought not to detract from an assessment of the work. But there is a question to be asked of a purveyor of wisdom who displays none in his dealings with the individuals in his life.

There was wisdom, or at least great intelligence and originality, in the early days. *The Divided Self* still comes across as a serious new attempt to describe the dynamics of schizophrenia. It was written before the collaboration with Esterson, while Laing was still a working psychiatrist in Gartnavel Hospital. He has no difficulty in acknowledging the reality of "insanity," and describes a plausible decline from "normal" schizoid thinking into psychotic insanity. If it isn't a final description of the aetiology of mental illness, at least it's an interesting view of it. On the other hand, his unquestioning belief in the existence of an authentic, absolute self which is subverted by society looks carelessly romantic, and no thought is given to the possibility of a predisposing biochemical component in mental illness (or its symptoms).

Fame struck. Laing went to a lot of dinner parties. He began his training analysis with Rycroft, and in spite of grave doubts on the part of the Institute's training committee ("Dr Laing is apparently a very disturbed and ill person"), he qualified as a psychoanalyst. Things started going strange once Kingsley Hall was up and running. Laing had founded a group known as the Philadelphia Association along with Esterson, David Cooper, Clancy Sigal and Sid Briskin, and these men formed the core group of loving brothers. The idea had been to find a house in which people could live while in the throes of a psy-

chotic episode, where the process of madness could run its course without intervention. Kingsley Hall in the East End had been formerly used as a settlement house. Gandhi had once lived there—and the brothers obtained it in 1965 for a peppercorn rent. It was a place to go crazy in and going crazy had already been defined as a counter-cultural necessity, so no one held back. "David Cooper was beginning to crack up . . . There was concern that Clancy Sigal was cracking up. Aaron Esterson and many others thought Ronnie was cracking up. Ronnie thought Aaron's problem was that he was unable to crack up." Adrian Laing doesn't mention whether there were any patients waiting their turn, but psychiatric nurse Mary Barnes had already settled in for her lengthy non-symbolic regression and was demanding full-time nappy-changing and bottle-feeding: who would have taken care of the lay crazies?

It was also the case that Laing panicked when faced by intractable madness. He was not a good practitioner. When Clancy Sigal's "true" self failed to emerge despite LSD sessions and non-interventionist therapy, and he flipped out too alarmingly even for Laing's tastes, he was forcibly sedated and handed over to the regular mad-doctors for sectioning. Sigal never forgave Laing, and when he later wrote a scabrously funny novel on the whole existential psychiatry scene, Laing threatened to sue if it was published in Britain.

Adrian Laing suggests that it was his father's excess of fame, too soon, and the slide into guru-in-chief of the counter-culture which was responsible for his decline. By 1967, in *The Politics of Experience*, he was writing, "We are all murderers and prostitutes," and later in the same book: "If I could turn you on, if I could drive you out of your wretched mind, if I could tell you I would let you know . . . I am trying to fuck you, dear reader, I am trying to get through." Adrian Laing confirms that the new philosophy was an amalgam of "Scotch whisky, Californian grass and Czechoslovakian acid" with, doubtless, more than a soupçon of megalomania sloshed in for good measure. Later came *Knots* and *Do You Love Me*, with such gems as "Was that a kiss? / or a hiss / from the abyss?," and in between Laing threw himself into the natural-birth movement, where he was not very much wanted by the likes of Leboyer and other obstetricians who were doing very nicely without him. By the late Seventies he changed tack and found an enthusiasm in rebirthing for adults rather than new birthing for foetuses, taking a troupe of re-birthers (including Adrian) around the country like itinerant soul-midwives. In the Eighties he could be found around Hampstead chanting Tibetan mantras and performing Native American warrior rituals for the greater good of his suburban souls. As his life got smaller and his concerns narrower, he became a hopelessly alcoholic and

unreliable shaman/showman who was liable to burst into tears in the middle of a lecture.

But was he one of his own existential heroes? Perhaps, by his own definition, he was. Very likely he would have said so. Possibly he would have settled for being an iconoclast, which lets him off the hook as a reformer. If causing a stir was all he wanted to do, then he succeeded. What you can't help feeling was that there was a terrible waste of talent, though such a thought is nonsensical. He must be credited with provoking psychiatry into rethinking its automatic reliance on drugs, ECT, brain butchery, and what often amounted to the imprisonment of sick people. Though it's tempting, it's too harsh to blame Laing for the callous pragmatism of Thatcher's version of care in the community. Yet as a reformer he never made it clear how, once the mad had been liberated from their chains, he was going to deal with their anguish. Indeed, he made that anguish seem exotic and desirable, which was, perhaps, his most damning fault. A doctor who does not take his patient's pain into account is failing at a most basic level.

One special difficulty for psychiatrists trying to relate to the psychotic is what information theory defines as the signal-to-noise ratio. Mad monologues are filled with random noise, exceptional skill is needed to distinguish between valid signals and meaningless interference. It might make life easier for everyone if shrinks were seen as telephone engineers of the psyche. Ever since Freud, mind-doctoring has been trying to present itself as a science, but the role confusion has always pulled patients in both directions. It's never clear when we settle on the couch or across the desk whether we have put ourselves in the hands of experts or sages. It seems more than likely that doctors have the same problem defining themselves.

Laing was undoubtedly a divided man; a charismatic ill at ease with his own intellect. It often looks as if each part went its own separate way, and his own puzzlement, as well as that of his onlookers, is understandable. Adrian Laing tells the story of his father on a speaking tour of the States in the early Seventies, when doctors in Chicago asked him to examine a young woman who was diagnosed as schizophrenic. She was silent, naked and had done nothing for months but rock back and forth. Laing, the charismatic, stripped off all his clothes and sat with her, rocking in time to her rhythm. After 20 minutes she started talking to Laing and the doctors were stunned. "Did it never occur to you to do that?" Laing asked afterwards. Even if it had occurred to the Chicago mind-doctors to get naked and rock the young woman back to health, they might have wondered where they were to find the time and re-

sources to deal with all their other patients. We aren't told what exactly the young woman said when she finally spoke. Maybe something like "Get your sodding clothes on. I'm the madwoman and you're the doctor, Doctor." Laing continued on to San Diego after performing his Attenborough-among-the-wild-things-number; he'd done his stuff. It was a personally creative moment, perhaps, but not a very serviceable one for the development of psychiatry.

ANNE FADIMAN

(1953–)

Born in New York City, Anne Fadiman inherited a legacy of words and books from her parents, Annalee Whitmore Jacoby Fadiman, a World War II correspondent, and Clifton Fadiman, a well-known critic and editor. She graduated from Harvard College in 1975 and worked as a writer and editor for *Life* magazine for nine years. In 1989 Fadiman married writer George Howe Colt, with whom she has two children. An article originally proposed for the *New Yorker* became the seed of her first book, *The Spirit Catches You and You Fall Down: A Hmong Child, Her American Doctors, and the Collision of Two Cultures* (1997), which won the National Book Critic Circle Award for Nonfiction. In this work, Fadiman writes about Lia Lee, a Hmong child whose diagnosis of epilepsy marks the beginning of an arduous journey through the American health system. Lee's parents and doctors struggle to understand each other's actions amid differing cultural perspectives.

In 1998 Fadiman published her first collection of essays, *Ex Libris: Confessions of a Common Reader*, drawn from her "Common Reader" column for the Library of Congress's *Civilization* magazine. Another compilation, *At Large and At Small: Familiar Essays*, followed in 2007. Additionally, Fadiman served as editor of *The American Scholar* from 1998 until 2004. She is credited with breathing literary life into the publication and creating a space that honored and perpetuated the essay form. Fadiman has taught writing at Yale University since 2005. In 2014 she wrote the introduction to *The Opposite of Loneliness*, a posthumously published book of essays and stories written by one of her students, Marina Keegan, who was killed in a car accident five days after her graduation from Yale. In 2017 Fadiman published a memoir, *The Wine Lover's Daughter*.

Never Do That to a Book

An earlier version of this essay first appeared as "For the Love of a Book" in the September/ October 1991 issue of *Civilization* magazine and was later published in *Ex Libris*, 1998. The essay that appears here is from a later paperback edition, *Ex Libris: Confessions of a Common Reader* (New York: Farrar, Straus, and Giroux, 2000), pp. 37–44, per the author's request.

When I was eleven and my brother was thirteen, our parents took us to Europe. At the Hôtel d'Angleterre in Copenhagen, as he had done virtually every night of his literate life, Kim left a book facedown on the bedside table. The next afternoon, he returned to find the book closed, a piece of paper inserted to mark the page, and the following note, signed by the chambermaid, resting on its cover:

SIR, YOU MUST NEVER DO THAT TO A BOOK.

My brother was stunned. How could it have come to pass that he—a reader so devoted that he'd sneaked a book and a flashlight under the covers at his boarding school every night after lights-out, a crime punishable by a swat with a wooden paddle—had been branded as *someone who didn't love books*? I shared his mortification. I could not imagine a more bibliolatrous family than the Fadimans. Yet, with the exception of my mother, in the eyes of the young Danish maid we would all have been found guilty of rampant book abuse.

During the next thirty years I came to realize that just as there is more than one way to love a person, so is there more than one way to love a book. The chambermaid believed in courtly love. A book's physical self was sacrosanct to her, its form inseparable from its content; her duty as a lover was Platonic adoration, a noble but doomed attempt to conserve forever the state of perfect chastity in which it had left the bookseller. The Fadiman family believed in carnal love. To us, a book's *words* were holy, but the paper, cloth, cardboard, glue, thread, and ink that contained them were a mere vessel, and it was no sacrilege to treat them as wantonly as desire and pragmatism dictated. Hard use was a sign not of disrespect but of intimacy.

Hilaire Belloc, a courtly lover, once wrote:

> Child! do not throw this book about;
> Refrain from the unholy pleasure
> Of cutting all the pictures out!
> Preserve it as your chiefest treasure.

What would Belloc have thought of my father, who, in order to reduce the weight of the paperbacks he read on airplanes, tore off the chapters he had completed and threw them in the trash? What would he have thought of my husband, who reads in the sauna, where heat-fissioned pages drop like petals in a storm? What would he have thought (here I am making a brazen attempt to upgrade my family by association) of Thomas Jefferson, who chopped up a priceless 1572 first edition of Plutarch's works in Greek in order to interleave its pages with an English translation? Or of my old editor Byron Dobell, who, when he was researching an article on the Grand Tour, once stayed up all night reading six volumes of Boswell's journals and, as he puts it, "sucked them like a giant mongoose"? Byron told me, "I didn't give a damn about the condition of those volumes. In order to get where I had to go, I underlined them, wrote in them, shredded them, dropped them, tore them to pieces, and did things to them that we can't discuss in public."

Byron loves books. Really, he does. So does my husband, an incorrigible book-splayer whose roommate once informed him, "George, if you ever break the spine of one of my books, I want you to know you might as well be breaking *my own spine*." So does Kim, who reports that despite his experience in Copenhagen, his bedside table currently supports three spreadeagled volumes. "They are ready in an instant to let me pick them up," he explains. "To use an electronics analogy, closing a book on a bookmark is like pressing the Stop button, whereas when you leave the book facedown, you've only pressed Pause." I confess to marking my place promiscuously, sometimes splaying, sometimes committing the even more grievous sin of dog-earing the page. (Here I manage to be simultaneously abusive and compulsive: I turn down the upper corner for page-marking and the lower corner to identify passages I want to xerox for my commonplace book.)

All courtly lovers press Stop. My Aunt Carol—who will probably claim she's no relation once she finds out how I treat my books—places reproductions of Audubon paintings horizontally to mark the exact paragraph where she left off. If the colored side is up, she was reading the left-hand page; if it's down, the right-hand page. A college classmate of mine, a lawyer, uses his business cards, spurning his wife's silver Tiffany bookmarks because they are a few microns too thick and might leave vestigial stigmata. Another classmate, an art historian, favors Paris Métro tickets or "those inkjet-printed credit card receipts—but only in books of art criticism whose pretentiousness I wish to desecrate with something really crass and financial. I would never use those in fiction or poetry, which really *are* sacred."

Courtly lovers always remove their bookmarks when the assignation is over; carnal lovers are likely to leave romantic mementos, often three-dimensional and messy. *Birds of Yosemite and the East Slope*, a volume belonging to a science writer friend, harbors an owl feather and the tip of a squirrel's tail, evidence of a crime scene near Tioga Pass. A book critic I know took *The Collected Stories and Poems of Edgar Allan Poe* on a backpacking trip through the Yucatán, and whenever an interesting bug landed in it, she clapped the covers shut. She amassed such a bulging insectarium that she feared Poe might not make it through customs. (He did.)

The most permanent, and thus to the courtly lover the most terrible, thing one can leave in a book is one's own words. Even I would never write in an encyclopedia (except perhaps with a No. 3 pencil, which I'd later erase). But I've been annotating novels and poems—transforming monologues into dialogues—ever since I learned to read. Byron Dobell says that his most beloved books, such as *The Essays of Montaigne*, have been written on so many times, in so many different periods of his life, in so many colors of ink, that they have become palimpsests. I would far rather read Byron's copy of Montaigne than a virginal one from the bookstore, just as I would rather read John Adams's copy of Mary Wollstonecraft's *French Revolution*, in whose margins he argued so vehemently with the dead author ("Heavenly times!" "A barbarous theory." "Did this lady think three months time enough to form a free constitution for twenty-five millions of Frenchmen?") that, two hundred years later, his handwriting still looks angry.

Just think what courtly lovers miss by believing that the only thing they are permitted to do with books is *read* them! What do they use for shims, doorstops, glueing weights, and rug-flatteners? When my friend the art historian was a teenager, his cherished copy of *D'Aulaire's Book of Greek Myths* served as a drum pad on which he practiced percussion riffs from Led Zeppelin. A philosophy professor at my college, whose baby became enamored of the portrait of David Hume on a Penguin paperback, had the cover laminated in plastic so her daughter could cut her teeth on the great thinker. Menelik II, the emperor of Ethiopia at the turn of the century, liked to chew pages from his Bible. Unfortunately, he died after consuming the complete Book of Kings. I do not consider Menelik's fate an argument for keeping our hands and teeth off our books; the lesson to be drawn, clearly, is that he, too, should have laminated his pages in plastic.

"How beautiful to a genuine lover of reading are the sullied leaves, and worn-out appearance . . . of an old 'Circulating Library' Tom Jones, or Vicar of Wakefield!" wrote Charles Lamb. "How they speak of the thousand thumbs that have turned over their pages with delight! . . . Who would have them a whit less soiled? What better condition could we desire to see them in?" Absolutely none. Thus, a landscape architect I know savors the very smell of the dirt embedded in his botany texts; it is the alluvium of his life's work. Thus, my friend the science writer considers her *Mammals of the World* to have been enhanced by the excremental splotches left by Bertrand Russell, an orphaned band-tailed pigeon who perched on it when he was learning to fly. And thus, even though I own a clear plastic cookbook holder, I never use it. What a pleasure it will be, thirty years hence, to open *The Joy of Cooking* to page 581 and behold part of the *actual egg yolk* that my daughter glopped into her very first batch of blueberry muffins at age twenty-two months! The courtly mode simply doesn't work with small children. I hope I am not deluding myself when I imagine that even the Danish chambermaid, if she is now a mother, might be able to appreciate a really grungy copy of *Pat the Bunny*—a book that *invites* the reader to act like a Dobellian giant mongoose—in which Mummy's ring has been fractured and Daddy's scratchy face has been rubbed as smooth as the Blarney Stone.

The trouble with the carnal approach is that we love our books to pieces. My brother keeps his disintegrating *Golden Guide to Birds* in a Ziploc bag. "It consists of dozens of separate fascicles," says Kim, "and it's impossible to read. When I pick it up, the egrets fall out. But if I replaced it, the note I wrote when I saw my first trumpeter swan wouldn't be there. Also, I don't want to admit that so many species names have changed. If I bought a new edition, I'd feel I was being unfaithful to my old friend the yellow-bellied sapsucker, which has been split into three different species."

My friend Clark's eight thousand books, mostly works of philosophy, will never suffer the same fate as *The Golden Guide to Birds*. In fact, just *hearing* about Kim's book might trigger a nervous collapse. Clark, an investment analyst, won't let his wife raise the blinds until sundown, lest the bindings fade. He buys at least two copies of his favorite books, so that only one need be subjected to the stress of having its pages turned. When his visiting mother-in-law made the mistake of taking a book off the shelf, Clark shadowed her around the apartment to make sure she didn't do anything unspeakable to it—such as placing it facedown on a table.

I know these facts about Clark because when George was over there last week, he talked to Clark's wife and made some notes on the back flyleaf of Herman Wouk's *Don't Stop the Carnival*, which he happened to be carrying in his backpack. He ripped out the page and gave it to me.

JAMAICA KINCAID

(1949–)

Born Elaine Potter Richardson in St. John's, Antigua, Kincaid credits her mother, Annie Richardson, with cultivating her voracious desire to read at a young age. Yet when the fifteen-year-old Kincaid was so caught up in a book that she failed to notice her brother's diaper needed to be changed, her furious mother destroyed all of her books in a bonfire. She writes of this incident in *My Brother* (1997), a nonfiction memoir of her half brother Devon Drew, who died of AIDS: "It would not be so strange if I spent the rest of my life trying to bring those books back to my life by writing them again and again until they were perfect, unscathed by fire of any kind." In 1965, at the age of seventeen, Kincaid left Antigua to work as an au pair in the United States and help support her family. She eventually stopped communicating with her family and attempted to reinvent herself. In 1973, she changed her name to Jamaica Kincaid, hoping the disguise would protect her from her family's ridicule if she failed as a writer. She did not return to Antigua for two decades.

In 1974, Kincaid became a staff writer at the *New Yorker*, a position she held for over twenty years. In 1979, she married Allen Shawn, the son of the magazine's editor. The couple had two children and divorced in 2002. Kincaid's first two books, both set in Antigua, were published to critical acclaim: *At the Bottom of the River* (1983), a collection of short stories, and *Annie John* (1985), a coming-of-age novel. Kincaid has since published numerous articles, essays, short stories, and novels. She has also published autobiographical fiction that often defies genre labels—namely, *Lucy* (1990), *The Autobiography of My Mother* (1996), and *Mr. Potter* (2002). Kincaid's other notable nonfiction includes *A Small Place* (1988), *Poetics of Place* (1998), *My Garden (Book)* (1999), and *Talk Stories* (2000). Kincaid said in a 1990 interview for *Harper's*

Bazaar that everything she writes is autobiographical: "I've never really written about anyone except myself and my mother." A professor at Harvard University, Kincaid also serves as a garden correspondent for *Architectural Digest*, a position she has held since 1998.

The Garden in Winter

An earlier version of this essay appeared as "A Fire By Ice" in the February 22,
1993, issue of the *New Yorker* and was later published as "The Garden in Winter"
in *My Garden (Book)*, 1999. This version is from the first paperback edition,
My Garden (Book) (New York: Farrar, Straus and Giroux, 2001), pp. 65–76.

One summer, early in the afternoon, I went to visit my friend Love. She and her mother (a perfectly nice woman, just to look at her) were walking in her garden. (Love's garden is in the shape of an enormous circle, subdivided into long and short rectangular-shaped beds, half-circle-shaped beds, square-shaped beds, and it is separated from her house by a wide sheet of obsessively well-cut grass and a deep border of iris, foxglove, and other June/July flower-bearing perennials.) Love was in a fretful mood (her mother's presence had made her that way) and was looking forward to seeing me (she told me so) and feeding me dinner, because I like the food she cooks (and in summer it is almost always something she has grown herself) and also perhaps because my presence would be a relief (this was not said, she did not tell me this). As Love and her mother walked around, they removed faded flowers, plants, and vegetables that were ready to be harvested (because Love grows vegetables and flowers quite freely together) and exchanged the silences and sentences typical of people who are bound together in a way they did not choose and cannot help (and so do not like), when her mother came on the bed where the Asiatic lilies were in bloom and broke one of their exchanges of silence by saying to her, "Just look at these nigger colors." Love was shocked by her mother saying this, but not surprised; after all, this was her mother, whom she had known for a long time.

Not so very long after Love and her mother had been walking in her garden, I arrived, and while Love stayed in the house and made us cocktails and small snacks of vegetables and a dip, her mother and I walked through the garden, because I had asked to do so (I always walk through Love's garden, but usually it is by myself), and her mother and I exchanged monuments of praise

to Love's gardening ability, and when we came to the bed of Asiatic lilies, I was visibly listening to Love's mother tell me some not very important piece of gardening information (I cannot remember it now, and so that is why I say it was not very important), but to myself I was wondering if, since I did not know her very well and was not very sure if I liked her, I should be my natural and true self or unnatural and untrue with her. Without being conscious of which self I had decided upon, I blurted out something true. I said, pointing to the Asiatic lilies, "I hate these colors." And then I went back to being unnatural and untrue, and would have forgotten that entire afternoon altogether except that after dinner, while Love and I were doing the dishes alone, she vented to me some of the irritation she felt toward the many people in her life whom she loved but did not like. She told me of her mother's casual but hateful remark, and I became so annoyed with myself for not sensing immediately the true character of the person with whom I had taken a walk in the garden, for had I known, I would have embraced the Asiatic lilies and their repulsive colors with a force that perhaps only death could weaken. If someone will go to such lengths to nourish and cultivate prejudice, extending to an innocent flower the malice heaped on innocent people, then I certainly wouldn't want to be the one to stand between her and her pleasure.

And then! The stone wall (visible from the back door of my house) that sensibly separates a terrace and a large flower bed from a sudden downward shift of the ground (but this is very nice to have, for when it snows my children like to slide down it) was in a dilapidated state and needed rebuilding. Two men, one overly fat, the other overly thin (this Jack Sprat style in couples is not an unusual sight in Vermont), came to rebuild it. One day, as they worked, I sat on a stone step (also in need of repair) observing them, reveling in my delicious position of living comfortably in a place that I am not from, enjoying my position of visitor, enjoying my position of not-the-native, enjoying especially the privilege of being able to make sound judgments about the Other—that is, the two men who were stooped over before me, working; and then I roused myself out of this, because I had to tell the overly fat man to save for me some of Mrs. Woodworth's roses (which he had dug up in the process of completely dismantling the wall; they weren't especially pretty roses, but they had been in that spot for over forty years and before that they had come from Mrs. Woodworth's mother's house in Maine and I had a feeling about them, a sentimental feeling that was completely false, a feeling no native can ever afford to have), and after I had told him that and he agreed to save the roses for me, he told me that he had been to New York City only once in his life and didn't wish to

go there again. And I made an instinctive decision to not make a reply, so he said that when he was a boy in school he had been to New York City on a day trip with his class, and on their way back home the bus he and his classmates were riding in had been pelted with stones by some people; and he said that not all the people who threw the stones were colored; and I said, Oh, but I wondered what he really wanted to say, and then he said that he liked colored people but his father did not. I said, Oh, to that, too, but I wondered what it was he really wanted to say; he said that his father did not like colored people because he was in the army with some colored men and they all got along very well until they were ordered into battle, and all the colored men in unison turned and ran away, and ever since then his father had not liked colored people. And then I was sorry that I had shared my organic cashews with him earlier that day, and I was sorry that I had brought him a nice glass of cold spring water to drink after he ate the cashew nuts; I said to him that it was so sensible of the soldiers to run away, I would most certainly have done the same thing, and he said nothing to that; and then I said that it was just as well that the soldiers were colored, because if they had been people who looked like his father (white), then most certainly his mother would have been someone who looked like me. And he stared at me and stared at me and said he saw what I meant, but that couldn't be true at all, because I couldn't see right away what I meant. The next day he brought me a small paper bag full of bulbs, each the size of three thimbles, and he did not know the name of the flower the bulbs would bear, he described it (small, white, star-shaped), and he said it would bloom early in the spring, much before anything else. I had wanted to plant the bulbs he gave me quite near the stone wall, and so I waited for the wall to be finished. And then the wall was finished and the paper that held the bulbs fell apart because I had left it unprotected on the ground and the bulbs spilled out and were scattered all over; at the beginning of each day as I began to work in the garden I would promise myself to plant them, at the end of each day I would resolve to myself to plant them; and then one day, with gestures that were completely without anger, I took the bulbs and placed them in the rubbish bin, not the compost heap.

It is winter and so my garden does not exist; in its place are these mounds of white, the raised beds covered with snow, like a graveyard, but not a graveyard in New England, with its orderliness and neatness and sense of that's-that, but more like a graveyard in a place where I am from, a warm place, where the grave is topped off with a huge mound of loose earth, because death is just

another way of being, and the dead will not stay put, and sometimes their actions are more significant, more profound than when they were alive, and so no square structure made out of concrete can contain them. The snow covers the ground in the garden with the determination of death, an unyielding grip, and the whiteness of it is an eraser, so that I am almost in a state of disbelief: a clump of lovage with its tall, thick stalks of celery-like leaves (with celery-like taste) did really stand next to the hedge of rhubarb; the potatoes were near the rhubarb, the broccoli was near the potatoes, the carrots and beets were together and near the potatoes, the basil and the cilantro were together and near the peas, the tomatoes were in a bed by themselves (a long, narrow strip that I made all by myself this summer with a new little tiller I bought, separating my garden from Annie's (my daughter); the strawberries were in a bed by themselves; all the salad greens were together and in a bed by themselves; the sunflowers, tall and short, and in various hues of yellow and half-brown, were clustered in groups over here, over there, and over here again; the scarecrow that scared nothing was here, the gun to shoot the things the scarecrow didn't scare was right here (lying in between the bundles of hay that were used to mulch the potatoes), unloaded, as was the line of silver (aluminum pie plates strung together) between the tepees covered with lima-bean vine (they bore pods but they were empty of beans). These colors (the green of the leaves, the red/pink stem of the rhubarb, the red veins of the beet leaves, the yellows and browns of the sunflowers) start out tentatively, in a maybe, maybe-not way, a sort-of way, and then one day, perhaps after a heavy amount of rain, everything is strong and itself, twinkling, jewel-like, and at that moment I think life will never change, it will always be summer, the families of rabbit or woodchuck or something will eat the beet leaves just before they are ready to be picked. I plot ways to kill them but can never bring myself to do it, I decide to build a fence around the garden and then I decide not to, there are more or fewer Japanese beetles than last year, who can really care; there are too many zucchinis, who can really care; and then, as if it had never happened before, something totally unexpected: I hear that the temperature will drop to such a low degree it will cause a frost, and I always take this personally, I think a frost is something someone is doing to me. This is to me how winter in the garden begins, with a frost, yet another tentativeness, a curtsy to the actual cold to come, a gentle form of it. The effect of the cold air on the things growing in the garden is something I still cannot get used to, still cannot understand, after so many years; how can it be that after a frost the garden looks as if it had been to a party in . . . hell; as if the entire garden had been picked up and placed just out-

side the furnace of a baker's oven and the fire inside the oven was constantly being fed and so the oven door was never shut.

I must have been about ten years old when I first came in contact with cold air; where I lived the air was only hot and then hotter, and if sometimes, usually only in December, the temperature at night got to around 75 degrees, everyone wore a sweater and a flannel blanket was placed on the bed. But once, the parents of a girl I knew got a refrigerator, and when they were not at home, she asked me to come in and put my hand in the freezer part. I became convinced then (and remain so even now) that cold air is unnatural and manmade and associated with prosperity (for refrigerators were common in the prosperous North) and more real and special than the warm air that was so ordinary to me; and then I became suspicious of it, because it seemed to me that it was also associated with the dark, with the cold comes the dark, in the dark things grow pale and die; no explanation from science or nature of how the sun can shine very brightly in the deep of winter has ever been satisfactory to me; in my heart I know the two cannot be, the cold and the bright light, at the same time.

And so between the end of summer and the shortest day of the year I battle a constant feeling of disbelief; everything comes to a halt rapidly, they die, die, die, the garden is all brown stalks and the ground tightening; the things that continue to grow and bloom do so in isolation; all the different species of chrysanthemums in the world grouped together (and some of them often are on display in a greenhouse at Smith College), all the sedum, all the rest of it, is very beautiful and I like it very much, but it doesn't really do, because it's against a background of dead or almost dead.

People will go on and on about the beauty of the garden in winter; they will point out scarlet berries in clusters hanging on stark brown brittle branches, they will insist that this beauty is deep and unique; people try to tell me about things like the Christmas rose (and sometimes they actually say *Helleborus niger*, but why? the common name sounds much better, the way common names always do), and this plant in bloom in December is really very beautiful, but only in the way of a single clean plate found on a table many months after a large number of people had eaten dinner there; or again they tell me of the barks of trees, in varying stages of peeling, and the moss of lichen growing on the barks of other trees and the precious jewel-like sparkle of lichen at certain times of day, in certain kinds of light; and, you know, I like lichen and I like moss, but really, to be reduced to admiring it because nothing else is there but brown bramble and some red stems and mist . . . It is so willful, this admira-

tion of the garden in winter, this assertion that the garden is a beautiful place then. Here is Miss Gertrude Jekyll (with whose writing I am so in love and am always so surprised when I see a picture of her again to realize how really quite ugly she was; and then again, she is such a wonderful example of the English people's habit of infantilizing and making everything cozy: a nice grouping of nut-bearing trees cannot remain a nice grouping of nut-bearing trees, they become The Nutwalk): "A hard frost is upon us. The thermometer registered eighteen degrees last night, and though there was only frost the night before it, the ground is hard frozen . . . How endlessly beautiful is the woodland in winter! Today there is a thin mist; just enough to make a background of tender blue mystery three hundred yards away, and to show any defect in the grouping of near trees."

But this is not true at all (of course, not to me); I want to say to her (but I can't, she's dead): This is just something you are saying, this is just something you are making up. I want to say that at this very moment I am looking out my window and the garden does not exist, it is lying underneath an expanse of snow, and there is a deep, thick mist, slowly seeping out of the woods, and as I see this I do not feel enraptured by it. But you know, white is not a color at all (the snow is white, the mist suggests white), white only makes you feel the absence of color, and white only makes you long for color and only makes you understand that the space is blank and is waiting to be filled up—with color.

It is best just to accept what you have and not take from other people the things they have that you do not have; and so I accept that I now live in a climate that has four seasons, one of which I do not fully appreciate, certainly from a gardener's point of view; what I would really like is to have winter, and then just the area that is my garden would be the West Indies, but only until spring comes, the season I like best, better than summer even. That is what I would really like. Since I cannot have it, I hope never to hear myself agreeing with this: "I determined to bring life to my garden in winter—to make autumn join hands with spring. Winter was to be a season in its own right, vital to the gardener who really wants to garden. I decided, like that innovative gardener, William Robinson, to banish the idea that 'winter is a doleful time for gardens.'" This is Rosemary Verey, and it is from her book *The Garden in Winter*; there was not one idea or photograph in this book to make me change my mind, and besides, this is just the sort of thing to give pleasure a bad name. The effort to be put into finding beauty in a dry branch, a leafless tree, a clump of limp grass, the still unyielding earth, is beyond me and not something I can do naturally, without inner help.

One very cold night this winter, I had just had dinner with my friend Kristen in a dreary restaurant in Bennington (but it's dreary only because they won't change the menu; year in and year out, they serve the same dishes, and though they are very good-tasting dishes, they are always the same; I write hostile letters to the chef, but they remain in my head, I never send them), and just as we were walking toward our cars, she pointed to a charred stalk, the remains of a purple coneflower (I had seen it in bloom when it had been in bloom), and she said, "Oh, that's so great. You know, I have decided to plant only things that will look good when they are dead and it's cold in my garden." Again this sense of the effort involved came over me and I thought of the lilies in my friend Love's garden. The reason I do not like those lilies is that years ago, when I was young, for a period of about a year I used to take a hallucinogenic drug at seven-day intervals; near the end of the year I was doing this, the hallucinogenic part of the drug had no effect on me, I experienced only the amphetamine part of it, and my stomach would be in a state of tautness and jitters at once. This hallucinogenic drug was sometimes square, sometimes round and glassy, and would fit well in the middle of my tongue; it was sometimes yellow, sometimes orange, the exact shade and texture of Love's lilies. I never fail to see those flowers, their waxy texture, their psychedelic shades, without becoming aware of my stomach. Over dinner I had been discussing with Kristen how overwhelming I found the beginning of winter, the middle of winter, the end of winter, and how much I missed my garden, and she mentioned seasonal mood shifts (those were her words exactly) and the number of mood modifiers that were available to the average person today. She said the word "Prozac" and I remembered that in response to something someone had said, I heard Fred Seidel (he is my son's godfather) say that Prozac was the aspirin of the nineties, and then not long after I heard Fred say that, I saw this drug; it was in the palm of a druggist's hand, he was showing it to me; I had asked him to show it to me; it was two-toned: a slight shade of green and a smudged white, winter colors, colors from "nature's most sophisticated palette" (Rosemary Verey). When my friend and I parted, she was still in a state of admiration over the asleep and dead before her, the remains of a fire by ice. At that moment I was thinking, I want to be in a place where people don't say things like that, I want to be in a place where people don't feel like that, see a landscape of things dead or asleep and desire it, move mountains to achieve its effect; by tomorrow I want to be in a place that is the opposite of the one I am in now. The only thing was, I did not know if that place would be a mood modifier or the West Indies.

KYOKO MORI

(1957–)

Born in Kobe, Japan, Kyoko Mori credits her mother's letter writing and her maternal grandfather's journaling with inspiring her to write. Her mother, Takako Nagai Mori, committed suicide when Mori was twelve. When her father, engineer Hiroshi Mori, married a year after her mother's death, Mori found herself at odds with him and her new stepmother. In high school, Mori traveled to Arizona as an exchange student. Back in Japan, she studied English in college before returning to the United States. She graduated from Rockford College in 1979 with a bachelor's degree in English. Mori then earned a master's degree and doctorate from the University of Wisconsin–Milwaukee. In 1984, the year she received her doctorate, Mori became a naturalized citizen and married Charles Brock. The couple divorced in 1997. In the meantime, Mori published her first book, the novel *Shizuko's Daughter*, to critical acclaim. Her first book of essays, *Polite Lies*, appeared in 1997. The autobiographical essays in this collection attempt to lay out differences between Japanese and American culture. Mori has since published additional fiction and nonfiction, including a memoir about a return trip to Japan, *The Dream of Water* (1994). Her latest memoir is *Yarn: Remembering the Way Home* (2009), in which she weaves together threads of multiple narratives: her life in Japan, her decision to leave Japan, her subsequent life in the United States, her marriage, and the history of fiber arts. The title chapter from *Yarn* was selected for inclusion in *The Best American Essays 2004*. Mori currently teaches writing at George Mason University.

Language

From *Polite Lies*, 1997. This version is from *Polite Lies: On Being a Woman Caught Between Cultures* (New York: Fawcett, 1999), pp. 3–19.

When my third grade teacher told us that the universe was infinite and endless, I wrote down her words in my notebook, but I did not believe her. An endless universe was too scary to be true—a pitch-black room in which we were lost forever, unable to find the way out. It worried me just as much, though, to think of the universe having an end. What was on the other side? I pictured a big cement wall floating in outer space, light-years away. At night, I dreamed that I was alone on a spaceship that orbited the earth in gradually widening circles. I didn't know how to turn the ship around or steer it out of its orbit. Outside the window the black sky stretched all around me, and the Earth looked like an old tennis ball, faded and fuzzy. Unable to go back home or to land on another planet, I circled around endlessly.

Now, thirty years later, I think of that dream when I fly to Japan from the American Midwest. On the twelve-hour flight between Detroit and Tokyo or Osaka, I imagine myself traveling in outer space for eternity, always getting farther and farther away from home.

Japan has not been my home for a long time. Though I was born in Kobe, I have not lived there as an adult. I left at twenty to go to college in Illinois, knowing that I would never return. I now live in Green Bay, Wisconsin. I am an American citizen. My life can be divided right down the middle: the first twenty years in Japan, the last twenty years in the American Midwest. I'm not sure if I consider Green Bay to be my "home," exactly. Having grown up in a big city, I am more comfortable in Chicago or Milwaukee. But even the small towns in the Midwest are more like my home than Japan, a country I know only from a child's perspective. I don't understand Japan the way I have come to understand the Midwest—a place I learned gradually as an adult so that I can't remember when I didn't know the things I know now and take for granted. I recall Japan with the bold colors and truncated shapes of a child's perception. My memory seems vivid and yet unreliable.

Since I left, I have made only five short trips to Japan, all of them in the last seven years, all for business, not pleasure. Japan is a country where I was unhappy: my mother killed herself when I was twelve, leaving me to spend my

teenage years with my father and stepmother. I usually think of those years as a distant bad memory, but a trip to Japan is like a sudden trip back in time. The minute I board the plane, I become afraid: the past is a black hole waiting to suck me up. When I was in kindergarten, I worried at night that my room was full of invisible holes. If I got out of my bed and started walking, I might fall into one of the holes and be dragged through a big black space; eventually, I would come out into the wrong century or on another planet where no one would know me. I feel the same anxiety as I sit on the plane to Japan, my elbows and knees cramped against the narrow seat: one wrong move and I will be sucked back into the past.

As soon as everyone is seated on the plane, the Japanese announcement welcoming us to the flight reminds me of the polite language I was taught as a child: always speak as though everything in the world were your fault. The bilingual announcements on the plane take twice as long in Japanese as in English because every Japanese announcement begins with a lengthy apology: "We apologize about how long it's taken to seat everyone and thank you for being so patient," "We are so sorry that this has been such a long flight and we very much appreciate the fact that you have been so very cooperative with us," "We apologize for the inconvenience you will no doubt experience in having to fill out the forms we are about to hand out."

Every fourth or fifth sentence has the words *sumimasenga* (I am sorry but) or *osoremasuga* (I fear offending you but) or *yoroshikereba* (if it's all right with you). In the crowded cabin, the polite apologies float toward us like a pleasant mist or gentle spring rain. But actually this politeness is a steel net hauling us into the country where nothing means what it says. Already, before the plane has left American airspace, I have landed in a galaxy of the past, where I can never say what I feel or ask what I want to know.

In my family, proper language has always been an obstacle to understanding. When my brother called me from Japan in 1993, after our father's death, and asked me to come to Japan for a week, he never said or hinted at what he wanted me to do once I got there. I could not arrive in time for the funeral even if I were to leave within the hour. He didn't tell me whether he wanted me to come all the same to show moral support or to discuss financial arrangements. In a businesslike manner, he said, "I was wondering if you could spare a week to come here. I know you're busy with school, but maybe you could make the time if it's not too inconvenient." When I agreed, he added, "It'll be good to see you," as if I were coming to visit him for fun. And I replied,

"I'll call my travel agent right away and then call you back," businesslike myself, asking no questions, because we were speaking in Japanese and I didn't know how to ask him what he really wanted.

Our conversation wasn't unusual at all. In Japanese, it's rude to tell people exactly what you need or to ask them what they want. The listener is supposed to guess what the speaker wants from almost nonexistent hints. Someone could talk about the cold weather when she actually wants you to help her pick up some groceries at the store. She won't make an obvious connection between the long talk about the cold weather and the one sentence she might say about going to the store later in the afternoon, the way an English speaker would. A Japanese speaker won't mention these two things in the same conversation. Her talk about the cold weather would not be full of complaints— she might even emphasize how the cold weather is wonderful for her brother, who likes to ski. She won't tell you how she hates the winter or how slippery and dangerous the sidewalks are. But if you don't offer her a ride, you have failed her. My Japanese friends often complain about people who didn't offer to help them at the right time. "But how could these people have known what to do?" I ask. "You didn't tell them." My friends insist, "They should have done it without being asked. It's no good if I have to spell things out to them. They should have been more sensitive."

Having a conversation in Japanese is like driving in the dark without a headlight: every moment, I am on the verge of hitting something and hurting myself or someone else, but I have no way of guessing where the dangers are. Listening to people speak to me in Japanese, over the phone or face to face, I try to figure out what they really mean. I know it's different from what they say, but I have no idea what it is. In my frustration, I turn to the familiar: I begin to analyze the conversation by the Midwestern standard of politeness. Sometimes the comparison helps me because Midwesterners are almost as polite and indirect as Japanese people.

Just like Japanese people, Midwesterners don't like to say no. When they are asked to do something they don't want to do, my Midwestern friends answer, "I'll think about it," or "I'll try." When people say these things in Japanese, everyone knows the real meaning is no. When people in Wisconsin say that they will "think about" attending a party or "try to" be there, there is a good chance that they will actually show up. "I'll think about it" or "I'll try" means that they have not absolutely committed themselves, so if they don't come, people should not be offended. In Japan or in the Midwest, when people don't

say yes, I know I should back off and offer, "Don't worry if you can't. It isn't important."

In both cultures, the taboo against saying no applies to anything negative. Once, in Japan, I was speaking with my aunt, Akiko, and my brother. My aunt was about to criticize my stepmother, whom she disliked. Because she was with my brother, who feels differently, Akiko began her conversation by saying. "Now, I know, of course, that your stepmother is a very good person in her own way. She means well and she is so generous."

I could tell that my aunt didn't mean a word of what she said because my Midwestern friends do the exact same thing. They, too, say, "I like So-and-so. We get along just fine, but" before mentioning anything negative about almost anyone. They might then tell a long story about how that person is arrogant, manipulative, or even dishonest, only to conclude the way they started out: "Of course, he is basically a nice person, and we get along fine." They'll nod slightly, as if to say, "We all understand each other." And we do. "I like So-and-so" is simply a disclaimer meant to soften the tone. I expect to hear some version of the disclaimer; I notice when it is omitted. If a friend does not say "So-and-So is a nice person" before and after her long, angry story, I know that she truly dislikes the person she is talking about—so much that the only disclaimer she can make is "I don't like to be so negative, but," making a reference to herself but not to the other person. The omission implies that, as far as she is concerned, the other person no longer deserves her courtesy.

When I go to Japan and encounter the code of Never Say No and Always Use a Disclaimer, I understand what is really meant, because I have come to understand the same things in the Midwest. But sometimes, the similarities between the two forms of politeness are deceptive.

Shortly after my father's death, my uncle, Kenichi—my mother's brother— wanted to pay respects to my father's spirit at the Buddhist altar. I accompanied him and his wife, Mariko, to my stepmother's house, where the altar was kept. Michiko served us lunch and tried to give Kenichi my father's old clothing. She embarrassed me by bragging about the food she was serving and the clothes she was trying to give away, laughing and chattering in her thin, false voice.

As we were getting ready to leave, Michiko invited Kenichi and Mariko to visit her again. She asked them to write down their address and phone number. Squinting at the address Mariko was writing down, my stepmother said, "Hirohatacho. Is that near the Itami train station?"

"Yes," Mariko replied. "About ten minutes north, on foot." Then, smiling and bowing slightly, she said, "Please come and visit us. I am home every afternoon, except on Wednesdays. If you would call me from the station, I would be very happy to come and meet you there."

"You are welcome to visit here any time, too," Michiko returned, beaming. "You already know where I live, but here is my address anyway." She wrote it down and handed it to Mariko.

Putting the piece of paper in her purse, Mariko bowed and said, "I will look forward to seeing you."

As I walked away from the house with Mariko and Kenichi, I couldn't get over how my stepmother had wangled an invitation out of them. The thought of her coming to their house made me sick, so I asked point-blank, "Are you really going to have Michiko over to your house?"

They looked surprised. Kenichi said, "We didn't mean to be insincere, but we don't really expect her to come to our house."

"So you were just being polite?" I asked.

"Of course," Kenichi replied.

I would never have guessed the mere formality of their invitation even though polite-but-not-really-meant invitations are nothing new to me. People in Wisconsin often say, "We should get together sometime," or "You should come and have dinner with us soon." When I hear these remarks, I always know which are meant and which are not. When people really mean their invitations, they give a lot of details—where their house is, what is a good time for a visit, how we can get in touch with each other—precisely the kind of details Mariko was giving Michiko. When the invitations are merely polite gestures, they remain timeless and vague. The empty invitations annoy me, especially when they are repeated. They are meant to express good will, but it's silly to keep talking about dinners we will never have. Still, the symbolic invitations in the Midwest don't confuse me; I can always tell them apart from the real thing.

In Japan, there are no clear-cut signs to tell me which invitations are real and which are not. People can give all kinds of details and still not expect me to show up at their door or call them from the train station. I cannot tell when I am about to make a fool of myself or hurt someone's feelings by taking them at their word or by failing to do so.

I don't like to go to Japan because I find it exhausting to speak Japanese all day, every day. What I am afraid of is the language, not the place. Even in Green

Bay, when someone insists on speaking to me in Japanese, I clam up after a few words of general greetings, unable to go on.

I can only fall silent because thirty seconds into the conversation, I have already failed at an important task: while I was bowing and saying hello, I was supposed to have been calculating the other person's age, rank, and position in order to determine how polite I should be for the rest of the conversation. In Japanese conversations, the two speakers are almost never on an equal footing: one is senior to the other in age, experience, or rank. Various levels of politeness and formality are required according to these differences: it is rude to be too familiar, but people are equally offended if you are too formal, sounding snobbish and untrusting. Gender is as important as rank. Men and women practically speak different languages; women's language is much more indirect and formal than men's. There are words and phrases that women are never supposed to say, even though they are not crude or obscene. Only a man can say *damare* (shut up). No matter how angry she is, a woman must say, *shizukani* (quiet).

Until you can find the correct level of politeness, you can't go on with the conversation: you won't even be able to address the other person properly. There are so many Japanese words for the pronoun *you*. *Anata* is a polite but intimate *you* a woman would use to address her husband, lover, or a very close woman friend, while a man would say *kimi*, which is informal, or *omae*, which is so informal that a man would say this word only to a family member; *otaku* is informal but impersonal, so it should be used with friends rather than family. Though there are these various forms of *you*, most people address each other in the third person—it is offensive to call someone *you* directly. To a woman named Hanako Maeda, you don't say, "Would you like to go out for lunch?" You say, "Would Maeda-san (Miss Maeda) like to go out for lunch?" But if you had known Hanako for a while, maybe you should call her Hanako-san instead of Maeda-san, especially if you are also a woman and not too much younger than she. Otherwise, she might think that you are too formal and unfriendly. The word for *lunch* also varies: *hirumeshi* is another casual word only a man is allowed to say, *hirugohan* is informal but polite enough for friends, *ohirugohan* is a little more polite, *chushoku* is formal and businesslike, and *gochushoku* is the most formal and businesslike.

All these rules mean that before you can get on with any conversation beyond the initial greetings, you have to agree on your relationship—which one of you is superior, how close you expect to be, who makes the decisions and who defers. So why even talk, I always wonder. The conversation that fol-

lows the mutual sizing-up can only be an empty ritual, a careful enactment of our differences rather than a chance to get to know each other or to exchange ideas.

Talking seems especially futile when I have to address a man in Japanese. Every word I say forces me to be elaborately polite, indirect, submissive, and unassertive. There is no way I can sound intelligent, clearheaded, or decisive. But if I did not speak a "proper" feminine language, I would sound stupid in another way—like someone who is uneducated, insensitive, and rude, and therefore cannot be taken seriously. I never speak Japanese with the Japanese man who teaches physics at the college where I teach English. We are colleagues, meant to be equals. The language I use should not automatically define me as second best.

Meeting Japanese-speaking people in the States makes me nervous for another reason. I have nothing in common with these people except that we speak Japanese. Our meeting seems random and artificial, and I can't get over the oddness of addressing a total stranger in Japanese. In the twenty years I lived in Japan, I rarely had a conversation with someone I didn't already know. The only exception was the first day of school in seventh grade, when none of us knew one another, or when I was introduced to my friends' parents. Talking to clerks at stores scarcely counts. I never chatted with people I was doing business with. This is not to say that I led a particularly sheltered life. My experience was typical of anyone—male or female—growing up in Japan.

In Japan, whether you are a child or an adult, ninety-five percent of the people you talk to are your family, relatives, old friends, neighbors, and people you work or go to school with every day. The only new people you meet are connected to these people you already know—friends of friends, new spouses of your relatives—and you are introduced to them formally. You don't all of a sudden meet someone new. My friends and I were taught that no "nice" girl would talk to strangers on trains or at public places. It was bad manners to gab with shopkeepers or with repair people, being too familiar and keeping them from work. While American children are cautioned not to speak with strangers for reasons of safety, we were taught not to do so because it wasn't "nice." Even the most rebellious of us obeyed. We had no language in which we could address a stranger even if we had wanted to.

Traveling in Japan or simply taking the commuter train in Kobe now, I notice the silence around me. It seems oppressive that you cannot talk to someone who is looking at your favorite painting at a museum or sitting next to you

on the train, reading a book that you finished only last week. In Japan, you can't even stop strangers and ask for simple directions when you are lost. If you get lost, you look for a policeman, who will help you because that is part of his job.

A Japanese friend and I got lost in Yokohama one night after we came out of a restaurant. We were looking for the train station and had no idea where it was, but my friend said, "Well, we must be heading in the right direction, since most people seem to be walking that way. It's late now. They must be going back to the station, too." After about ten minutes—with no train station in sight yet—my friend said that if she had been lost in New York or Paris, she would have asked one of the people we were following. But in her own country, in her own language, it was unthinkable to approach a stranger.

For her, asking was not an option. That's different from when people in the Midwest choose not to stop at a gas station for directions or flag down a store clerk to locate some item on the shelves. Midwestern people don't like to ask because they don't want to call attention to themselves by appearing stupid and helpless. Refusing to ask is a matter of pride and self-reliance—a matter of choice. Even the people who pride themselves on never asking know that help is readily available. In Japan, approaching a stranger means breaking an unspoken rule of public conduct.

The Japanese code of silence in public places does offer a certain kind of protection. In Japan, everyone is shielded from unwanted intrusion or attention, and that isn't entirely bad. In public places in the States, we all wish, from time to time, that people would go about their business in silence and leave us alone. Just the other day in the weight room of the YMCA, a young man I had never met before told me that he had been working out for the last two months and gained fifteen pounds. "I've always been too thin," he explained. "I want to gain twenty more pounds, and I'm going to put it all up here." We were sitting side by side on different machines. He indicated his shoulders and chest by patting them with his hand. "That's nice," I said, noncommittal but polite. "Of course," he continued; "I couldn't help putting some of the new weight around my waist, too." To my embarrassment, he lifted his shirt and pointed at his stomach. "Listen," I told him. "You don't have to show it to me or anything." I got up from my machine even though I wasn't finished. Still, I felt obligated to say, "Have a nice workout," as I walked away.

I don't appreciate discussing a complete stranger's weight gain and being shown his stomach, and it's true that bizarre conversations like that would never happen in a Japanese gym. Maybe there is comfort in knowing that

you will never have to talk to strangers—that you can live your whole life surrounded by friends and family who will understand what you mean without your saying it. Silence can be a sign of harmony among close friends or family, but silent harmony doesn't help people who disagree or don't fit in. On crowded trains in Kobe or Tokyo, where people won't even make eye contact with strangers, much less talk to them, I feel as though each one of us were sealed inside an invisible capsule, unable to breathe or speak out. It is just like my old dream of being stuck inside a spaceship orbiting the earth. I am alarmed by how lonely I feel—and by how quietly content everyone else seems to be.

In Japanese, I don't have a voice for speaking my mind. When a Japanese flight attendant walks down the aisle in her traditional kimono, repeating the endlessly apologetic announcements in the high, squeaky voice a nice woman is expected to use in public, my heart sinks because hers is the voice I am supposed to mimic. All my childhood friends answer their telephones in this same voice, as do the young women store clerks welcoming people and thanking them for their business or TV anchor women reading the news. It doesn't matter who we are or what we are saying. A woman's voice is always the same: a childish squeak piped from the throat.

The first time I heard that voice coming out of my own mouth, about three years ago, I was lost at a subway station in Osaka. Though there were plenty of people gathered around the wall map I was trying to read, I did not stop any of them. I flagged down a station attendant, identifiable by his blue uniform. "*Ano, sumimasen,*" I started immediately with an apology ("Well, I'm so sorry to be bothering you"). Then I asked where I could catch the right train. Halfway through my inquiry, I realized that I was squeezing the air through my tightly constricted throat, making my voice thin and wavering. *I have to get out of here*, I thought. *It's a good thing I'm leaving in just a few days.*

I was afraid of being stuck in Japan, unable to speak except in that little-bird voice. I'm afraid of the same thing every time I go there.

People often tell me that I am lucky to be bilingual, but I am not so sure. Language is like a radio. I have to choose a specific station, English or Japanese, and tune in. I can't listen to both at the same time. In between, there is nothing but static. These days, though, I find myself listening to static because I am afraid to turn my dial to the Japanese station and hear that bird-woman voice. Trying to speak Japanese in Japan, I'm still thinking in English. I can't turn off what I really want to say and concentrate on what is appropriate. Flustered, I try to work out a quick translation, but my feelings are untranslatable and my

voice is the voice of a foreigner. The whole experience reminds me of studying French in college and being unable to say or write what I thought.

In my second-year French class, I had to keep a journal. I could only say stupid things: "I got up at six. I ate breakfast. It's cold. I'm tired." I was reduced to making these idiotic statements because I didn't have the language to explain, "It's cold for September and I feel sad that summer is over. But I try to cheer myself up by thinking of how beautiful the trees will be in a month." In my French, it was either cold or not cold. Nothing in between, no discussion of what the weather meant. After finishing my entry every day, I felt depressed: my life sounded bleak when it was reduced to bad weather and meal schedules, but I wasn't fluent enough in French to talk about anything else. Now, my Japanese feels thin in the same way.

In any language, it is hard to talk about feelings, and there are things that are almost unsayable because they sound too harsh, painful, or intimate. When we are fluent, though, we can weave and dodge our way through the obstacles and get to the difficult thing we want to say; each of us weaves and dodges in slightly different ways, using our individual style or voice. In the way we say the almost unsayable, we can hear the subtle modulations and shifts that make each of our voices unique.

When I studied the poetry of Maxine Kumin, Anne Sexton, and Sylvia Plath in college, I was immediately drawn to their voices. I still love the eloquence with which these poets talk about daily life and declare their feelings, balancing gracefully between matter-of-fact observations and powerful emotions. After a particularly emotional statement, the poets often step back and resume describing the garden, the yew trees and blackberries, before returning to the feelings again. They say the almost unsayable by balancing on the edge of saying too much and then pulling back, only to push their way toward that edge again. Reading them in college, I wanted to learn to speak with a voice like theirs.

My whole schooling has been a process of acquiring a voice. In college and graduate school, I learned to speak, write, and think like my favorite writers— through imitation and emulation, the way anyone learns any language. I have not had the same experience in Japanese. The only voice I was taught was the one that squeezed my throat shut every time I wanted to say, *Help me. This is what I want. Let me tell you how I feel.*

On my trips to Japan, I am nervous and awake the whole way. Sitting stiffly upright in the cone of orange light, I read my favorite novelists in English;

Margaret Atwood, Amy Tan, Anne Tyler. I cannot shed my fear of the Japanese language. When the plane begins its descent toward Tokyo or Osaka and the final sets of announcements are made in the two languages, I don't try to switch from the English station of my mind to the Japanese. I turn the dial a little closer to the Japanese station without turning off the English, even though my mind will fill with static and the Japanese I speak will be awkward and inarticulate. I am willing to compromise my proficiency in Japanese so that I can continue to think the thoughts I have come to value in English.

Yet as the plane tips to the right and then to the left, I feel the pull of the ground. Gravity and nostalgia seem one and the same. Poised over the land of my childhood, I recognize the coastline. The sea shines and glitters just like the one in the old songs we sang in grade school. The mountains are a dark green and densely textured. It comes to me, like a surprise, that I love this scenery. *How could I have spent my adult life away from here?* I wonder. *This is where I should have been all along.* I remember the low, gray hills of the Midwest and wonder how I could have found them beautiful, when I grew up surrounded by real mountains. But even as part of me feels nostalgic, another part of me remains guarded, and my adult voice talks in the back of my mind like a twenty-four-hour broadcast. *Remember who you were*, it warns, *but don't forget who you are now.*

ELIZABETH HARDWICK

(1916–2007)

Cited as one of the major literary essayists of the twentieth century, Elizabeth Bruce Hardwick was born in Lexington, Kentucky. She did undergraduate and graduate work at the University of Kentucky, earning a master's degree in 1939. Afterward, she continued her graduate studies at Columbia University in New York. In 1949 she married poet Robert Lowell, with whom she had one daughter. Hardwick and Lowell divorced in 1972, by which time she had established herself as an astute critic of literature. She had co-founded the *New York Review of Books* in 1963, and she continued to serve as an advisory editor. Hardwick's first two publications were novels, *The Ghostly Lover* (1945) and *The Simple Truth* (1955). While a third novel, *Sleepless Nights* (1979), was nominated for a National Book Critics Circle Award, the bulk of Hardwick's literary reputation rests on her nonfiction. Her first collection of essays, *A View of My Own: Essays in Literature and Society*, appeared in 1962, and several others followed it: *Seduction and Betrayal: Women and Literature* (1974), *Bartleby in Manhattan and Other Essays* (1983), *Sight-Readings* (1998), and *American Fictions* (1999). In 1986 Hardwick was selected as the first guest editor of Robert Atwan's now long-running series *The Best American Essays*. A frequent contributor of essays and reviews to numerous periodicals, Hardwick published a short biography of Herman Melville in 2000. She died in 2007.

Melville in Love

From the June 15, 2000, issue of the *New York Review of Books*, pp. 15–20.

I.

Herman Melville died in 1891 at the age of seventy-two. He was buried next to his son Malcolm in a cemetery in the Bronx. His death was marked negatively, as it were, by an absence of public ceremony; just another burial of an obscure New Yorker. This obscurity, or neglect, was to become part of the dramaturgy of Melville's image, even for those who hadn't read him in the past, as well as for those, more than a few, who haven't read him in the present. The man and his work—nine novels, brilliant shorter fictions, poems, and his departing gift to American literature, the beautiful *Billy Budd*, published after his death—were unearthed in the 1920s and the whole skeleton given a voluptuous rebirth.

Melville was not a gifted angel winging up from the streets, the slums of the great metropolis, Manhattan. His father, Allan, came from a good merchant family of Boston who could claim the sort of heraldic honor that to this day, two centuries later, keeps the prideful busy with the genealogists; that is, service in the American Revolution. Allan's father, Thomas Melville, was among the young men who, in 1773, boarded the ships of the East India Company and dumped their tea in the water. A felicitous bit of patriotic vandalism which the family could claim like a coat-of-arms to hang with noble diggings in their Scottish ancestry. Melville's mother was Maria Gansevoort of Albany, prominent Dutch early settlers. Her father was also a hero of the Revolution, fighting at Fort Stanwix against Indian and Tory troops.

When Melville was twelve years old, his father, Allan, died of what seems to have been a virulent pneumonia. He died as he had lived, in debt, a condition for which the Melvilles may be said to have had an almost genetic liability. (Dollars damn me! the author, Herman, could honestly announce. His life after the financially advantageous marriage to the daughter of Judge Lemuel Shaw of Boston was ever to be punctuated by "on loan from Judge Shaw" and "paid for by Judge Shaw.") The father's business in imported luxury goods had led him to move the family from Boston to New York, where the son, Herman, was born in 1819 on Pearl Street. Matters did not go as profitably as the beleaguered entrepreneur had hoped and so it was to be a move to Albany, the

principality of the much more prudent Gansevoorts. However, the radiance of these solid patroons did not cast its beams of solvency and, with the death of the father, creditors were in scowling pursuit.

In Albany, unremitting black weather for the Melville household. The widow and her children were forced to sell much of their furniture and other effects and to escape in ignominy to a cheaper town, Lansingburgh, nearby. Herman for a period taught school, took an engineering diploma at Lansingburgh Academy, failed to get a position, wrote some youthful sketches which were published in the local paper—and then, and then perhaps we can say his true life began. However, the life he left behind, the losses, the grief, the instability, the helpless love of a helpless young man in a damaged family marked his sensibility quite as much as the wanderlust, the strong grip of the sea, so often claimed as the defining aspect of his nature. In 1839, he signed on as a common seaman on the *St. Lawrence*, a merchant ship bound for a four-month trip to Liverpool. He was soon to be twenty years old.

Melville's state of mind is revealed some years later with a purity of expressiveness in the novel *Redburn*, one of his most appealing and certainly the most personal of his works. He is said to have more or less disowned the book, more rather than less, since he claimed it was only written for tobacco. Whether this is a serious misjudgment of his own work or a withdrawal, after the fact, from having shown his early experience of life without his notable reserve and distance is, of course, not clear. For a contemporary reader, Redburn, the grief-stricken youth, cast among the vicious, ruined men on the ship, walking the streets of Liverpool in the late 1830s, even meeting with the homosexual hustler Harry Bolton might have more interest than *Typee*'s breadfruit and coconut island and the nymph, Fayaway. But it is only pertinent to think of *Redburn* on its own: a novel written after *Typee*, *Omoo*, and *Mardi* in the year 1849, ten years after he left Lansingburgh to go on his first voyage.

"Cold, bitter cold as December, and bleak as its blasts, seemed the world then to me; there is no misanthrope like a boy disappointed; and such was I, with the warm soul of me flogged out by adversity." Melville was not a boy when he joined the *St. Lawrence* but the remembrance of his father and the lost years seem in detail to represent his actual thoughts at the time. Despair, rooted in experience, in love of family, and a young son's defenseless anxiety amidst the tides of misfortune leave their mark on his character and on his view of life. The opening pages are a profoundly moving poem to his dead father, to the memory of evenings in New York, talk around the fireside of the

cities and sights of Europe, the treasures Allan brought home from his business travels to Paris. There was a large bookcase filled with books, many in French, paintings and prints, furniture, pictures from natural history, including a whale "big as a ship, stuck full of harpoons, and three boats sailing after it as fast as they could fly."

The sea, the traveler's passionate curiosity and longing, "foreign associations, bred in me a vague prophetic thought, that I was fated, one day or other, to be a great voyager, and that just as my father used to entertain strange gentlemen over their wine after dinner, I would hereafter be telling my own adventures to an eager auditory." Most vivid in his memory was an intricately made glass ship brought home from Hamburg. The figurehead of the magical ship "fell from his perch the very day I left home to go to sea on this *my first voyage*." Things are fragile and subject to spots and stains, the rude damages of family life, but the shattering of the familiar glass beauty, named *La Reine*, adds another mournful accent, symbolic if you like, to the breakage in Melville's early life, if we consider these pages to be a recapitulation of the past feeling as they appear to be.

Nothing in Melville is more beautifully expressed than the mood of early sorrow in the forlorn passage at the opening of *Redburn*. It brings to mind the extraordinarily affecting last word in *Moby-Dick*. The word is *orphan*.

> I had learned to think much and bitterly before my time. . . . Talk not of the bitterness of middle-age and after life; a boy can feel all that, and much more, when upon his young soul the mildew has fallen; and the fruit, which with others is only blasted after ripeness, with him is nipped in the first blossom and bud. And never again can such blights be made good; they strike in too deep, and leave such a scar that the air of Paradise might not erase it.

"Such blights that can never be made good," the chastening of experience, the deathbed struggle of his father, his mother an improvident widow, his own straggling lack of a future occupation; all of these burdens formed Melville's early sense of the ambiguity, the chaos of life quite as much as the Dutch Reform Calvinism of his mother and underlined his surpassing sympathy for the pagan, the ignorant, even the evil. The black-comedy subtitle of *Redburn* is "Son-of-a-Gentleman, in the Merchant Service." A friend, seeing off the young recruit, tells the captain to take good care of him since his uncle is a senator and the boy's father had crossed the ocean many times on important business. On shore the captain appeared to take this information in an agreeable man-

ner, but once at sea he violently spurns the boy's misbegotten idea of paying a friendly visit to his cabin. In the midst of young Redburn's good manners and proper upbringing, his being the son of a Melville and a Gansevoort is a grotesque irrelevance; the truth of his life as others see it is his abject penniless-ness, his humbling ragged clothes.

He will be homesick and yet the anonymity, the nakedness of background are not unwelcome. The ocean is an escape and not a practical decision, not a job from which a young man could send money home to honor a struggling family. It is common in Melville's seagoing stories to find that once back in port the crew will be robbed of its miserable wages by the inspired accounting chicanery of the captain and the owners. Melville's first voyage did nothing to deflect the furtive position of his family when the importunate grocer, land-lord, or dressmaker knocked on the door.

Going to sea gave Melville his art, but it also set him apart by drastic experience from most of those who surrounded him. He sat at his desk dressed in a shirt and tie and went about as a gentleman, if a somewhat shabby one in the matter of clean linen as Hawthorne noted some years later. Of his seventy-two years, Melville was an active seaman for only about three and a half, but he returned from those years with an imagination peopled with the ferociously un-stable, the demonic, the miserable, the flogged and the floggers, the bestiality in the crowded befouled quarters on a U.S. Navy ship as well as on the whal-ers. Hawthorne, whom he met in the Berkshires, had spent his youth at Bow-doin College where his friends were Longfellow and Franklin Pierce, later to be president. Melville's years at sea, along with perhaps troubling sexual yearn-ings, left him a man shaded, at heart a stranger hiking about country trails, bearing children, drinking brandy and smoking cigars with those who knew the outcast as only a phantom on the streets or locked up in asylums.

The first voyage: In *Redburn*, on board the *Highlander*, as the fictional ship is named, there is a man named Jackson, one of the most loathsome portraits in Melville's fiction. About him, a descriptive vocabulary of depravity is sum-moned with a special intensity. Yellow as gamboge, bald except for hair behind his ears that looked like a worn-out shoe-brush, nose broken down the middle, a squinting eye, the foul lees and dregs of a man. Jackson is wasting away from his "infamous vices," venereal disease, and yet he is or was the best seaman on board, a bully feared by all the men, this "wolf, or starved tiger," with his "deep, subtle, infernal looking eye." He had been at sea since the age of eight and "had passed through every kind of dissipation and abandonment in the worst parts

of the world." He told "with relish" of having crewed on a slave ship where the slaves were "stowed, hue and point, like logs, and the suffocated and dead were unmanacled" and thrown overboard.

Jackson's end comes on the return voyage when the ship is off Cape Cod. He orders "haul out to windward" and with a torrent of blood gushing from his lungs falls into the sea. Melville has imagined this ruined men with a visual and moral brilliance, shown his repellent body with an awful precision, and yet consider his concluding feelings about the miserable Jackson:

> He was a Cain afloat, branded on his yellow brow with some inscrutable curse, and going about corrupting and searing every heart that beat near him. But there seemed even more woe than wickedness about the man; and his wickedness seemed to spring from his woe; and for all his hideousness, there was that in his eye at times, that was ineffably pitiable and touching; and though there were moments when I almost hated this Jackson, yet I have pitied no man as I pitied him.

Jackson's woe, Ahab's "close-coiled woe," and Melville's woe in his youth. *Redburn* was written ten years after the first journey, after the publication of the three previous books. It is a return to his voyage on the *St. Lawrence*, but he has made Redburn a boy, a lad, a shabby waif even though when he himself set sail he was nineteen years old and there is no reason to believe he came on in tatters like the men prowling the waterfront, homeless, illiterate, and wasted. Still when Melville looked back he did so as a writer and magically created Redburn for the purposes of a kind of fiction and for his memories of Liverpool, his first foreign city. The personal accent of the opening pages of grief and forlornness are so striking that they may be read as a memory of the twelve-year old Melville, the time of his father's death. Redburn carries his father's out-of-date guide to Liverpool and walks the streets in a mood of filial homage. "How differently my father must have appeared; perhaps in blue coat, buff vest, and Hessian boots. And little did he think, that a son of his would ever visit Liverpool as a poor friendless sailor-boy." What Melville's eye perceives and how his intelligence judges it were quite apart from the conventional sightseeing of the charming dandy, his father. Instead, on a Liverpool street called Launcelott's-Hey, among the dreary, dingy warehouses, Redburn hears a feeble wail that leads to a searing dirge.

In a cellar beneath the old warehouse, he sees a figure who "had been a woman." On her livid breast there are "two shrunken things like children." They have crawled into the space to die. The sailor inquires about the terri-

ble sight, questions ragged, desperate old women in the alleys. The old beggarly people, destitute themselves, are contemptuous of the ghastly family group who have had nothing to eat for three days. A policeman shrugs; the lady at Redburn's rooming house refuses help; the cook, when asked for food, "broke out in a storm of swearing." Redburn snatches some bread and cheese and drops it down the vault. Frail hands grasped at the food but were too weak to catch hold. There is a murmuring sound asking "faintly [for] something like 'water'" and Redburn runs to a tavern for a pitcher, refused unless he pays for it as he cannot. In his tarpaulin hat he draws water from Boodle Hydrants and returns to the vault.

> The two girls drank out of the hat together; looking up at me with an unalterable, idiotic expression, that almost made me faint. The woman spoke not a word, and did not stir. . . . I tried to lift the woman's head; but, feeble as she was, she seemed bent upon holding it down. Observing her arms still clasped upon her bosom, and that something seemed hidden under the rags there, a thought crossed my mind, which impelled me forcibly to withdraw her hands for a moment, when I caught a glimpse of a meager little babe, the lower part of its body thrust into an old bonnet. Its face was dazzlingly white, even in its squalor, but the closed eyes looked like balls of indigo. It must have been dead some hours. . . .

> When I went to dinner, I hurried into Launcelott's-Hey, where I found that the vault was empty. In place of the woman and children. a heap of quick-lime was glistening.

The scene of tragic extremity is composed with a rhetorical brilliance: the dying children with "eyes, and lips, and ears *like any queen*," with hearts which, "though they did not bound with blood, yet beat with a dull, dead ache that was their life"; and the dramatic insertion of pushing the mother's arm aside to reveal yet another being, a dead baby; and the return the next day to find the hole with *glistening* quicklime. Here we have the last rites, a gravestone offered for a street burial, a requiem for a hole in Launcelott's-Hey—the majestic reverence of Herman Melville.

Redburn visits the noted sights of Liverpool, hears the Chartist soapbox orators, street singers, men selling verses on current murders and other happenings; pawn shops, the impoverished dredging the river for bits of rope, the rush of life that brings to mind Dickens and also Mayhew's study of the obscure populace in *London Labour and the London Poor*. Throughout Melville's

writings there is a liberality of mind, a freedom from vulgar superstition, occa-
sions again and again for an oratorical insertion of enlightened opinion. Note
a side glance in Liverpool, written in the year 1849:

> Three or four times, I encountered our black steward, dressed very handsomely,
> and walking arm in arm with a good-looking English woman. In New York,
> such a couple would have been mobbed in three minutes; and the steward
> would have been lucky to have escaped with whole limbs. Owing to the friendly
> reception extended to them, and the unwonted immunities they enjoy in Liver-
> pool, the black cooks and stewards on American ships are very much attached
> to the place and like to make voyages to it . . . at first I was surprised that a col-
> ored man should be treated as he is in this town; but a little reflection showed
> that, after all it was but recognizing his claims to humanity and normal equal-
> ity; so that, in some things we Americans leave to other countries the carrying
> out of the principle that stands at the head of our Declaration of Independence.

Sentiment and agitation for the emancipation of the slaves was common
enough in the Northeast at the time, but Melville's "reflection" was a stretch of
opinion to include the right of a black man and a white woman to mingle as
they wished socially and, he seem to be saying, sexually. When the Civil War
arrived, Melville followed it with some distress of spirit about the slaughter.
Around the conflict he wrote, in *Battle-Pieces*, the finest of his poems.

In the docks Redburn observes the emigrants crowding into the ships to
make their way to America. Again Melville speaks:

> There was hardly any thing I witnessed in the docks that interested me more
> than the German emigrants who come on board the large New York ships sev-
> eral days before their sailing, to make everything comfortable ere starting. . . .
> And among these sober Germans, my country counts the most orderly and
> valuable of her foreign population. . . . There is something in the contemplation
> of the mode in which America has been settled, that, in a noble breast, should
> forever extinguish the prejudices of national dislikes. . . . You can not spill
> a drop of American blood without spilling the blood of the whole world. . . .
> Our blood is as the flood of the Amazon, made up of a thousand currents all
> pouring into one. We are not a nation, so much as a world; . . . we are without
> father or mother.[1]

[1]Philip Rahv, in a collection of essays, *Discovery of Europe* (Houghton Mifflin, 1947), reprints
passages from *Redburn* and comments about the description of the German emigrants: "An
extraordinarily moving celebration of the hopes lodged in the New World and one of the
noblest pleas in our literature for the extinction of national hatreds and racial prejudice" [au-
thor's note].

The last pages of *Redburn* introduce the ineffable Harry Bolton, a young Englishman met on the Liverpool docks. Bolton is perfectly formed, "with curling hair, and silken muscles.... His complexion was a mantling brunette, feminine as a girl's; his feet were small; his hands were white; and his eyes, were large, black, and womanly, and, poetry aside, his voice was as the sound of a harp." A warm friendship develops and in the fiction Redburn and Bolton go from Liverpool to London for a curious bit of private tourism. In London there is a remarkable visit to a male brothel—a strange, fastidiously observed, rococo urban landscape unlike any other dramatic intrusion in Melville's writings or in American literature at the time.

Some commentators speculate that Melville's dislike of *Redburn* was owing to his subsequent realization that he had exposed his own homoerotic longings. Whatever his unconscious or privately acknowledged feelings may have been, Melville was innocent of the instinct for self-protection on the page. The readers of his own time, the publishers and booksellers do not seem to have paused before the enthusiastic and relishing adjectives surrounding male beauty. Hershel Parker's monumental biography has gathered the reviews, and the complaint about the Harry Bolton pages is that they are an unsuitable "intrusion," largely for reasons of fictional crafting. Parker quotes an odd mention of the alliance between Redburn and Harry Bolton: "A dash of romance thrown in amongst a duster of familiar and homely incidents" is the quotation; impossible to parse except as an instance of the relaxed language and hasty reading of reviewers for the press.

In *Redburn*, the boat is in the Liverpool harbor and the crew is free to roam the city, and Melville is free to have his young hero meet the intriguing person named Harry Bolton. Bolton is lifelike as a certain type of frenzied, melodramatic young homosexual down on his luck and as such he is as embarrassing and interesting as life itself. Redburn, that is, Melville at his desk, is both accepting and suspicious of Harry, but there is everything about the encounter as told that seems to reveal either a striking innocence of heart and mind or a defiance in offering the scenes to the public. Nothing in the early parts of the novel would lead us to anticipate the extravagant, interesting, sudden dive into a richly decorated underworld.

The two meet on the streets of Liverpool and Redburn is immediately attracted. Harry is not a dumb, deadened fish in the human pool of the seamen; he is a friendly stranger, an English youth, fluent in self-creation. It is difficult

to imagine how this handsome youth with the perfectly formed legs and so on, this "delicate exotic from the conservatories of some Regent-street," came to the "potato-patches of Liverpool." In a bar, Harry will be chatting about the possibility of going to America and thus the friendship with this "incontrovertible son of a gentleman" begins. Harry will tell his story: born in the old city of Bury St. Edmunds, orphaned, but heir to a fortune of five thousand pounds. Off to the city, where with gambling sportsmen and dandies his fortune is lost to the last sovereign.

More elaboration from the new friend: embarked for Bombay as a midshipman in the East India service, claimed to have handled the masts, and was taken on board Redburn's ship which was not due to leave for a few days. Together in the roadside inns, every fascination—more news about the companion and his friendship with the Marquis of Waterford and Lady Georgiana Theresa, "the noble daughter of an anonymous earl."

Harry is stone-broke one moment, but darts away and will return with money which will provide for an astonishing trip to London. (There is no record of a trip from Liverpool to London during this early journey in 1839 nor by the time the book was published in 1849 when Melville sailed to London for the first time almost two weeks after the publication of *Redburn*.) When they alight in the city, Harry puts on a mustache and whiskers as a "precaution against being recognized by his own particular friends in London." A feverish atmosphere of hysteria and panic falls upon poor Harry and is proof of the chiaroscuro mastery with which his character and the club scene that follows are so brilliantly rendered. And fearlessly rendered in sexual images of decadence and privilege in an astonishing embrace.

The club is a "semi-public place of opulent entertainment" described in a mixture of subterranean images—Paris catacombs—and *faux* Farnese Palace decorations. In the first room entered, there is a fresco ceiling of elaborate detail. Under the gas lights it seems to the bewildered gaze of Redburn to have the glow of the "moon-lit garden of Portia at Belmont; and the gentle lovers, Lorenzo and Jessica, lurked somewhere among the vines." There are obsequious waiters dashing about, under the direction of an old man "with snow-white hair and whiskers, and in a snow-white jacket—he looked like an almond tree in blossom. . . ." In a conventional club manner, there are knots of gentlemen "with cut decanters and taper-waisted glasses, journals and cigars, before them."

Redburn, throughout the scene, is curious and alarmed by Harry's way of leaving him standing alone in this unaccountable atmosphere. They proceed to a more private room; so thick are the Persian carpets he feels he is sinking into "some reluctant, sedgy sea." Oriental ottomans "wrought into plaited serpents" and pornographic pictures "Martial and Suetonius mention as being found in the private cabinet of the Emperor Tiberius." A bust of an old man with a "mysteriously-wicked expression, and imposing silence by one thin finger over his lips. His marble mouth seemed tremulous with secrets."

Harry in a frantic return to private business suddenly puts a letter into Redburn's hand, which he is to post if Harry does not return by morning. And off he goes, but not before introducing Redburn to the attendant as young Lord Stormont. For the now terrified American, penniless son of a senator and so on, the place seemed "infected" as if "some eastern plague had been imported." The door will partly open and there will be a "tall, frantic man, with clenched hands, wildly darting through the passage, toward the stairs." On Redburn goes in images of fear and revulsion. "All the mirrors and marbles around me seemed crawling over with lizards; and I thought to myself, that though gilded and golden, the serpent of vice is a serpent still." The macabre excursion with its slithering images passes as in a tormented dream and Harry returns to say, "I am off for America; the game is up."

The relation between the two resumes its boyish pleasantries. Back on ship, Harry, in full *maquillage*, comes on deck in a "brocaded dressing-gown, embroidered slippers, and tasseled smoking-cap to stand his morning watch." When ordered to climb the rigging, he falls into a faint and it becomes clear that his account of shipping to Bombay was another handy fabrication. Nevertheless, Redburn remains faithful in friendship, and they land in New York. The chapter heading is: "Redburn and Harry, Arm and Arm, in Harbor." Redburn shows him around, introduces him to a friend in the hope of finding work, and then leaves him as he must, since he could hardly take the swain back to Lansingburgh. Years later he will learn that Harry Bolton had signed on another ship and fallen or jumped overboard.

In the novel there is another encounter, this of lyrical enthusiasm untainted by the infested London underworld. It is Carlo, "with thick clusters of tendril curls, half overhanging the brows and delicate ears." His "naked leg was beautiful to behold as any lady's arm, so soft and rounded, with infantile ease and grace." He goes through life playing his hand organ in the streets for coins.

Now, on the deck, Redburn sinks into a proxysm of joy at the sound of the "humble" music:

Play on, play on, Italian boy!... Turn hither your pensive, morning eyes... let me gaze fathoms down into thy fathomless eye.... All this could Carlo do— make, unmake me;... and join me limb to limb.... And Carlo! ill betide the voice that ever greets thee, my Italian boy, with aught but kindness; cursed the slave who ever drives thy wondrous box of sights and sounds forth from a lord- ling's door!

The scenes with Harry Bolton were not much admired; as an "intrusion," contemporary critics seemed to rebuke them for structural defects rather than for the efflorescent adjectives, the swooning intimacy of feeling for male beauty of a classical androgynous perfection that will reach its transcendence in the innocent loveliness of Billy Budd, his heartbreaking death-bed vision.

Hershel Parker, the encyclopedic biographer and tireless Melville scholar, finds no charm in the "flaccid" Harry Bolton and has interesting thoughts on why Melville was so clearly dismissive of *Redburn*, a work of enduring interest. "What he thought he was doing in it, as a young married man and a new fa- ther, is an unanswered question." And: "... Only a young and still naive man could have thought that he could write a kind of psychological autobiography ... without suffering any consequences." Parker suggests that Melville came to understand the folly of what he had written, came to acknowledge that he had revealed homosexual longings or even homosexual experience.

Parker provides another item in the atmosphere that surrounded the days and nights of the writer. At the time, there sprang up in America a group called the Come-Outers, a sect wishing to follow Paul's exhortation in II Corinthi- ans 6:17: "Wherefore come out from them, and be ye separate." It was the object of the group to reveal information ordinarily held private. Parker's re- search seems to indicate that Melville knew about the sect, but did not no- tice that he had "unwittingly joined the psychological equivalent of this new American religious sect; in mythological terms, he had opened Pandora's box when he thought he was merely describing the lid."

It is not clear whether the Come-Outers were, as in the present use of the term, to announce themselves as homosexual when such revelations were rel- evant. In the biblical text, Paul seems to be referring to Corinthians who were worshiping idols or pretending to virtues they did not practice, such as sorrow while rejoicing, pretending poverty while piling up riches.

However, if Melville rejected *Redburn* because he came to see it as an em-

barrassing and unworthy self-revelation, why did he open the pages of the subsequent *Moby-Dick* with the tender, loving union of Queequeg and Ishmael, a charming, unprecedented *Mann und Weib*? Another wonder about life and art: Where did Melville come upon the ornate and lascivious men's club he described with feral acuteness in *Redburn*? There is no record found in the cinder and ashes of Melville's jottings to bring the night journey into history. But does the blank forever erase the possibility that the extraordinary diversion actually took place? Harder to credit that Melville, in his imagination or from what is sometimes called his use and abuse of sources, was altogether free of the lush, disorienting opening of the door.

The presence of delicate, hardly seaworthy men, some in officer positions on the rigorously hierarchical sailing vessels, is an occupational puzzle that has the accent of reportage, or at least, of plausibility. In *Omoo*, Captain Guy, the commander of the ship, is not one of the usual, pipe-smoking tyrants, but an original being. He is "no more suited to sea-going than a hairdresser." In one astonishing scene, we find the captain coming from his quarters to investigate the noise of a fight. In perfect "camp" rhythm, Melville's companion, called Doctor Long Ghost, cries out, "Ah! Miss Guy, is that you? Now, my dear, go right home, or you'll get hurt." Selvagee, in *White Jacket*, with his cologne-baths, lace-bordered handkerchiefs, cravats and curling irons, although an inept sailor, is a lieutenant on a U.S. naval ship.

Jack Chase, the educated, manly friend in *White Jacket*, was an actual shipmate never to be forgotten. A man of the world, a brave, respected seaman of the foretop who recites to the winds verses from Camoëns. Yet he is something of a misfit like most sailors; he drinks and wanders the world as he will. Chase stayed in the heart, forever cherished, the only unwavering, beyond the family, friendship of Melville's life. In *White Jacket* he is addressed: "Wherever you may now be rolling over the blue billows, dear Jack! take my best love along with you, and God bless you, wherever you go!" The same sense of the beloved lost wanderer will forty years later illuminate the dedication to *Billy Budd*: "To Jack Chase, Englishman / Wherever that great heart may now be / Here on Earth or harbored in Paradise."

The beautiful Billy Budd is a foretopman, ready to climb up the rigging. He is far from the pretty street hustler Harry Bolton, for whom work under sail is a mysterious and burdensome affliction. Billy is strong, free, and innocent; an illiterate, an orphan, reminding one of a freshly hatched, brilliantly colored bird. He has the body of a Greek Hercules, with a "lingering adolescent expres-

sion in the as yet smooth face all but feminine in purity of natural complexion . . . the ear, small and shapely." In the story, Claggart, the master-at-arms, takes a violent dislike, a raging enmity, to the popular young seaman. He will accuse Billy of wanting to bring the crew to mutiny and, in a confrontation in the captain's cabin, an outraged Billy strikes a blow which kills Claggart. According to marine law, Billy must be hanged and his body cast into the sea.

Melville, in the careful examination of Claggart's soul, inserts a very modern reflection that looks beneath an unnatural enmity and finds there a twisted, jealous, thwarted love.

> When Claggart's unobserved glance happened to light on belted Billy rolling along the upper gun deck in the leisure of the second dogwatch, . . . that glance would follow the cheerful sea Hyperion with a settled meditative and melancholy expression, his eyes strangely suffused with incipient feverish tears. Then would Claggart look like the man of sorrows. Yes, and sometimes the melancholy expression would have in it a touch of soft yearning, as if Claggart could even have loved Billy but for fate and ban.

Thinking about the sharp stabs in the thicket of Claggart's character, the critic F. O. Matthiessen writes: ". . . A writer to-day would be fully aware of what may have been only latent for Melville, the animal element in Claggart's ambivalence. Even if Melville did not have this consciously in mind, it emerges for the reader now with intense psychological accuracy."

Melville married Elizabeth Shaw, the daughter of Judge Lemuel Shaw of the Massachusetts Supreme Court. They had four children, one of whom, the son Malcolm, put a gun to his head. The marriage was deeply troubled during the time Melville, in another riveting, iconographic biographical fact, was chained to his desk in the New York Custom House for nineteen years. A separation was considered but the couple persevered for forty-four years. Whether the fated meeting with Harry Bolton in *Redburn* opened a seam of private apostasy in Melville's life is not known. There are no love letters, no uncovered affairs with male or female "arm-in-arm, in harbor." The fair young men have a dreamlike quality that fades with the break of day and there we leave them.

Further Reading

The following essayists and their selected works from the sixteenth century to the end of the twentieth century beckon further study of women and the essay. With a handful of exceptions from the earliest moments of the modern essay, the authors who appear here, as elsewhere in this book, wrote in English. They are a sample—though a substantial one—of women writing essays in the long history of the genre. There are more women, more essays, in more languages to explore. Start here if you wish, but do not end here. This book is not the last word. It is part of a larger conversation on women and the essay, an invitation to join in—as a scholar, as a reader, as a lover of women's essays. There is always more to do, more to say, more to enjoy.

1500–1700

ASTELL, MARY (1666–1731)
 A Serious Proposal to the Ladies, 1694
 Some Reflections Upon Marriage, 1700
BEHN, APHRA (1640–89)
 Preface, *The Lucky Chance*, 1687
 "An Epistle to the Reader,"
 The Dutch Lover, 1673
DE GOURNAY, MARIE LE JARS
(1565–1645)
 *Preface to the Essays of Michel de
 Montaigne by his Adoptive
 Daughter, Marie le Jars
 de Gournay*, 1595
 *Apology for the Woman Writing
 and Other Works*, 1641

1701–1800

BARBAULD, ANNA LAETITIA
(1743–1825)
 Miscellaneous Pieces in Prose, 1773
CHAPONE, HESTER (1727–1801)
 *Letters on the Improvement
 of the Mind*, 1773
 Miscellanies in Prose and Verse, 1775
CHUDLEIGH, LADY MARY (1656–1710)
 *Essays Upon Several Subjects
 in Prose and Verse*, 1710
EDGEWORTH, MARIA (1768–1849)
 Letters for Literary Ladies, 1795
GRIFFITH, ELIZABETH (1727–93)
 *Essays, Addressed to Young
 Married Women*, 1782

RITCHIE, ANNE THACKERAY [LADY RITCHIE] (1837–1919)
Toilers and Spinsters and Other Essays, 1874
ROBINS, ELIZABETH (1862–1952)
Way Stations, 1913
STEPHENS, ANN SOPHIA (1810–86)
High Life in New York, 1843
STEWART, MARIA (1803–79)
Maria W. Stewart, America's First Black Woman Political Writer, 1987
STOWE, HARRIET BEECHER (1833–96)
Palmetto-Leaves, 1873
SWISSHELM, JANE (1815–84)
Letters to Country Girls, 1853
TERHUNE, MARY VIRGINIA (1830–1922)
Common Sense in the Household, 1871
TILMAN, KATHERINE DAVIS CHAPMAN (1870–1922)
The Works of Katherine Davis Chapman Tillman, 1991
WAKEFIELD, PRISCILLA (1751–1832)
Variety, or Selections and Essays, 1809

1901–2000

ABEEL, ERICA (1937–)
I'll Call You Tomorrow and Other Lies Between Men and Women, 1981
ACKERMAN, DIANE (1948–)
A Natural History of the Senses, 1990
ADDAMS, JANE (1860–1935)
Jane Addams: A Centennial Reader, 1960
ALLEN, PAULA GUNN (1939–2008)
The Sacred Hoop, 1986
ANGIER, NATALIE (1958–)
The Beauty of the Beastly, 1995
Woman, 1999

ARENDT, HANNAH (1906–1975)
Essays in Understanding 1930–1954, 1994
ASCHER, BARBARA LAZEAR (1946–)
Playing After Dark, 1986
The Habit of Loving, 1989
Dancing in the Dark, 1999
AUSTIN, MARY (1868–1934)
The Land of Little Rain, 1903
Beyond Borders, 1996
BAROLINI, HELEN (1925–)
Chiaroscuro, 1997
BARRECA, GINA (1957–)
Too Much of a Good Thing Is Wonderful, 2000
BEARD, JO ANN (1955–)
The Boys of My Youth, 1998
BLAKELY, MARY KAY (1948–)
American Mom, 1994
BLY, CAROL (1930–2007)
Letters from the Country, 1981
BOGAN, LOUISE (1897–1970)
Selected Criticism, 1955
BOMBECK, ERMA (1927–96)
The Best of Bombeck, 1972
BONNER, MARITA (1899–1971)
Frye Street and Environs, 1987
BORICH, BARRIE JEAN (1959–)
Restoring the Color of Roses, 1993
BRENNAN, MAEVE (1917–93)
The Long-Winded Lady, 1969
CANTWELL, MARY (1930–2000)
American Girl, 1992
CARTER, ANGELA (1940–92)
Nothing Sacred, 1982
Expletives Deleted, 1992
CASTILLO, ANA (1953–)
Massacre of the Dreamers, 1994
CLARK, ELEANOR (1913–96)
Rome and a Villa, 1952

CLEGHORN, SARAH N. (1876–1959)
The Seamless Robe, 1945
CROCE, ARLENE (1934–)
Writing in the Dark, Dancing in the "New Yorker," 2000
DEEN, ROSEMARY (192?–)
Naming the Light, 1997
DINNERSTEIN, DOROTHY (1923–92)
The Mermaid and the Minotaur, 1976
DUNBAR-NELSON, ALICE RUTH MOORE (1875–1935)
The Works of Alice Dunbar-Nelson, 1988
EHRENREICH, BARBARA (1941–)
The Snarling Citizen, 1995
ELEANORE, SISTER MARY (1890–1940)
Certitudes, 1927
EPHRON, NORA (1941–2012)
Crazy Salad, 1975
FAR, SUI SIN [EDITH MAUDE EATON] (1865–1914)
Mrs. Spring Fragrance & Other Writings, 1995
GALLAGHER, MAGGIE (1960–)
Enemies of Eros, 1989
GILMAN, CHARLOTTE PERKINS (1860–1935)
The Home: Its Work and Influence, 1903
GIOVANNI, NIKKI (1943–)
Sacred Cows . . . and Other Edibles, 1988
Racism 101, 1994
GLASGOW, ELLEN (1873–1945)
A Certain Measure, 1943
GOMEZ, JEWELLE (1948–)
Forty-Three Septembers, 1993
GOODMAN, ELLEN (1941–)
Close to Home, 1979
Value Judgments, 1993

GORDON, MARY (1949–)
Good Boys and Dead Girls, 1992
Seeing Through Place, 2000
GORNICK, VIVIAN (1935–)
Approaching Eye Level, 1996
GRAY, FRANCINE DU PLESSIX (1930–)
Adam & Eve and the City, 1987
GREELY, LUCY (1963–2002)
As Seen on TV, 2000
GREEN, DOROTHY AUCHTERLONIE (1915–91)
The Music of Love, 1983
GRIFFIN, SUSAN (1943–)
The Eros of Everyday Life, 1995
HAHN, EMILY (1905–97)
On the Side of the Apes, 1971
HAIGHT, ELIZABETH HAZELTON (1872–1964)
Essays on Ancient Fiction, 1936
Essays of the Greek Romances, 1943
HAMPL, PATRICIA (1946–)
I Could Tell You Stories, 1999
HARRISON, BARBARA GRIZZUTI (1934–2002)
Off Center, 1980
The Astonishing World, 1992
HARRISON, JANE ELLEN (1850–1928)
Alpha and Omega, 1915
HASSELSTROM, LINDA (1943–)
Land Circle, 1991
HIESTAND, EMILY (1947–)
Angela the Upside Down Girl, and Other Domestic Travels, 1998
HOOKS, BELL (1952–)
Talking Back, 1989
Outlaw Culture, 1994
HOLTBY, WINIFRED (1898–1935)
Women and a Changing Civilisation, 1936
HOUSTON, PAM (1962–)
A Little More About Me, 1999

HOWE, SUSAN (1937–)
My Emily Dickinson, 1985
The Birth-Mark, 1993
HUBBELL, SUE (1935–)
On This Hilltop, 1991
*Broadsides from the Other
Orders*, 1993
Far Flung Hubbell, 1995
Waiting for Aphrodite, 1999
HUSTVEDT, SIRI (1955–)
Yonder, 1998
HUXTABLE, ADA LOUISE (1921–2013)
Architecture Anyone?, 1986
IVINS, MOLLY (1944–2007)
*Molly Ivins Can't Say That,
Can She?*, 1991
Nothin' But Good Times Ahead, 1993
JOHNSON, DIANE (1934–)
Terrorists and Novelists, 1982
JORDAN, JUNE (1936–2002)
Civil Wars, 1981
Moving Towards Home, 1989
Affirmative Acts, 1998
KAEL, PAULINE (1919–2001)
Deeper into Movies, 1973
Movie Love, 1991
KAPPEL-SMITH, DIANE (1951–)
Night Life, 1990
Desert Time, 1992
KING, FLORENCE (1936–2016)
The Florence King Reader, 1995
KINGSOLVER, BARBARA (1952–)
High Tide in Tucson, 1995
KINGSTON, MAXINE HONG (1940–)
Hawai'i One Summer, 1987
KIRKLAND, WINIFRED MARGARETTA
(1872–1943)
*The Joys of Being a Woman
and Other Papers*, 1918
*The View Vertical and
Other Essays*, 1920

KITCHEN, JUDITH (1941–2014)
Only the Dance, 1994
KRAMER, JANE (1938–)
Europeans, 1988
LAMOTT, ANNIE (1954–)
Traveling Mercies, 1999
LAWRENCE, ELIZABETH (1904–1985)
Gardening for Love, 1987
LE GUIN, URSULA K. (1929–2018)
*Dreams Must Explain
Themselves*, 1975
Dancing at the Edge of the World, 1989
LESSING, DORIS (1919–2013)
A Small Personal Voice, 1975
LEVERTOV, DENISE (1923–97)
Light Up the Cave, 1981
New & Selected Essays, 1992
LIMB, SUE (1946–)
Out on a Limb, 1999
LOH, SANDRA TSING (1962–)
Depth Takes a Holiday, 1996
LORDE, AUDRE (1934–92)
The Audre Lorde Compendium, 1996
MACAULAY, ROSE (1881–1958)
Catchwords and Claptrap, 1926
Personal Pleasures, 1935
MADELEVA, SISTER MARY (1887–1964)
*Chaucer's Nuns, and
Other Essays*, 1925
MAIRS, NANCY (1943–2016)
Plaintext, 1986
Ordinary Time, 1993
MASO, CAROLE (1956–)
Break Every Rule, 2000
MCCARTHY, MARY (1912–89)
Occasional Prose, 1985
MITFORD, NANCY (1904–73)
The Water Beetle, 1962
A Talent to Annoy, 1986
MORA, PAT (1942–)
Nepantla, 1993

MORAGA, CHERRIE (1952–)
Loving in the War Years, 1983
NYE, NAOMI SHIHAB (1952–)
Never in a Hurry, 1996
O'CONNOR, FLANNERY (1925–64)
Mystery and Manners, 1969
OLIVER, MARY (1935–)
Winter Hours, 1999
OLSEN, TILLIE (1912–2007)
Silences, 1978
ORLEAN, SUSAN (1955–)
The Bullfighter Checks Her Makeup, 2000
OSLER, MIRABEL (1925–2016)
A Gentle Plea for Chaos, 1989
A Breath from Elsewhere, 1997
OSTRIKER, ALICIA (1937–)
Dancing at the Devil's Party, 2000
PAGLIA, CAMILLE (1947–)
Sex, Art, and American Culture, 1992
Vamps & Tramps, 1994
PARKER, DOROTHY R. (1893–1967)
Constant Reader, 1970
PEMBERTON, GAYLE (1948–)
The Hottest Water in Chicago, 1992
PERÉNYI, ELEANOR (1918–2009)
Green Thoughts, 2002
POGREBIN, LETTY COTTIN (1939–)
Column in the *Ladies' Home Journal*:
"The Working Woman," 1971–81
POLLIT, KATHA (1949–)
Reasonable Creatures, 1994
PORTER, KATHERINE ANNE (1890–1980)
The Days Before, 1952
The Collected Essays and Occasional Writings of Katherine Anne Porter, 1970
PRATT, MINNIE BRUCE (1946–)
Rebellion, 1991

QUINDLEN, ANNA (1953–)
Living Out Loud, 1988
RAVER, ANNE (?–)
Deep in the Green, 1995
RHYS, GRACE (1865–1929)
About Many Things, 1920
A Book of Grace, 1930
RICH, ADRIENNE (1929–2012)
On Lies, Secrets, and Silence, 1979
ROBINS, ELIZABETH (1862–1952)
Way Stations, 1913
ROBINSON, MARILYNNE (1943–)
The Death of Adam, 1998
ROOSEVELT, ELEANOR (1884–1962)
What I Hope to Leave Behind, 1995
ROSE, PHYLLIS (1942–)
Never Say Goodbye, 1991
RUGG, AKUA (1946–)
Brickbats & Bouquets, 1984
ROSS, LILLIAN (1927–2017)
Reporting, 1964
Talk Stories, 1966
Takes, 1983
SACKVILLE-WEST, VITA (1892–1962)
Country Notes in Wartime, 1940
In Your Garden, 1951
SARTON, MAY (1912–95)
I Knew a Phoenix, 1959
A World of Light, 1976
SAYERS, DOROTHY (1893–1957)
Creed or Chaos?, 1940
Unpopular Opinions, 1946
SCOTT, GAIL (1945–)
Spaces Like Stairs, 1989
SILKO, LESLIE MARMON (1948–)
Yellow Woman and a Beauty of the Spirit, 1996
SLATER, LAUREN (1963–)
Welcome to My Country, 1996

STANTON, ELIZABETH CADY
(1815–1902)
*Elizabeth Cady Stanton as
Revealed in Her Letters, Diary,
and Reminiscences,* 1922
STEINEM, GLORIA (1934–)
*Outrageous Acts and Everyday
Rebellions,* 1983
THEOROUX, PHYLLIS (1939–)
Peripheral Visions, 1982
TISDALE, SALLIE (1957–)
Talk Dirty to Me, 1994
TOTH, SUSAN ALLEN (1940–)
*How to Prepare for Your High
School Reunion, and Other
Midlife Musings,* 1988
England for all Seasons, 1997
TRILLING, DIANA (1905–96)
Claremont Essays, 1964
We Must March My Darlings, 1977
TUCHMAN, BARBARA (1912–89)
Practicing History, 1981
ULLMAN, ELLEN (CA. 1950–)
Close to the Machine, 1997
VOWELL, SARAH (1969–)
Take the Cannoli, 2000
WHARTON, EDITH (1862–1937)
*French Ways and Their
Meanings,* 1919
In Morocco, 1920

WELDON, FAY (1931–)
Godless in Eden, 1999
WELTY, EUDORA (1909–2001)
The Eye of the Story, 1978
A Writer's Eye, 1994
WHITE, BAILEY (1950–)
Mama Makes Up Her Mind, 1993
Sleeping at the Starlite Motel, 1995
WHITE, KATHARINE S. (1892–1977)
*Onward and Upward in
the Garden,* 1979
WILDER, LOUISE BEEBE (1878–1938)
My Garden, 1916
WILLIAMS, PATRICIA J. (1951–)
The Alchemy of Race and Rights,
1991
The Rooster's Egg, 1995
WILLIAMS, TERRY TEMPEST (1955–)
An Unspoken Hunger, 1995
WILLIS, ELLEN (1941–2006)
Beginning to See the Light, 1992
No More Nice Girls, 1992
WORDSWORTH, ELIZABETH
(1840–1932)
Essays Old and New, 1919
WYMAN, LILLIE BUFFUM CHACE
(1847–1929)
American Chivalry, 1913
ZWINGER, ANN (1925–2014)
Shaped by Wind and Water, 2000

BIBLIOGRAPHY

Bacon, Francis. *The Essays of Francis Bacon*, edited by Clark Sutherland Northup. Boston: Houghton Mifflin, 1908.

Ballard, George. "Margaret Duchess of Newcastle." In *Memoirs of Several Ladies of Great Britain*. Oxford, 1752.

Bauschatz, Cathleen M. "Imitation, Writing, and Self-Study in Marie de Gournay's 1595 'Préface' to Montaigne's *Essais*." In *Contending Kingdoms: Historical, Psychological, and Feminist Approaches to the Literature of Sixteenth-Century England and France*, edited by Marie-Rose Logan and Peter L. Rudnytsky. Detroit: Wayne State University Press, 1991, pp. 346–64.

Baym, Nina. Introduction. In *The Gleaner*, by Judith Sargent Murray. Schenectady, N.Y.: Union College Press, 1992, pp. iii–xx.

Bloom, Lynn Z. "The Essay Canon." *College English* 61, no. 4 (1999): 401–30.

Braxton, Joanne. Introduction. In *The Work of the Afro-American Woman, by Mrs. N. F. Mossell*. New York: Oxford University Press, 1988, pp. xxvii–xlii.

Brown, Sterling A., Arthur P. Davis, and Ulysses Lee, editors. *The Negro Caravan: Writings by American Negroes*. New York: Arno, 1969.

Cavendish, Margaret. *The World's Olio*. London, 1655.

Child, Lydia Maria. *Letters from New-York*. New York, 1843.

Cobbe, Frances Power. *Life of Frances Power Cobbe*, 3rd ed., vol. 2. London, 1894.

DuPlessis, Rachel Blau. "*f*-Words: An Essay of the Essay." *American Literature* 68, no. 1 (1996): 15–45.

Fern, Fanny. "Gail Hamilton—Miss Dodge." *Eminent Women of the Age: Being Narratives of the Lives and Deeds of the Most Prominent Women of the Present Generation*, edited by James Parton. Hartford, Conn., 1869, pp. 202–20.

Gass, William. "Emerson and the Essay." In *Habitations of the Word: Essays*. New York: Simon and Schuster, 1985, pp. 9–49.

Gerould, Katharine Fullerton. "An Essay on Essays." *North American Review* 240, no. 3 (1935): 409–18.

Good, Graham. *The Observing Self: Rediscovering the Essay*. New York: Routledge, 1988.

Gournay, Marie le Jars de. *Preface to the Essays of Michel de Montaigne by His Adoptive Daughter, Marie le Jars de Gournay*, edited and translated by Colette Quesnel, Richard Hillman, and Francois Rigolot. Tempe, Ariz.: Medieval and Renaissance Texts and Studies, 1998.

Halsband, Robert. Introduction. In *Lady Mary Wortley Montagu: Essays and Poems and "Simplicity," a Comedy*, edited by Halsband and Isobel Grundy. Oxford: Oxford University Press, 1993, pp. 3–5.

Hillman, Richard. "Introduction to Marie le Jars de Gournay (1565–1645)." In *Marie le Jars de Gournay: Apology for the Woman Writing and Other Works*, edited and translated by Hillman and Colette Quesnel. Chicago: University of Chicago Press, 2002, pp. 3–20.

Joeres, Ruth-Ellen Boetcher, and Elizabeth Mittman. *The Politics of the Essay: Feminist Perspectives*. Bloomington: Indiana University Press, 1993.

Mack, Phyllis. "Women and the Enlightenment: Introduction." In *Women and the Enlightenment*, edited by Margaret Hunt, et al. Binghamton, N.Y.: Haworth, 1984.

Marchalonis, Shirley. "Women Writers and the Assumption of Authority: The *Atlantic Monthly*, 1857–1898." In *In Her Own Voice*, edited by Sherry Lee Linkon. New York: Garland, 1997, pp. 3–26.

Montaigne, Michel de. *The Complete Essays of Montaigne*. Translated by Donald M. Frame. Stanford, Calif.: Stanford University Press, 1958.

Moody-Turner, Shirley. "'Dear Doctor Du Bois': Anna Julia Cooper, W. E. B. Du Bois, and the Gender Politics of Black Publishing." *MELUS* 40, no. 3 (2015): 47–68.

Morley, Christopher, editor. *Modern Essays*. Harcourt, 1921.

Ocasio, Rafael. Interview with Judith Ortiz Cofer. *Callaloo* 17, no. 3 (1994): 730–42.

Ozick, Cynthia. "She: Portrait of the Essay as a Warm Body." In *Quarrel & Quandary*. New York: Knopf, 2000, pp. 178–87.

Stanton, Donna C. "Autogynography: Is the Subject Different?" In *The Female Autograph: Theory and Practice of Autobiography from the Tenth to the Twentieth Century*, edited by Stanton. Chicago: University of Chicago Press, 1987, pp. 3–20.

Stephen, Leslie. "The Essayists." *Cornhill Magazine* 44 (September 1881): 278–97.

Stokes, George Stewart. *Agnes Repplier: Lady of Letters*. Philadelphia: University of Pennsylvania Press, 1949.

Suzuki, Mihoko. "The Essay Form as Critique: Reading Cavendish's *The World's Olio* through Montaigne and Bacon (and Adorno)." *Prose Studies* 22, no. 3 (1999): 1–16.

Tierney, James E. "The Study of the Eighteenth-Century British Periodical: Problems and Progress." *Papers of the Bibliographical Society of America* 69 (1975): 165–86.

Waldman, Katy. "Is Nonfiction the Patriarch of Literary Genres?" *Slate*, 17 Sept. 2014.

Whitmore, Charles. "The Field of the Essay." *PMLA* 36 (1921): 551–64.

Woolf, Virginia. "The Duchess of Newcastle." In *The Common Reader*, edited by Andrew McNeillie. New York: Harcourt, 1984, pp. 69–77.

———. "The Modern Essay." *The Common Reader*, edited by Andrew McNeillie. New York: Harcourt, 1984, pp. 211–22.

———. "Montaigne." *The Common Reader*, edited by Andrew McNeillie. New York: Harcourt, 1984, pp. 58–68.

———. *A Room of One's Own*. 1929. Reprint, New York: Harcourt, 1989.

Wright, Nazera Sadiq. *Black Girlhood in the Nineteenth Century*. Urbana: University of Illinois Press, 2016.

PERMISSIONS AND CREDITS

The editor and publisher are grateful for permission to include the following copyrighted material in this volume.